Completely revised and updated

Presentation Techniques

Completely revised and updated

Presentation Techniques

A guide to drawing and presenting design ideas

Dick Powell

LITTLE, BROWN AND COMPANY
Boston New York Toronto London

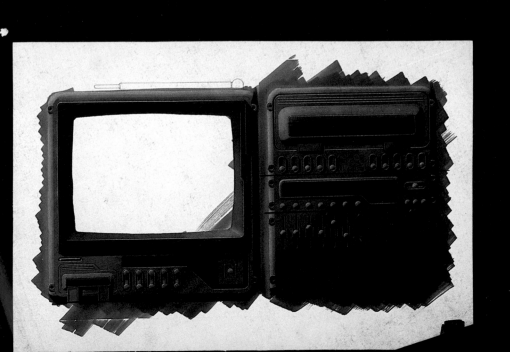

*For Lucy, Jemma, Oscar
and Freddie*

Author's Acknowledgments
Special thanks to Ed Holt and Henry Arden for all the photographic sessions; to Richard Seymour for help and support; and to Norbert Linke of General Electric Plastics; Peter Naqelkerke of Philips BV, and Henry Kleyn van Willigen of Yamaha Motors NV for permission to use their drawings. Special thanks also to those people who gave up their time to create stage-by-stage examples, and to those who spent time sourcing and supplying gallery material.

Thanks also to all the companies who supplied graphics products, especially Royal Sovereign for Magic Markers and 3M for the tapes used in the full-size tape drawings. Finally, thanks to Colin Grant and Mike Wade for helping to put the first edition together; and to Muffy Dodson, Mike Wade and the team at Macdonald for their assistance with this revised edition.

Picture Credits
All drawings were done by the author except for those credited otherwise, the line drawings on p.14 (coloured by the author), pp. 28-39 and pp. 51-61, which were done by Geoff Dicks, and the illustrations on pp. 152, 153 and 155. which were done by Richard Seymour. The illustration on p.7 was supplied by the Midland Bank plc and that on p.8 bottom courtesy of the Frank Lloyd Wright Memorial Foundation. Special photography was done by Ed Holt and Henry Arden.

Pictures on pages 1, 2, 3, and 5:
Four finished presentation boards showing rendered elevations of a hi-fi stack. (see pages 86-7).

A LITTLE, BROWN BOOK

© 1985 by Dick Powell
First published in Great Britain by
Orbis Publishing Limited, London 1985

Reprinted 1986, 1987, 1988
by Macdonald & Co (Publishers) Ltd

This edition reprinted in 1994, 1995
by Little, Brown and Company (UK)

British Library Cataloguing in Publication Data

Powell, Dick
 Presentation techniques, a guide to drawing
 and presenting design ideas.
 1. Design, Industrial
 I. Title
 745.2 TS171

Little, Brown and Company (UK)
Brettenham House
Lancaster Place
London
WC2E 7EN

Colour reproduction by Imago Publishing Ltd.

Printed in Italy
ISBN: 0 316 91243 3

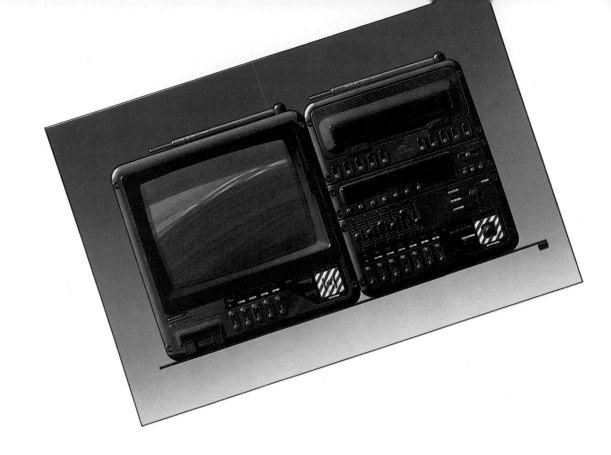

Contents

1 Introduction

Design is the creative process which brings ideas to reality. To help meet this challenge, the industrial designer needs to master a wide range of skills from clear, concise report-writing to modelmaking — and all backed up by an extensive understanding of materials and manufacturing processes. But, whatever the level of involvement, from the conceptual thinking behind an innovative new product to the resolution of a difficult moulding problem, the designer will invariably find that, of all these skills, the most important is drawing.

An industrial designer who cannot draw is certainly less efficient and almost always less creative than one who can. Yet, surprisingly, drawing is one of the forgotten subjects of design education, a casualty of the designer's bid for a recognized place in the commercial world. Mistakenly seen by many as an anachronistic indulgence in the fine arts, drawing is *the* basic tool of the industrial designer's trade. Without this skill, too many designers are forced to design only what they can draw, rather than draw what they can design.

Industrial design is a three-dimensional discipline by definition, but unlike a graphic artist who both conceives and executes ideas in two dimensions, the industrial designer must shift first from a three-dimensional idea to a two-dimensional sketch, and then back again to a three-dimensional model. If you can communicate your design ideas well to others, you are also better equipped to communicate them to yourself; you can, so-to-speak, hold a conversation with yourself as you work, shifting quickly and easily from drawing to drawing as an idea develops, and keeping pace with the speed of your own thinking. During the early phases of a design project, this skill allows you to sift through, and sort out, a huge number of potential opportunities, while your less adept colleagues may still be mocking up their first ideas and discovering where they can be improved. Wherever product appearance is an important factor, drawing skills become indispensable in the resolution of complex forms and in bringing them to a stage where they can be modelled. The more a designer exercises these skills, the better he or she will become at product styling, and the better able to visualize and understand ideas as they develop.

It is a hard task indeed to *teach* people to draw; it is, however, an ability that can be developed by careful nurturing and constant practice, particularly by drawing from life. Drawing from life teaches you to look, and to analyse the way you see things, and to understand why the world looks the way it does and, in so doing, understand why one thing can support another, and why some things look more harmonious than others. This book will not be of much use to those who cannot draw at all but is aimed squarely at those who have the ability but lack the basic techniques which can help them to present their ideas to others.

In every design project you tackle, you will need to present your ideas to a client or colleague. For many, presentation can be an intimidating and difficult task, and the less it is done, the more difficult it becomes. What ought to be a natural transition from a working to a presentation drawing becomes a major obstacle to be overcome simply through lack of confidence and ignorance of techniques. This book will bring you up to date with the techniques and, once your confidence is boosted by a little practice, it should be possible to bring about a really significant improvement in the standard of your presentation drawing. One of the best ways of developing such abilities is to analyse finished drawings and see how different techniques are used in practice. For this reason many chapters in this book feature stage-by-stage illustrations, which show in detail how an image is built up, and conclude with gallery sections of finished work, which provide further opportunity for analysis. It should thus prove useful for students and professionals alike, both as basic instruction and as a glossary to refer to when faced with the task of presenting ideas.

History

The 'presentation drawing' goes back to a time when a patron commissioned an artist, craftsman or architect to create an artefact to his specification: a piece of sculpture, a building, a piece of furniture, a monument or whatever. Then, as now, the designer had to show the patron, as best he could, what the end result would look like. Technical drawings apart (which were of course the actual reference for the builders), these presentation drawings started life as pencil sketches and, principally in architecture, developed apace as technical drawing skills progressed using line-work. No real presentation drawings were possible until the advent of perspective during the Renaissance, which, for the first time, gave the patron or client a real chance of understanding an object in three dimensions. It was principally in architecture that these skills were developed with the generation of perspective systems to help the draughtsman accurately define what his building would look like. There have been many books on architectural rendering with some truly superb examples (like the Sir Edward Lutyens/Cyril Farey and Frank Lloyd Wright illustrations shown here), which the serious industrial design student should refer to. It was, however, only with the dawn of the Industrial Revolution that the subject matter of this book began to emerge as a definitive skill.

Wherever goods were to be mass-produced, there were draughtsmen producing the technical drawings from which the tools and dies could be made, and the product produced. The patron, customer, client or manager, however, usually lacked the skill needed to 'read' these drawings and therefore understand what the product would be like *before* it was actually made. Architects

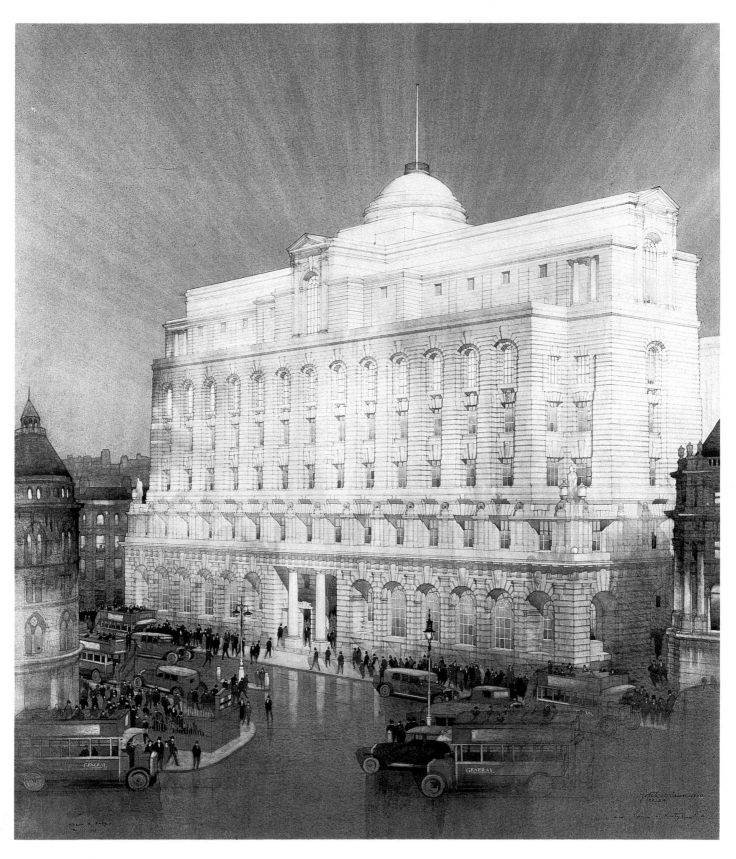

A superb water-colour perspective (1925) by
Cyril Farey of Sir Edwin Lutyens's design for
the Midland Bank's head office, Poultry,
London, completed in 1939.

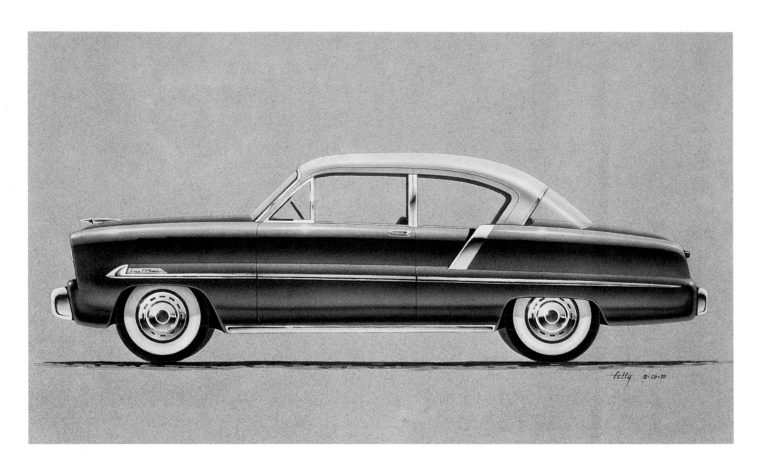

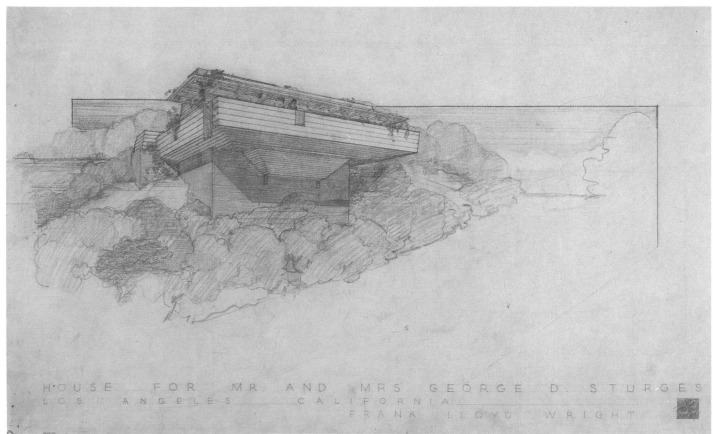

HOUSE FOR MR. AND MRS. GEORGE D. STURGES
LOS ANGELES CALIFORNIA
FRANK LLOYD WRIGHT

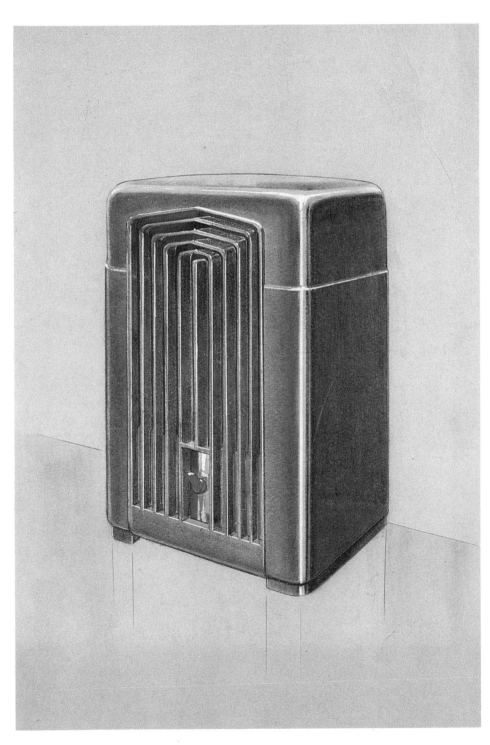

and artists, who had the necessary design and drawing skills, were called in both to improve the appearance of the product and to illustrate it so that others could understand. As the industrial design profession nervously got underway, drawing became central to the designer's role.

We can see the results of the work of these early designers, but few examples of their drawings survive because then, as now, once the product is in the marketplace, the drawing has fulfilled its purpose and can be thrown away. Most early examples were done in pencil or ink, with a water-colour wash, or perhaps, later on, with coloured crayons. Paint was the favoured medium for a long time, and was usually applied with a brush. The airbrush became very popular with designers in the late fifties and early sixties, before the advent of the marker in the mid-sixties. Since then, the marker has dominated, and only looks like being overtaken by the sharp rise in computer graphics. The technical explosion in electronics is making computers accessible to all, and the vast increases in processing power and memory will bring sophisticated drawing programs within the reach of all designers before very long. Once that happens, traditional rendering skills may disappear as the new media take off. However, make no mistake, whether the object in the hand is a coloured pencil, a marker or a computer control, the basic design and visualizing skills needed to use them effectively remain the same.

As well as the techniques and media changing over the years, rendering itself has rather gone out of fashion. The early industrial designers were involved in product design only peripherally, primarily as stylists. They soon discovered, however, that in order to be effective, they needed a deeper understanding of production techniques, engineering, marketing, ergonomics and so on. This experience with, and general appreciation of, all aspects of product development, coupled to a natural creativity, made the designer into an effective problem solver and innovator. As this role developed, designers have found themselves responsible to both client and consumer, sorting out ergonomic, safety and performance factors to satisfy both parties. This new and wider role brought with it a much improved professional status, partly because the ability to rationalize and quantify is more tangible (and, incidentally, more bankable) than the ability to articulate and resolve aesthetic problems. Certainly, this new responsibility gave designers much needed access to the real decision makers,

Opposite page, top: *US car rendering, dated 29 December 1950, drawn by a Mr Fetty and probably originating from the Ford styling studio at Dearborn near Detroit. The drawing is done with gouache directly on to coloured Ingres paper. Using mainly an airbrush for the larger areas of colour and modelling of the bodyside shape, details have been added with a brush and crayons.*

Above: *A Raymond Loewy design for a moulded fan heater (1938) for GEC. Pencil, gouache and charcoal on grey paper.*

Opposite page, bottom: *A perspective drawing (1939) by Frank Lloyd Wright of the Sturges House, California, done with pencil and coloured crayons on tracing paper mounted to board.*

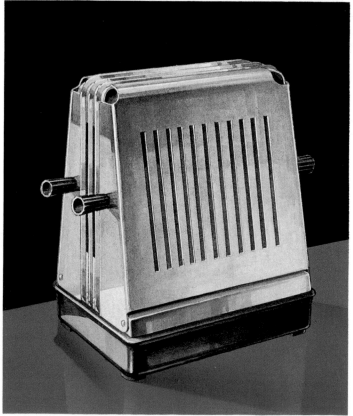

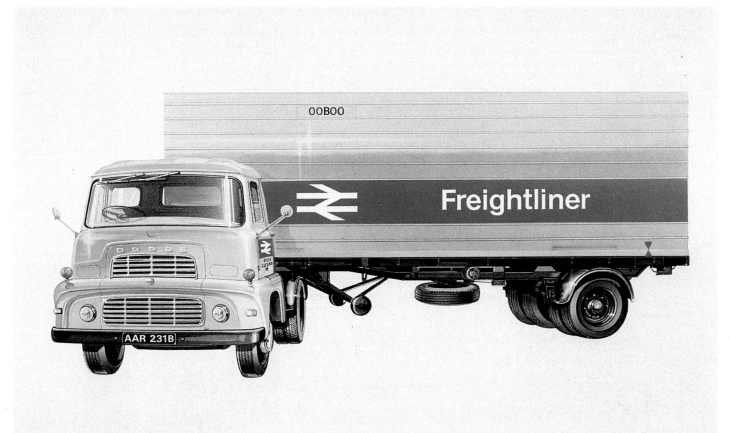

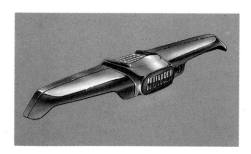

Above: *Humber Super Snipe rear badge and tailgate lift (c. 1950). Drawn by Hugo G. Poole working for the Humber division of the Rootes Group in the UK. It is done with a combination of techniques – mainly gouache but also with some crayon and pen work.*

Opposite page, top: *Sports car for General Motors (1962) – designer unknown. Crayon and gouache on black card.*

Opposite page, left: *A presentation drawing by Raymond Loewy – a design for a fan heater (1938). Pencil on tracing paper mounted to card.*

Opposite page, bottom right: *Electric toaster (1957) – designer unknown. Water-colour on board with airbrushed background.*

but in the process of acquiring respectability they have tended to lose their early artistic roots. This has been reflected in the colleges where model-making skills have assumed far greater importance than drawing skills.

It is through the model, of course, that an idea reaches three dimensions for the first time, and both designer and client can truly assess the design. A rendering *can never* be a substitute for a model and it is a fool who goes straight to tooling without investing in a model first (many have done it and learnt the hard way!). Good quality models, however, cost a lot of money and take time to produce, making it uneconomical to produce more than one or two. The making of a model can also commit the designer to a layout, proportion and style at a very early stage in the design process; in the eyes of the client, the job appears nearly finished, leaving the designer with limited options. With good quality visuals, on the other hand, the designer can give the client many directions and illustrate specific trade-offs between, for example, cost and appearance. Once a favoured direction emerges the designer can then track as rapidly as possible to models, ensuring at the same time that all the technical, ergonomic and user problems have been correctly addressed.

Partly as a result of the economic downturn in the late seventies, clients have been less and less able to afford endless models, and so rendering skills are, once again, becoming more important. The public perception of 'design' has also undergone an important change during the late eighties as consumers recognize its benefits and in turn put pressure on manufacturers to provide well-designed good. This trend will probably continue because of the huge diversification of product lines to suit smaller and smaller market segments; instead of one portable radio, companies will now produce several versions, each aimed at a particular type of person with his or her own lifestyle. This diversification is re-emphasizing styling (or 'appearance design') skills which, in turn, bring drawing and rendering skills back into focus again.

Top: *Livery for British Rail Freightliner container lorry by Don Tustin (1963). Gouache and brush onto board, with the container itself and the slight screen reflection airbrushed.*

2 Materials

There is a bewildering choice of drawing materials available and every designer has his or her preferences for this or that particular product. Having established that one works well and suits his or her particular style, a designer will stay with it and avoid picking up an alternative brand which might introduce a new, unforeseen effect at the wrong moment. Seasoned designers will need no advice on what to use, but for the newcomer it is often difficult, especially with a limited budget, to know what to buy.

It seems obvious to say so, but do buy the best available and learn how to look after your materials. Too many students, faced with a low budget, buy second-rate products which make an already difficult task even harder. What follows is a personal appraisal of currently available materials which I use, how they work and what to look out for.

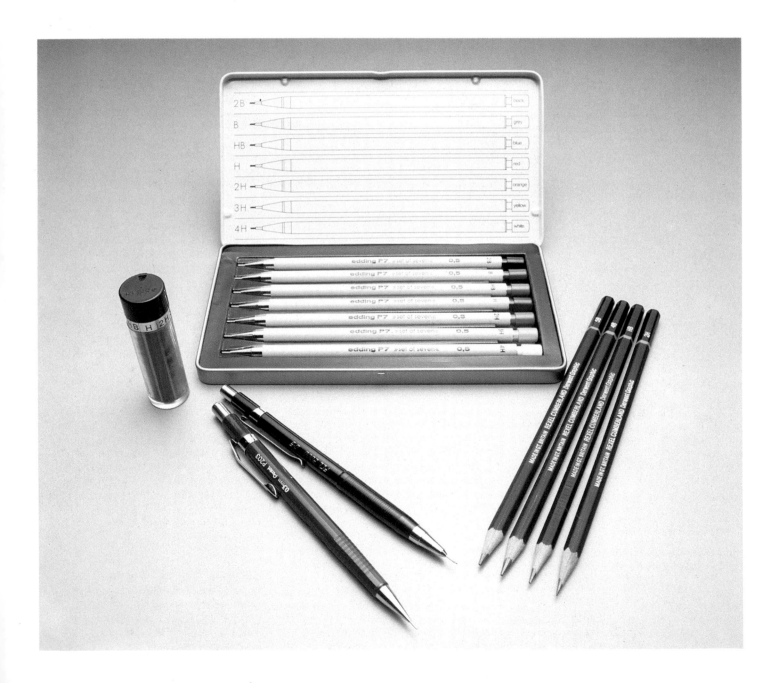

Pencils

Pencils are the most commonly used drawing tool and have been for centuries. They are flexible, versatile and easy to rub out, and there is one for every kind of drawing. Some, like propelling pencils, were developed for drafting work but are also used for sketching. For working up ideas and sketching I prefer to use coloured pencils (see p. 17), despite their drawback of being difficult to erase.

Traditional pencils

Traditional wooden pencils are available in a range of hardnesses – nineteen in all – from 9H (very hard) to 8B (very soft). They are excellent for freehand sketching but tedious to keep sharp. I only ever use them for drawing from life because they are more sensitive to changes of pressure and angle.

Clutch pencils

Clutch pencils accept a range of leads in different degrees of hardness and in different colours. Pushing the button on the top releases the lead and allows it to be drawn out as the lead is used up and withdrawn into the barrel when not in use. A special sharpener is needed, so these have some of the disadvantages of traditional wooden pencils without their advantages of light weight and sensitivity.

Propelling pencils

Propelling pencils are similar to clutch pencils but with very fine leads available in four sizes (0.3, 0.5, 0.7 and 0.9mm) and several degrees of hardness. The leads are fine enough to obviate the need for sharpening. For most drawing purposes avoid heavy-duty or status-symbol pencils with self-propelling and auto-retract features and go for a lightweight construction with a smooth round profile; this makes them easy to revolve on long lines to obtain an even finish. I keep a boxed set of 0.5mm pencils with seven degrees of hardness 2B, B, HB, 2H, 3H, 4H, which are indispensable for working up a perspective from sketch through to finished drawing.

Traditional wooden pencils are hard to beat for flexibility of line and shading but, of course, need constant sharpening. Many designers sketch with propelling pencils (left) although these are really more suitable for drafting. In the background are the Edding 'set of seven' pencils (together with refills), which are best kept together in their box. They come in a range of hardnesses from 2B to 4H and are light and a pleasure to use.

Papers and Boards

Layout paper

The designer's stock in trade, layout paper, is available in A-size pads and rolls in a selection of weights and types. Layout paper is ideal for setting up a perspective drawing because the drawing can be built up using underlays. The paper's slight opacity cuts out unwanted construction lines and yet is transparent enough for tracing through; it is also ideal for use with markers. The lighter the paper, the flatter the finish that can be obtained with the marker and unfortunately, unless coated, the more sheets under the top sheet will be ruined. To prevent this, some layout papers, like Letrapads, are coated on the underside to prevent bleeding through. These are sufficiently translucent to allow tracing through but give much greater brilliance because the colour is retained in the top sheet rather than being shared between two or three. On the negative side, their surface peels off very easily under masking tape and can sometimes break up under repeated marker application. With this type of pad you must also be careful, if you tear a sheet out, not to use the reverse side, as the coating makes it useless for working on.

Your choice of paper will depend on the type of finish you want; some designers prefer a lot of bleed and others like a tight finish. Surprisingly, there are enormous differences between brands; some are better than others and some respond better to one brand of marker than anyone. I keep two types of pad for everyday use: one (Frisk Studio 45 Layout) which is lightweight and translucent, for working up ideas and underlays, and the other (Letrapad) which is bleedproof and very white although still transparent enough to see through, for finished drawings. Because of its white finish and bleedproof characteristics this paper brings out the best in markers and gives a great deal of depth and brilliance to the colours.

Coloured paper

Much depends on the type of drawing but I nearly always use Ingres paper because it accepts marker as well as pastel and crayon and is available in a wide range of colours. Like all fairly thick papers it absorbs marker quickly, which makes it difficult to obtain a flat finish. Ingres paper usually has a smooth finish on one side and a slightly corrugated finish on the other; unless you want a rougher texture, always use the smooth side.

Boards

For airbrush work I prefer a heavy (six-sheet) board with a smooth, hard surface which will not be disturbed by the removal of adhesive masks and will also allow mistakes to be scratched out. This type of hard-surface board, such as Frisk CS10, is expensive but stands up to a lot of abuse. Because it is comparatively non-absorbent, care is needed to avoid excessive build-up of ink which could eventually lift off at an awkward moment.

For general mounting of finished work be sure to get a board which is white, as many papers are semi-transparent and need the added intensity of a white background. They should also be rigid enough to stop the drawing bubbling off as the board flexes. I use a foamcore board (KAPA Featherlight) which has two surface sheets and a foam infill. It is therefore rigid and extremely light; this is very important when you are running for a train with thirty A2 concept boards tucked under your arm. Also, surprisingly, the sheer volume of thirty drawings when mounted to foamcore can do much to 'pad out' a thin presentation!

Rubbers

For nearly all occasions use a soft, plastic rubber which can be easily cut to obtain a clean crisp edge. Most are sold with a protective sleeve to keep the unused portion clean. I also keep a hard plastic rubber which holds its shape for longer when trimmed to a point or edge. For ink work on tracing paper or film, the new ink rubbers, which 'dissolve' the ink, work very well and can also do double duty as an everyday hard rubber.

Markers

The humble marker has come a long way since its introduction in the 1960s. There are now literally hundreds of different types for marking on every conceivable surface from paper to concrete and in line widths from 0.1mm to 40mm. From the designer's point of view the most important are 'art' or 'studio' markers, so called because they are available in a wide range of colours (over one hundred) and are designed specifically for studio use. Their development spawned a new type of presentation drawing – 'marker rendering'.

Most designers are fiercely defensive about their chosen brand of marker but few articulate the reasons why. The following is therefore a list of characteristics to look for when investing in markers:

Colour range. There should be at least a hundred colours in the range including a graded selection of 'warm' and 'cool' greys. Successful systems of the future will probably extend this feature to include graded tints of other colours as well. For example, all the

primary and secondary colours might be available in a light and medium tint as well as full strength.

Colour consistency. If a colour starts to run out, you should be able to pick up another one and continue with no detectable change to the colour. Equally, if you buy a colour in London it should be indistinguishable from the same one bought in Edinburgh.

Colour continuity. When filling in a large area there should be no change to the colour across the work.

Nib shape and consistency. The most versatile nib is chisel-shaped for drawing both fine and broad lines. It should be hard enough to resist abrasion and maintain a crisp finish, yet soft enough to produce clean, flat colour. Nibs that are too hard produce a streaked effect which is difficult to lose, while nibs which are too soft tend to bleed and spatter. Some manufacturers, such as Pantone and Mecanorma, produce a selected range of colours in fine tips as well as broad, and one, AD Marker, offers four interchangeable nibs for maximum flexibility at the drawing board. This is a good idea in theory (it also saves money) but can be time-consuming and messy in practice.

Ease of use. Ergonomically, the marker should be easy to hold and work with, and to cap and un-cap efficiently. It should be clearly marked with a name (not just a number which can be difficult to memorize) and with a colour identification strip on the barrel rather than the cap. Most manufacturers try and match this colour strip to the contents, with varying degrees of success, so you should only use this as a rough guide and rely instead on your memory of that colour, or do a quick test on an adjacent piece of paper. The marker should be shaped to prevent it rolling off the drawing board and designed in such a way that, when a batch of them is in use, it is easy to select the right colour quickly.

Right: *This cut-away view shows all the parts that go to make up a Magic Marker. The manufacturing tolerances and quality control need to be very tight to prevent loss through evaporation and on-shelf deterioration. The felt wadding can be eased out with a scalpel and clipped into a bulldog clip for use as a giant marker.*

Right: *A sequence of photographs showing the flexibility of line that the chisel-shaped tip of the marker offers – from quite fine, when used on its edge, to very broad, when used flat.*

Below right: *A selection of markers. The Holbein Illust marker range (from Japan) in the background is one of the most comprehensive available. On the left in the centre are a fine and a broad Pantone marker, flanked by two Design markers from Nouval in Japan – the one on the left is double-ended to guarantee colour continuity between the fine tip and bullet top. On the right are a Mecanorma marker, a Design marker (from the USA) and an Edding marker. In the centre are the original Magic Markers which are available worldwide and still one of the most popular with designers.*

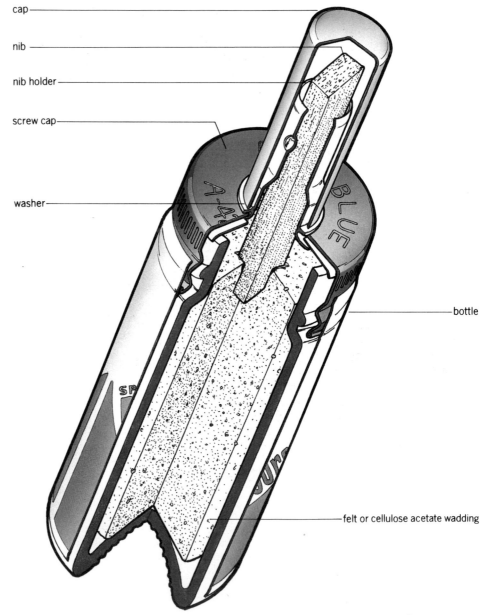

cap —
nib —
nib holder —
screw cap —
washer —
bottle —
felt or cellulose acetate wadding —

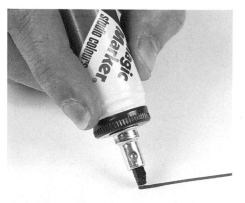
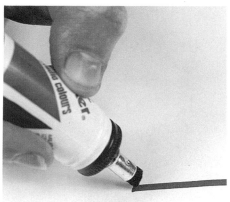
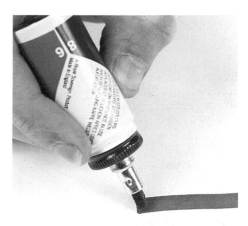

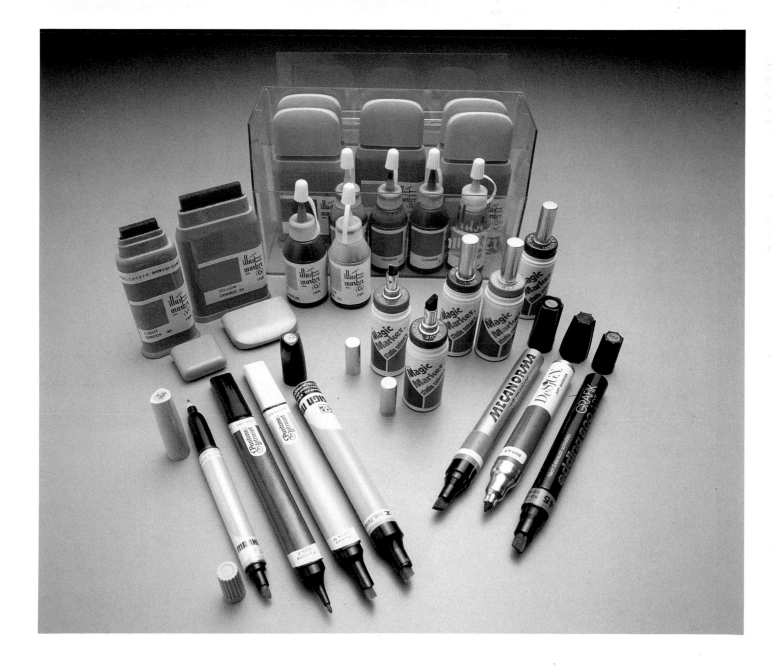

Flow characteristics

Markers should perform well in four main areas:

Bleeding. It should be possible to marker accurately up to a line without having to make allowances for the marker. Also, when working adjacent to a previously laid colour, there should be no bleeding of one colour into the next.

Colour pull. You should be able to work confidently with a light-coloured marker over the top of a well-dried darker colour without the light marker dissolving the dark colour and 'pulling' it into the new area of colour. It is a characteristic of all markers that they will do this if worked hard, but some brands are much worse than others.

Splash and blodge. This is caused by a loosely packed felt nib or an overfilled marker. If you pick up a new marker and work it to a line, there should be no splashing of colour across the line. The nib should be tight enough to avoid stray pieces coming loose, as this will cause unscheduled blodges.

Flat colour. It should be possible to infill an area with colour and leave it totally flat. The technique required to do this is described in more detail on page 61, but involves working fast enough to maintain a 'wet front'. This means constantly backtracking across previously covered areas to keep them wet and working the front edge of colour along until the area is filled. Obviously this is difficult to do with very large areas of colour and for these it is best to make your own 'giant' marker. This can be done either by wrapping cotton wool and lint around a piece of card, as shown in the picture, or by removing the wadding from the barrel and clipping it into a bulldog clip. Some areas that require infilling have such a convoluted shape that it is impossible to maintain a 'wet front'. In these instances be sure to leave the edge somewhere where it can be disguised later on, such as a highlight or 'shut-line'. (Shut-line is the industry term for the joint-line between two panels, one of which is usually an opening panel.)

Colour fastness

It would be nice to preserve marker work for posterity, but none of the ranges are resistant to ultra-violet degradation. It is, however, possible to extend the life of a marker drawing by spraying it with a UV-retardant fixative or by laminating it in plastic.

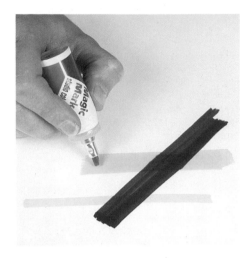

Above: *Going over a dry black area with a yellow marker should not cause colour 'pull'.*

Below: *A sequence of photos showing the construction of a giant marker using a piece of card, masking tape, cotton wool, a scalpel and some lint. Before applying ink, slightly wet the marker with cleanser/solvent.*

Papers

It is vital that you work on a paper or ground that suits your style and your markers. Not all papers are the same, and because the main method of drying is absorption and to a lesser extent evaporation, different papers will give different results. If you want a splodgy edge and large areas of flat semi-transparent colour, then use a lightweight layout paper; but if you want a clear crisp finish with dense colours, then go for a special marker pad.

Starting out

For someone buying markers for the first time it is difficult to know what colours to buy. Greys are available in two ranges, 'warm' and 'cool', consisting of nine shades which are numbered 1 to 9, from light to dark. (In this book marker colour names spelt with an initial capital letter indicate the Magic Marker range.) I advise the initial purchase of four Warm and four Cool Greys (perhaps Nos 2, 4, 6 and 8), a black and some primary colours. Thereafter the range can be extended as required but it is best to concentrate on those colours which extend the tonal range of the

1

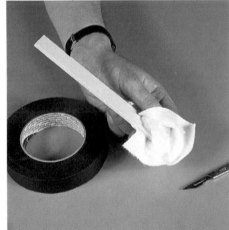

2

3

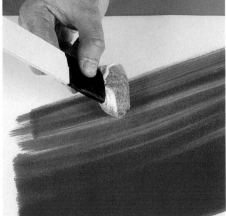

4

primary colours, rather than use your greys to tone down colours, which usually makes them appear slightly muddy. Refer to the colour chart on pages 65–69 to help you select markers for specific rendering tasks.

Colour charts

It is important to keep a record of colours, preferably on the type of paper you use. This is essential for colour selection because it is an accurate record if you later need to replace a colour, or if you need a colour you do not use very often and therefore cannot remember its name. The charts issued by the manufacturers rarely resemble the actual colours.

Looking after markers

Be sure to recap markers tightly to avoid drying out. If a marker appears to be dry, this can often be the nib rather than the complete contents. There are some commercially available solvents (see p. 24) which will enliven the nib, allowing capillary action to restart and causing ink to flow again. It is also possible to use solvents to revitalize a totally

'dead' marker. Those that unscrew can simply be topped up with solvent, those that don't unscrew must be filled via the nib with a syringe. This is a useful practice for students because the cost of art markers is painfully high, but the results are usually less than perfect and, more important, unpredictable. The colour, much weaker than before, varies in intensity suddenly and often bleeds profusely; for these reasons keep topped up markers separately, and clearly identified.

A selection of the large range of coloured pencils available. The popular Berol Prismacolors (back right) are soft without being too waxy. In the foreground are the two Derwent ranges: the Studio set on the left is slightly harder than the Artist set on the right. The black barrels of the Studio set make it less easy to identify the colours at a glance. The Mitsubishi 'Uni' range (back left) are very similar to the Derwent Artist range.

Coloured Pencils

Choose pencils which are soft enough to obtain a soft tonal graduation, when held at a shallow angle to the paper, and yet hard enough to create a crisp line, without snapping, when held perpendicular to the paper. It is also important that they are available in a large range of colours (over sixty). Avoid waxy crayons which will smear and make subsequent overlaying with paint impossible.

Most manufacturers supply crayons in long flat boxes so that the full range may be displayed to advantage. These packs do not stand up too well in use and most designers end up using old tins and jars. Storing crayons 'point-up' in this way protects the point and makes colour selection easy; indeed, it would be nice if manufacturers supplied sets in specially designed tubs.

The most favoured types are Derwent's Cumberland and Studio pencils and Berol's Prismacolors. The Cumberlands seem softer than the Studio range but the Studio colours hold their point better and are probably a

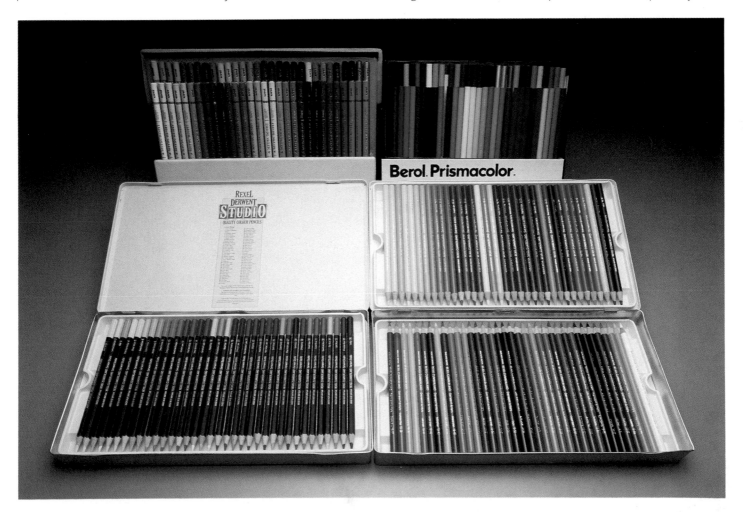

better all-round crayon. The Prismacolors are now easier to get hold of around the world and are certainly the best for producing graded finishes.

Right: Using coloured pencils

1. Coloured pencils should be hard enough to give a good tight line when sharpened and used upright; too soft a pencil will snap suddenly and leave a nasty mark on the drawing. For long lines always revolve the pencil to keep the width even.

2. To get a smooth tonal graduation, lay the pencil right over so that it is at a shallow angle to the paper.

1

2

Coloured Pastels

Coloured pastels should be conté- rather than oil-based, and soft but not too crumbly. It really is worth buying the boxed sets as they will last a lifetime if looked after, and only require occasional replenishing of the most used colours. (Be sure that the brand you invest in is also available in single sticks as well as sets.) I use Faber-Castell Polychromos which are available in seventy-two colours, more than enough because shades can easily be mixed. Their square section prevents them rolling annoyingly off the drawing board and they come in a wooden box, protected from breakages by a bubble-pack liner. The other most popular brand among designers

are Rembrandt pastels which come in a huge selection of colours but are much softer than the Polychromos. This can make them smudgier and more difficult to control.

Pastels are enormously versatile and can be used in many different ways and in conjunction with many different materials. They can be used directly on the paper or scraped into a fine dust which can be applied with cotton wool. They can also be dissolved in solvents and used like markers in broad, bold, brush strokes. Finally, a piece of work can be easily masked off for application and the pastel rubbed away with an eraser to create highlights.

Opposite page, top: *Faber-Castell's boxed set of seventy-two Polychromos pastels. As well as pastels you will need cotton wool (balls, pads and buds), talcum powder and a toilet roll.*

Using coloured pastels to obtain a smooth finish

1. Scrape a small pile of dust off the side of the stick with a scalpel. If you do not have the exact colour you need, several sticks can be used together and mixed up in a small pile to obtain the desired colour.

2. Add a small amount of talcum powder and blend this into the pile of pastel dust; the amount you use is a matter of personal preference. The pastel will go on smoother if you use about 50/50 but will be harder to rub out. I use only about 10 per cent pastel.

3. Taking some clean cotton wool, dab it in the pastel dust until you have sufficient loaded onto the pad, and apply it gently in smooth strokes. You can mask with 'Post-it' notes or tape but do not worry about the colour spreading further than you want. Remove excess dust with a toilet roll, and tidy the edges with a soft rubber.

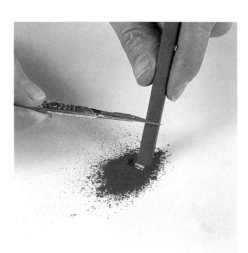

1

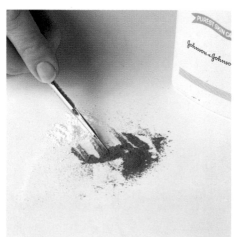

2

3

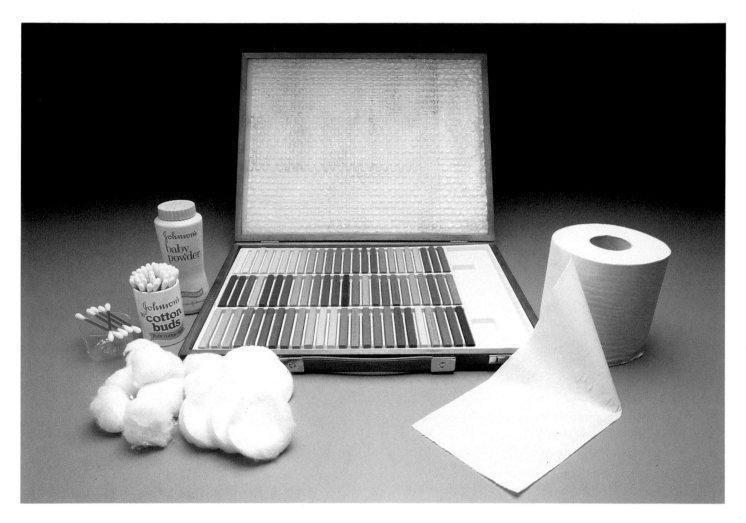

4. *After tidying up, and if required, highlights can be created by rubbing away the pastel to reveal the white paper beneath.*

Using coloured pastels to obtain broad fields of colour
1. *Lightly soak the pad with cleanser or solvent, dip it into a pile of pastel dust, and apply just like a marker.*

2. *Unlike a marker, however, once the solvent has dried, the pastel can be rubbed out to create highlights (although not quite back to pure white paper).*

4

1

2

Pens: Ballpoints, Felt Tips, etc.

There is a huge variety of 'pens' to choose from: felt tips, roller tips, fibre tips, ballpoints, brush pens, etc. with both water-soluble and permanent inks. Find out what suits you best but be careful with the soluble variety if you intend to use paint later, because the water dissolves the ink and discolours the paint. I keep fine- and medium-tipped permanent-ink pens in black for general edging work and sketching. It is important to choose one which is undisturbed by subsequent marker application and just visible under a black marker.

I rarely use coloured fineliners (like those available from the marker manufacturers) because I have yet to see them available in sufficient colours and with an ink/nib combination that gives an indistinguishable colour finish from their broader-tipped brothers. The best solution is probably that used in the Japanese Nouval marker, and since adopted by Edding, which has a broad marker at one end and a fineliner at the other, both sharing the same ink and wadding – thus ensuring colour consistency.

Many designers like to sketch with traditional ballpoints. Of course, ballpoint lines cannot be erased, although I have known this to be a positive advantage with some designers who welcome the way the technique 'forces' their design thinking and makes for economical sketching. Black ballpoints are also very useful for laying in details and crisping up edges on a rendering (like shut-lines on vehicle doors).

A selection of fineline pens. Ball Pentel on the left gives a good range of line thicknesses when it is leaned over and is unaffected when overlaid with marker. The Nikko Finepoint is also a very good all-round sketching, drawing and writing pen.

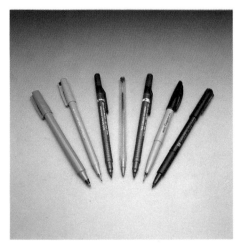

Paint and Inks

Before the advent of markers, gouache rendering was pretty much the norm for presentation drawings but the raw speed of markers has almost completely killed off the technique. Gouache is, however, indispensable for producing highlights and putting in very fine details like lettering, logos, etc., where opacity is essential.

For airbrushing the choice is between paint, which is opaque, and ink, which is translucent. Gouache is ideal for the former, but with the latter there is a wide choice of media. These break down into three categories: water-based inks, water-soluble inks which are water-resistant when dry, and solvent-based inks. The first category, water-based inks, are more difficult to use because overspraying can dissolve earlier applications. The second category, water-soluble inks, enjoy the most widespread use, although most are shellac-based and therefore necessitate rinsing through with methylated spirits or other appropriate solvent. I use Royal Sovereign's Magic Color because it is a water-soluble ink which can be freely mixed but dries to a water-resistant finish and requires no rinsing through of the airbrush with spirits (although they do supply a cleanser for dissolving dried ink in the airbrush). The third category, solvent-based inks, are used extensively in the auto industry for spraying full-size renderings. They are not . designed for spraying and care must be taken to ensure adequate ventilation to avoid a build-up of dangerous fumes which is both a health and fire hazard.

Brushes

I keep three finest-quality sable brushes (sizes 00, 1, 3), and one size-10 synthetic watercolour brush (for mixing and loading airbrush inks). The golden rule with brushes is buy the best and look after them; never lend them to anyone, never leave them point down in water and always rinse them through immediately after use.

Airbrushes

Decide what you want an airbrush for before you buy one (see Chapter 7). Few designers have the time to do full airbrush renderings but there are still some things which are difficult to do any other way (and an airbrush is also useful for spraying small models). Students often believe that an airbrush is the answer to their rendering problems and rush out and buy one, only to discover that it isn't. It is an expensive item, so make sure you really

need it and look for one which suits your needs and buy the best. Stick to double-action brushes (down for air, back for paint) with a reasonable size cup. If you intend to use it for large-scale tape drawings go for a large-capacity suction-fed device, otherwise opt for a gravity-fed type.

Keep your airbrush clean and rinse it through if you need to leave it for all but the shortest periods.

Ancillary equipment

You will also need an air source which will be either an air compressor or cans of air propellant. I wouldn't recommend old car tyres (unpredictable supply and dirty air) or a footpump/tank (too energetic!). Your final choice will depend on how much you use an airbrush and how much you want to spend.

If you are really interested in airbrushing, it is worth buying a book devoted exclusively to the subject and borrowing an airbrush to experiment with. This may be difficult as my final recommendation is that if you own one, don't lend it to anyone.

New developments

The latest generation of airbrush-like products are the 'spraymarkers'. These are a welcome addition that bridges the gap between the marker and the airbrush. The Letrajet spraymarker blows air across the tip of a fineline Pantone marker in much the same way as a traditional 'diffuser'. The results are somewhat similar, in that the spray is fairly coarse. Nonetheless it is a potentially useful product that eliminates the tiresome cleaning-out associated with airbrushes.

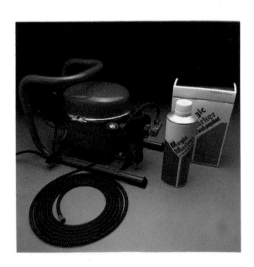

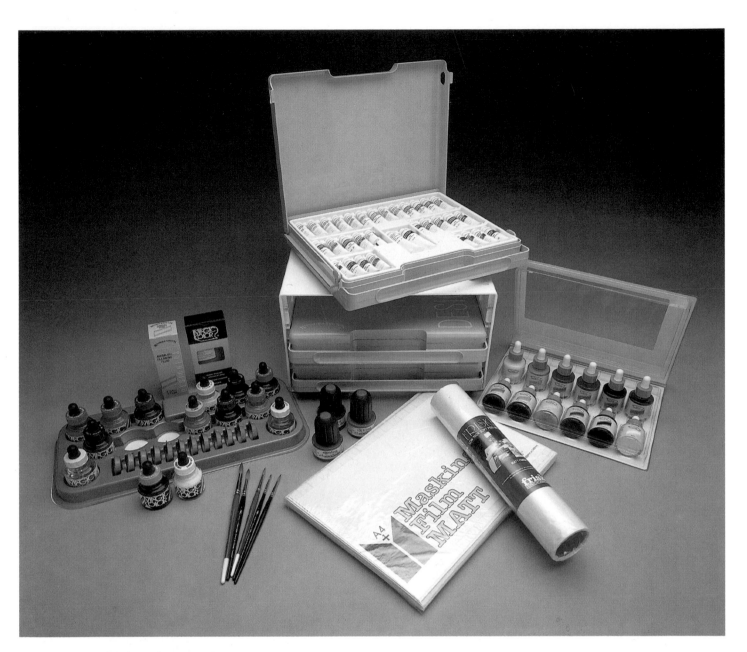

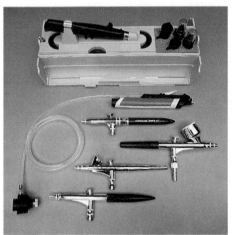

Opposite page, left: *Air sources – a compressor and a can of propellant with its packaging. Choose a compressor that runs quietly, has a pressure tank and switches on and off automatically.*

Left: *Airbrushes. On top is the Aztec, beneath that the Letrajet for spraying Pantone markers, and below that the classic Aerograph Super 63 together with a selection of other makes.*

Above: *This selection of paints and inks includes, in the background, a boxed set of Windsor and Newton's Designer's gouache – the best available. On the left and right are two types of airbrushing inks, and in the foreground two types of masking film.*

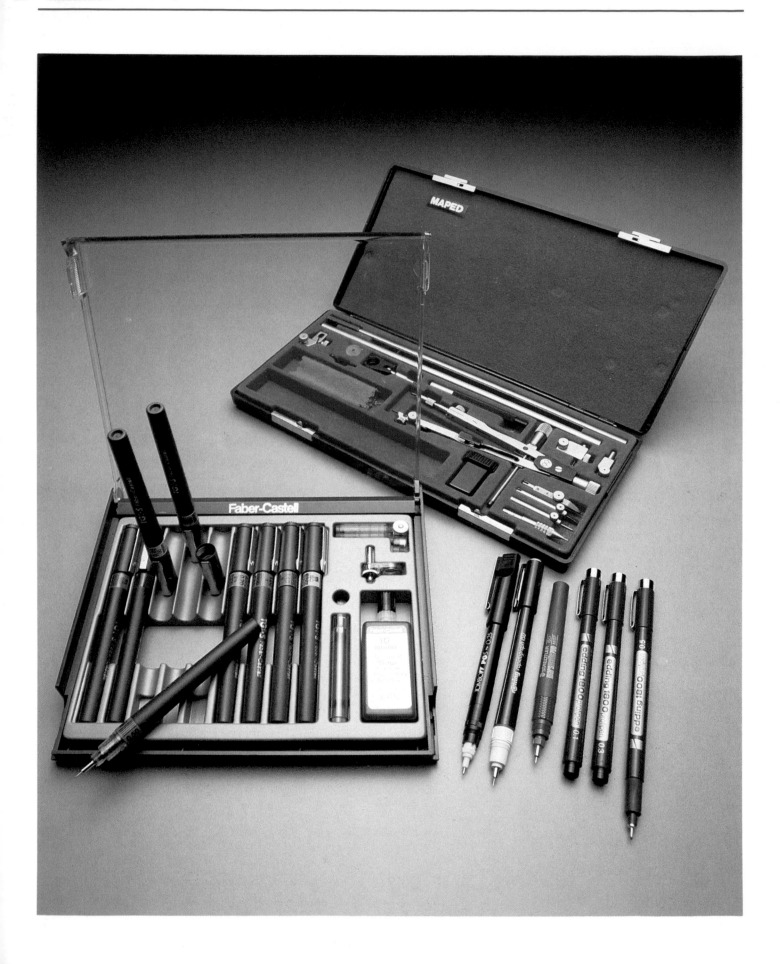

Technical Pens and Instruments

Most designers will already have a set of technical pens as they are indispensable for drafting work. There is little to choose between the various brands: each claims to be less prone to drying up or leakage than its rivals. New on the market are two types of technical pen working on a different principal. One, the Tombo PGS, uses a nylon tip which is replaceable and the other, the Pentel Ceranomatic, a ceramic tip. Both of these are very useful for general drawing work and don't clog so easily. On the negative side, they are slow to dry on non-absorbent surfaces like Polyester film and tracing paper, and this makes them frustrating to use for drafting work.

Technical instruments

Again most designers will already have a set of these. A useful addition for cutting circles, especially on masking film, is some compass blades, which slot in where the lead is usually clamped.

Scalpels, Tapes and Adhesives

Scalpels

There is an enormous choice of knives for every purpose but keeping one for this and one for that means keeping stocks of all the different types of blades. I use traditional surgical scalpels for practically everything; these have extremely sharp disposable blades in a variety of shapes. The handles are excellent for tasks requiring delicate control, like mask-cutting, but are rather less suitable for trimming out thick card. Rather than keeping a heavier-duty knife for this, I keep a second scalpel handle with the middle 'fleshed out' with masking tape so that more pressure can be applied.

Tapes

The most widely used tape is masking tape and I keep this in both a high tack (very sticky) and a low tack (less sticky). I also keep black photographic tape (in 2in, 1in, ¾in, ½in and ¼in sizes) for both masking and tape-drawing purposes (meaning, literally, drawing with tape – see p. 120). This is supplemented with rolls of super-fine, flexible black and white tapes, also used for tape drawing. Finally, it is useful to keep double-sided tapes and 'invisible' or 'frosted' tape for repairs to technical drawings.

Left: *Technical pens and instruments. In the background is a set of technical instruments and in the foreground technical pens with, on the left, Faber-Castell's TG 1 pens.*

Adhesives

I use an aerosol adhesive (Scotch Spray Mount by 3M) which is excellent for lighter, mounting jobs and especially useful for sticking down complex and delicate bits of paper. Gone are the days when a complex cut-out shape had to be carefully coated with gum. Spray Mount deposits a thin film of adhesive which won't squeeze out of the edges and is easy to reposition; bubbles and wrinkles can also be smoothed out. For heavier-duty mounting (i.e. paper on board) I use a stronger spray adhesive (Scotch Photo Mount by 3M). This doesn't have the repositioning capability but is less susceptible to bubbling off in changeable climatic conditions. (See p. 154.)

One word of caution: all these spray glues tend to hang in the air and are therefore easily inhaled into the lungs. This is a real health hazard so try and fix up an extractor to keep a constant flow of air to take the glue out of the studio. Some studios now ban the use of spray glues but this can seriously slow up work flow, so until someone comes up with a better idea make sure you minimize the risks.

Straight-Edges, Curves and Sweeps

Straight-edges

One of my most important and treasured pieces of equipment is a 600×70mm clear PVC straight-edge. This was guillotined from a 1mm thick sheet of flat PVC but could equally be made by scoring the sheet with a scriber or scalpel, snapping out the desired piece and then lightly finishing it with wet-and-dry paper.

The material is not attacked by most of the solvents found in markers and its whippiness makes it easy to use on a crowded board. Unlike a ruler, its transparency is unaffected by bevels and printing, and so allows a clear view of the work underneath. The larger-than-usual width is also important: when using a conventional ruler to set up perspectives, the edge not in use can distract the eye because it is too close to the edge in use; this can, surprisingly, make it more difficult to judge diminishing rates to an out-of-picture vanishing point. With this type of straight-edge there is a slight risk, particularly with technical pens, of the ink flooding under the edge; on these occasions lay a strip of masking tape on the underside to space the rule from the paper. Finally, never cut against your straight-edge; always use a steel rule.

Curves and sweeps

Clear PVC is also an ideal material for (radius) curves and sweeps. (A 'radius curve' is an

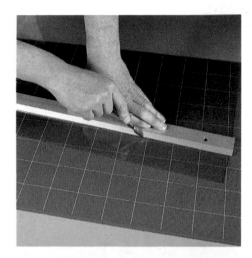

Making a straight-edge
You will need a sheet of clear PVC about 1mm thick. Score the surface with a scriber or scalpel to establish a line of stress (top), and then, leaning heavily on the ruler, snap upwards (above). Finish off the edge with wet-and-dry paper.

edge used to draw curves of constant radius, whereas a 'sweep' is an edge used to draw curves of changing radius.) Flexibility is essential when manoeuvering a long sweep on a crowded board, enabling one end to be used without shifting bits and pieces to make room for the other. Sets of curves and sweeps are difficult to find in shops, where they are often referred to as ship's curves and usually made of acrylic which is attacked by most solvents. They are quite expensive to buy but, like the straight-edge, easily made out of PVC sheet, provided you can borrow a set to trace around. This is done by carefully scribing around the master (being careful not to damage it); once a shallow groove is established the master is removed and the groove enlarged by further working with the

scriber or scalpel. Finally the curve can be snapped out with care, and finished with wet-and-dry paper.

Keep curves and straight-edges clean by wiping down with a rag, or tissue paper, soaked in solvent (check first that this doesn't dissolve the PVC). Doing this immediately after use with markers is an important habit to get into, particularly when changing colours. This prevents the reappearance of unwanted colour at a later date.

Ellipse Templates

Ellipse templates are very expensive and usually come in increments of 5 degrees, from 10 right up to 80 degrees, and in size (major axis), from 2mm to 250mm. They are typically available in small, large and extra-large sets. This is one occasion when it is worth investing in good-quality templates which should be thin, flexible and transparent, with one surface slightly matt to avoid reflection. They should be arranged so that the minor axes share a common line (preferably parallel to the edge of the template), and printed with fine lines to indicate both axes. Avoid the type that has ellipses segmented and arranged concentrically, as these are tedious and time-consuming to use, although, of course, they are unavoidable with extra-large ellipse templates. The best extra-large templates are like those made by the Alvin company, which allow you to see the whole of the ellipse. They are an application of the following property discovered in ellipse curves: the curve in any ellipse quadrant can be divided into two segments – the portion near the major axis having a curvature individual to that ellipse

only, while the portion near the minor axis possesses near-congruence to corresponding portions in the adjacent larger and smaller ellipses of the same degree.

It is possible to make the larger sizes of template in the same way as the curves and straight-edges, provided you can find someone who is prepared to lend you a set to work from (it's not a job for the faint-hearted). Use a thin material and don't try to make the smaller sizes.

Many students simply can't afford to invest in good-quality template sets and buy cheap substitutes that are more difficult to use. It is far better to buy good ones individually and build gradually to a full set. Unless you do a lot of technical illustration you won't need anything below 15 degrees (too thin) or above 60 degrees (getting close to a circle); start by buying a small 45-degree and a large 45. This may mean building a rendering around the ellipse guides available so, as soon as you can, buy a 30- and a 60-degree set and then gradually fill in the remaining increments starting with the 15.

Above: *In the background are Alvin (formerly Leitz) ellipse templates in large and small sizes; the extra-large ones are not shown. In the foreground are a selection of sweeps from Linex; these are acrylic which are more rigid than PVC but more vulnerable to attack by the solvents in markers.*

Miscellaneous

Board brush
A broad, soft brush is necessary for sweeping away rubbings from the work and from the drawing board. Don't use it for sweeping away excess pastel dust or it will transfer the colour to each successive drawing.

Bridge
A bridge is a rigid straight-edge, probably of acrylic, mounted at either end on blocks to keep it clear of the paper. This acts as a rest for the heel of the hand when using paint and minimizes the risk of smudging; it is also useful for drawing straight lines with a paint-brush. It is not, to my knowledge, commercially made but is easily put together with an old ruler or scrap of acrylic.

Talcum powder
Talcum powder 'lubricates' paper and ensures a smooth, easy application of pastel dust. (Looked at through a microscope, paper appears mountainous and full of troughs; talc simply fills in the troughs.) Talc can make erasing marginally more difficult because the eraser tends to slide rather than bite. Dusting with talc also knocks back the intensity of colour so that subsequent marker application creates a new tone. Finally, dusting with talc takes out the stickiness of marker 'pools' which have a tendency to form on low-absorption paper.

Carbon tetrachloride
This dissolves pencil lead, so is useful for cleaning pencil marks off tracings after the application of ink.

Solvents and solvent inks
Solvents are used for many purposes, such as cleaning the drawing-board and equipment, topping up markers, dissolving pastel dust, producing background effects, etc. The most widely used are Flo-master cleanser and inks, originally destined for use in refillable markers. Some of the more enlightened marker manufacturers make their solvents and inks commercially available, but these are often difficult to obtain because of their toxicity and flammability. It is a good idea to find out what the major constituent of the solvent in your favoured brand of marker is (probably xylene) and try and get hold of some. Failing that, use Flo-master. Lighter-fuel is just about acceptable for some brands of marker and is also indispensable for dissolving glues. Some of the solvents used in screen printing also work quite well. Experiment with what suits you and your brand of marker.

Tissue paper

A roll of soft toilet paper is ideal for keeping things clean, and is especially useful for removing excess pastel dust from the surface of a drawing without spreading or smudging it. Use the whole roll, revolving it and tearing off the stained sheets as you go.

Cotton wool, cotton pads and buds, and lint

These are useful for applying pastel dust and making your own broad markers.

Masking film

Masking film is essential for airbrushing, but check first that it won't pull away the surface you are working on.

Liquid mask

Liquid mask is a masking fluid that can be painted on, airbrushed over and then rubbed or peeled away; it is useful for fine work.

Tracing-down paper

Tracing-down paper is impregnated on one side with graphite or chalk and is used much like carbon paper for transferring a drawing onto another surface. It is available in graphite colouring, red, white, yellow and photographic 'drop-out' blue. Although they can be purchased in shops, it is easy to make a graphite sheet if you own a lead 'pointer' (sharpener). Sprinkle some solvent onto a cotton-wool or lint pad, dip it into the graphite shavings from the pointer and wipe evenly over some tracing or layout paper. Once dry, this makes a cheap and effective alternative to bought-in sheets, and cuts out the chore of 'back-coating' the underlay (see p. 110).

Post-it notes and tape

It is hard to remember how offices functioned before the invention of these amazingly useful note pads! The notes (and the tape if you can get it) are perfect for masking when using pastel or airbrush as the glue leaves no residue and does not disturb the drawing underneath. Unfortunately, all the samples which I have found are too absorbent for use when masking against markers, but no doubt the manufacturers will produce something soon to meet this need.

A selection of the other materials you will need. Clockwise from the left: board brush (from China), masking tape, Photo and Spray Mount, rotary pencil sharpener, battery-powered pencil sharpener, Flo-master ink and cleanser, Edding marker ink, black tape, bridge, pencil and ink rubbers, super thin black tapes from Letraset and Formaline, scalpels, a simple compass and a cutting mat.

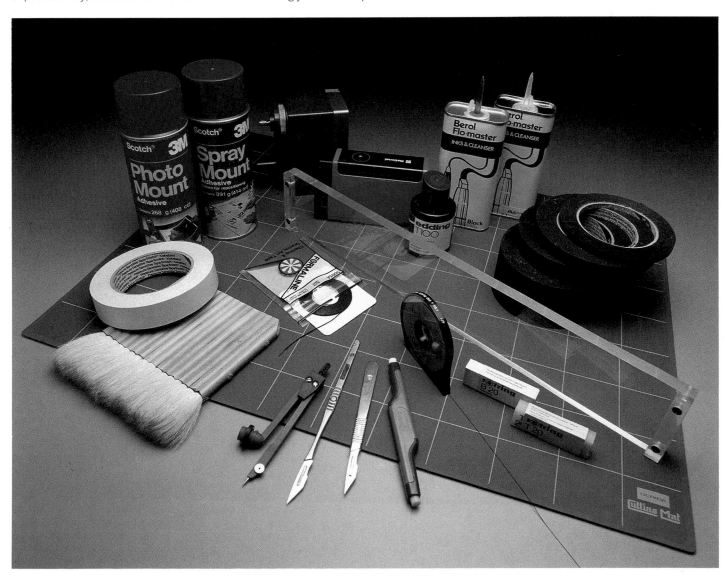

3 Perspective Drawing

This chapter cannot hope to cover perspective drawing anywhere near as comprehensively as some of the specialist books on the subject. From the designer's point of view, however, much that is covered in these books is irrelevant. Many are aimed at architectural drawing which makes them difficult to adapt to the designer's needs, and most offer long-winded, if accurate, systems. This chapter therefore assumes a working knowledge of perspective and concentrates on cutting corners and producing reasonably accurate views quickly and easily.

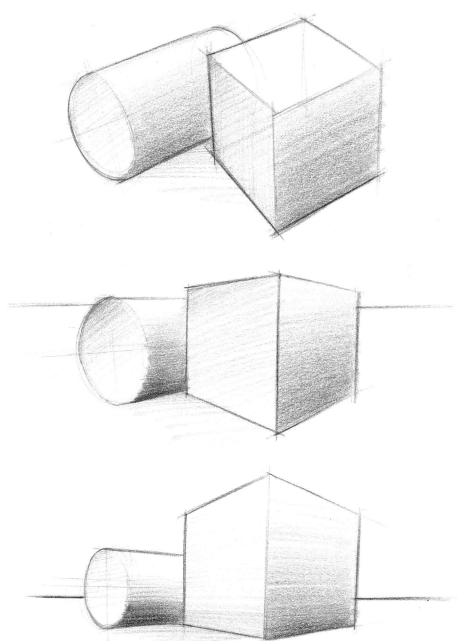

Freehand Sketching

Good perspective is fundamental to good rendering. Without it the drawing has no chance of succeeding, and central to good perspective is basic drawing ability. This ability is not a manual dexterity, it is a cerebral process that hinges on the way we *see* things. Designers who draw well cannot only see immediately if a perspective is 'wrong' and how best to put it right but, more importantly, they are constantly developing their visual skills and honing their sensitivity to three-dimensional form. This command of three-dimensional form allows them to visualize and draw products as if transparent, and also enables them to organize internal parts quickly and easily into the optimum configuration. For example, the designer who can draw can more easily resolve complex mould shut-lines and the coring of injection-moulded parts.

There are two occasions when, despite considerable freehand drawing skills, a perspective system of some sort may become necessary. One is producing finished visuals from freehand sketches; many designers, although proficient enough, lack the confidence to do this and for them a perspective system can make all the difference. The other is when absolute accuracy is important, particularly if working from a GA, or General Arrangement, drawing (technical drawing that defines overall dimensions and layout). A good example of this would be a presentation where you want to show several alternative concepts all built around the same basic internals. Producing an accurate drawing of the internals, and using it as an underlay for the renderings, will ensure that each is in proportion to the next.

Three drawings to indicate scale
Three different views of the same two objects show how important it is to establish scale. This is dependent on the level of the horizon line, in other words whether you are looking down on, or up at, the object, and the rate of convergence of parallel lines, in other words how near, or far away, you are from it. In the first view the suggestion is of a small, perhaps table-top, object. The second suggests a bigger object such as a freight container, while the third is perhaps more appropriate to a building.

Choosing a View

The choice of view will depend on three factors. Firstly, it must show your design and its main features and details to their best advantage. Secondly, it must help define the scale of the product. This is determined by the position of the eyeline/horizon and the rate of convergence of parallel lines. Remember that small things are usually viewed from above and large things from lower down. Thirdly, it must be interesting to the viewer, which means that the composition of the whole drawing on the page will require careful attention.

There will be many occasions when you will want, and need, to disregard any, or all, of these three guidelines. This is particularly true if you want to get more 'drama' into the drawing by taking an ultra-low, or other unusual, viewpoint. Sometimes this can be achieved by simply repositioning the drawing on the page; indeed, many newcomers fail to appreciate that the perspective itself is still 'good' no matter which way up you position the drawing.

Size of Drawing

When I first left college I tended to do all my renderings far too small, to a point where they were actually becoming difficult to do. Because of, or as a result of, this, they also became oppressively tight and controlled. Later on, the average size grew as my confidence grew and I adopted a more fluid approach where my arm was doing the work rather than my wrist.

In our office we standardize presentations into A-size formats (with the exception of full-size renderings of large products). The final choice of size depends, to a degree, on the size of the product. Where possible, keep the drawing as near life size as you can without it dominating the page. This is clearly impractical for anything much bigger than a typewriter so, if your product is only marginally bigger, be sure to drop the size sufficiently to avoid confusion over scale.

The size of the drawing will also be influenced by your choice of media. For example, markers are not ideal for tackling tiny drawings and crayons are less suitable for large drawings.

Choosing a view
These three sketches of the same camera illustrate the kind of drawing that it is useful to do before embarking on a constructed perspective. In this case, either of the two upper views are sufficiently descriptive of the form and give a good impression of scale. The lower view might tell the viewer more about the detailing along the front but would not give a good impression of the whole. Remember to choose a view that shows the design and its key features to best advantage.

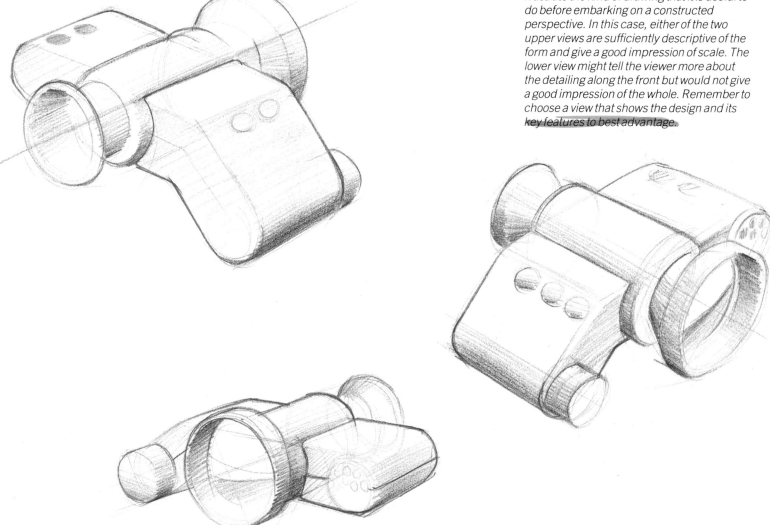

Setting up the Perspective

There are a couple of shortcuts which you can take to avoid the chore of setting up a perspective from scratch:

1. Use a Polaroid camera: it may well be that you are working with sketch models to help rough out a complicated form, and these can be used to great advantage. Simply apply some thin black tape along the major axis and critical changes of direction (this is necessary because a polaroid is quite small and much detail will be lost). Once the best view is established and the shot taken, blow it up on a photocopier (amazingly, it will stand enlargement up to A2) and use as an underlay for your rendering.
2. Use an existing photo of a similar product of the same size and proportion and blow it up on the photocopier. Use it as an underlay, trace it off and put in the main perspective lines to vanishing points, etc.

If none of these methods is available or suitable, then you will have to construct the drawing from scratch using a perspective system. The following pages outline some possible methods.

The Cube Method

I have found the easiest, simplest and most flexible method is to draw a cube in the view required for the drawing, because this is the basic building block of perspective construction and can also be used as the unit of measurement. In this way everything is considered in proportion rather than directly measured; a dimension is assessed as being twice that of another, rather than being, say, 50mm. Equally you might think of a dimension as being 2.5 cubes (i.e. units) in length.

If you use this system a lot, you will gradually build up a library of cubes and grids from many different viewpoints and you will simply reach into the drawer and select the right one.

For those starting from scratch, however, you will have to construct the basic cube.

Drawing the basic cube
This can be done in a number of ways:

1. Actually make a cube out of card or plastic and photograph it (again a polaroid is very useful for this). Be sure to divide each face into four smaller squares, put in the diagonals and finally inscribe a circle, or series of concentric circles, on each side. Enlarge the photo on a photocopier or Grant enlarger.

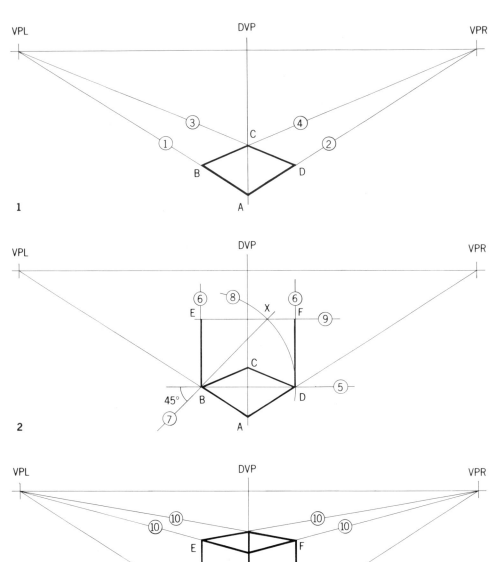

2. Use an off-the-shelf perspective grid. These are available in many different views and you can easily create a cube or matrix of cubes by simply tracing off.
3. Use a computer to generate a cube (or indeed the complete view) — see 'Computer Aided Design', page 47

By now it cannot have escaped your attention that I have left the traditional method until last. There are many books about perspective and most designers are familiar with at least one of the mechanical methods of setting up a perspective drawing. Few designers have the time, or inclination, to do laboured perspectives. For this reason choose a method that is simple, such as that described

by Jay Doblin in his excellent book *Perspective: A New System For Designers*. The adjoining diagrams illustrate the construction of a 45/45-degree cube and a 30/60-degree cube to get you started.

Left: Constructing a cube in 45/45-degree perspective

1. Draw the horizon and position the two vanishing points (VPL and VPR) on it. Bisect the distance between the vanishing points to find the diagonal vanishing point (DVP). Drop a vertical from this point and draw two lines ① and ② from VPL and VPR at the desired angle A, which will be the angle at the base of the cube nearest to the viewer. Draw two more lines ③ and ④ from the vanishing points to intersect on the vertical. This forms the perspective square ABCD with the vertical AC as a diagonal.

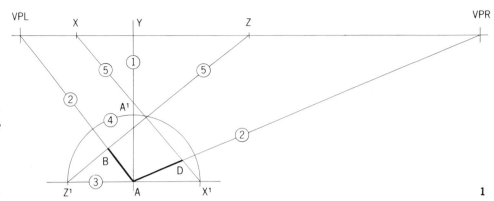

2. Put in the other diagonal ⑤ which should be parallel to the horizon. Erect verticals from B and D ⑥. Place your compass on point B and swing an arc from point D through 45 degrees (⑦ and ⑧) to locate point X. Draw a horizontal line ⑨ through X to locate E and F, which completes the diagonal plane EFDB.

3. Complete the top face of the cube by drawing lines ⑩ from both vanishing points through points E and F.

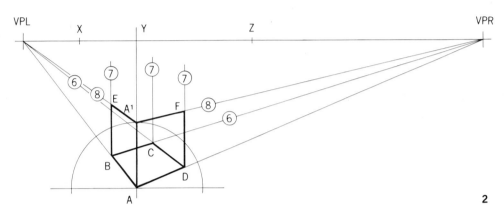

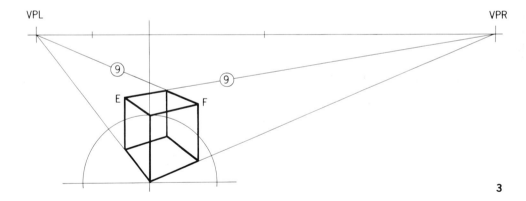

Above right: Constructing a cube in 30/60-degree perspective

1. Draw the horizon and position the two vanishing points (VPL and VPR) on it. Bisect the distance between the vanishing points to locate Z. Bisect the line VPL/Z to find Y. Bisect the line VPL/Y to find X. Drop a vertical ① from Y and mark a point A at the desired distance below the horizon. Draw lines ② to point A to form the nearest angle of the cube. Draw a horizontal line ③ through A. Decide the height of the cube at A¹. Place your compass on point A and draw an arc ④ through A¹ to locate points Z¹ and X¹ on the horizontal line ③. Draw lines X/X¹ and Z/Z¹ ⑤ and locate their intersection points on lines ② at B and D.

2. Draw lines ⑥ to complete the perspective square ABCD. Erect the remaining three verticals ⑦. Draw lines ⑧ to A¹ to locate E and F.

3. Complete the cube by drawing perspective lines ⑨ to E and F.

Subdividing and extending the cube

The diagrams on this page and the next show first how to divide up the cube into smaller units by drawing diagonals and then how to extend it into a matrix in all three directions. It is most important as you extend the original cube to constantly cross-check what you are doing and avoid the build-up of error. As you project a new point into space, double-check it by independently projecting from another source, such as a diagonal. You will quickly learn that distortion is inevitable. Swing a circle from a point which is mid-way between the vanishing points and passes through them. As your image approaches this circle, the level of distortion will become increasingly unacceptable.

Surprisingly, many students fall into the trap of making the nearest corner of their cube, or grid, less than 90 degrees. There are *no* circumstances when this can be possible. Try holding a record cover at eye level, it will appear as a line; now put it on the floor and look at it in plan-view, all the corners are true right angles. As you look at it in every position between these two, the nearest angle will vary from 180 to 90 degrees; it can never be less. Any cube whose nearest corner touches the circle drawn through the vanishing points must have a nearest angle of 90 degrees (two lines drawn from the points of intersection of the diameter and circumference to any point on the circumference must meet at right angles) and must therefore be distorted.

The golden rule when extending your cube, or doing any kind of perspective, is to trust your eye and not the system. You can help yourself in this respect by adopting a different viewpoint to the picture from time to time. There are several ways of doing this:

1. Screw up your eyes to cut out distracting construction lines.
2. Step back from your drawing board frequently, so that you can take in the whole drawing without having to move your eye.
3. Look through a reducing glass, which gives the same effect as stepping back.
4. If the paper is transparent enough, turn it over and look from the other side. This is the most useful method because, having spotted an error, you can correct it on the back. Turn the paper over again and erase the old lines to reveal the new ones showing through from behind. If you are working on opaque paper you can achieve the same effect of viewing from behind by looking at it in a mirror.

Your eye can quickly come to accept an error which can gradually get out of control, so make at least one of the above checks frequently to keep everything in shape.

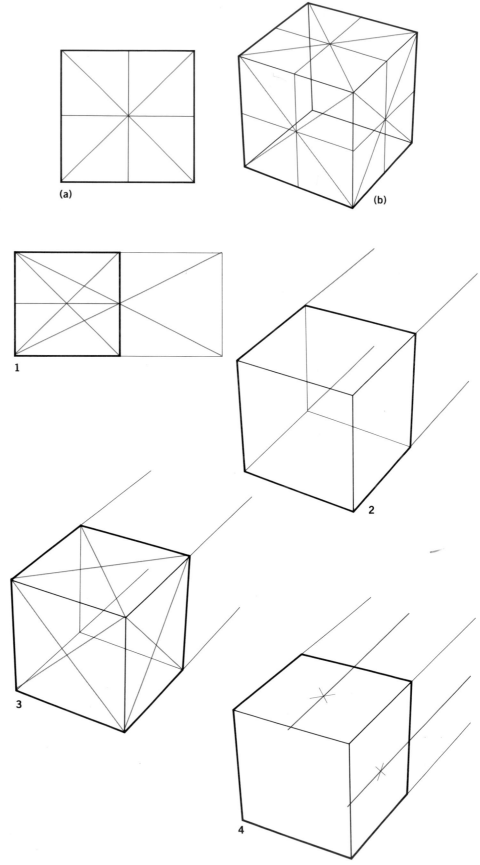

Left: Subdividing the cube

(a) As with any perspective situation, look first at a measured elevation. This information is then easily transferred to the perspective view.

(b) The cube can therefore be subdivided by drawing diagonals to find the mid-point of each face and then dividing it into four smaller squares. For the inexperienced eye, this is not as easy as it looks. Each vertical and horizontal line must converge at the same rate in order to appear parallel. Help yourself to do this by comparing them with the hidden lines of the cube which are nearer and therefore easier to judge from.

Left and right: Extending the cube into a matrix

1. As with subdividing the cube, look first at an elevation. You can see that a single square can be extended into a rectangle by finding the mid-point of one side and drawing diagonal lines from each corner through this point to find the opposite corner of the rectangle. This information can easily be transferred to the perspective view.

2. Extend the 'horizontals' in the desired direction towards an imaginary vanishing point.

3. Draw the diagonals to find the mid-points of each face of the cube.

4. Draw perspective lines through these centres to find the mid-points of each opposite line.

5. Draw diagonal lines through these points (and remember that these are the diagonals of the perspective rectangle) to locate the corners of the new cube.

6. Complete the new cube by connecting up these corners. As you do so, check that the rate of convergence is consistent with adjacent lines.

7. When extending a cube into a matrix, be sure to constantly cross-reference by also drawing the diagonals of the new, larger square as well as using the diagonals of the rectangle.

5

6

7

Ellipses and Circles in Perspective

To help understand a circle in perspective, look first at a plan-view of a circle circumscribed by a square (as illustrated opposite page, top). Notice that the centre of the circle coincides with the centre of the square and that the circle touches the square at the mid-point of each side. It should therefore be a simple matter to transpose these conditions onto a square drawn in perspective.

It can be shown mathematically that a circle in perspective is a true geometric ellipse, so it will also help to look at a true ellipse to see whether there is any help to be had from this end. An ellipse has a major and a minor axis at right angles to each other, it is also symmetrical about both axes so that each half of each axis is the same length. When an ellipse is viewed as a circle in perspective, the axis of rotation of that circle coincides with the minor axis.

This is the most common mistake made by students when first attempting to draw circles in perspective (except, strangely, those parallel to the ground like cups), because regardless of the view of the circle they nearly always draw the ellipse with the major axis vertical. If you are in any doubt about this, try drawing a range of perspective cubes above, below and on the horizon. If you then draw in an ellipse on one of the vertical faces, only on the horizon is the ellipse upright, and the more the cube is above or below the horizon the more the ellipse is leaned over. If the circle is parallel to the ground, it can be seen that its axis of rotation will be vertically downwards, and therefore the minor axis of the ellipse will also be vertically downwards, with the major axis at right angles to it and therefore parallel with the horizon. This is usually the easiest way to draw ellipses so, if you have trouble drawing freehand ellipses, turn the paper so that the minor axis is vertical on the paper and the major axis horizontal; it is also helpful to tick off lightly the intended distances along the axis.

Rules for drawing circles in perspective are therefore:

1. A circle in perspective is a true geometric ellipse.
2. A circle in perspective will touch its circumscribing square at the mid-point of each side.
3. A circle in perspective and its circumscribing square will share the same centre.
4. The ellipse will be geometrically symmetrical about its axis.

5. The axis of rotation of the circle will coincide with the minor axis of the ellipse.

Although these are important rules for the designer it is only fair to say that they are not totally correct (see opposite page). For our purposes, however, they are entirely adequate.

Above: Properties of ellipses
A geometric ellipse has a major and minor axis and is symmetrical about these axes (x=x and y=y).

Below: Axis of rotation
When an ellipse is viewed as a circle in perspective, the axis of rotation of that circle coincides with the minor axis. In other words, if the circle you are trying to draw was made of cardboard and you could spin it, then its axle, which of course must pass through the circle's centre and at right angles to it, will coincide with the minor axis of the ellipse.

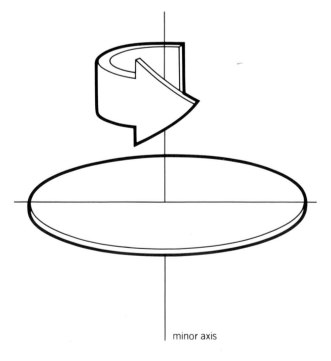

Right: Anomaly

1. As with the cube, look first at an elevation of the circle and its circumscribing square. The centre of the circle and the centre of the square coincide, and the circle touches the sides of the square at their mid-points.

2. This information can be transferred to the perspective view. However, as a student it seemed to me that a circle in perspective could not possibly be a true ellipse as can be shown thus:
Construct a square in perspective with its centre on the horizon. Next, divide it in half vertically by dropping a vertical line through the centre. (It will already be divided horizontally by the horizon.) As we have seen, our perspective circle will touch the circumscribing square at the mid-points of each side and will share the same perspective centre. Now, because of the effects of diminishing distance, that half of the square nearest to the vanishing point (x^1) must be smaller than that half further away from it (x). Equally, therefore, that half of the ellipse nearer the vanishing point must be smaller than that half nearer to you the viewer. Therefore it is not symmetrical and so cannot be a true geometric ellipse. The anomaly here is that, while a circle in perspective is indeed a true ellipse with its minor axis coinciding with the axis of rotation, the geometric centre of the ellipse does not coincide with the centre of the square *but is in fact shifted slightly towards the viewer*.

3. A schematic diagram may help you understand why this is so. Draw a circle with your eyepoint some way from it. Next, draw visual rays from this point, which are tangential to the circle, and then connect these tangent points together. What you actually see when looking at a circle in perspective is this chord, and the further away your eyepoint the nearer this centre gets to the true one.

4 and 5. For the same reason, it can be seen that the ellipses used to draw concentric circles in perspective cannot share the same geometric centre but will be offset slightly one from another. For all practical purposes this anomaly can be ignored because the offset is so small. Only those who are involved in super accurate measured construction and who will, in any case, be using a proper system need worry. Certainly your client will probably care little for the niceties of perspective theory!

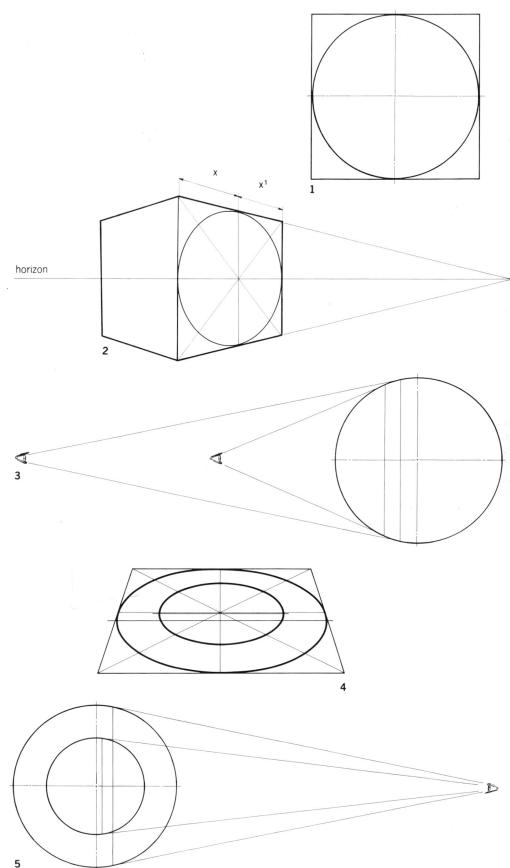

Ellipse guides/templates

Most designers will keep a set of ellipse guides simply because it is very hard to draw crisp ellipses freehand or even using French curves. Nevertheless, as with all perspective, do practise drawing ellipses freehand at all angles of inclination or you will find yourself depending on the guides instead of your eye. Remember that ellipse guides are just that – guides.

To draw an ellipse within a constructed circumscribing square, first find its centre using diagonals and then draw in the axis of rotation and a line at geometric right angles to it. Next choose the ellipse whose perimeter comes closest to touching the mid-point of each side of the square when the minor axis is aligned with the axis of rotation and the major axis is aligned with the line at right angles to it. You are unlikely, even with a full set of guides, to find the *exact* ellipse required in both size and inclination, so use the nearest one to it. If this still looks unsatisfactory, it is usually possible to move the guide slightly as you draw each half of the ellipse to approximate to the 'in-between' ellipses.

Remember also, that with a cylindrical object the ellipse nearest the viewer may be, say, a 35-degree ellipse but, as the cylinder recedes, the ellipses will come closer to the plan-view and you will find that a 40-degree and then a 45-degree will be a better fit in the circumscribing square. However, the further away the circumscribing square is from the viewer, the more distorted it will become and, equally, the more difficult it will be to accommodate an ellipse.

It is also useful to bear in mind, particularly for those with a limited selection of guides, that, if the product to be drawn is generally cylindrical, like a bottle or screwdriver, an ellipse template can be used to create the view without needing to start from scratch.

Changing the value of the ellipse

As a cylinder drawn in perspective recedes from the viewer, the value of the ellipse should change because we are seeing more of a plan-view of it.

Constructing views from an ellipse guide

1. Lay in an ellipse of the right size with the minor axis at approximately the right inclination for your intended view; be sure to mark off the major and minor axes. Extend the minor axis in both directions and remember that this line must go to one of the vanishing points (VPR). Next drop two verticals, AC and BD, which are tangent to the perimeter and then draw a line that runs through the two tangent points and the centre of the ellipse; this line must go to the other vanishing point (VPL). Drop another vertical through the centre of the ellipse.

So far, little skill or judgement has been called for. The next step is to finish off the circumscribing square and to do this you will

need to estimate the rate of diminishment (and therefore the proximity of the vanishing point) of the remaining two lines, AB and CD, with respect to the centre line already established. The two lines should recede to the vanishing point and each should be equidistant from the centre line as measured along a vertical drawn at any point. Be careful not to impose too great a degree of diminishment or the vanishing point will be too close and therefore distortion will be more likely. The resulting trapezoid should be a circumscribing square in perspective (given the offset centre anomaly we have chosen to ignore).

2. Next, use your judgement to draw in four perspective lines from each corner of the square to the other vanishing point, bearing in mind that they should all converge at the same rate. Start with the line closest to the axis of rotation and work outwards. Obviously, if the vanishing points are not 'off the board' and you want more accuracy, you can put in a horizon from the previously established vanishing point (VPL) and where this horizon line intersects the axis of rotation will be the second vanishing point (VPR). Next, you will have to estimate where to put the vertical (EF), which defines the second side of the cube, and this you will have to do completely by eye. Do it lightly at first and complete the rest of the cube, especially the unseen faces,

to give you the maximum visual information on which to base a decision. Look at the completed cube and decide whether it looks distorted. If it looks out of proportion, move the line to correct it and complete the rest of the cube again. With this method, remember that every step of the way, distortion can creep in, so it should only be treated as a quick guide.

Right: Constructing a circular shape using an ellipse guide

1. Ellipse guides can also be very useful for building up views of complex circular shapes, such as bottles, from elevations, provided their axis of rotation is vertical. Simply take the elevation (or a single profile and centre-line) and draw horizontal section lines at regular intervals and at key changes of direction.

2. Because the bottle is small, we can use a single template. If, on the other hand, it was a much larger object, we would select one for the top, one for the middle and one for the base. Draw the ellipse which, with both axes aligned, has the profile passing through the point of intersection of the major axis and the perimeter of the ellipse. This will produce a skeletal view, and it only remains to connect up the resulting silhouette to complete the construction. Note that the silhouette and cross-section diverge away from one another as the bottle flares outwards and then in again at the base.

3. The whole process is equally useful but less easy when drawing the same product on its side. In this case it is obviously necessary to first construct, or sketch, the elevational view in perspective complete with vertical section lines. If you need to set up an accurate perspective, then this method probably isn't worth the trouble because you may as well construct all the necessary circumscribing squares. If, however, you are reasonably confident that you can do this at least partly by eye, it will save a lot of time. (You need to be able to divide a single line into equal parts with a regular rate of diminishment. The way I do this is to draw the line and mark off each end; then I estimate the mid-point in perspective to one side of the measured centre, divide the two halves in half again and so on). Next, draw a geometric right angle through each section centre to indicate the major axis. Then, offer up the ellipse guides until you find one which, when both axes are aligned, has its circumference passing through the point of intersection of the section-line and its corresponding vertical. Repeat this for each section to create a skeletal view and then join up the silhouette.

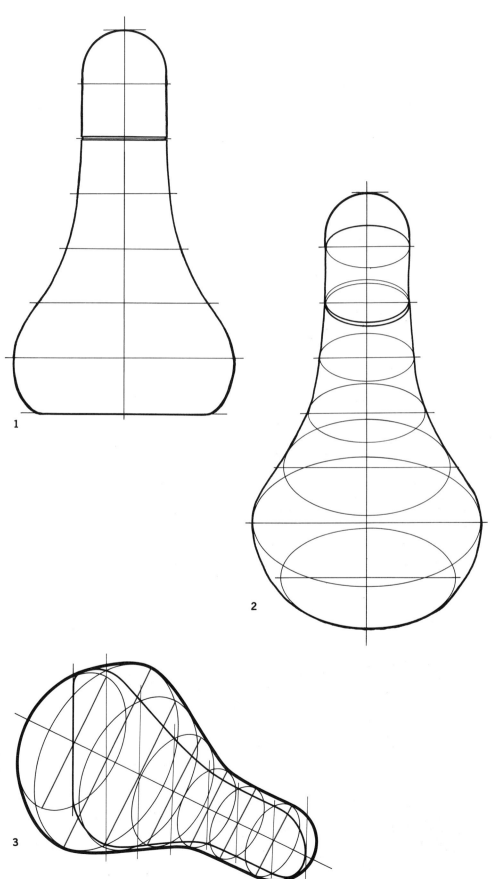

Dividing up a Circle in Perspective

There will be many occasions when you will have to divide up a circle in perspective into segments. With a circumscribing square this is fairly easy because you already have increments of 45 degrees established by the diagonals. Finer divisions can be obtained by using your eye to divide each segment in half again (or into thirds). Do this on opposite segments and check for accuracy by joining up through the centre.

If you are not working within a circumscribing square, use the major and minor axes as the established 90-degree angles and use your eye to subdivide into 45-degree sections and then in half again, checking across the centre as you go. As with dividing a line in perspective into equal parts, remember that this is not a geometrically equal division because the equal segments are not evenly disposed around the perimeter of the ellipse, but are concertinaed around the major axis. This is much more noticeable with the 'thin' ellipses. If accuracy is essential, many template manufacturers print a protractor around the largest ellipses with increments already marked off.

Spheres

A sphere in perspective is, of course, a perfect geometric circle and can therefore be drawn with a compass. Invariably, though, this is insufficient because more detail is required or because the spherical part must relate to another part of the product. For nearly every application it is necessary to draw the equatorial ellipse and at least two others; the diagrams below illustrate how to do this.

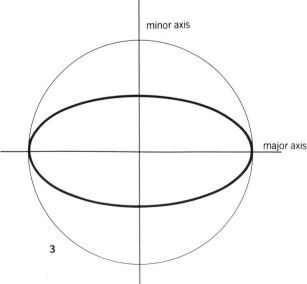

1

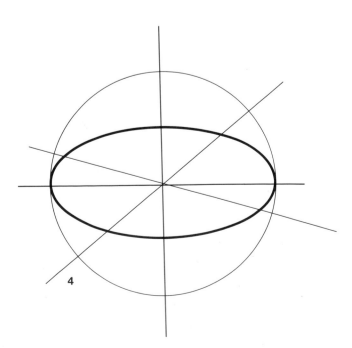

2

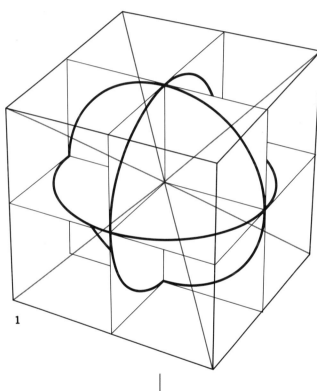

minor axis

major axis

3

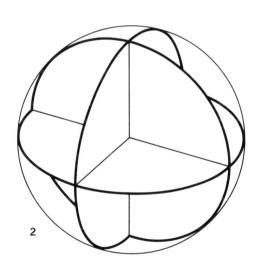

4

Spheres

1 and 2. A sphere in perspective is, of course, a true geometric circle. More often than not, however, you will need more information than is provided by simply drawing a circle. You will probably need the equator and any two ellipses which run through the north and south poles at right angles to each other. This can be done by first constructing a circumscribing cube and then working inwards by finding the centre of the cube using diagonals. Set up three circumscribing squares and their corresponding ellipses and then swing a circle of the appropriate radius to complete the sphere.

3. If, however, your product is nearly all spherical, then it is possible to work backwards using ellipse templates. To do this, first choose the ellipse for the equator remembering that this will determine how much you will be looking down on the sphere. Draw in the ellipse and both its axes, and swing a circle, of the same diameter as the major axis, from the centre.

4. Next, divide the ellipse into four equal segments either by eye or with an ellipse protractor. This creates two lines at perspective right-angles to each other.

5. Draw a line passing through the centre and at geometric right-angles to one of these two lines. You now have the major and minor axes for an ellipse and two of the points, X, on the circumference of the first ellipse, through which it should pass. Find the new ellipse (with the same length major axis as the equatorial ellipse) that, when aligned with both axes, passes through both points X.

6. Repeat the process for the other side.

7. The intersection of these two ellipses on the original minor axis locates the north and south poles.

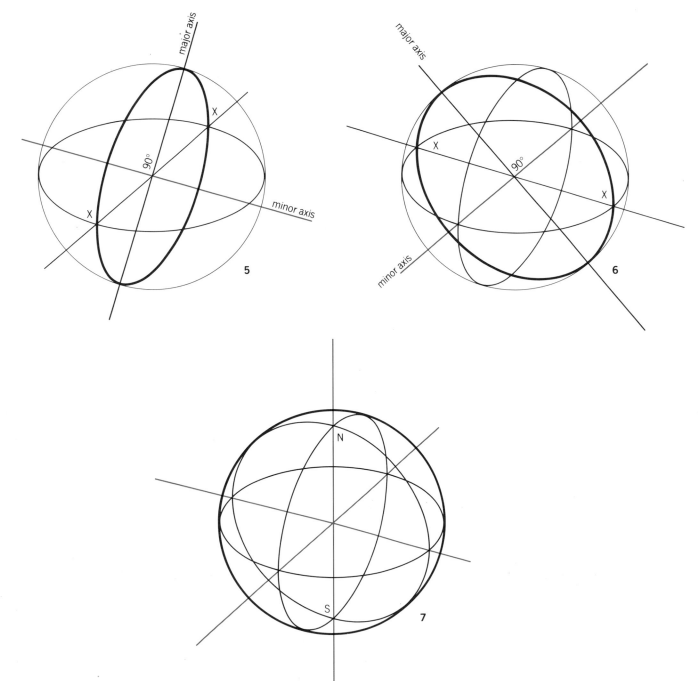

Radii

One of the most common characteristics of contemporary products is the radiussed edge. Radii help to soften a product and reduce its visual bulk; they are also predictable and easy to manufacture. It is important to understand how to draw them because you will then see exactly why they contribute to reducing visual bulk. It will also help you understand parts of the following chapter which describe how we perceive reflections in radiussed forms.

Radiussed edges

As an illustration of what is involved in constructing radiussed edges, the following diagrams show how to draw them onto the basic cube.

1. Look first at the side elevation and observe where the centres of the radii and spheres lie in relation to the outside skin. The side of a radiussed cube is made up of square flat areas interconnected by cylinders at the edges, with the quadrants of a sphere in each corner. Armed with this information it is relatively simple to construct a cube, with spheres and cylinders at the appropriate places, working from the centre-line outwards.

Most of the time, however, the radii are not such a dominant feature of the product and therefore do not warrant such accurate construction.

2. First of all, draw a cube and lay in the lines which describe the extremities of the radii, i.e. the lines at which the flat planes become rounded. These lines are crucial because they define the point at which the form changes direction and the point where light (and therefore colour) begins to change. If you analyse the nearside corner, itself a cube, you can see how this can be divided into three intersecting ellipses which themselves define a sphere. The minor axes of each ellipse form the back three lines of the cube. I find it helpful to visualize each ellipse quadrant as the line which marks the change of direction between that which is cylindrical and that which is spherical.

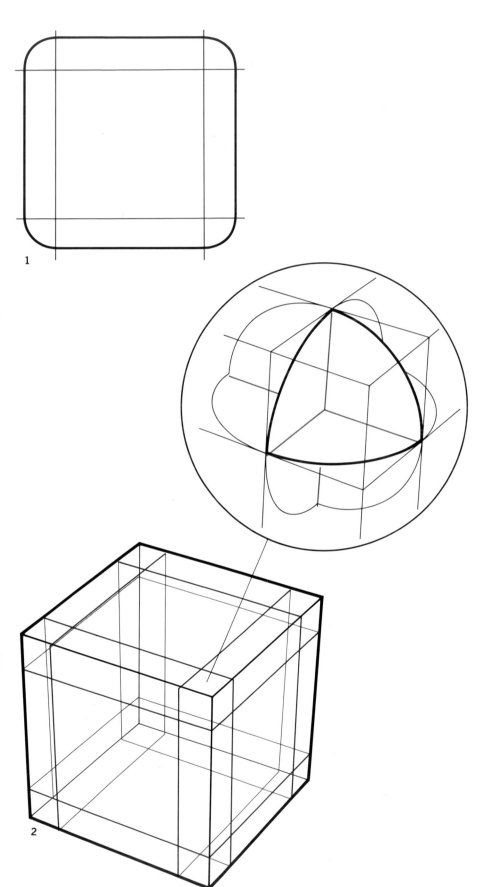

3. All that remains is to freehand in the ellipse quadrants on each corner. It helps, at this point, to think of the cube as three separate 'ribbons' wrapping around at 90 degrees to each other. Starting with the left nearside face, wrap one ribbon over onto the top by sketching in a smooth curve between the two faces. Next, wrap it over onto the rear face in the same way, drawing in first the two curves, and then the new falling-away edge tangent to them. Continue the wrap down the back, on to the base and back up the front so that you have a complete ribbon. Be sure to work as carefully on the unseen planes as on the front, at least until you have sufficient confidence.

4. Use exactly the same process starting with the right nearside face, working over the top and back across the base until you have another ribbon at right angles to the first.

5. Finally, work from the left nearside face across to the right nearside face, and then around the two unseen faces and back to the front.

6. All that remains to be drawn are the missing corners, which can easily be sketched in freehand. The final underlay has all the necessary information about changes of direction which we will need for later colouring up; note, too, how the radiussed cube looks so much smaller than the original because all the falling-away edges have moved inwards.

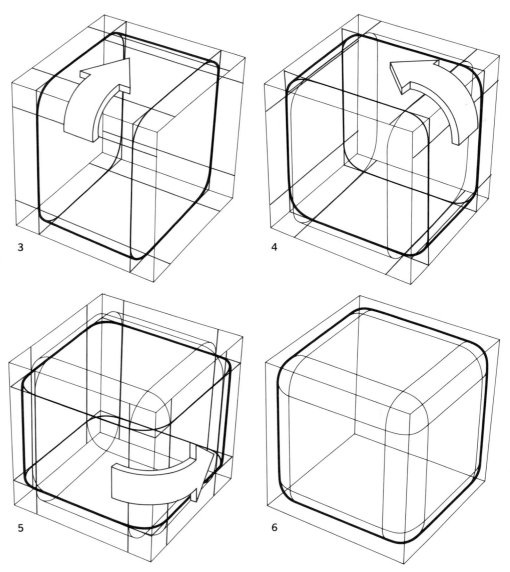

Compound Forms

Armed with the ability to draw rectilinear and circular forms in perspective (cubes, cylinders, cones and spheres), it is relatively easy to construct much more complex shapes by building up a perspective grid and working from side, front, and end elevations. Once a grid is established, the appropriate cross-sections can be drawn in perspective. These are usually the centre lines of the product, and you are therefore working from the inside to the outside of the product. Once sufficient sections have been drawn in, it is simple to complete the drawing freehand.

Three-Point Perspective

Most students taking their first steps into the world of perspective will want to begin with a two-point perspective where all verticals are parallel. To my eye, this always looks wrong because it does not correspond with reality. Remember that a good eye for perspective is essential for sketching and keeping everything in shape; and you cannot hope to educate your eye if you always work with a two-point system which ignores converging verticals. By all means start with a cube drawn in two-point perspective, but then move in the verticals as evenly as possible so that they lead approximately towards the third vanishing point. If you are unsure, quickly extend the cube to the required dimension and check that you haven't overexaggerated by imposing too much convergence in the verticals.

Conclusion

Examine the stage-by-stage examples and finished underlays on the following pages, so that you understand the process of building up a view. Then try it for yourself with one of your own designs.

It is pointless to move onto the following chapters if you are not confident that the underlay you have produced for your product is accurate. No amount of careful colouring up or jazzy backgrounds will conceal a distorted perspective. Go back and try to get it right first. With perspective, practice really does make perfect because you are constantly educating your eye; the more you do it, the better you will become.

Example 1:
From GA Drawing to Underlay

Hairdryer

The following example takes simple elevational views from basic cube through to perspective line drawing (master underlay).

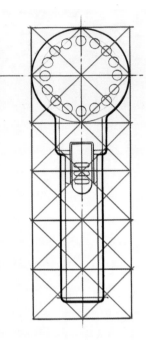

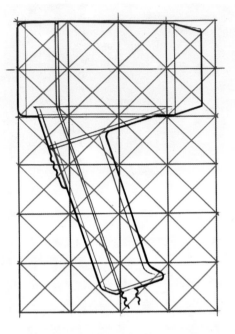

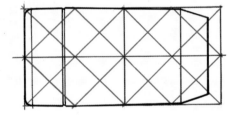

1

Stages

1. This is a fairly typical example of a GA drawing that a designer might be faced with. For technical reasons he or she may be working from scale drawings to ensure that the product will go together and that everything is in proportion. The first thing to do is to decide what view of the hairdryer is required, in this case a rear three-quarter view. This was sketched out freehand first to check that the view described the form adequately and to establish the most logical starting point for constructing the grid. Since the back, top edge of the dryer is nearest to the viewer, the GA was squared up from this point using the overall diameter of the circle as the cube's dimension. Our grid will therefore be approximately three cubes high, two cubes long and one cube across.

2. The nearest cube is drawn first (in this case using a cube left over from an earlier drawing). This is then extended one cube to the right and three down, checking all the time that distortion is under control.

3. The side elevation of the dryer is then sketched in along the centre line of the grid. The major ellipses are also put in lightly, using guides. Because the handle is suspended above the base of the grid, it is easier to project the lines which describe the edges of the handle to the bottom of the original GA grid and then mark those points onto the base of the perspective matrix; these can then be projected back up. In this way the angle of the handle can be accurately determined.

4. At this point, to avoid confusion, the matrix was slid under another sheet of layout paper to cut out unwanted construction lines. The elevational section can be extended either side to the required width, and the lines which define the intersection of handle and cylinder become clearer. The cylindrical lines are now put in more clearly, particularly the two which define the radius around the back rim.

5. The radii along the handle are first defined (in exactly the same way as we did with the cube) to establish how far the falling-away edges must be moved in. The rear face of the dryer is divided first into four, then eight, then sixteen to establish the centres for the intake holes. These can then be put in easily, using the same value of ellipse guide as for the larger circle but in a much smaller size. The other details such as the switch and grommet are put in by eye last of all.

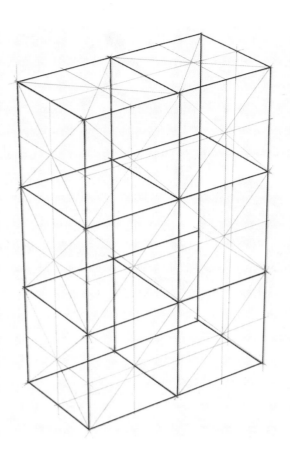

2

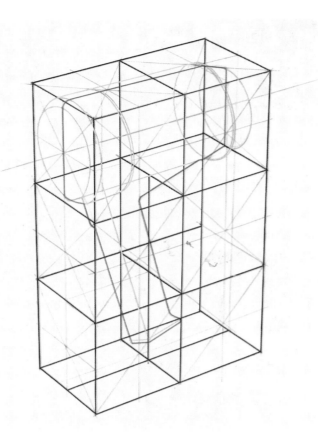

3

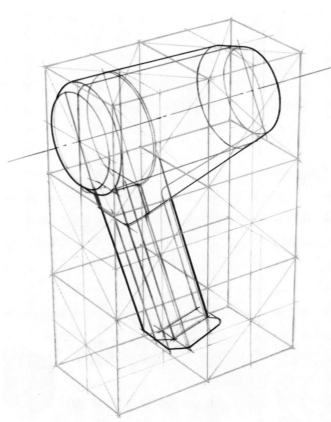

4

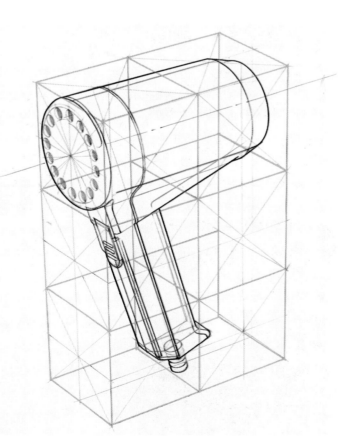

5

Example 2:

Freehand Underlay

Camera

This example is very similar to the hairdryer but is done freehand without a grid.

Stages

1. The major cylindrical form is drawn first. This is done with a 45-degree template which is stepped along the minor axis of the cylinder to produce the lens, main body and viewfinder. As you work along the minor axis, make sure you raise a vertical within each ellipse to keep the sectional view correct. The unit which hinges off the main cylinder is projected using the major axis of ellipses already used for the main body. Verticals are also dropped tangential to the lens hood and their centres joined up to establish a horizontal and approximate left-hand vanishing point. The major vertical down the face of the lens hood is also extended as the main guide for locating the front of the handle. As with the hairdryer, once the centre-line of the handle is established, it can be extended to left and right to define the handle width before the radii are put in.

2. All the main parts are firmed up and the details lightly laid in. The microphone cover is constructed by dividing the front ellipse into the right size of segments and wrapping the divisions around onto the cylinder. Concentric ellipses are then put in to locate all the centres for the tiny ellipses. Some juggling by eye is necessary when doing this kind of detail at such a small scale.

3. Finally, the remaining details, buttons, lettering, grip details, etc., can be put in. When doing lettering in perspective, you must treat the words in exactly the same way as any other detail, and put in as many construction lines as you need to define each letter. At the very least this means a line top and bottom divided into the number of letters. Remember that when doing capitals the letter 'i' takes up half the room of other letters. When working in lower-case, you also need construction lines for the ascenders and descenders as well as making allowances for the other 'thin' letters.

For clarity it sometimes helps to shade key areas as you go along. This helps your mind to read the drawing as a three-dimensional object in space and establishes one part as being 'in front' of another; and it therefore helps you decide whether the perspective is right.

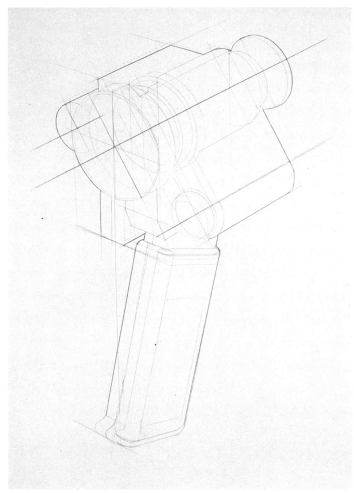

1

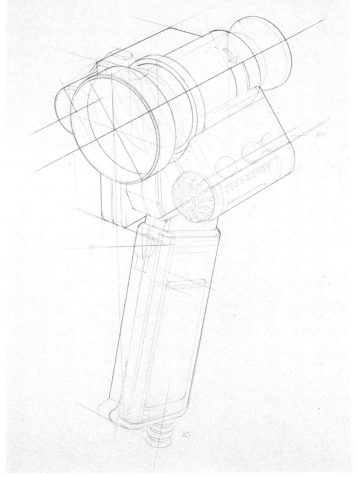

2

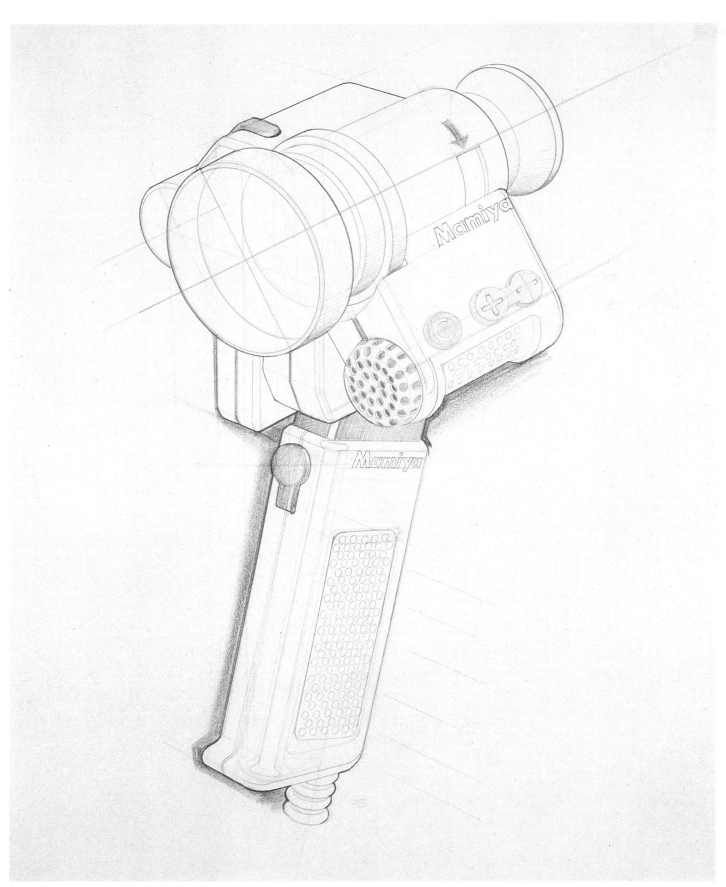

Left: Underlay for beer-making machine
(finished rendering p. 140)
This drawing was done in pencil on layout paper and was set up by eye. Note how the cut-away area is kept to the minimum to reveal as much as possible without incurring too much extra drawing.

Above: Underlay for bathroom unit
This underlay was built up using the cube method from a commercial perspective grid; once the matrix was complete, the grid was discarded, and the details put in by eye. Note how the radii at each end make the product look smaller, and how the angle of each ellipse is marked for future reference.

4 Computer Aided Design – CAD

Many designers and design studios have a micro for myriad different office functions, from word processing to project planning. Graphic designers have found out how their computer, when connected to a laserwriter, can be used for 'Desktop publishing', and industrial designers are now using them for CAD and visualization.

The author at work on one of Seymour/ Powell's Apple Macintosh II computers. A large screen is essential for CAD work, and full colour helps in clarifying complex layers in a drawing but, until the advent of low-cost full colour printers, colour is a bonus rather than a necessity. Within a design office, where each designer may have his own computer, the machine will be used for many other things such as electronic mail, accounts, budgets, proposals and project planning, so flexibility and accessibility are very important as well as cost – a requirement which could rule out high-end CAD systems and workstations.

Using a Computer for Perspective and Rendering

Even the most basic micro can handle rudimentary perspective, and programmes exist to run on most types of machine. More processing power and capacity is needed for CAD and 'wireframe' type perspectives that can be viewed from different angles and even rotated in space; still more speed, power and capacity is needed for true three-dimensional modelling in colour.

It will not be long, however, before every designer is using a micro at some stage in the design process, either for CAD and the technical implementation of a design or for extremely slick visualization. The greatest potential for three-dimensional systems lies in the difficult transition from idea to rough model: many designers can easily articulate ideas in their heads (probably better than most CAD systems) but the difficulty lies in transcribing the idea into three dimensions quickly and efficiently. The micro will be of enormous benefit for this because the designer will be able to move from the sketchpad to a rudimentary CAD system working with orthographic views that are dimensionally accurate and within which the necessary parts and mechanisms can be accommodated. The CAD system can then instantly produce a wireframe perspective so that the designer can see the effect of changes and optimize the solution. At the end of this process you can print out the drawings for the production of sketch models: indeed, three-dimensional photocopiers are becoming available which allow the downloading of CAD data and which then direct a laser in a sweep around a mass of resin; the action of the laser on the raw material causes it to solidify as the laser passes over it, allowing the build up of a solid 3D form. More prosaically, the drawings can be used in the workshop to produce a foam or wooden mock-up that is dimensionally spot-on. For further stages in the design process the information is already logged in the computer and can therefore easily be used as the basis for a full set of working drawings. It can be used in 3D modelling modules which allow the designer to produce startlingly realistic visuals in full colour which can be viewed from any angle and rotated in front of the viewer. The drawback at the moment is that to manipulate complex visuals in full colour demands powerful and expensive systems, but the gap between them and the everyday office micro is narrowing fast.

A whole book could be written about the use of computers in the product design process, but I have had to limit the space allocated to it, at least until a few years hence when we will wonder how we every managed without a computer. I have assumed that most readers do not have access to huge and expensive minis and mainframes and so have limited the following example to what can be achieved using an everyday micro – in this case an Apple Macintosh, much loved by designers for its graphic interface, ease of use, WYSIWYG (what you see is what you get), and software standards which allow users to learn new programmes extremely quickly.

Example
Hairdryer

This is the same hairdryer layout shown on pages 40-41 but done with a programme called MacPerspective running on an Apple Macintosh. It is not a true CAD system nor indeed is it a very comprehensive 3D programme, but it does have the advantage of being exceptionally easy to use and very inexpensive. It is ideal for the designer who does not have a natural flair for perspective and finds it difficult to set up a perspective view; at its most basic level it can even be used to generate simple matrices of cubes to use as dimensionally accurate underlays as described earlier in the chapter. It is not intended for the production of lavish finished visuals although, as with nearly all software that runs on the Macintosh, the drawing can easily be pasted into more sophisticated drawing programmes where it can be fully rendered. The programme uses a co-ordinate system which is absolutely essential when you are trying to create a dimensionally accurate drawing. The computer needs to maintain in memory a three dimensional 'map' of the object at all times, and it uses the coordinate system to achieve this. You can still 'point and squirt' using the mouse but you will always default to the nearest coordinate point. The advantage of the system is that because the computer retains all the information describing the object, it is comparatively simple to look at it from another point of view, or even get inside it. The disadvantage is that the computer is not easily able to tell which lines are in front and which lines are behind, and so the result is a 'wireframe' drawing. Using this as a basis, the more sophisticated systems can do hidden-line removal and full shading and rendering using a variety of different lighting conditions. For our purposes though, a wireframe drawing is all we need for a working underlay.

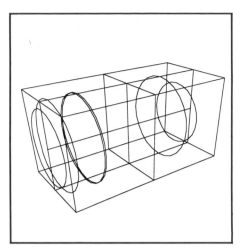

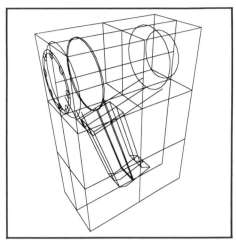

Stages

1. A cube matrix is not strictly necessary but the coordinate system needs a point from which to calculate distances and in this case I have chosen the near corner of the cube as the 'origin'. Dimensions are then quickly entered using an intuitive method which is similar to the way you might do it manually.

Once the two cubes are drawn, a circle is drawn on the left-hand cube face and a slightly larger one 5mm to its right. This is then duplicated and moved to the right to form the split lines and the circle defining the start of the cone. A new circle is then drawn for the nozzle itself.

2. Next I have extended the cubes to create the same matrix as shown on pages 40-41 inside which I will create the handle. Much like the manual system, I created the centreline section (as it would be seen in side elevation) and then copied it 12mm either side to establish the handle, and then completed it by joining up the newly created points. Because the handle is at an angle to the main cylinder, it is a good idea to change the origin point to speed up the process. For the air intake holes, a single circle was drawn and then duplicated around the perimeter of the back surface – the intermediate circles will be put in at the rendering stage. The handle split line has also been put in at this stage.

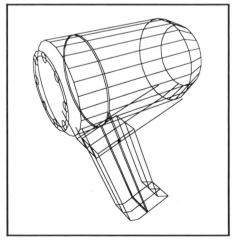

3. The circles are actually made up of straight lines drawn every 15 degrees (although for more accuracy these can be drawn every 2 degrees) and these 15 degree points around the circumference of each circle are joined up to help define the surface of the cylinder, and the front conical nozzle.

4. The previous 'wireframe' stage is more than adequate to use as a working underlay but the programme does allow you to do manual 'hidden line' removal if you wish. Note how the edge of the triangular plinth fails to join up with the surface of the cylinder at the front – this is because the wireframe has been drawn without edge radii.

Design for British Rail Locomotive
produced at the Royal College of Art
by Mike Starling

*This fully rendered image of the front
of a locomotive was produced on a
sophisticated system at the Royal College
of Art under the guidance of the lecturer in
charge – Michael Starling. Like many current
systems in use throughout industry, the data
for the image can take a long time to input and
organize, but because the data represents a
true three-dimensional object, it can be
viewed from any position and in a variety of
lighting conditions. Once the data defining
the object is established, the colour of the
design can also be modified and varied in a
fraction of the time it would take to do a visual.
Graphics too can be scanned in, enlarged,
modified, and then pasted onto the three-
dimensional surface. The time taken to
render the image from the input data varies
with the power of the computer being used.
Not so long ago, a time of several hours was
not uncommon, but more recently such
drawings can take only minutes for the
processor to recalculate and redraw. The real
pay-off with this process comes after design
approval when, because the data defining the
object is established, it can be used to
produce the model and even tooling using
CNC controlled equipment. The latest
equipment to reach the market are computer
driven three-dimensional solid modellers,
which use a laser to cut a three-dimensional
model from resin. In the car industry, it is not
uncommon to have a computer controlled
five-axis robot arm machining a car exterior
from a huge block of foam driven directly from
the CAD system which the designer has been
working on.*

Left: Cell phone assembly
produced at SDRC by Mike Starling

*This drawing shows how a commitment to
CAD at an early stage in the design process
reaps benefits later on in the design
development process. Here the basic sub-
assemblies of the product – the front case
half, the main PCB complete with its display
and keypad, and the shielded transmitter/
receiver assembly are shown together as if
ready for assembly.*

1

2

An electronic product
produced at the Computer Image Centre/
Corporate Design Centre of Sharp
Corporation

*These two pictures show how the same object
can quickly and easily be viewed in a variety
of colour and graphic treatments.*

3

Video-camera
produced at the Computer Image
Centre/Corporate Design Centre of
Sharp Corporation

*This sequence shows the build up of an
image for a video camera from wireframe
drawing to finished image.*

*1. The wireframe drawing which contains
all the information describing the contours,
volumes, and surfaces of the object. The
computer holds all this information in
memory and so can reconstruct the drawing
from any viewpoint and any magnification.*
*2. The wireframe drawing is then transferred
from a data file to an image file for rendering;
the operator can determine the light sources,
colours, finishes, location of graphics etc
before the image is finally rendered on
screen. This process can take some time and
the photo shows the display as the rendered
image is being produced.*
*3. The finished image, fully rendered and
complete with all product graphics, always
necessary on a perspective view like this.*

5 Colouring Up

After you have achieved a line drawing of your product design, you are faced with the problem of what to do next. You are probably also considering what colours and finishes to use for the product and working against the clock to meet a deadline – the pressure is on. Before reaching for a marker, however, you need to be in the right frame of mind and you need to plan a great deal in advance.

Attitude

The most usual pitfall to avoid is being 'precious' about a drawing, to a point where you hold back and hesitate because of the risk of making an error. Obviously the nearer a drawing gets to being finished the more precious you will become. The first thing therefore is to be *bold*. Rendering is, in any case, a gross (but effective) simplification of reality; being bold about colour choice, tone, highlights, etc. actually makes it easier. It's like looking at the product through half-closed eyes, which eliminates all but essential details. If you are in doubt about anything, for example, how dark to make a shadow, or how light to make a highlight, then go several degrees darker or lighter than you judge is right.

If you are a beginner, approach the rendering in the knowledge that it will probably take two or three goes to build up your confidence to a point when you can attack the final version. For this reason, never work directly on your master underlay and, if possible, practise on photocopies or dyeline prints so that you don't have to constantly redraw it. Even when you are just sketching through ideas, try and maintain a fluid approach and never be afraid of consigning an effort to the bin. If you don't try, and trying means experimenting a lot, then it will take you a lot longer to improve.

The second attitude to develop is a strong sense of graphic balance. Every drawing you do is a complete graphic image which, like a painting, is subject to simple rules of composition. Obviously, the view you choose is very important but consider also how it is placed on the page and whether the colours are working well together. Look at the size of the image in relation to the page, and whether the general presentation of the drawing looks good. There usually comes a point where the overall quality of the rendering begins to take over from its original purpose, which is to present a design concept to your client. Don't worry about this because, to begin with, it is not an unhealthy attitude and in any case, as you become more confident, your sense of graphic balance improves to a point where it becomes almost automatic.

Probably the most important key to good rendering is observation. The more rendering you do, the more you will look at products around you and begin to understand why they look the way they do. This in turn will improve your ability to determine the disposition of tone, reflection and shadow in your drawing, and the better you get at this the more you will appreciate just how important keeping your eyes open really is. You will find yourself looking at objects in a different way, trying to work out why there is a reflection here or a highlight there. You will begin to understand why we perceive a colour as we do, and how it changes depending on its surroundings and the lighting. In absent moments you will probably find yourself looking carefully at complex reflections trying to work out exactly what is being reflected where and why.

The greatest single effect of your improved understanding of why things look the way they do will manifest itself in your design work, because you will begin to appreciate form and how shapes relate to each other; you will be able to see where formal decisions have failed in existing products and why a successful design works so well. Your visual vocabulary, or 'visual experience', will be greatly expanded, which will allow you to command more design options and so improve your ability as a creative designer.

The final point to bear in mind is economy. Remember that as a designer you are trying to give an impression of reality, rather than portraying reality itself. You want to put across an idea or design to your client, not impress him with the quality of your draughtsmanship. There is therefore no need to be absolutely faithful to rigid lighting conditions and accurate reflections; concentrate instead on using only those elements which help describe the finish or form you are trying to illustrate. The conventions which follow below may be clichés in the design world but that is of no importance to the client. Provided the client interprets the drawing in the way you intend, then you have achieved your objective.

Planning

Too many people believe that it is skill with this or that media that makes a designer good at rendering. Of course, this is important, but not as important as really understanding how reflections, colours, highlights and so on work. Designers who understand why we see things the way we do can turn their hand to any media, because they know what to draw. After that they will need constant practice with a new medium to perfect their rendering; as with perspective, practice really does make perfect. So there is no need to worry about your intended media too much at this stage.

Getting back to the blank sheet of paper, or uncoloured underlay – where do you begin? There are two basic approaches to be considered: the first, the more traditional way, concentrates on imagining the product illuminated by a single light source usually behind and to one side of the viewer, i.e. over the left- or right-hand shoulder; the second is to consider the product in terms of reflections.

The first method is indispensable for determining shadows and highlights but it is misleading, in my view, to think of the light as 'coming' from anywhere in particular. This is because the actual colour we perceive in a

product, be it a car or vacuum cleaner, is a function of four variables:

1. The intrinsic colour of the surface.
2. Its reflectivity and finish.
3. The colour and tone of its surroundings.
4. The location and intensity of light sources.

Of these four variables the first is a design decision while the second and third are more interdependent than the fourth. We shall come back to the exact light source later in the chapter but for the moment we will concentrate on reflected light. We must look at the line drawing and decide what is being reflected and where, and how best to portray it.

To do this we shall first consider some basic shapes and observe how their form is described with reflections and how matt (non-reflective) surfaces are subject to the same conditions. We shall also illustrate and explain some of the conventions that you can use in your own rendering. We shall consider each shape at its most reflective: i.e. mirror, or chrome, and then observe how the reflected image is identical in form, but not colour, to that seen in a gloss-plastic version; and we shall look at a totally matt version and see how it responds to the same reflected images.

Cube

The chrome cube has no colour; the colours we see in it are entirely a function of its surroundings. Each surface is effectively a mirror which reflects in full colour and without distortion objects, landscape and light sources around it, but the 'picture' we read in each surface represents only a limited part of the surrounding environment. The easiest way to work out what is happening on these surfaces is to make a cardboard cube and laminate some mirror-finished polyester film, like Mylar, to each face, or simply hold a small mirror as if it were the side of the cube. Try placing it on a sheet of gridded paper, and move coloured shapes up to the surface, watching all the time what happens to the reflections. Try and cast a shadow onto the mirrored surface and you will find it very difficult. Observe how anything at right angles to the surface appears to pass right through.

You can see that if you wanted to draw a chrome cube you would first have to imagine it in its surroundings, and probably actually draw some of those surroundings. (To find out how to do this, refer to p. 59.)

If we now imagine a highly polished, gloss-plastic cube, it too reflects in exactly the same way as the chrome cube. The same images we saw in the sides of the chrome cube can

be seen just as crisply delineated in the plastic version. They are also sharp, pictorial reflections, but, unlike the chrome cube which reflects in full colour, they are made up out of the tonal range of the cube's intrinsic colour. Test this by finding something with a flat, polished and coloured plastic surface (a piece of coloured acrylic is ideal) to compare with the mirrored cube above. Take a red, yellow and blue coloured pencil and try holding them at right angles to the surface of the mirror – the reflected image is perfect in every detail including colour. Next, try them against the polished plastic – the shape and crispness of the reflection is the same but most of their intrinsic colour is lost. Exactly how much of this colour is reflected depends on the colour of the base material, but for rendering purposes you can ignore the subtleties of reflected colour and use a tone of the base colour. There is one small exception to this guideline and that is gloss black, which reflects a lot of colour. This may be one occasion therefore when you need to go further than simply using the tonal range of the base colour. The more experienced and

confident you get, the more you will begin to exploit the potential of reflected colour; but for the moment it is best to ignore it.

Remember also that, with super-glossy, coloured surfaces which have been lacquered, the more acute your angle of view to the surface the more reflected colour you will see, and the closer it comes to a right-angle the more intrinsic colour you see; at low angles of incidence the glossy lacquer is very reflective and you see the surroundings, but when viewed directly from above you see right through the lacquer to the underlying colour. It is important to understand this when rendering glass and other transparent, or semi-transparent, materials, as they behave in exactly the same way.

So, to draw a glossy plastic cube you need to think of it in exactly the same way as the chrome cube, which means considering each surface in terms of its reflections. At the other end of the scale you should study a matt-black cube to see how it might look in similar circumstances. Before you do, however, it is important to understand why the matt surface looks matt and why the

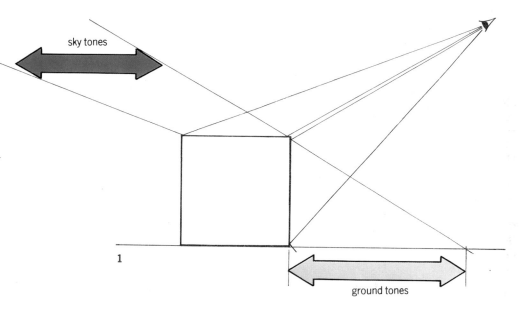

Cube
1. This is a schematic representation of what you would see on the flat surfaces of a chrome cube. In each surface there is a specific area of the surroundings unaffected by distortion. In the top you will see an area of sky, or ceiling, and in the side you will see an area of the base immediately in front of the cube.

sky tones

ground tones

1

polished surface is reflective. The polished surface (and the mirror is the perfect example of this) is absolutely flat. If you look at it under a microscope, you will see that the absence of surface aberration allows light to reflect off it in a coherent and predictable way. The matt surface, however, when seen under the microscope, is finely textured and pitted, which scatters the reflected image in all directions. This makes it impossible to read the reflected images because they become blurred and indistinct. Only the brightest of images, such as light sources, will be seen.

If you repeat the experiment with the coloured pencils against a flat matt surface, it is very difficult to see any reflection. Next, position a light source so that you can see its reflection and watch how the image which is sharp and crisp on the glossy surface is blurred and diffused on the matt one. This effect is especially important when drawing matt finishes because highlights (that is concentrated areas of reflected light) are ill-defined and soft compared to their glossy counterpart.

To sum up then, you should consider each surface of the cube separately, whatever its finish, in terms of what is being reflected. I usually treat the top, upward-facing surface as the lightest because it reflects the sky, if outside, and the ceiling complete with lights, if inside. Both the remaining faces will be darker and one will be darker still. Usually the larger of the two gets the lighter treatment but this can depend on which side of the product needs most emphasis. You can apply this method to any rectangular product even if it is multi-faceted — just remember that every plane which faces in the same direction will reflect approximately the same information and will, therefore, be similar in its tonal value.

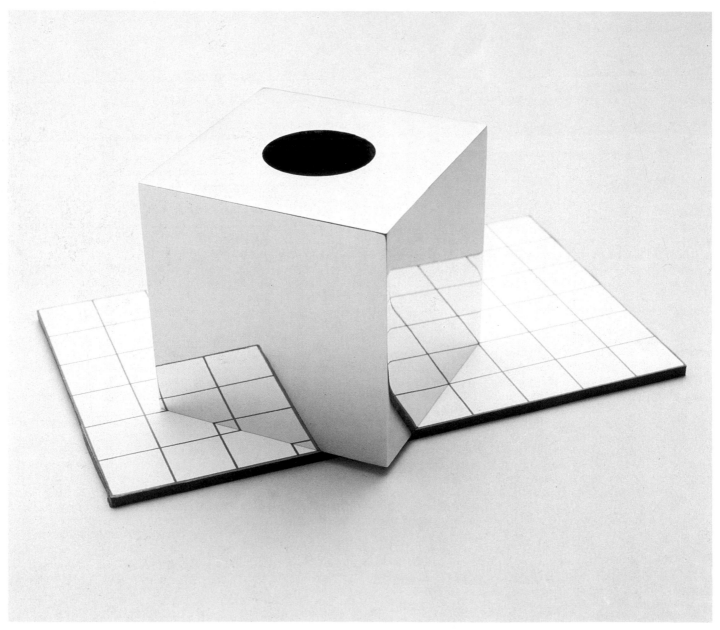

Cube (cont.)

2. In this chrome cube, shot in a photographer's studio, the top surface, apart from the black hole, is reflecting the 'sky' (actually a large light) above, and the two sides are reflecting their respective parts of the gridded rectangle and the beige paper on which it sits. Note how, on the near right-hand corner, the reflection of the rectangle is 'pulled', or distorted, into the edge giving it an almost liquid appearance.

3. The view of this chrome cube is the same as that used later to construct reflections (see pp. 59–60), so that you can see how these were built up. It is impossible to give a good impression of a chrome cube without drawing at least some of the surroundings. In other words, if you were to take away the block on which the cube sits, the viewer would make very little sense of the reflections. The top is reflecting sky, and the hole through the middle is reflecting ground at the top and sky at the bottom; in between is the horizon. The reflections are crisp and sharp, and the corners (which, like those of a radiussed cube, focus and compress the surroundings) are strongly contrasted.

4. With gloss plastic it is not really necessary to go to all the bother of constructing the reflections, as a good impression can be obtained from a more general approach. (However, if you had placed the cube on the same block as before, then you would see exactly the same reflections but in tones of blue). Each face is treated separately: the top is reflecting sky, or ceiling, and has a vertical window reflection running across it. The nearside face is considerably darker and is graded slightly so that it is lighter at the bottom. The face with the hole through it is slightly darker still and is also graded towards the bottom; this is to give the most contrast at the top edges where the highlight runs; the

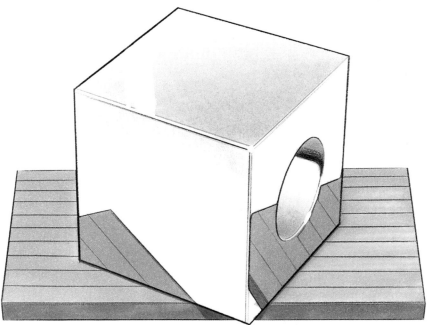

3

4

highlight itself is backed either side with a dark crayon to make it appear brighter. The hole is exactly as in the chrome cube but with a shadow across it.

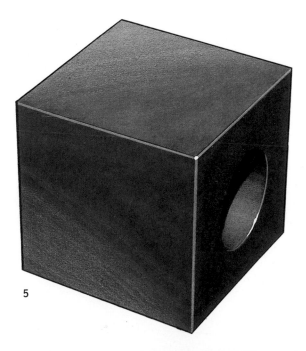

5

5. With the matt-black cube all the reflections are lost leaving only a gradual tone across each face. The top face is lighter still and slightly graded from front to back. The hole now has a fuzzy instead of a sharp highlight although the shadow across it is still crisp.

Cylinder

Having seen how a completely flat surface reflects, we must now look at what happens when a surface is curved in a single plane. This is best explained by looking at a simple geometric cylinder in the same context as the cubes.

Horizontal cylinder

1. This is a schematic representation of the 'desert cliché' – what you would see in the side of a chrome cylinder with the sky at the top, the ground towards the bottom and the horizon in-between.

2. This cylinder was photographed in a studio but illustrates the desert cliché well. We were unable to simulate the sky, so, as with the cube, we had to use a large light with a piece of blue graded paper tacked onto it. Note how the flat end of the cylinder reflects an undistorted image of the surroundings.

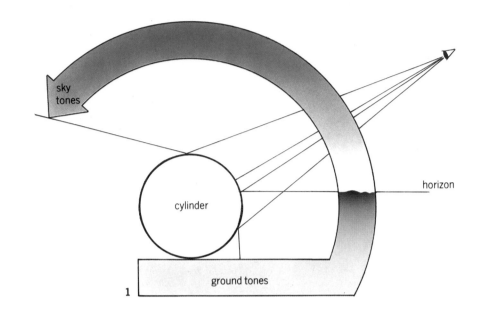

sky tones

cylinder

horizon

ground tones

1

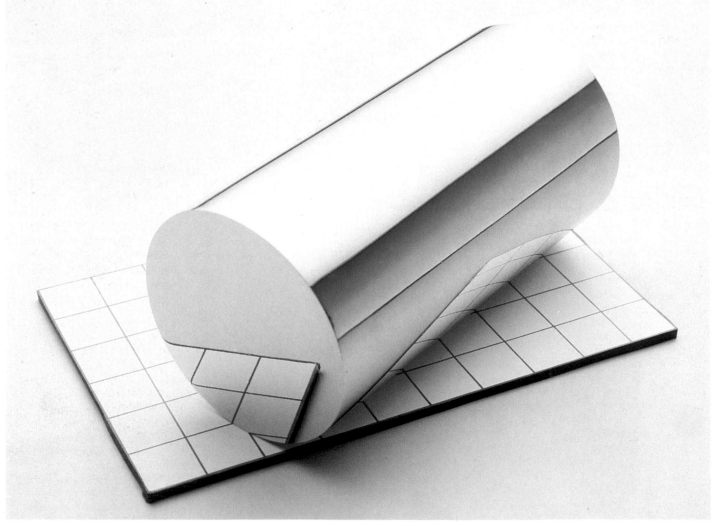

2

We have seen how chrome, because it is the most reflective of materials, can give us all the information we need to understand other finishes. So let us consider first what we might see reflected in the surface of a chrome cylinder. This is best understood by imagining a chrome cylinder laid horizontally in the artificial and uncomplicated environment of a desert, with you, the viewer, looking down at it. What you see in the surface of the cylinder is a distorted view of the surroundings. At the top of the curve you see the sky, in the middle you see the horizon, and as your eye scans the lower part of the curve you see the desert floor being reflected. As your eyepoint moves up and down, so the horizon moves up and down as well. In very reflective surfaces, like chrome, there tends to be great contrast between lights and darks, so imagine that it is dawn or dusk in the desert, with the sun low on the horizon. This throws the horizon into dark shadow and, with the sky above it at its lightest, produces a very high contrast. The colours in the reflection, as in the cube, are exact and true to the real image. I call this reflection the 'desert cliché', and it can be applied to chrome in almost any situation. You can see it in any glossy curved surface, especially in the sides of cars where glass and polished paintwork reflect strongly. Often it is not the true horizon (in a perspective sense) that is reflected but the roofline of adjacent buildings. It is perhaps best to think of it as a positive and high contrast change between light and dark.

Of course, many products are for interior use, so there is unlikely to be a true horizon to be reflected. However, the effect is still easy to see, often as a table edge, or simply the border between light and dark. Most commonly it is a window being reflected and because the window is usually the brightest part of the room the wall in which it is set is the darkest. This, as in the desert, provides the high contrast and 'edge' that makes reflective surfaces look reflective.

Turning the cylinder through 90 degrees produces a very different reflection, when viewed from above. The horizon will not be visible until you drop your viewpoint to horizon level; instead, the surface reflects a distorted view of the desert floor which appears to wrap around the cylinder. This is best observed by taking a small section of chromed tube and placing it, end-on, on a piece of gridded paper. With tubes of a large diameter the reflections can become quite complicated (see photo on p. 56), but with thin tubes of small diameter the reflections typically resolve into a series of dark and light verticals. In tubular chrome furniture, for example, it is often best to suggest the

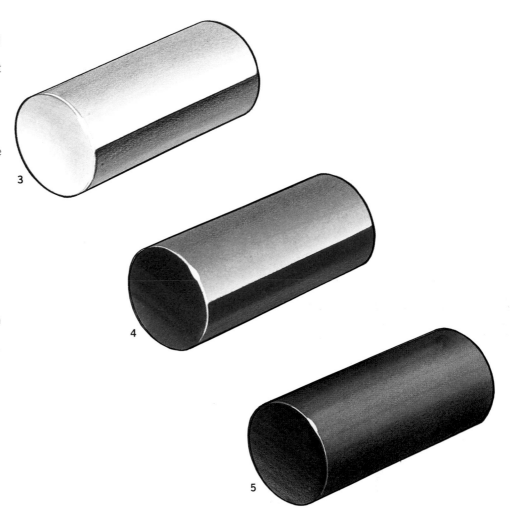

3

4

5

reflective finish in the horizontal elements and at the changes in direction and leave the verticals almost untouched. Alternatively, it is sometimes possible to get away with the desert cliché on verticals with no loss of credibility to the drawing.

The gloss-plastic cylinder, of course, whether horizontal or vertical behaves in exactly the same way as the chrome version but, like the cube, reflects in tones of its intrinsic colour rather than in true colours. The horizon will probably be the darkest area, and the sky will be reflected as a light tone at the horizon, getting slightly darker as it wraps around. Below the horizon the desert floor will be a dark tone becoming lighter as it wraps around away from us.

The matt cylinder reflects exactly the same environment but, as with the cube, the information is blurred and indistinct. The light source, in this case the area above the horizon, will be seen as a hazy highlight running along the cylinder. The graduation of tone around the surface will be much more subtle and appear as a consistent change of value as it wraps around.

3. In this rendered visual of the chrome cylinder you can clearly see the desert effect. The flat end did not look quite right with just a flat sandy colour being reflected (it is difficult for the viewer to make sense of the reflected image without seeing the real one) so, since chrome appears predominantly black and white, this was left white with some blue to provide contrast to the highlight around its circumference.

4. In the gloss-plastic version the same desert effect, with a sharp horizon, can be seen. Note how, like the chrome version, the horizon is 'pulled' (distorted) into the little radius where the highlight runs around the circumference. In this example a darker tone in the flat end is more appropriate to give contrast to the highlight, and this is slightly graded from top to bottom.

5. The matt-black cylinder shows the horizon/sky reflection resolved into a smooth tonal transition.

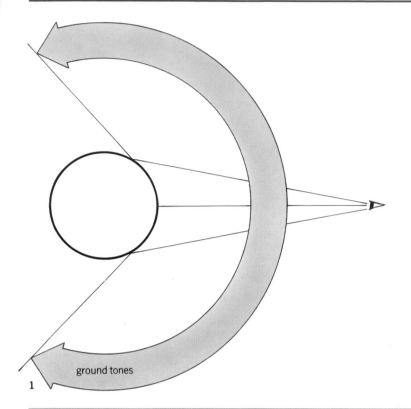

1

ground tones

3

4

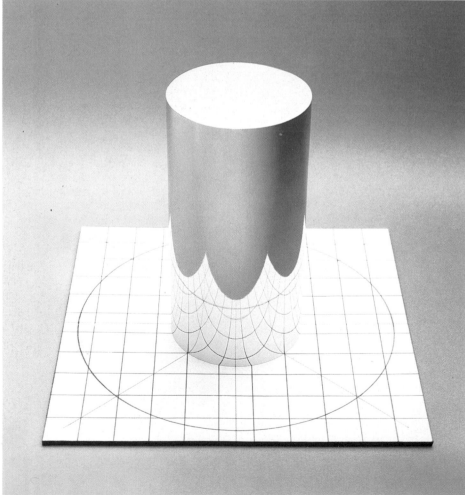

2

Vertical cylinder

1. Maintaining the high viewpoint on the cylinder but turning it through 90 degrees produces a very different effect. All you can see in the cylinder is a distorted view of the desert floor. If you lowered your viewpoint so that it was perpendicular to the vertical face, you would be able to see almost all the horizon, with yourself in the middle foreground.

2. The photo shows how, with a fairly high viewpoint, the surface of the cylinder reflects the ground around it. You can see how even the two back corners of the square are just visible. Note, too, how the red squares and the circle drawn on the base, are reflected.

3. The rendering of the chrome cylinder shows how it is possible to use the desert cliché without losing credibility, and without the need to draw in the base. For maximum realism it should have been drawn, like the cube, on a surface which could have been reflected. In practice, though, this is extremely difficult to do and you are as likely to get it wrong as right. As a compromise I have, in the past, used the distorted corner to suggest a base surface.

4 and 5. As with the other examples, the gloss-plastic cylinder is exactly the same as the chrome but in tones of blue, and in the matt-black version the highlight is resolved into a hazy, but smooth, tonal transition.

Sphere

The sphere combines the effect of the cylinder in a horizontal and vertical position, producing a reflected image of the surroundings which is distorted, like a fish-eye lens. The reflections appear most distorted near the edge of the sphere and least distorted on a line drawn from your eyepoint through to the centre. As with the previous examples, it is easiest to imagine a chrome finish in the desert and work out in side and top elevation exactly what is being reflected. You will see the high-contrast horizon relatively undistorted in the middle but being 'pulled' and 'stretched' as it nears the edge and your view is more tangential to the surface. In the immediate foreground you will see the desert floor and you, the viewer, and right at the bottom a reflection of the sphere's own cast shadow, while above the horizon is a complete vista of the surrounding sky. As with the other examples, the gloss-plastic sphere reflects the same images but in tones of its true colour and the matt-black version resolves all the reflections into a smooth tonal transition.

Reflections in any compound curved surface are difficult to predict but as your experience builds up you will become more and more adept at it. It is very useful to keep a selection of reflective shapes which you can refer to; for example, a polished billiard ball or a silver spoon (which gives both convex and concave reflections). I also keep a couple of mail-order catalogues because there is endless visual reference in there for all kinds of shapes and finishes.

Sphere

1. The reflections in a sphere are a combination of those seen in the vertical and horizontal cylinders. This photograph of a sphere, shot in a studio, was specially set up in order to simplify the reflections. (Since the sphere reflects like a large fish-eye lens, the photo would otherwise have shown the entire studio complete with the photographer and his camera.) Note how the red squares are distorted as they wrap around the surface.

5

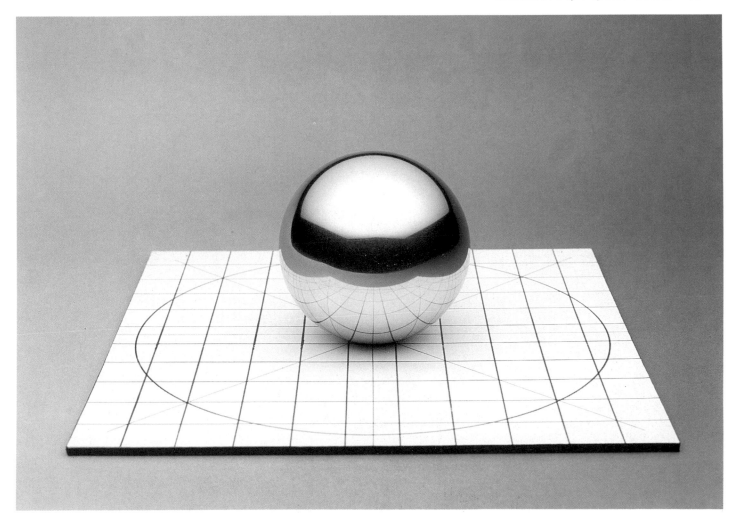

2

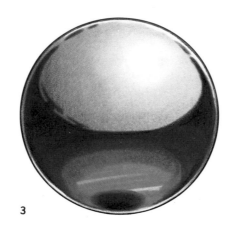

3

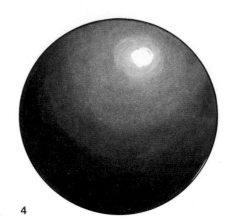

4

Sphere (cont.)
2. The chrome sphere shows the horizon being distorted as it nears the edge, with the desert floor being reflected in the lower hemisphere. In this case the sun (highlight) is higher in the sky and can be clearly seen.

3 and 4. The gloss-plastic sphere is, of course, identical but in tones of blue, while the matt-black one is continuously toned from the highlight outwards.

Radiussed Edges

Armed with these three basic examples of how reflections work we can begin to combine them into more product-like shapes. Perhaps the most typical of modernist forms is the flat-sided geometrical shape with radiussed edges. In the previous chapter we constructed a cube with radiussed edges and I referred to the usefulness of this constructional technique in determining the disposition of reflections.

First, consider the radiussed cube in side elevation, breaking it down into flat, cylindrical and spherical surfaces. In the flat side of the cube you will see, like a mirror, an undistorted image of another section of the surroundings (probably the ceiling or sky). Between these two areas, the radius is reflecting a total picture of the remaining environment. If you could walk across the surface, you would see every detail of those surroundings; the radius has the effect of focusing this large amount of information into a very small area. This is why radiussed edges often appear very bright, as highlights.

Note that in the side elevation the rate of change from flat surface to radius is gradual at first so that the horizon (or highlight) does not occur at the line where the radius starts, but some way up its surface. Note also that if this were a matt-finished cube we would read one tone on the top surface and one (probably darker) in the side. Between the two there would be a gentle and consistent

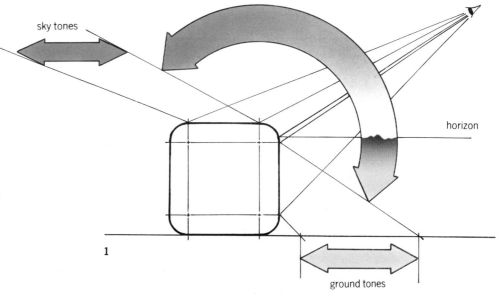

sky tones

horizon

1

ground tones

graduation to a bright but hazy highlight.
Apart from the desert/horizon convention there are some other useful and easily controllable reflections which can be used to advantage.

Radiussed cube
1. This schematic diagram illustrates what you might see if you looked down upon a radiussed cube. In the front face there would be a reflection of a limited part of the surface on which the cube is sitting; this would be distortion free. In the flat area of the top face you would see an undistorted image of the sky, or ceiling. In the radius between these two flat planes you would see everything else. This is why you tend to get highlights on

radiussed edges; for example, if the sun was in the sky behind you, you would see it being reflected in the radius even if you moved your viewpoint lower down or higher up. For the same reason the radius has a focusing effect, picking up many individual lights (spotlights on a track for example), and resolving them into a band of light that is brighter than the rest of the cube.

A common mistake among students rendering radiussed edges for the first time is to draw the highlight as broad as the radius. Because the curvature of the radius from the vertical is gradual, the horizon normally lies slightly above the imaginary line which defines the end of the flat plane and the beginning of the radius.

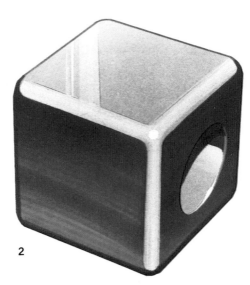

2

2 (Above). Tonally, this gloss-plastic radiussed cube is the same as the one on page 53 with the top reflecting sky, etc. The radii are treated as three broad highlights; note how they are 'pulled' in that characteristic liquid look as they reach the back corners. Giving all three highlights equal brightness is the easiest way to render the radii, but they could have been treated differently, with the vertical probably being a similar tone to its two adjacent sides (it is, after all, a vertical cylinder reflecting the ground on which it sits) and the highlight sweeping around the top only.

Reflections in a Flat Surface

As we have seen, a flat reflective surface behaves exactly as a mirror. That is, it reflects a true, undistorted image of a fixed part of its environment. It is easiest to understand this everyday effect by positioning a pencil at 90 degrees to a mirror and looking at the reflection. It appears as if the pencil passes straight through the mirror surface, and the apparent length of the reflected pencil is the same as the original pencil (in perspective, of course, because of the effects of diminishing distance). This effect is the most predictable of all reflections and can be used to construct more complicated reflections on those occasions when absolute accuracy is important. The adjacent illustrations show how to construct simple reflections in the side of a cube.

If, however, you had chosen to sit the cube on a small circle (which, in perspective, appears as an ellipse), then, after constructing a circumscribing square around the ellipse, you could use the same basic technique as that illustrated to construct the reflection of the circumscribing square. Once this is done it is very simple to lay in the ellipse within it.

Below: Constructing reflections in a flat surface

1. To get the feel of this single and obvious reflection, construct a perspective cube (as described in the previous chapter) sitting on a block. We need to work out where, in each face, the reflection of the block will appear.

2. The easiest way to do this is to treat each vertical face completely separately and, whichever one you choose, imagine it as part of a much larger mirror and extend its base line accordingly. Ignore the rest of the cube for the moment and concentrate exclusively on this 'mirror face'. Mark off a series of lines (shown in red) along the base, that pass through the mirror face (shown in blue) and are at right angles to it in perspective. This means they will share the same vanishing point as adjacent faces of the cube. Where a line crosses a detail on the base, in this case the edge, a point (X) can be marked off; you

can then estimate the position of the reflection of this point (X^1), as it will lie on the same construction line and at an equal distance in perspective on the other side of the base line. It is as if this point has been rotated through 180 degrees to give a symmetrical point about the base line of the mirror. Remember that where a line actually meets the mirror face (A and B) its reflection starts at this point.

It does not matter at this stage where you draw the red/blue lines because you quickly learn to recognize the important points to be reflected and put the lines through these key points. In this example, you do not really need all the red/blue lines, only the one which runs through point Y, which helps you to locate Y^1. Joining Y^1 to A and B would construct the reflection. If, however, line YB was wavy or there was a complex pattern on the base, you would need all of the red/blue lines. Note that the thickness of the base is also reflected in the mirror.

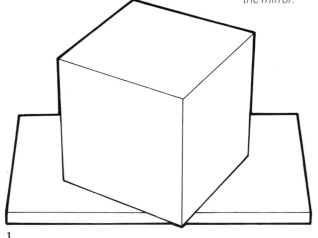

1

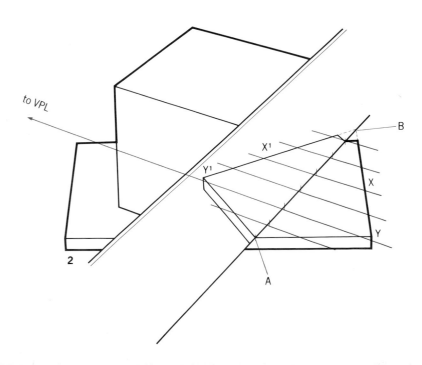

2

Constructing reflections (cont.)

3. Finally it only remains to reduce the mirror face back to its real size, rubbing out all extraneous lines in the process and just leaving the relevant part of the reflection.

4. Repeat the process for the other face of the cube.

5. Reduce the mirror face back to its original size, again eliminating unwanted construction lines.

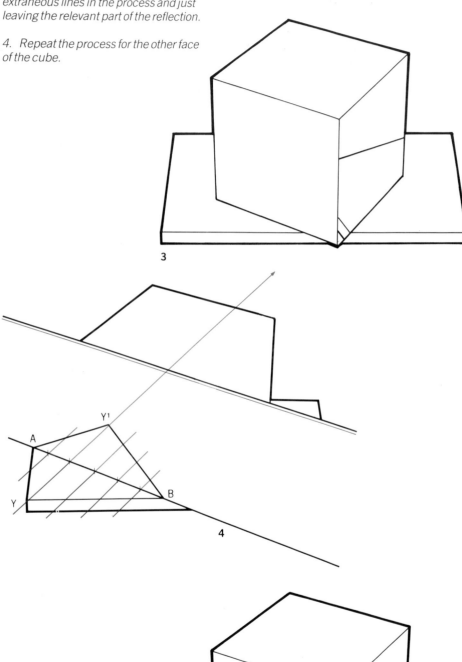

Remember that, provided the mirror face and surface being reflected are at right angles, then the reflected image shares the same vanishing points as the real image. Once the mirror face is rotated from the vertical, then the reflected image is also rotated in the same direction and all the construction lines should bend accordingly.

This basic technique can be easily used in two other clichés. The first is placing the product on a surface. Depending on the type of product, choose a surface that is easy to reflect. The most commonly used are tiled walls and floors but nearly any abstract pattern can be used to good effect. The second is using a part of the product itself. Rather than imagining the environment, or actually drawing a selected part of it, you may be able to use an element of the product itself to effect a bold reflection. For example control knobs, handles, folding covers or any moving parts may be positioned so that we see their reflection in adjoining surfaces. This allows us to choose the best possible reflection and to construct it as easily as possible.

The Window Cliché

The window cliché is one of the most commonly used conventions to make surfaces look reflective. Cartoonists use it extensively, as do photographers when setting up product shots (although, of course, they simulate it by using a 'fish-fryer' light).

I use it most in horizontal surfaces. Nearly all windows are set in vertical walls and usually the wall in which the window is set is the darkest in the room; this provides the high contrast necessary for making things look glossy. Any horizontal surface, such as a table, or the top of our cube, will reflect the window as a high contrast *vertical* band (any line at right angles to the mirror surface will appear to pass through it). If the surface is slightly angled then the reflection will also be angled. You can therefore use the window reflection to indicate changing planes as, for example, in a record turntable top.

Below: Reflecting a part of the product

1. To make a surface look reflective it is often possible to position a part of the product so that its reflection can be seen in another part. In this example the open lid is reflected in the top of the cube and the shape on the side is reflected in that side. If the shape is itself reflective, then this will have a reflection of the cube in its side. As a general rule (and contrary to expectation) the reflected image is slightly darker than the true image.

2. It can be very effective to place the product on a surface or in an environment that reflects it – although this says more about the surface's finish than the product's.

Bottom: How highlights work

Highlights, or 'chings', are the reflections of bright light sources – the sun if outside, and lamps if inside. The areas in shadow are those areas diametrically opposite the light source.

Highlights and Shadows

It is appropriate at this stage to return to the second basic approach outlined at the beginning of the chapter and imagine the product illuminated by a single light source. I usually position this almost directly over my head and to the left or right depending on which side of the product has most interest.

You can of course put the light source anywhere you choose, to obtain more dramatic effects, but once you do this you increase the shadowed part of the drawing considerably. Backlighting, for example, is difficult to do and throws the bulk of the product into shadow making it difficult to render (no highlights) and more difficult for the viewer to understand. Remember also that the focusing (or catch-all) effect of the radii that 'fall away', or point away, from the viewer are less pronounced, so that even the brightest, broadest light source behind will yield only a pencil-thin highlight on a falling-away edge. Highlights, sometimes called 'chings', are the reflections of the light source itself. In the case of an exterior view this would be the sun, and with an interior view will probably be a single spotlight or track of spotlights.

When putting in highlights, do not think of the light as coming from anywhere, but rather think of it in terms of where on the product the light source will be reflected. With the light source, whether sun or spotlight, almost directly over your head and slightly to one side, all the near edges and curves will catch the highlight, and their focusing effect will be at its most pronounced.

It is also, of course, the light source which determines the disposition of shadows, so it is convenient to consider the two effects together. With the light source above and behind the viewer, the shadows are thrown behind and below the product, so that they have an absolutely minimal effect on the ground or base. Where they do become crucial is when the product has a part (or parts) throwing a shadow across itself. In this case it is nearly always essential to put in the shadow and it is usually not difficult to estimate its position.

Remember that the colour of the shadow appears as a dark tone of the material on which the shadow is cast. This means that, if a shadow is thrown across two different materials, you should change the colour you use for each part as it passes across the two materials. Remember also that there is virtually no shadow on chrome.

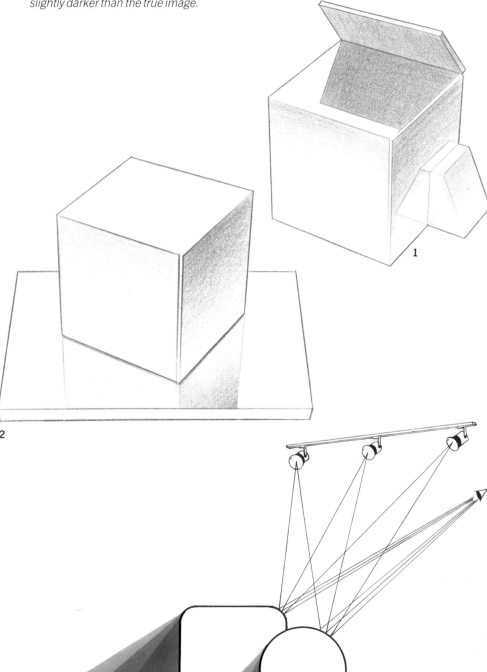

1

2

6 Marker Rendering

Of all the materials available to the designer the marker is probably the most widely used. It has spawned a wide range of techniques because it is fast, easy-to-use, compatible with other materials and gives strong punchy results. It has also done much to break down the barrier between working sketches and finished drawings. This, in turn, means that designers are less likely to finish the design work and then sit back and ponder on how best to do the finished visuals, because they will have been working with colour from a much earlier stage in the design process.

Although designers refer to 'marker rendering' as a single technique, most visuals of this type rely heavily on other media as well, such as coloured crayons, pastels and paint. Each marker only contains a single colour which, when applied, leaves a defined edge and therefore makes the rendering of soft, gradual toning very difficult to achieve. So, for soft organic shapes it is perhaps less suitable than pastels or coloured pencils.

The marker itself is an unforgiving medium and cannot be erased if wrongly applied. Paradoxically, it is also a medium that demands a *bold* approach for best results. Because it is so fast and so immediate, it is easier to avoid the 'precious' approach to a drawing. Too many students use the marker indecisively and become over-concerned at slightly blurred edges where, perhaps, they have strayed over the line. This approach produces dull, static drawings instead of fluid, loose visuals which always look more effective. Many beginners will follow the same course as I did, starting off too tightly and then gradually loosening off as you build up experience; try and short-circuit this process by constantly practising a more fluid approach.

Marker rendering, more than other techniques, is best at giving an impression, rather than a true picture, of reality. This impression of reality is similar to that obtained by screwing up your eyes when looking at an object. You are trying to distil the essence of the object by simplifying the tonal values and details, in order to create an impression (or series of clues) with which to reconstruct an image close to reality. Provided enough information is supplied, the mind can draw on visual experience to fill in the gaps. The really good renderers are the designers who are as economical as possible with their marks on the paper, but still manage to create an informative visual.

To help you achieve this economy it is a good idea to *exaggerate* what you would see through half-closed eyes; in other words, simplify the image, and then render it with more contrast and bolder strokes than you judge would be there in reality. One pitfall for the beginner to avoid is overworking the drawing. Learn to be economical and resist the temptation to cover every square inch with the marker. Often it is more a question of where *not* to put colour, rather than a question of where to put it. In fact, the surface of most marker papers will not stand too much overworking and will quickly reach saturation point; scrubbing of the marker on the paper will also quickly break up the surface.

Try to avoid a rigid, stilted approach to the drawing which is usually the result of lack of confidence and a hesitant hand. The marker really demands drawing from the elbow and not the wrist. You have to keep it moving just to avoid 'puddling', or flooding the paper, so, as a medium, it doesn't suffer fools gladly. There is only one solution, and that is constant practice. The more you practise the better you will become, and the better you become the more confidence you will have.

Basic Techniques

Using the tip. Use the chisel tip to provide a range of line thicknesses. When working the marker, be sure not to let the tip dwell on the paper where it will form a blodge.

Infilling flat areas. This is the most basic use of the marker and the starting point for most beginners. It is very important that you begin by mastering this technique because, once you have acquired the necessary control to do it, everything else is simple. Try to work freehand (without rulers and masks) as often as possible to help build up confidence.

The key to obtaining a flat finish is the maintaining of a 'wet front'. This means that you must work fast so that the front edge of ink does not have time to dry out completely. To do this you will have to backtrack constantly over the front edge to keep it wet and on the move. Before laying down a flat area of colour, try and plan out a route for the marker that will allow you to maintain this wet front. If this is not possible try and leave the wet front at a joint-line or change of direction where it will not be noticed.

Marker streaking. The experienced marker-user often uses the 'streaking' quality of the marker to good effect. It can help describe a form, suggest a reflection, relieve the visual monotony of a flat surface or simply give the drawing some direction. Many designers maintain stocks of run-down markers, with which they can obtain a wider range of streaking effects than is possible with full markers. I recommend that beginners master the application of flat colour before going on to exploit the potential of streaking. One of the first areas where the novice will want to exploit streaking effects is in the rendering of round, tubular shapes which are difficult to do in any other way.

Masking. Masking is done with either low-tack masking tape or masking film but be sure to test your paper first to ensure that the surface is undisturbed by the tape or film. It is a very useful technique where a bold, streaky finish is required to finish at right angles to a line, but without the hardening of edge that normally results if the marker is gradually decelerated to a halt. The masking allows the flow of the streaks to continue uninterrupted.

It is much safer to work across the tape or film than along it as this helps prevent bleeding under the mask. When working with giant markers it is usually essential to mask.

Below: *To fill a square like this with flat colour is not as easy as it looks, because you must work fast and with confidence. The photograph shows six intermediate stages starting at the top left: turn the square so that the left edge is horizontal and lay a strip of colour up to the line, turn the square back and lay another strip along the top line. Take the marker back into the left corner and work it outwards in diagonal passes ensuring that you go over the two lines often enough to keep them wet. Put in a strip of colour along the bottom edge (turning the page if you are not too confident of staying within the line) and infill from the bottom-left corner keeping the leading edge wet. Finally, work this wet edge across to the right-hand line.*

Right: *In this illustration of marker streaking a series of Warm Grey markers have been used to build up a cylindrical shape.*

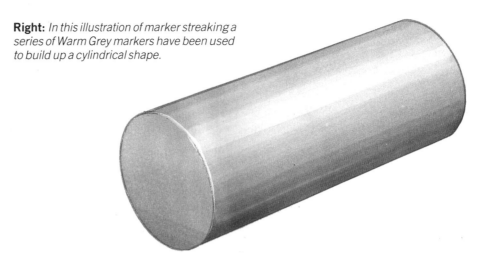

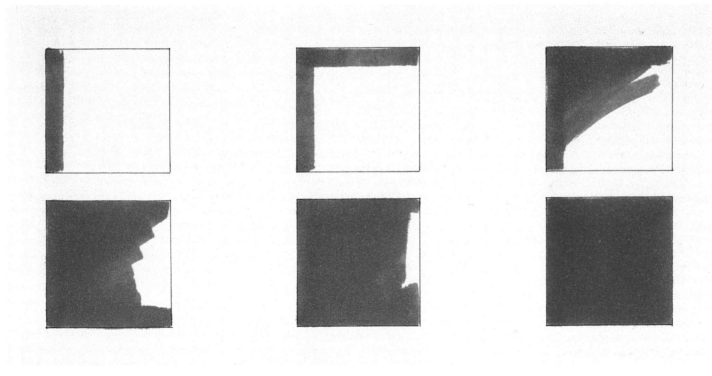

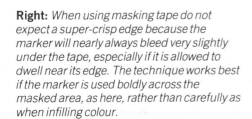

Right: *When using masking tape do not expect a super-crisp edge because the marker will nearly always bleed very slightly under the tape, especially if it is allowed to dwell near its edge. The technique works best if the marker is used boldly across the masked area, as here, rather than carefully as when infilling colour.*

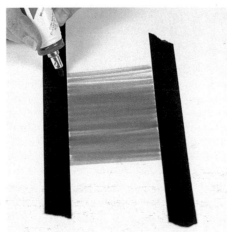

Working to a line. On all but the longest lines practise working freehand as often as possible. Try to work to the line in one continuous sweep rather than a series of short jerks. Above all, don't worry if you go over the line or miss it completely in places. A line drawn afterwards with a coloured pencil will tidy it up effectively and the eye will read this line in preference to the jagged edge.

When working with a ruler use the marker quickly to prevent ink being drawn under the ruler. Be especially careful when using new, well-filled markers with soft nibs where there is a risk of bleeding. On these occasions work with the ruler bevel-side down and/or positioned on a part of the drawing that is less important. Most plastic rulers are attacked by the solvents in markers and will eventually deteriorate; this is not usually the case with the PVC straight-edge described on p. 23. Whatever you use, be sure to clean it frequently with a tissue dampened with solvent. This is particularly important when changing from one colour to another, as there is a risk of traces of the first colour appearing in the second.

Toning and blending. It is quite possible to blend adjacent areas of colour together to produce a more gradual change than is normally obtainable from marker inks. This is only possible on papers with a low absorption rate, such as Vellum, Crystalline and thin layout papers, and is best done before the marker application has completely dried out. Depending on the size of the area being blended, work with a cotton bud, tissue or lint pad soaked in solvent and, if necessary, ink taken from the end of the marker. This is particularly useful for blurring the crisp edge of the marker where it meets the white of the paper. Another technique for colour blending is to slip a sheet of acetate under the paper. Because the acetate is totally impervious, the ink will not be absorbed by lower layers of paper and will tend to form puddles. The whole area being worked can then be kept wet more easily, allowing the colours to be blended.

Overcoating. Depending on the rate of absorption of your chosen paper, one marker is capable of producing two, and sometimes three, tones of its colour. This is the normal and most obvious way of achieving different colour values. To obtain the greatest difference in value, be sure to wait until the first application is absolutely dry before going over it again. With most papers the third overcoat produces very little change and subsequent coats will saturate the paper. This causes puddling which can dry to a sticky finish. A light dusting with talc will eliminate the stickiness and also 'knock back' the colour to allow a further coat. On some papers (particularly Vellum) further tonal values can be achieved by working on the reverse side of the paper; this is not possible on marker papers which have been treated to prevent bleed-through.

Tonal Rendering

One of the basic requirements of good rendering is knowing how to use colour to model three-dimensional objects: the world is a three-dimensional place and virtually everything you want to depict has a complex form which reflects light and throws shadows. Sometimes these are hard objects with clearly defined breaks in the form, where a sharp contrast between surfaces will not look odd and is often desirable, and at other times they are soft organic surfaces which blend and flow together in smooth tonal transitions. In the former case it does not matter if the colour dries before you apply an adjacent colour, but in the latter you need to work fast to keep the colour wet so that newly laid colours can be subtly blended.

Whatever you are drawing it is important to understand how the colour of an object changes from the light areas to the dark areas. The background to this has been explained in the previous chapter, but for the beginner faced with buying colours which will deliver the right tonal transitions it can become quite difficult. Assuming the object of your drawing is a single colour, say yellow, your first task will be to match that yellow as closely as possible to a marker colour. It is not always possible to find a single colour that will do the job and sometimes you will have to combine two colours overlaid one on another. This colour becomes the mid tone of the object you are drawing, and you now need to expand this tonal range in order to fully model the surface of the object. For the lighter tones, much will depend upon the surface finish of the object — gloss or matt. If it is to be glossy, it is often easier to use pastels because they can be easily erased to produce high contrast highlights, as in cube no. 4 on page 53, but with a matt object you will need lighter markers to establish the light surfaces. If the object is a dark colour, such as black or dark blue, this is not always necessary because you can use white pastels and crayons over the basic mid-tone marker to render the lighter surfaces, as in cube no. 5 on page 53.

As previously described, the standard method of creating darker tones of the same colour is through overlaying. This gives quite a subtle tonal shift which is usually insufficient for sharp modelling, so a second darker colour is needed. The beginner is often tempted into his box of cool or warm greys for this shadow tone, but this invariably makes the colour 'muddy', so to keep the perception of the colour clear and bright it is essential to choose a new colour. This second colour can, in turn, be overlaid to produce a still darker tone. A third colour is then usually necessary to produce the really dark tones, and this can be overlaid yet again for deep shadows. In this way a subtle transition of six tones can be produced by careful selection and overlaying. For example, when working with a bright yellow as your base colour use a yellow ochre for the mid tones and a light brown for the darker areas. Alternatively, if you want a warmer, more vibrant appearance, use a yellowy orange and a pure orange respectively.

It is not really practical to illustrate here which colour pastel goes with which colour marker, and in any case it is quite simple to do; match the colour of the pastel stick directly with the colour of the marker. Because the pastel is applied as a dust, the whiteness of the paper shows through and you automatically achieve a lighter tone. On the other hand, for the beginner, it can be a dificult task assembling a palette of marker colours that work well together to give sufficient tonal contrast, and yet can be successfully blended together for tonal transitions.

The more practised and experienced you are the easier it becomes to select the right marker, but for the beginner a chart such as this one can save a lot of time testing markers in the shop, and a lot of money wasted in buying colours you don't need. The colours correspond with markers from the Magic Marker range of colours, but the subtlety of colour is difficult to maintain in the normal four-colour printing process. If you do not have access to this range of markers use the chart to try to match colours approximately: go to your local graphics store and test your colour choice carefully — actually block out the colours as a cube and see how they work together before buying. As you build up your stock of colours it is a good idea to make a reference chart such as this so that you have a record of what works and what doesn't. If you do make a chart, be sure to use your regular marker paper and fix it to a board with a tape hinge down the centre; this allows it to fold over and thus protect the colours from direct light.

Preparation

On the practical side, ensure that the paper you have chosen is suitable (some treated papers don't like masking tape). If you are not working on a bleed-proof pad, be sure to slip a couple of backing sheets beneath the top one. This is obviously important if you intend to work with solvents as it is easy to ruin a whole pad with bleed-through. If the pad is running out, I recommend switching to a new one because subsequent overworking with crayons will reveal the texture of the card backing-sheet.

Make sure that you have all the materials you need to complete the job and that the markers have sufficient life left in them. Ensure that the range of markers and pastels you have selected to achieve the necessary contrast and tonal transitions will work together. It is usually a good idea to do a rough first (perhaps on a photocopy of the underlay or on a freehand sketch), to check where the different colours will go and where the reflections will lie. Plan everything carefully, at least till you are more experienced.

Below: Magic Marker Colour Chart

This colour chart was all done with the Magic Marker range but could easily be done in any other brand, although some experimentation would be needed. The limitations of printing have made it very difficult to achieve accurate colour matching, so you should only refer to the **colour names** *when referring to this chart. Each colour has been used only once (unless stated as overlaid x 2) to give a reasonable tonal balance, but more subtle effects can of course be obtained through overlaying. It is by no means a comprehensive chart of what can be achieved with this range of markers, but it is a good starting point for the beginner.*

COLOUR CHART

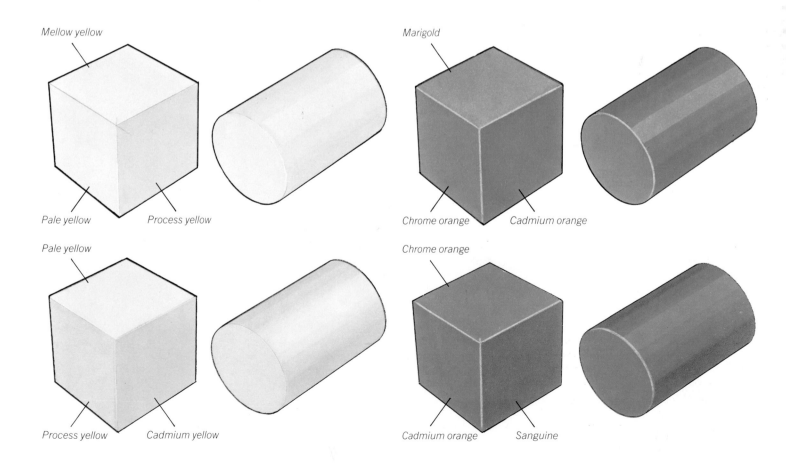

Mellow yellow
Pale yellow
Process yellow

Marigold
Chrome orange
Cadmium orange

Pale yellow
Process yellow
Cadmium yellow

Chrome orange
Cadmium orange
Sanguine

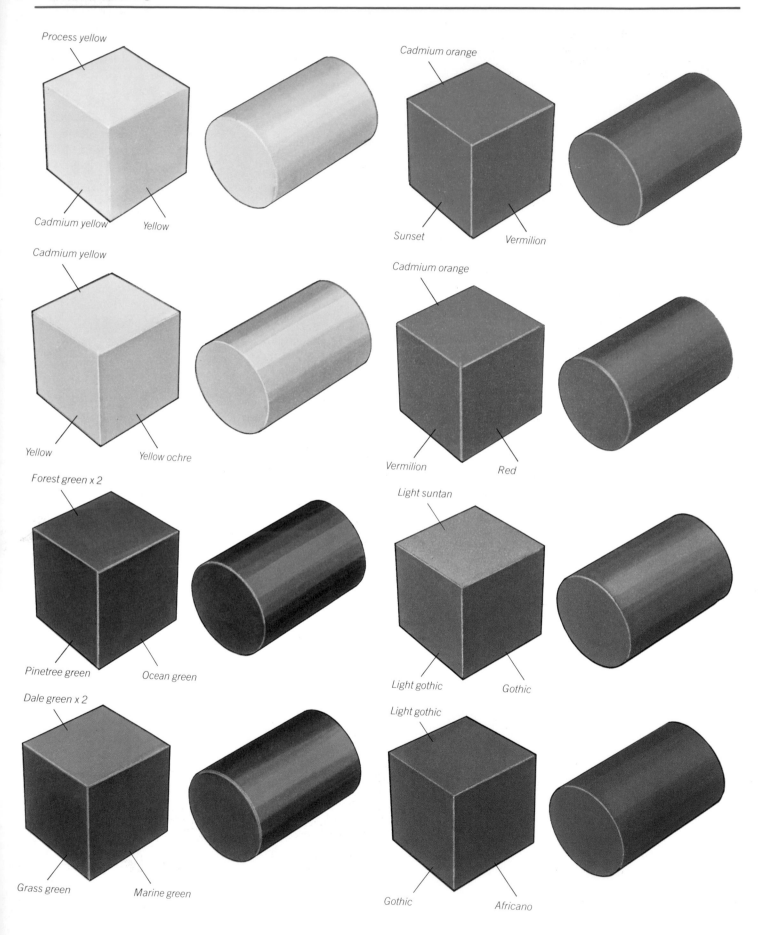

Process yellow
Cadmium yellow
Yellow

Cadmium yellow
Yellow
Yellow ochre

Forest green x 2
Pinetree green
Ocean green

Dale green x 2
Grass green
Marine green

Cadmium orange
Sunset
Vermilion

Cadmium orange
Vermilion
Red

Light suntan
Light gothic
Gothic

Light gothic
Gothic
Africano

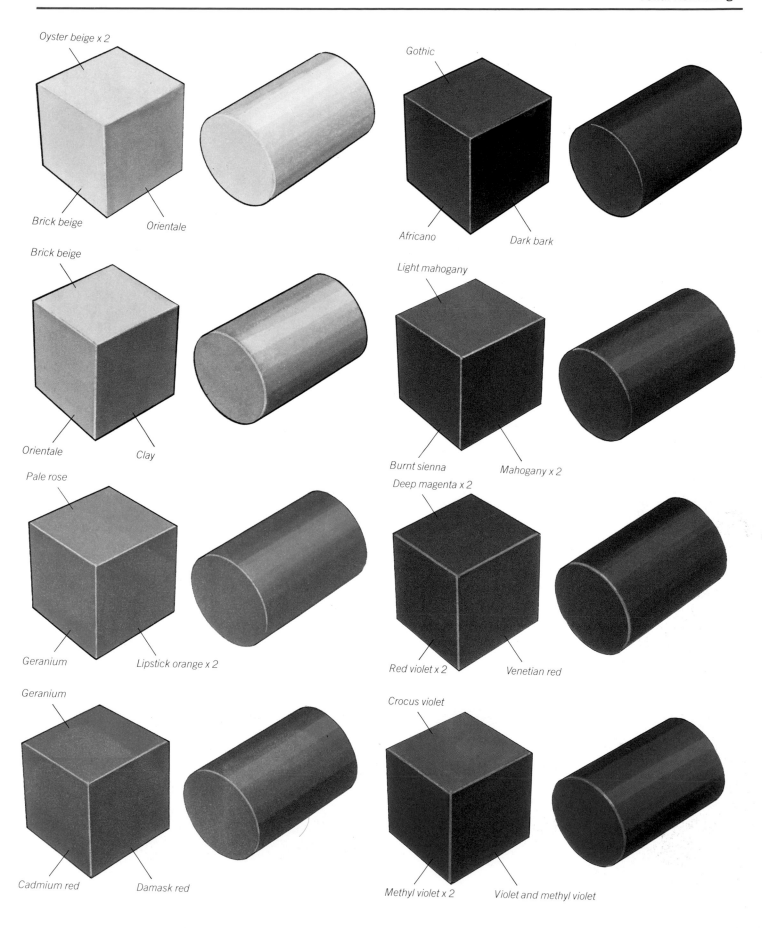

Oyster beige x 2

Brick beige

Orientale

Brick beige

Orientale

Clay

Pale rose

Geranium

Lipstick orange x 2

Geranium

Cadmium red

Damask red

Gothic

Africano

Dark bark

Light mahogany

Burnt sienna

Mahogany x 2

Deep magenta x 2

Red violet x 2

Venetian red

Crocus violet

Methyl violet x 2

Violet and methyl violet

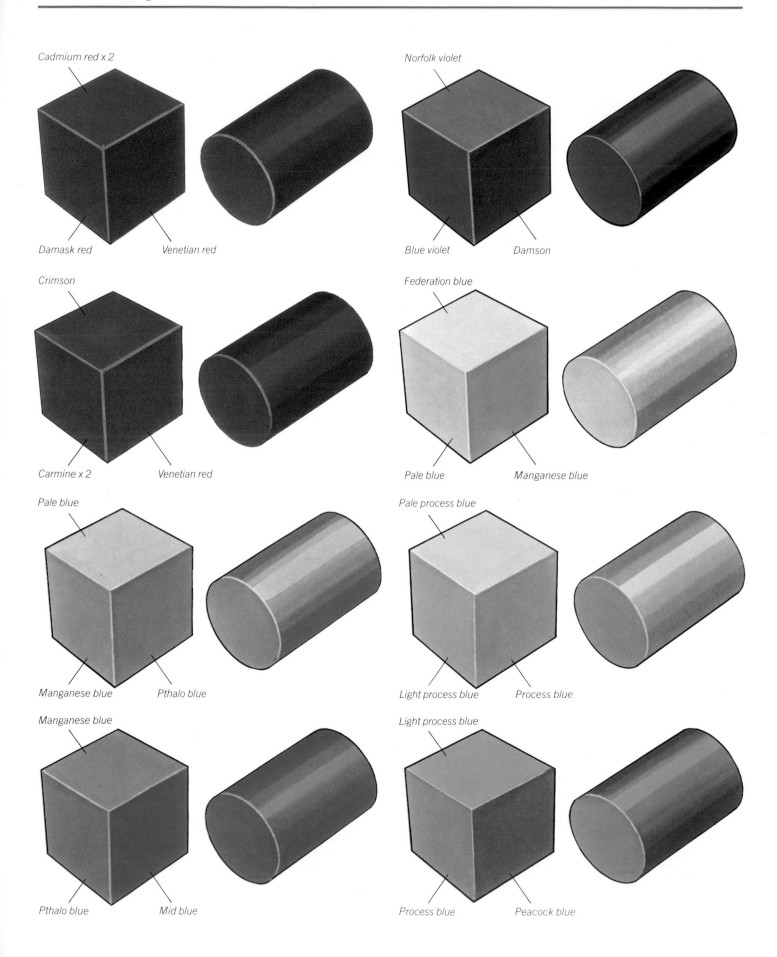

Cadmium red x 2

Damask red Venetian red

Crimson

Carmine x 2 Venetian red

Pale blue

Manganese blue Pthalo blue

Manganese blue

Pthalo blue Mid blue

Norfolk violet

Blue violet Damson

Federation blue

Pale blue Manganese blue

Pale process blue

Light process blue Process blue

Light process blue

Process blue Peacock blue

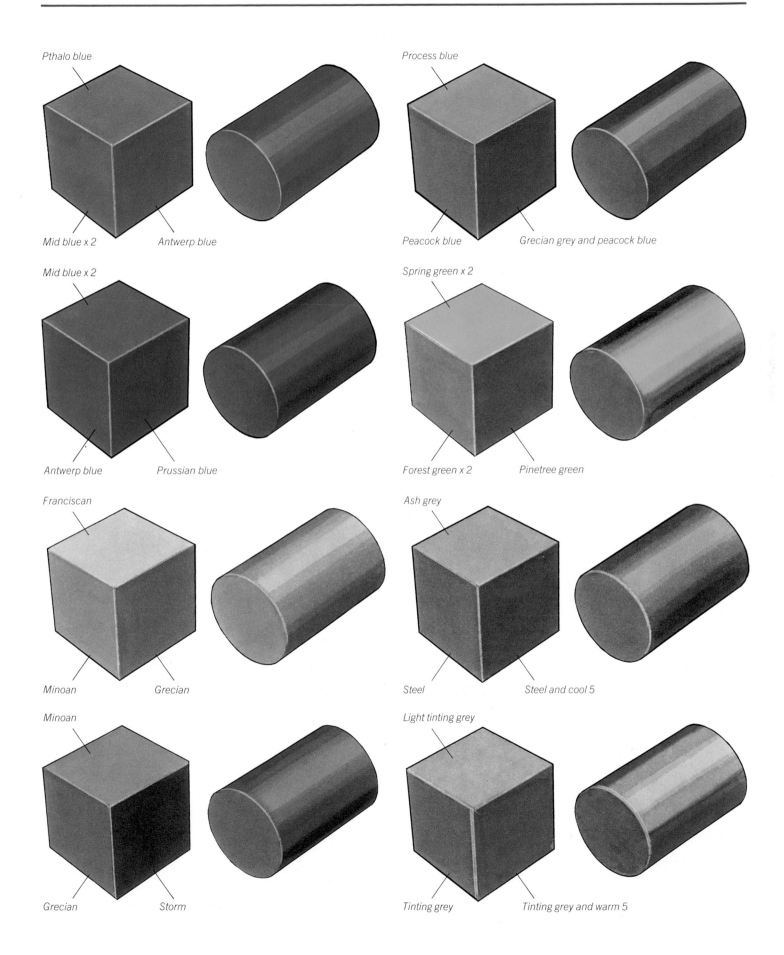

Pthalo blue
Mid blue x 2 Antwerp blue

Mid blue x 2
Antwerp blue Prussian blue

Franciscan
Minoan Grecian

Minoan
Grecian Storm

Process blue
Peacock blue Grecian grey and peacock blue

Spring green x 2
Forest green x 2 Pinetree green

Ash grey
Steel Steel and cool 5

Light tinting grey
Tinting grey Tinting grey and warm 5

Sketch Rendering

The following stage-by-stage examples describe in detail how a particular rendering was produced. They have been divided into two sections, sketch rendering and finished rendering, although the dividing line between the two is fairly arbitrary and depends on the type of work you do. Sketch rendering refers to the drawings you might do as part of the design process and finished rendering refers to the type of drawing you do once the design is finalized, and you only need to present it.

All rendering is about communication – with the client, with your colleagues, and with yourself. As you work, you produce ideas and solutions and the last sparks off the next as you hold a 'visual conversation' with yourself. You must not slow down this process by getting too deeply involved in the details of working up a solution. Later, perhaps, you will go back through those first thoughts and select a few for further progression. Once, however, product appearance becomes a key factor and you are taking critical decisions that affect appearance, then, even though this is only for your own reference, it is important to render each concept well enough to avoid misleading yourself. At some stage you may also need to discuss those ideas with your colleagues and while, as designers, they are visually literate, you need to give them as clear a picture as possible – your best ideas could fall at the first post because you failed to put the case effectively. Finally, you will often present sketch ideas to the client – both as back-up to the final solutions and in their own right. As back-up, they lead the client through your thinking and underscore the final recommendations and, if they are good enough to stand alone, they can be used to underline the conceptual nature of an early design phase. In these circumstances, it is too early to give the client a fixed idea of what the product will be like, and a tight, finished visual can erroneously give him the impression that the job is nearly over.

Too often one hears students excusing an inadequate drawing with the words 'it's only a sketch', believing that the word sketch somehow endorses a sloppy approach to drawing where mess is tolerable. The real secret to good sketch rendering, however, is *economy*: minimum marks for maximum information. In an ideal world this would work hand in hand with a loose, fluid approach which makes every sketch look as if it was dashed off in minutes, even though many designers actually work very hard at making their visuals look sketchy!

Example 1:
Mechanical Digger

This is a typical example of the kind of project where you might only be concerned with the design of certain key parts rather than every aspect of it. For example, the brief might be to redesign the cab but leave everything else unchanged, and in these circumstances you would almost certainly work from an existing underlay. Since you are not directly concerned with the design of everything else, you need to be able to block in these areas quickly, and sufficiently well, to allow you to concentrate on the job in hand.

Stages
1. The view was chosen from a photograph in a brochure and enlarged to a workable size (A2) leaving the cab area completely blank. Once the idea for this was sufficiently thought through, the whole drawing was traced out using a Nikko Finepoint and a slightly thicker Overhead Projection pen for the perimeter. The tread detail was also lightly sketched with

the Finepoint so that it would remain visible under the Black marker. One way of rendering glass is to work from the back to the front; in other words, you draw something behind the glass that can be modified or distorted by reflections or tints. For this reason, all of the interior is blocked in, as if in silhouette, and a background is run behind the cab which can be seen through the glass.

1

2

2. A Cadmium Yellow marker is used first to block in all the yellow parts; the bucket has been done by streaking across its width with a lighter touch near the bottom. The upward-facing surfaces of the wheels are left untouched. Once this has dried, the same marker is used on all the right-facing surfaces to make them slightly darker. A Warm Grey 4 is used on the lights and hydraulic rams to establish the horizon and desertscape.

3. The background was masked up with black tape and then a Pale Blue marker used in a positive 'brush stroke' right across the tape, not worrying too much about maintaining a clean edge where the blue meets the yellow, because this can be cleaned up later. The Pale Blue is overlaid towards the right-hand side so that it is denser and, once the tape is removed, the ragged edge of the rectangle is tidied up.

4. To model the downward-facing surfaces further, a Yellow Ochre marker is used on the less dark parts, such as the undersides of the cylindrical parts, inside the wheels at the top and inside and under the bucket, and a Clay marker on the really dark parts, such as the wheel arch and underneath the bucket. A tiny bit of white pastel is put on the right-facing windows and taken off below the horizon level with a Cool Grey 3 marker. A white crayon is used to lighten the horizon on the side windows and to rough-model the exhaust and tyres (the white within the treads is removed with the Black marker). A sky-blue coloured pencil is used on the headlamps overlaid with fine black pen lines and white crayon. The black Overhead Projection pen is applied to near parts, such as on the bucket and the falling-away back edge of the cab, so that they stand forward from the parts behind. Finally, white gouache is used for the highlights.

3

4

Example 2:
Sports-model Direction Finder

This is fairly typical of the kind of sketch visual that many designers would use to explore an idea, and present it to a colleague for discussion, or even to a client. It is obviously less well resolved than an end-of-phase visual, both in the level of detail shown and with regard to the technical package. However, that doesn't matter at this early stage, when it is more important to get the concept down quickly.

Stages
1. The idea is drawn straight onto the marker paper, using a Fineline pen and a thick Overhead Projection pen for the perimeter line. An outline window is put in behind the product to make it 'float' off the page slightly.

2. Cadmium Yellow is used for the left and right facing surfaces with the lighting above and slightly behind; once dry, this is further modelled by overlaying the same colour, again to create darker tones. Ash Grey is used for the strap, aerial and battery pack, and darkened where necessary with a Steel marker. Cadmium Red is used for the arrow and the Steel used again to create a shadow on top of the battery pack; a Cool Grey 9 is used for the display, reflecting the background 'window' which runs behind.

1

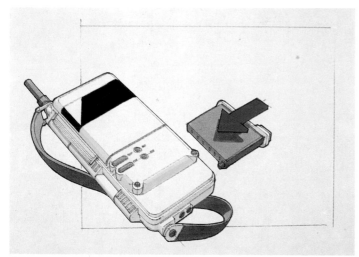

2

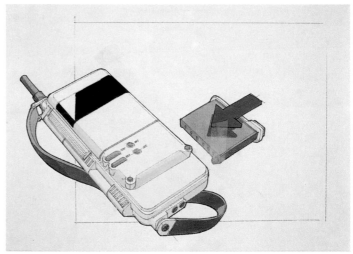

3

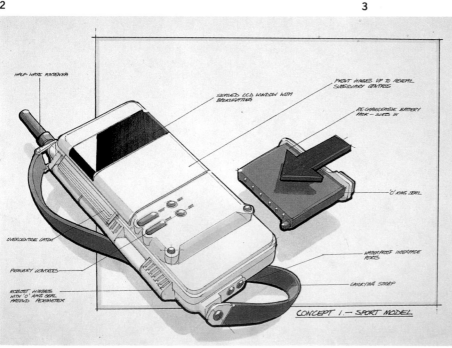

4

3. Post-it tape is used to mask-off the perimeter of the drawing; this is not strictly necessary but it does save on cleaning up overspill afterwards. Yellow pastel, mixed with a touch of talcum, is wiped on to give a graded finish from the near corner to the far corner, and the tape removed.

4. The finished sketch. A white crayon is used to lighten the right-hand side of the display and white gouache is used on the far edges to produce highlights. The falling-away edges on the underside are further strengthened with the black Overhead Projection pen and the background window is reinforced with the same Cadmium Yellow marker. A drop-shadow is put under the product using a Pale Blue marker; this makes the product 'sit' on the background and positions it in space; note also how it makes the battery-pack appear to 'float'. Finally, lead-off lines and explanatory notes are added to complete the presentation.

Finished Rendering

The design work is done, the solution agreed, and you need to produce a superb visual to show the client. Many designers reach this decisive point in the project where the creative work has to stop, because there is only sufficient time left for the finished rendering. The type of drawing you do will depend on your experience and ability, but you will probably be striving for as photographic a likeness as you can achieve, which also shows the product to its best advantage.

Example 3:
Vacuum Cleaner

A view looking slightly down on the cleaner was chosen to help establish the size of the product and to suggest that it is on the floor. The drawing was set up with the cleaner head and pipe lying in front so that a reflection of this can be seen in the side of the cleaner. There is also a reflection of the underside of the handle in the top surface which was constructed according to the method described on page 59. The cleaner was treated in the same way as the basic cube, with the top surface as the lightest and its nearest corner slightly darker to provide contrast to the highlight. The angled surface near the handle was made a little lighter

because it would be reflecting something different. The horizon was run along the highlight and wrapped around the back.

Stages
1.　The underlay is traced off using a red crayon (as this will not ruin the drawing if dislodged by the marker) and a fineliner used within the black areas to allow the details to show through. When tracing off, it is a good idea to put in simple registration marks (the cross by the wheel), just in case you get the underlay out of alignment and need to trace down a detail later.

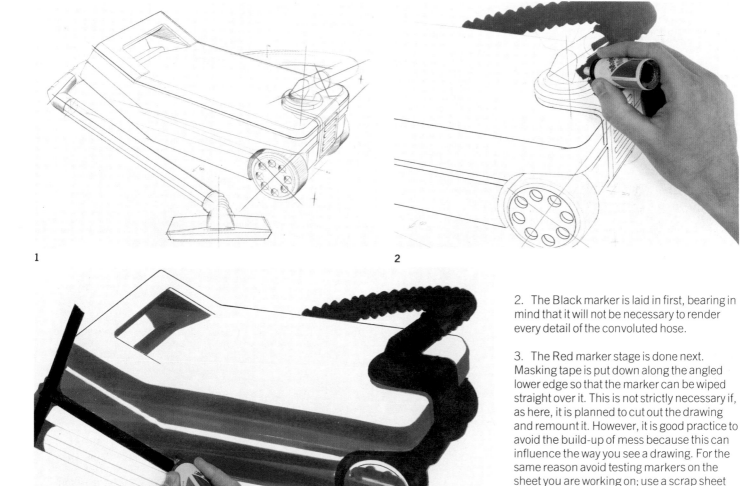

1

2

3

2.　The Black marker is laid in first, bearing in mind that it will not be necessary to render every detail of the convoluted hose.

3.　The Red marker stage is done next. Masking tape is put down along the angled lower edge so that the marker can be wiped straight over it. This is not strictly necessary if, as here, it is planned to cut out the drawing and remount it. However, it is good practice to avoid the build-up of mess because this can influence the way you see a drawing. For the same reason avoid testing markers on the sheet you are working on; use a scrap sheet instead.

A Cadmium Red marker is used as the base colour and then a Venetian Red for the darker areas and to suggest the tube's reflection. Next, the side is lightly streaked with the burnt orange colour of a Sanguine marker. Note that the reflection of the handle is also put in with marker.

4. The whole drawing is lightly dusted with talcum powder both to 'lubricate' the paper for the pastel, and to tone down the colours very slightly so that subsequent marker applications 'pull' the colours back (most noticeably on the black). Warm Grey 4 is used for the ground tones in the tube. Some red pastel is mixed up to match the Cadmium Red and applied to the top surface, working from the front to the back. Dark red pastel is added to the mix to darken further the near corner. Excess pastel is cleaned off with a roll of soft tissue which is revolved as it is used to avoid spreading the dust to unwanted areas. There is no need to worry about the dust getting everywhere, as, provided it isn't rubbed in too hard, it is easily erased and, in any case, hardly shows on the black and red areas. If two adjacent colours had to be put in with pastel, it would be better to mask off each in turn to prevent the spread of unwanted colour. Some designers favour the use of fixative before applying the second colour, but do not do this unless you are satisfied that a light application of fixative will not affect the surface and make more markering difficult.

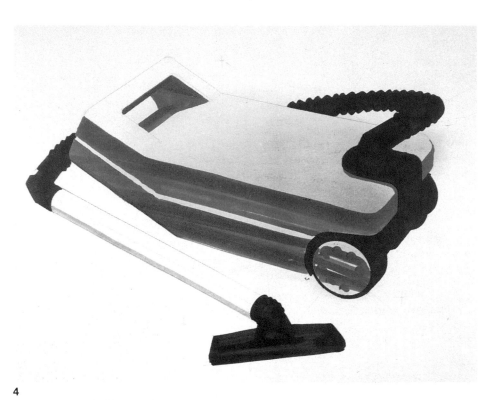

4

5

5. To create the highlight in the radius, the pastel is removed with a clean soft rubber. The drawing is worked into again with the markers to remove talc/pastel and lift the colour. It is important to be selective or everything will return to how it was before; the blacks and alongside the horizon on the nearside radius are particularly emphasized.

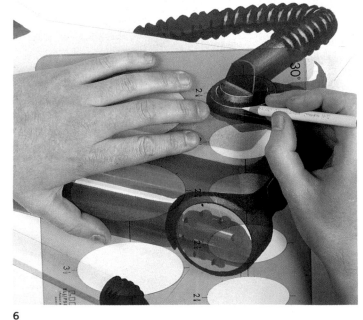

6

6. Coloured crayons are employed to tighten up the drawing. The white is used on all the black areas to model their shape, and guides are used to keep the ellipses crisp. A blue pastel is used to create the sky tone in the tube and the horizon detail is sharpened with a black crayon running through to a sandy crayon as the tube wraps around. (Note how the reflection of the hose where it exits from the cleaner had been forgotten and had to be put in at this stage.)

7. White gouache is used in a 'blobby' consistency to put in the highlights (the temptation to put one on every kink of the hose must be resisted).

8. The drawing is trimmed out with a scalpel in readiness for the final mounting. An off-the-shelf graded paper was chosen as these look very professional. To give contrast to the lighter, left-hand end of the drawing, graded paper is laid down with the darker end to the left. Where there is a lot of untouched white paper, as here, it is better to cut away the background behind the rendering to prevent it showing through and dulling the colours. The rendering is placed on the background in the desired position and lightly marked around with a soft pencil. The background is trimmed away about 4mm inside this line so that there is no possibility of misalignment. Both the background and the drawing are stuck to a fresh sheet of paper before final mounting to card or foamcore.

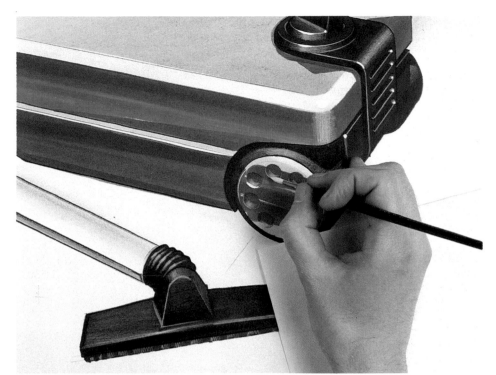

7

8

Example 4:
Electric Drill

If you were actually designing an electric drill the chances are that, like the generator on page 78, you would be working on scale elevations and rendering them up as you go. Your final presentation to the client would probably consist of these visuals, backed up by sketch models. However, for whatever reason, you may not wish to make models at such an early stage, preferring instead to present a fully rendered three-quarter view which can give a good all-round impression of the product.

Stages
1. In this example, the underlay was drawn out from an existing photo to establish the perspective. The right view was found in a catalogue and enlarged up to about life size (either a Grant enlarger or a photocopier can be used). To help keep the perspective true, the minor axes of the main circles are laid in first (chuck, handle-mount, motor housing) and then the ellipses that define those shapes are put in with ellipse guides.

2. The underlay is traced off onto a white layout paper using a pencil and a black fineliner for the black areas. All of the black is put in completely flat so that an impression of the drawing is immediately built up.

3. The yellow and red areas are put in flat and then the same markers are used again to produce crude modelling of the shapes. A Warm Grey 4 is used on the chuck as the basis for a desertscape. The whole drawing is lightly washed with talc to knock back the tones and then the Black marker is used again on the side-facing and lower parts to increase contrast, leaving the lighter (talced) parts untouched. The Antwerp Blue is used again to remove the talc on the lower-facing blue parts.

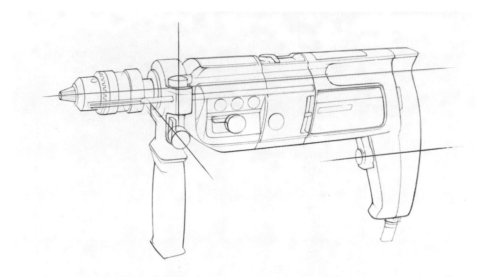

1

2

3

4. This shows the drawing at a stage about halfway through the pencil work with the white crayon used extensively on the black areas to model the radii into soft highlights. Note how the white has been worked across both the blue and the black together and then differentiated later with a black and a white crayon along the joint-lines. When doing joint-lines always use a black, or dark tone of the base colour, on the falling-away edge, and a white crayon on the facing edge. The desertscape is finished off with a blue crayon for the sky, a black for the contrasty horizon and a sandy crayon for the lower half. At this stage it was considered that the drawing lacked contrast, so a Prussian Blue was added to the deep recesses and under-facing areas. The red parts are modelled with dark reddy-brown and white crayons.

4

5

5 The finished rendering. White gouache has been used for the highlights on all the near corners and radii. The words HOLT and TZ 750 have been hand-lettered with white gouache, while the remaining graphics have been suggested by double parallel lines done with a white crayon. For final presentation the drawing is trimmed out and mounted to a graded background, so that it appears to float.

Example 5:
Generator

There are advantages and disadvantages to working on full-size elevational views. It is very easy, particularly for the inexperienced designer, to take liberties with the form and ignore the more complex three-dimensional problems of the design. On the positive side, however, you get a true sense of scale and therefore of proportion. With this kind of design problem you will probably be working both with sketches of three-quarter views, and with full-size technical drawings, especially if you are juggling internal components to achieve the best layout. Once you have a possible technical solution, it is a fast and effective transition to the fully rendered side-view. In our studio we would normally present a card or foam 'space model' (sketch model) to accompany the visual because many clients find it hard to read scale views. Nonetheless, a visual of this type not only gives the client a good impression of appearance, but also a genuine indication of scale and proportion. To help establish scale further, the drawing can be mounted to foamcore, trimmed out and photographed propped up in its intended environment, so that it appears real.

Stages

1. A good quality white layout paper that is unaffected by successive applications of tape and masking film was chosen and the elevational view was traced off using a black fineliner. The plan-view shown here is not a true plan-view of the entire generator but only of the top strip detail.

2. A Black marker is used to put in the fine details such as around the name plate and up the sides. Next, the black areas are well masked so that there is no possibility of inadvertently spreading the black to unwanted areas. Only two of the buttons were masked, using film, as the others will be black and can be put in later with crayons. In retrospect, it would have been quicker to ignore these two coloured buttons and render them completely separately for pasting up at the end. Black photographic tape is used to mask the radius along the top of the plan-view and down the right-hand side. A broad marker is made up (see p. 16) and the Black or Cool Grey ink is wiped from the bottom left to the top right in bold diagonal sweeps, using the marker in such a way as to leave the right-hand corner almost white. After a single pass, the tape covering the radii is removed and the process repeated, taking care not to overwork the area.

1

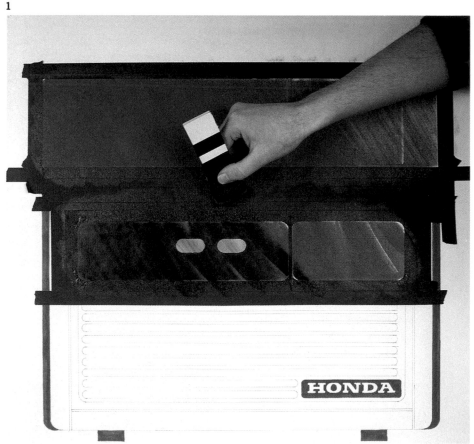

2

3. All the masking is carefully peeled off, revealing bleed under the tape; this is not serious because on a drawing of this size it really won't be noticed that much. The red front-elevation is masked out with tape, and film used to protect the name plate and the work just done. As with the top view, tape is used to mask a strip along the top and right-hand radii so that these will remain slightly lighter. Conversely the bottom and left-hand radii are masked up so that these can be given an extra coat of red. Once this is done, the broad marker is used in the same way as with the Black leaving the top right nearly white; the masking on the radii is removed and the process repeated. (For the purposes of photography the main red area of this drawing had six coats instead of two or three, so much of the contrast was lost – be sure not to let this happen. If you do overwork the inking, you will find that the colour pools and goes slightly sticky. This can be removed either by using a putty rubber, or dusting lightly with talc).

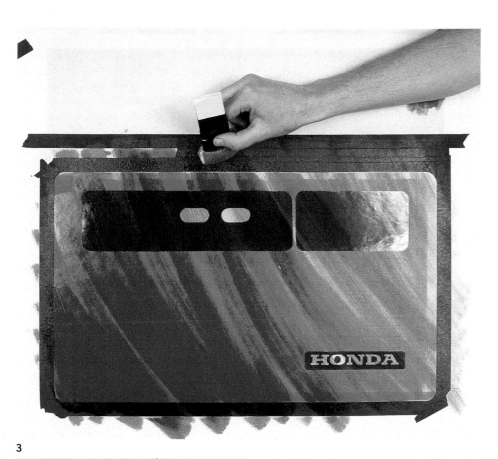

3

4. All the masking is peeled off and a Venetian Red and a Light Mahogany marker used to lay in the dark areas of the red parts and a Black marker for the darker areas on the plan-view (for example, the filler-cap recess) and control panels. Warm Grey 4 is streaked right across the middle of the lettering to create a horizon, and a Mid Blue and Cadmium Yellow are used for the buttons.

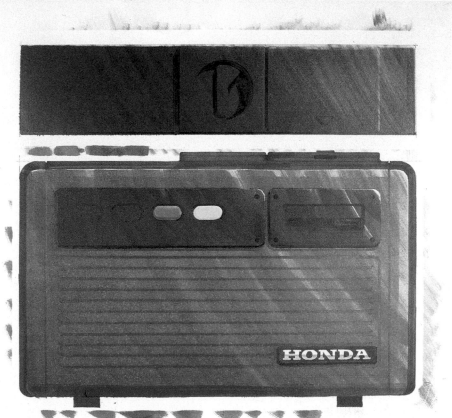

4

5. The drawing is finished off using the white crayon for all the edges facing upwards or to the right, and a dark crayon for all edges facing to the left or downwards. The desertscape is modelled in the usual way and white gouache used for the highlights at about two o'clock on the convex curves and seven o'clock on the concave curves (e.g. the button recesses). Use dry-transfer lettering if absolute accuracy is important or a white crayon if it is not. A medium-tipped black fineliner is used around the perimeter before trimming out and remounting to white board.

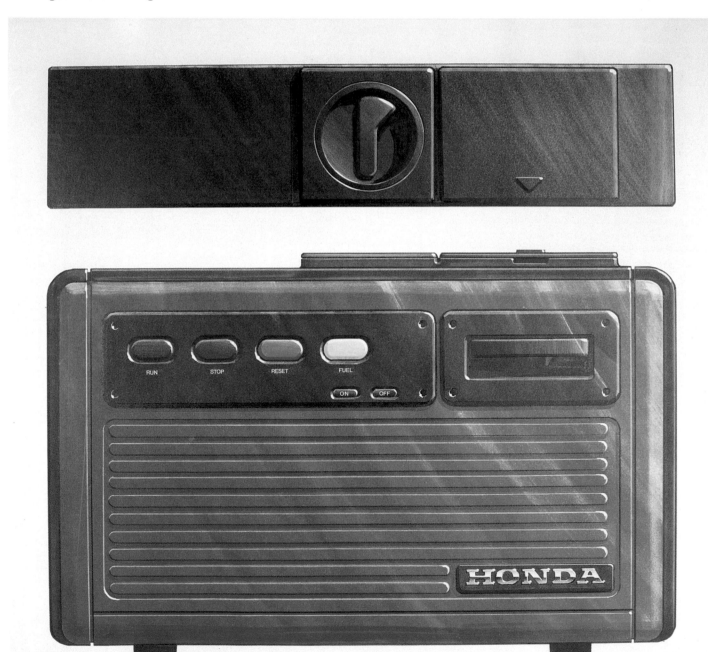

Example 6:
Motorcycle

by Richard Seymour and Dick Powell

A lot of motorcycle concept design is done in elevation, and invariably final ideas tend to be presented in this way. This works fine once the concept is fairly well defined and you are progressing towards full-size tape drawings and clay models, but for early concepts – particularly, as here, for a new type of off-road motorcycle – it is far more effective to do a three-quarter view. The perspective was drawn straight 'off the top of the head' by Richard Seymour. He used a Fineliner onto A2 marker paper and then beefed up the perimeter with a thick Overhead Projection pen.

Once the line drawing was complete it was taken to a photocopying bureau and enlarged to A1 onto our supplied marker paper. Always take several copies – for roughing out what you are going to do, for later masking, and just in case you make a mistake and have to start again.

Stages
1. The drawing has been enlarged and those areas which will be black are put in with a Cool Grey 9 marker.

2. A Minoan Grey marker is used for all the right-facing and lower parts; great care is needed when using a marker on a photocopy, as excessive overworking will smudge the black line badly. The trick is to run the marker very lightly over the lines; where possible, do not go over them at all, but rather work around them. On a drawing of this size it is also a good idea to rely more on pastel than on marker, as it is difficult to get a good finish on very large areas if you are having to work carefully around, and over, photocopied lines. Any stickiness produced can be removed with gentle daubing with a putty rubber.

3. The Minoan Grey is used again to create preliminary modelling, and reinforced in the darker areas by Grecian Grey. A combination of Sunset, Cadmium Red, and Damask is used for the tail light and spring.

1

2

3

4. A blue-grey tone is mixed up with pastel and applied to the upward-facing surfaces; the seat, while the same colour, is less reflective than the bodywork in front of the filler cap, so less underlying white is allowed to show through. A rubber is used to remove the pastel to create highlights on the upward-facing surfaces of the wheels, crankcases etc. White pastel is used on the upward-facing surfaces of the tyres, including the lower tyre rim.

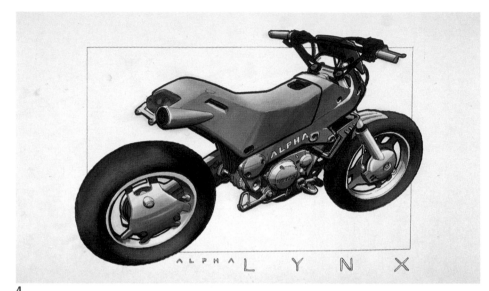

4

5. The drawing ready for mounting. The white pastel on the dark, lower-facing areas of the wheels has been removed by a further application of Cool Grey 9 (which also has the effect of darkening them further). The tyre tread was loosely marked out with a white pencil and then the C9 marker was used to remove the pastel to give the effect of 'cutting' in the grooves; a white crayon was then used to highlight near-facing edges. All the other black parts needed some rough modelling with a white pencil, but very little pencil work was needed on the grey areas; some further reinforcement of the dark tones with the Grecian grey marker was necessary to provide more depth and contrast, particularly in the wheelarch, under the engine etc. White highlights were painted with gouache (over the top of the black line work where necessary), and the name was painted in with blue gouache.

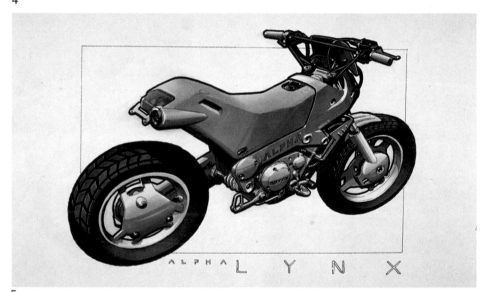

5

6. The background technique used here is quite quick, but not for the faint hearted as there is some risk to the original. A second photocopy is selected, and all those areas which will have the background finish are cut out, leaving the rest as a mask for your original. Here, the thick black line around the perimeter comes into its own — be sure to cut along the middle of this line to allow for movement and difficulties with positioning the mask accurately. The spray paint will not show up on top of this line, but if you cut the mask on the outside of this line (and therefore make the mask too big), you risk leaving white gaps between the drawing and the background which will show up badly. This cut mask is lightly sprayed with Spray Mount, allowed to dry, and then accurately positioned over the finished drawing. It is

helpful to have someone to help you with this as it can be very difficult to get it reasonably positioned. Some people dispense with the Spray Mount to avoid this problem, but this increases the risk of the spray paint blowing, or bleeding under the mask.

6

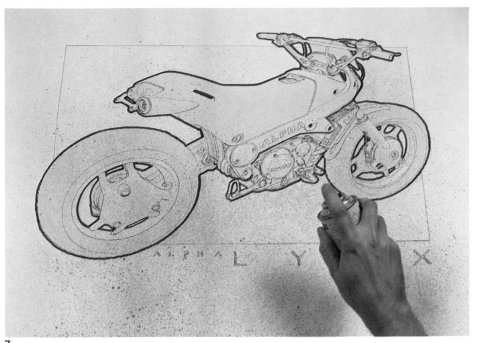

7. Any kind of spray finish can be used for the background – even an airbrush can be used with or without a spatter cap. In this example, ordinary car touch-up paint (cellulose) is used in two different colours, and graded from the bottom right to top left. Unlike most background techniques, this one offers no opportunity for experimentation, so be careful, and remember that, as with any airbrushing, the tone of the sprayed area will look lighter because of the adjoining white paper. There is, therefore, a real temptation to put down too much colour, but you won't see this until it is too late. Always spray less than you think is right.

8. The finished drawing.

7

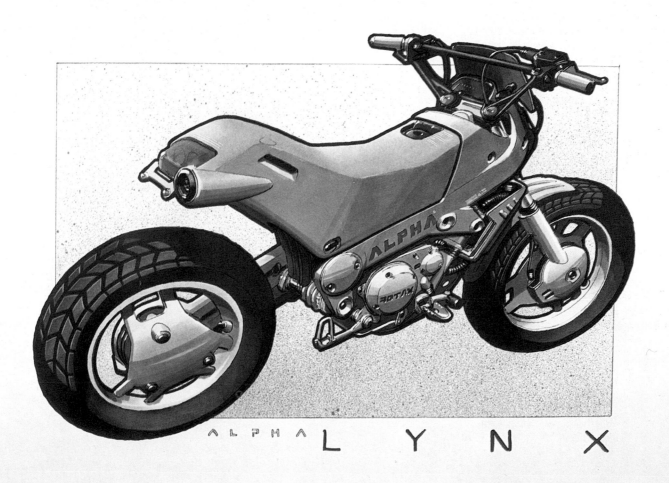

Example 7:
Fryer

The design for this fryer, in common with all of the design work undertaken at Seymour-Powell, was evolved both on paper and in three dimensions. Working in this way is always better because it ensures that you are not surprised when you eventually get into three dimensions. We used a polaroid of the foam model to set up the view and perspective, choosing a top three-quarter to show the filter cover and control panel. This was then enlarged on a photocopier to the maximum size that our large ellipse guides could cope with and the result, which after such substantial enlargement was fairly blurred, was then trued-up using straight edges and guides. This was then traced off using a Spectrum Blue pencil as the final colour was to be all white. As a student I always found white objects a problem to draw on white paper and reached inevitably for pale grey markers and various "off-whites". It was my partner who introduced me to the Pale Blue technique, which is incredibly fast and effective principally because you need to cover so little of the surface because the paper should be doing all the work. There is a thin dividing line between making the object look white and laying on too much colour and having it end up looking pale blue.

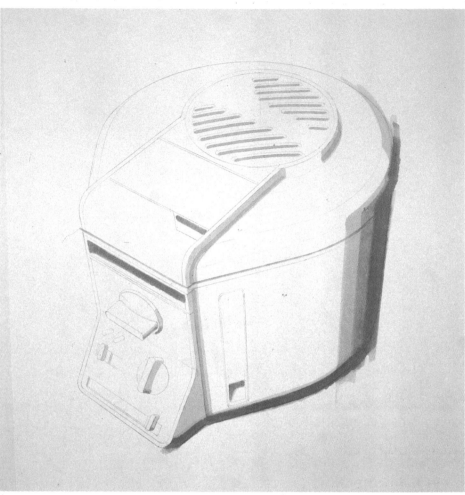

1

1. I have elected to have the product reflecting light from top left and very slightly behind it. You can see the blue pencil work which remains relatively undisturbed by overworking with markers. I have used Federation Blue (an ultra pale blue) and Pale Blue to model the right-facing surfaces and shadow-areas. Note how, where the form rolls around the back, each of these markers has been used twice in order to achieve a reasonable blend.

2. Pale blue pastel is used, mixed with a touch of talcum powder and wiped on with cotton wool, starting on the right-facing side. Post-it notes are used as a masking medium to allow the pastel to be applied with an up and down motion without compromising the upper surface. These ubiquitous bits of paper, and the various tapes which share the same non-marking adhesive, are brilliant for masking pastel, crayon, and even marker if you are careful not to let the ink through. Note how the pastel is applied to be darker on the right in order to blend with the marker, and also on the left where the surface once again becomes more right facing.

3. Once the Post-it notes are removed, they can be repositioned along the right-hand edge of the control panel to prevent pastel overspill on to the side of the drum. Pastel is also used on the top surface, working from the back to the front; the top has a slightly curved surface so only the back half is coloured. The sloping part of the control panel and other upward-facing parts

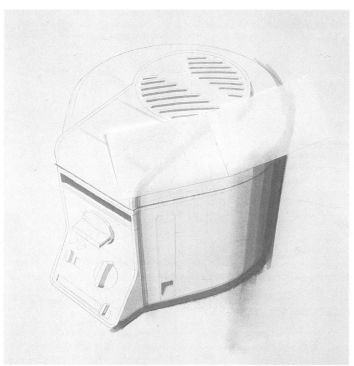

2

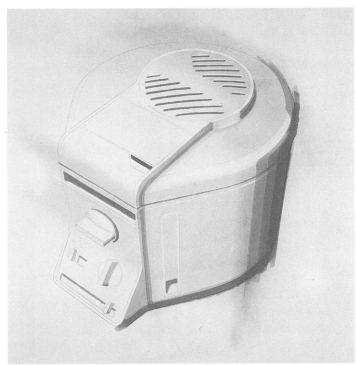

3

are also left white. At this stage there is a great temptation to work some more blue into the image, but remember that when the drawing is mounted on a darker background these surfaces will suddenly appear very white. The small amount of pastel overspill on the nearside highlight is rubbed out, and the other highlights (such as the lid split-line and around the stored handle) are also created using a rubber. Post-it notes are also very useful when doing this, as they allow you a continuous run with the rubber onto surfaces which you do not wish to erase.

4. The finished drawing: all the edges have been tidied up using a Spectrum Blue pencil and a dark blue-grey pencil (black would give too much contrast). The graphics, which at this stage of the design process are far from definitive, are dotted in with a pink pencil, and white gouache highlights are painted on the near-facing edges. Finally, a thick black line is used around the image to help 'hold' it together. The drawing is then scalpelled out and Spray Mounted to a graded background – always put the darker side of the paper against the lighter side of the drawing to create more contrast and make the whites 'whiter'. To help the fryer appear to sit, a drop shadow has been put in using a Manganese Blue.

4

Example 8:

Hi-fi

With this presentation for Philips, the brief called for alternative images and styling for budget hi-fi for young people. The 'combi' set consisted of a hi-fi stack using all existing internals, tape drives and so on but with some flexibility on button layout where new PCBs would be used, and a TV set which could also be sold separately but which could run through the hi-fi. As one of about ten finished presentation boards, each one expressing a different theme, the quality of the finished visual needed to be fairly realistic as the client wanted to use the same material for research in consumer groups. We elected to go for rendered elevations, both for speed and dimensional accuracy and because of the boxy nature of the product. We also presented side and back views to complete the picture.

Stages

1. The underlay has been traced off on a drafting machine, using a Finepoint pen that resists bleeding quite well; all the centre-lines used in the construction are left in to give the drawing a pseudo-technical look. The TV and the hi-fi are drawn separately but pasted up together for rendering.

All the black parts, including windows such as the tuning scales, are filled up with a Cool Grey 9 marker. A Black or Super Black would also do, but these tend to go a little mauve when you work over them with a white crayon. Besides, using a C9 gives you room to manoeuvre later on, if you find that you need to extend the tonal range. Holbein 'fatties' are used for blocking in the overall grey finish; these Japanese markers offer a slightly bluer tint in their range of cool greys than those from other manufacturers. When using fatties, be sure that they are

freshly filled as they always dry out if unused for even short periods of time. Line them up close to you if, as here, you need to use them quickly in order to maintain a wet front and a smooth tonal transition. Here the Cool Grey 4 has been used top left, the Cool Grey 5 in the middle and the Cool Grey 6 at the bottom right. Returning to Magic Markers, a Cool Grey 9 has been used to create the shadow areas along the bottom, on the right-hand side, and in and around all the switch recesses. Note how all the line work can still easily be seen under the marker ink, and that the screen itself is ignored at this stage.

2. The next phase of the drawing is to use white pastel to lighten the top and left-facing edges. Limited use of masking can save you a lot of rubbing out later on; here, the inside of the screen bezel moulding is being lightened and Post-it notes are used to keep pastel from adjacent areas. Note how the top and left side of the cassette door have been lightened; the masking was then moved to provide an eraser shield so that the pastel could be removed from the reflective surface of the window to leave a crisp finish.

2

3. The detail modelling is nearly completed, with the exception of the lower right-hand unit.

The small amount of pastelling has been finished and the hard work of detail modelling with a white and black crayon is half complete. Note how the pastel on the upper and left-facing edges has been reinforced with crayon, and that this runs over the dividing gap between the units on the hi-fi stack as this will be put back later with a C9 marker; the pastel has also been removed from the screw bosses with an eraser. This detail modelling occupies easily the largest part of the time it takes to complete the drawing.

4. The finished drawing. Once the detail modelling was complete, a fresh appraisal of the tonal values was made, and I elected to darken still further some of the shadow areas using the C9. The aerials (which I had forgotten) were redrawn, rendered with Cadmium Red and Damask Red, modelled with a white crayon and cut out for eventual pasting to the background. For the screen, I took a fresh piece of marker paper, laid it over the drawing and traced off a rough outline of the required screen shape which was overall about 10mm larger than needed. This was then rendered, using the wad from an opened Steel marker swept loosely from left to right and, like the hi-fi, graded from the top left to the lower right. This was allowed to dry and further graded with the same maker, with just a touch of Cool Grey 6 in the lower right. White pastel was then applied in the top left-hand corner and worked down to an horizon line, which was further emphasized by rubbing the Steel marker to provide the streaked effect. The screen was then 'intercut' into the drawing. This is done as follows: the back of the TV visual is lightly sprayed with Spray Mount

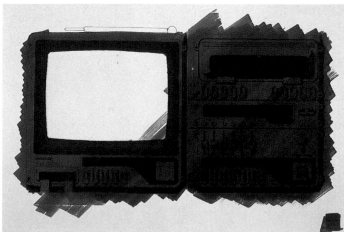

1

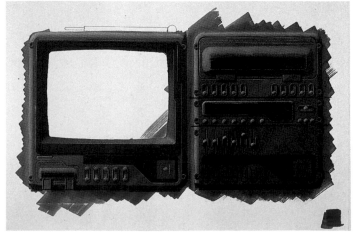

3

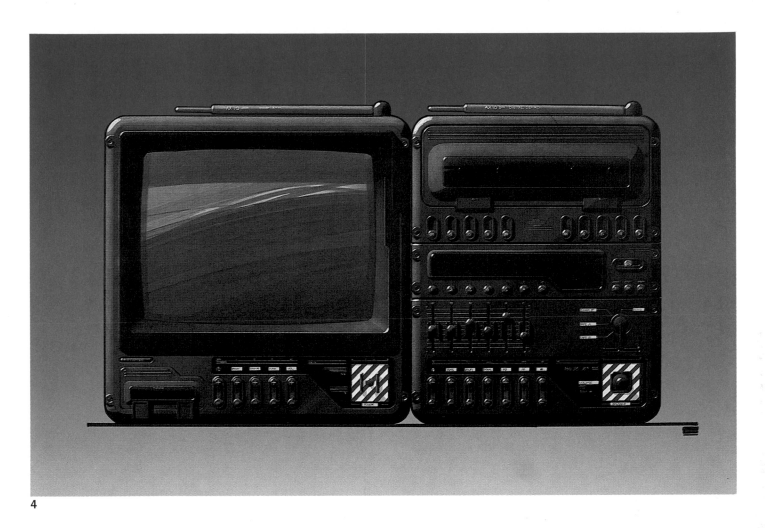

4

and tacked down on top of the screen visual in roughly the right position (hence the need for the 10mm margin). The two are then cut out simultaneously to ensure that the screen is an exact fit in the TV visual when the two are mounted down together.

The fluorescent flashes that surround the major controls were also intercut, as it would have been impossible to marker around them at an earlier stage and fluorescent paint needs a white background if it is to work. The stripes were therefore painted on a fresh piece of paper using a sable brush and, once dry, lightly Spray Mounted to the back of the visual. The switch and joystick were intercut at the same time so that when finally assembled, the fluorescent patch could be dropped flush onto the visual and then these other elements dropped into holes left in the patch. This can become something of a jigsaw puzzle, but is the only way I know of getting bright clean colours into this type of visual. (As a process it can be very useful when making decisions about colour for different elements. For example, if the buttons and controls needed to be a

different colour from the body of the unit, they could be cut out and alternative colours tried on a piece of paper underneath to reveal how well, or otherwise, the colours work together; other combinations of colours can also be tried in this way before you commit yourself.)

All the various elements of the drawing were then Spray Mounted to a fresh sheet of layout paper and a perimeter line was put in; the completed drawing was then cut out and mounted on a graded blue background. At this stage, the shadow under the screen cowl was put in with the Steel marker and, to promote further the illusion of an horizon, the reflected light is shown coming through the reflection from behind; this is done with a white crayon and then with white gouache, which is also used for highlights in the normal way. The beige graphics were painted with gouache using a fine sable brush and a steady hand; where long, straight lines are called for, use a ruler initially laid down flat to the paper and then tilted up along its near edge to provide a rest and guide for the brush. The reversed-out

graphics on the major controls were blocked in with gouache and, once this was dry, a fineliner was used to write the appropriate words. For ultra-finished presentations, manufacturers in this line of business keep dry-transfer sheets with all the appropriate words pre-prepared, along with logotypes and brand-names, etc. If this kind of finish is also important for you, and hand lettering is not good enough, you can easily put together artwork and have a sheet of dry transfers made up.

Pens
For the Parker Pen Company
by Seymour/Powell

*These six drawings were part of a much
larger presentation to the client exploring
many different possibilities for a new range
of pens. Each design was drawn up twice full
size as the finished product is too small to
effectively render actual size, and each was
accompanied by a block model in machined
aluminium to demonstrate silhouette and
allow the client to actually hold and assess
the design. They are coloured with marker
and crayons and mounted to the
background with a drop-shadow.*

Concept drawings
For Philips BV
by Seymour/Powell

These three drawings were part of an important presentation to the client showing the possibilities of using newly available technology to create new products. The objective is not so much to show a particular design for the product but more to give shape and form to an idea for a new type of product. For this reason the 'lifestyle' element of the presentation is as important as the drawing of the product itself. In each case, the background has been drawn freehand and then 'knocked back' by overlaying polyester film or tracing paper. to allow the product to 'float'. If you use this technique be careful not to laminate the visuals as the film can cause bubbling and separation of the plastic.

Motorcycle Concept
For Yamaha Motor
by Seymour/Powell

A presentation drawing done for the client as one of a series showing possible new developments for certain niches of the motorcycle market. When working around a tight 'package' like this it is usually quicker to work in side elevation provided the overall three-dimensional form is always kept in mind. It has been done, for the most part,

freehand, with minimum use of templates and instruments, in order to produce a loose 'sketchy' result while still remaining clear and informative. The marker drawing has been trimmed out and mounted to a streaked Flo-master background.

Central-heating pump

This concept was drawn to show off the high finish available from Lexan polycarbonate, and this was achieved by using a strong contrasty horizon. Note how the reflection of the pipes onto the main body, and the semi-circle onto the key pad, help to make the mouldings look glossy. The metal casting in the middle is a semi-matt die-casting and therefore has less contrast along the horizon. The key pad in the foreground was done separately, by first using a Black marker and then rendering in the blue buttons and steel-coloured LCDs before wiping white pastel across the whole face from top left to bottom right. This was then wiped away boldly with an eraser to produce the impression of a reflection; the blue grid over the surface was added with a coloured pencil. Despite the fact that this is not a true front elevation, the dry-transfer lettering works effectively.

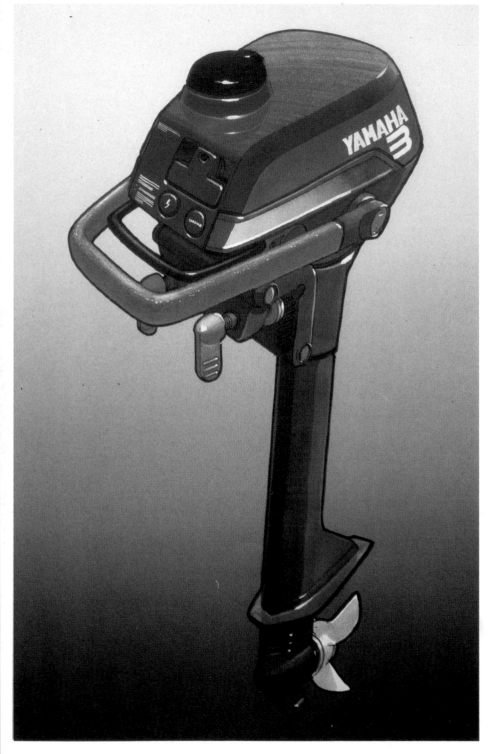

Above: 3HP Outboard Motor
For Yamaha Motor
by Seymour/Powell

This category of outboard tends to derive its look from its bigger brothers and so the brief for this project called for a design that looked visually practical and functional rather than *sleek and aggressive. The drawing has been done with a selection of blue markers (Mid. Antwerp and Prussian) with modelling in white and black pencil. Rather than show the design mounted to the back of a boat, it was decided to choose a view that was similar but allowed the product to float against its background.*

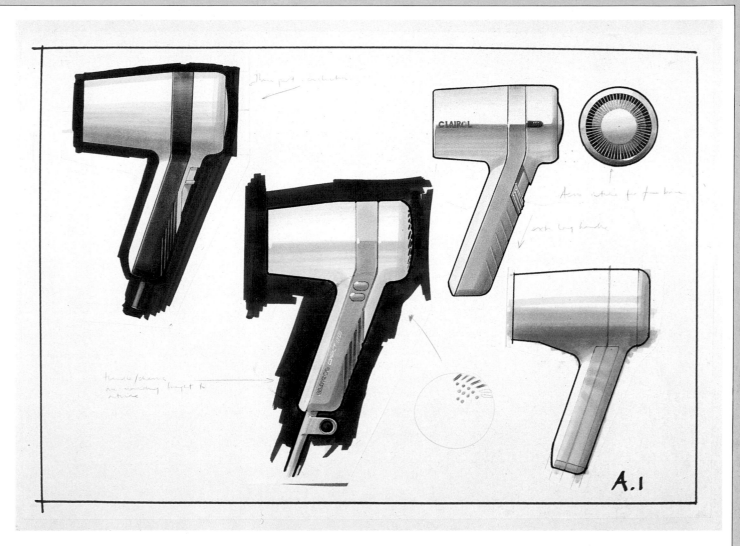

Opposite page, bottom: Reel-to-reel tapedeck
For Philips CID
by Lyn Peppal

A good quick technique for product rendering is to work on dyeline drawings: the perspective and general design can be worked up progressively on tracing paper and then a whole series of prints run off on which to work. This has the advantage of removing the fear of failure as you can always have a spare print to hand and the original always remains intact. Some dyeline print processes give a nice bluey quality to the paper and linework (hence 'blueprint') and this can be used to good effect. The technique works best with dark coloured objects as bright clear colours come out slightly muddy on this type of paper. Note the brave use of reflections across the front of the clear plastic cover and the painstaking hand lettering that is always necessary on a perspective view like this.

Opposite page, top: Refrigerator concept
For General Electric Plastics
by Roy Watson

This is a clean descriptive visual specifically put together to show construction, design and the look of the product in one drawing. The basic drawing has been quite carefully constructed but with only minimal separation between the exploded parts (see chapter 10 Descriptive Drawing). Colouring is kept to a minimum so that the drawing retains its constructional quality but still helps to describe the finish and look of the various parts.

Above: Hairdryer Concept Sketches
For Clairol
by Seymour/Powell

These sketches have been montaged together onto a single sheet of paper for internal presentation only; apart from the one at top right they have all been hacked out of the pad rather than carefully trimmed around the perimeter. This stage of the design process within the Seymour/Powell office usually takes place prior to the production of foam models and finished drawings and the sheet represents one of many concepts then under review.

Right: Video Camera
For National Panasonic
by Yoshiaki Iida of ICI Design Institute Inc.

This drawing is fairly typical of the kind of drawing generated for presentation to management when the concept is nearly frozen and the model is about to be commissioned. All three major views of the camera are shown so that there can be little left to the imagination, or for senior management to misunderstand. The drawing is very detailed and the linear quality of the side covers is nicely emphasized by the horizontally streaked background that grades from light to dark behind.

Right: Motorized bicycle wheel
by Seymour/Powell

This drawing was done with markers and some coloured crayon, particularly on the wheel itself. The three background windows are all covered with Polyester film to reduce their strength with respect to the main drawing.

Left: Plastic saddle
The main drawing was done using markers while the background exploded view was inked first with technical pens before colouring up. The old etching of a pair of horses was photocopied on to the back of a piece of polyester drafting film and all three images stuck down to the airbrushed background.

7 Airbrush Rendering

Airbrush rendering no longer enjoys the popularity among designers which it had before the advent of markers in the late sixties, simply because of the sheer sweat of doing an airbrush rendering, which can take almost three times as long as an equivalent marker drawing. For the designer, airbrushing is also a great deal less 'interactive' than marker rendering which is more integrated into the design process; with airbrushing it is very much a case of reaching a design decision, clearing the desk, planning the drawing and then executing it. Once this process is underway there is very little room for manoeuvre or last-minute changes to the drawing – you are committed from the minute you start masking.

Despite these drawbacks, the airbrush gives the finest finish and slickest effect of all the techniques available to the product designer and is certainly the most enjoyable and rewarding to use. Indeed, many designers take up airbrushing as a hobby for the sheer pleasure of doing it, and welcome the infrequent opportunity of using it as part of a presentation.

If you are a beginner, don't rush out and buy an airbrush in the misguided belief that it will, as if by magic, transform the quality of your drawings. Successfully mastering the finesse of control required is only half the battle – the real skill is needed for masking and planning the drawing and, of course, knowing exactly where to put which tone. If you are seriously interested in airbrushing and haven't already done so, buy one of the books which specialize in the subject because this chapter cannot hope to cover every aspect of it and, apart from the following section on basic techniques, is really intended for those who are already familiar with airbrushing.

Gouache is still the most popular airbrush medium among product designers and is very forgiving because mistakes can be easily covered by the opacity of the paint. Despite this, I prefer transparent inks because they require less masking, although greater skill is required to judge tonal balance. In addition, the colours have more depth and brilliance because the underlying white substrate can be seen through the ink. The technique with these inks is to work from dark to light, so, if you were rendering a matt cube, you would first peel off the mask from one side and give this a flat tone with the airbrush. Next, you would peel the masking from the second side and give this its first coat and, in the process, the previous, still-exposed side, its second coat. Finally, you would peel off the top surface and give this a light coat, and in the process give the two previously coloured areas a second and third coat respectively. As you will see, each successive coat makes the previously applied ones one tone darker.

The problems begin when you have a complex shape with maybe eight different shades of the same colour, and it is obviously very important to pull off the right bit of masking at the right time. Additionally, of course, it is also vital that you get the very first coat right, because there is a strong tendency to start too dark so that, when you are half way through, the ink has been overlaid as much as is feasible and the dark areas are already too dense, or, worse, become sticky and prone to lifting off with overmasking. Indeed, with all airbrushing, because you cannot see the whole drawing which is covered with masking, there is a tendency to do everything too dark – the golden rule, therefore, is to spray considerably less than you judge is right, at least until you have gained some experience. The great advantage with transparent inks is that you rarely have to reposition a mask once it is removed (and risk misalignment or ink getting underneath) and you only have to remask between colours, all of which adds up to considerable time saving.

Basic Techniques

This short section is intended for those designers who are picking up an airbrush for the first time and wonder where to begin. What follows will help you get started, but cannot be as comprehensive as some of the specialized books or, better still, tuition and demonstration by an experienced user.

Confidence. More than any other medium, you need to practise and perfect the basic skills of using an airbrush before you rush headlong into a finished rendering. Take the time to build confidence in your own ability by practising the basic exercises so that you no longer have to think about how to do them, only where to use them.

Getting going. Practise controlling the mechanism of the airbrush to give you the right balance of paint and air. For filling in large areas you will need all the air and all the paint that your brush can deliver, whereas for super-fine work you will need a small amount of paint and a correspondingly small amount of air. To avoid blodging you will quickly realize the importance of 'air on' first (before the paint) when starting to spray, and 'air off' last when stopping.

Line. Once you have familiarized yourself with controlling the mechanism, practise some freehand lines, trying to achieve an extra thin one (such as the example which is often included with the brush as part of the quality control testing) right up to a broad swath of colour. You will find that width is dependent on distance from the paper – working close to the paper will produce a fine line, and working far away from it will spray a wide one. You will also find that it is not *that* simple! As you get closer you need to back off the 'throttle' and reduce both paint and air to avoid producing a blodge; you will also need to combine this delicate throttle control with the speed of your brush across the paper. In other words, it is alright to throttle up when working close to the paper provided you are moving the brush fairly speedily, but if you slow down, or stop, you will quickly overload or flood the area directly under the brush. Once you are fairly confident of dialling up line widths to order, practise working with a ruler to produce straight lines.

The top line in this example of airbrushing different line widths (as shown in the sequence below) is done with the tip of the nozzle about 10mm above the paper and using a bridge to guide the airbrush in a straight line.

The second line is the thinnest achievable. The nozzle of the airbrush is actually placed on the paper and up against a ruler or bridge but, of course, off to one side of the area to be sprayed. This 'start-up area' is used to check the throttle settings for the fine line you intend to spray. The airbrush is then slid along the ruler edge to produce a straight line.

The third line is done in exactly the same way but with the bridge tilted up to raise the nozzle about 20mm from the paper.

The fourth line, or swath, is done by tilting the bridge right back and overspraying several times.

The fifth line, a very broad swath, is done freehand by passing the airbrush repeatedly across the ground to build up the density.

The final example shows the ruler used as a mask to create a sharply defined edge: the ruler is held firm to the ground and the ink sprayed right into the edge from the paper side. Spraying from the other side, over the top of the ruler, will produce a slightly more hazy finish.

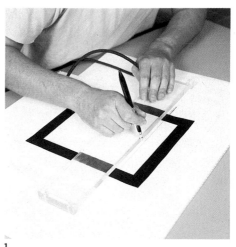

1

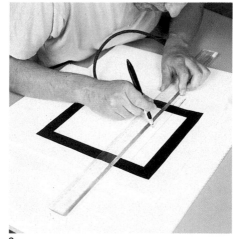

2

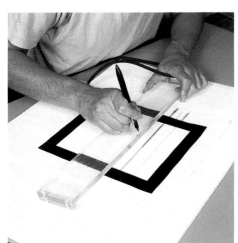

3

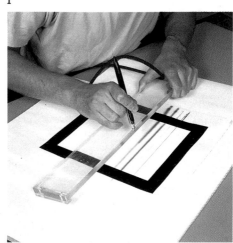

4

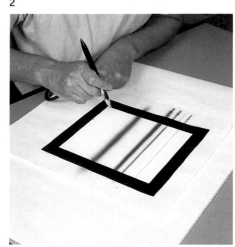

5

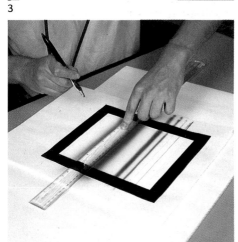

6

Tone. Producing a completely flat area of colour with an airbrush is surprisingly difficult to do, but well worth practising. Perhaps more appropriate to the medium is the graduated tone which grades from very dark to very light – practise it on very small areas and on very large areas (such as backgrounds).

Freehanding. This is the term I use to describe any airbrushing where spraying starts and stops within a masked area. Most of the time you always start airbrushing off to one side of the area to be sprayed (usually on the mask) and then move the airbrush over the intended area – all without really thinking about it. The masking itself provides the edge to the area you are working on, while you control the tonal balance and effect within the masked area. Often, however, you will need to produce a soft, fuzzy shape or line that is not bounded by any masking, which would of course leave a line. A good practice exercise to test your skills is to try and airbrush a sphere without any masking at all – no starting and stopping areas and no edges.

Masking up. The first difficulty that most beginners face is actually laying down masking film, particularly in large sheets, so that there are no air bubbles or uneven patches. The two most usual problems are getting the sheet down, finding that you misjudged it and haven't covered the drawing, and manhandling a large sheet into position without it folding up on itself. The adjoining illustrations show how to avoid these problems.

Cube, cylinder and sphere. Start by trying to render our old friends in a matt or satin finish; you will quickly find that it is possible to produce startlingly good results very quickly. Progress from these to glossy versions, and then into more complex shapes – a good one to practise is a smooth, doughnut shape because the mask can be cut exceptionally quickly with two passes of a compass-mounted scalpel blade, and it also demands deft control and freehanding.

General preparations. As with markers, make sure that you have everything to hand and that your hands and work area are clean. If you are using a board as your ground, wipe it over with a tissue soaked in lighter-fluid to remove any greasy fingermarks that would not show until you tried to overspray them. Apart from the inks themselves you will need two water containers (one for clean and one for dirty water), a roll of tissue paper for cleaning out between colours, a large brush for loading colours into the airbrush, and a

dustbin to spray into when rinsing through. Finally, make sure that you know exactly what you are going to do and in what order – if you are unsure, experiment on a photocopy or sketch *first* before you get too deep into the drawing.

1

2

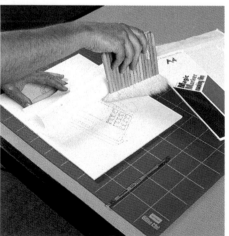

3

Masking up
1. Select, or cut, a sheet of film sufficient to cover the drawing and lay it face down (i.e. film side toward you) on the drawing. Slide it to one side and roll back about 50mm (2in) of film and trim off an equal amount of the backing sheet.

2. Still holding the rolled-back portion, slide the sheet over the drawing until the other edge is well over the area to be sprayed; gently lower the rolled edge onto the drawing surface. This positions the film in the right place and ensures that no area will remain unmasked.

3. Lift the sheet at the unexposed end and fold it back on itself to free the cut end of the backing sheet so that it can be slid out from underneath. Once you have a hold of this edge, fold the whole sheet back again so that it is lying over your hand. Using a soft brush, or cotton wool, clear the previously rubbed-down 50mm strip of air-bubbles by wiping them out to the sides. When this is done, slowly pull away the backing sheet, wiping continuously as you do so with the other hand to remove bubbles and wrinkles.

It sounds complicated but really isn't, and will save you a lot of time.

Example 1:
Electronic Movie Camera

The underlay for this camera was taken from that done on pages 42-3. This in turn was originally done as an entry for a 'Camera of the Future' competition and, to give myself the best chance of winning, I decided on an airbrush presentation to seduce the judges (successfully as it turned out!). This was not the first camera I had done, and had found airbrushing to be the only way to simulate the complex coating found on lenses. Also, of course, it works wonderfully well on cylindrical parts, as here.

I planned to use only three masks – one for the blacks, one for the bluey-greys and one for the small parts (buttons, lens etc), but things didn't turn out quite as intended. The cylindrical parts have a soft highlight running at about two o'clock on the concave surfaces and seven o'clock on the convex ones. The body parts are treated in the same way as the basic cube with the nearside, angled face reflecting the most light (to match the two o'clock highlight on the cylinders).

Stages
1. The back of the underlay is coated with graphite, using a 6B pencil, and this is rubbed in gently with some cotton wool; a 2H pencil is then used to trace the underlay through onto a sheet of 'Line and Wash' board. A sheet of layout paper sufficient to cover the entire board is chosen and a

window cut in it to expose the line drawing. A sheet of masking film is laid over this using the technique described on the previous page and the perimeter of the black parts and each individual crescent-shaped segment are carefully cut out.

The forward-facing *rim* of the lens and the rangefinder (far side) are peeled off and sprayed flat and then the tiny part of the rangefinder visible beyond the lens is peeled off and sprayed. Next, the furthest of the two crescents inside the lens hood is peeled off and sprayed to a soft highlight. This mask is replaced and the process repeated for the nearer of the two, again replacing the mask when it is finished. The nearest of the concave sections on the hood is peeled off and sprayed to a soft highlight at two o'clock, the mask replaced and the next two sections removed. These can be done together because they are approximately the same diameter and there is no need to define an edge (because they are surrounded by a different colour). It is not necessary to replace these masks after spraying because there is no immediate danger of overspraying; they are simply covered with a sheet of paper. The process is repeated for the eye cup, replacing each section as the next is done, with, again, no need to replace the final one.

The microphone is divided into four areas: the highlight itself, running around the top and down to about three o'clock, the continuation of the highlight running on round the radius that divides the front face

from the cylinder, the cylindrical section and the flat front. The highlight continuation is peeled off and a wisp of black blown across it. Then the cylindrical section is peeled off and the form modelled to the same two o'clock, soft highlight as the lens hood. Care is taken not to overdo this, because it is only done to differentiate the various parts from each other. Next, the front face is peeled off and a graded tone given from top to bottom, concentrating the spraying in the lower half where the tones should nearly blend. Finally the mask is peeled from the highlight, which is sprayed from the far side round to about one o'clock to grade the radius.

The small bit of protruding cable was done before the grommet and then the underside of each convolution of the grommet lightly sprayed using a small coin as a mask; this was overlaid again with a simple tubular effect running to a soft highlight up the middle. All of the masking can now be removed.

2. A piece of masking film is relaid across the drawing and all the grey areas trimmed out. The masking is peeled from the darkest parts first – the deep shadow beyond the microphone and the lower-facing radii – which are sprayed. Next, the masking is removed from the slightly angled lower-facing edge beneath the lens hood, and this is sprayed. All the masking from the forward-facing surfaces, including that of the lens-mount bezel and the edge of the arrowed groove, is removed and these are sprayed flat.

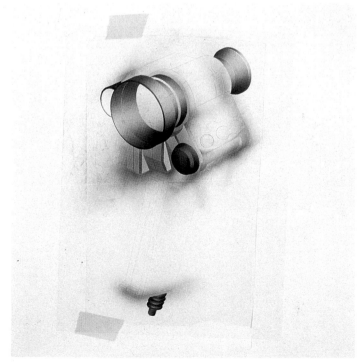

1

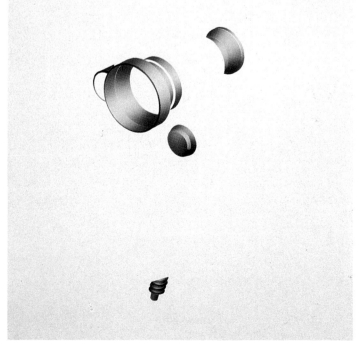

2

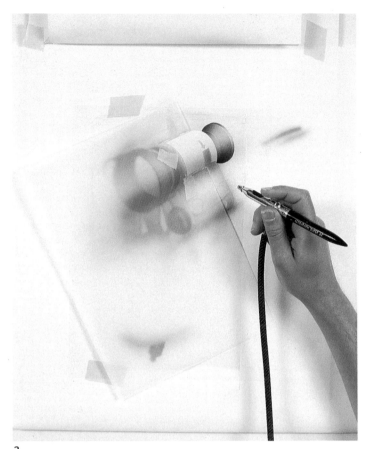

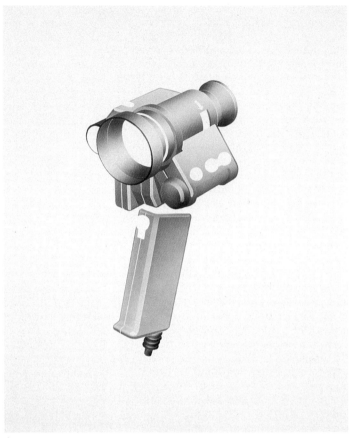

3

4

3. Next, the cylindrical part of the main body is airbrushed to the same soft highlight as the black parts done earlier. To avoid the cylindrical effect overlaying onto the forward-facing rim of the bezel, a tracing paper mask is cut to protect it.

4. This shows all the grey work complete. After the cylindrical body, the handle is airbrushed by doing the falling-away shadows first and then the left-facing surface, followed by the forward- (and slightly upward-) facing surface, leaving the highlight and moulding joint-line covered; note how the surfaces are graded from top to bottom. Finally, the radii joint-lines are uncovered and lightly oversprayed to take the edge off the white from the top downwards. After the handle is done, the final spraying is carried out on the angled diagonal face and the top surface beyond the cylindrical unit. All the remaining masking is carefully peeled off to see how successfully the tonal balance has been judged.

5. The drawing is remasked and all the remaining coloured parts are trimmed out ready for spraying. The button on the top surface is done first with the masking cut away around the vertical face, this is

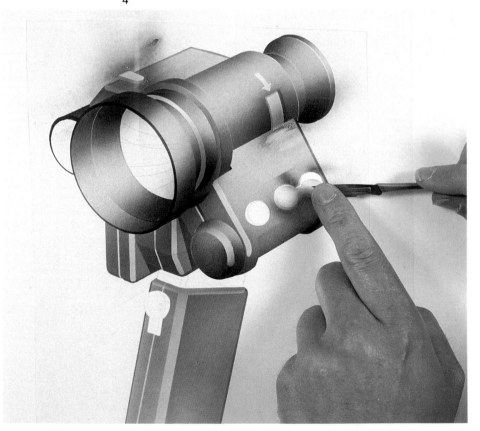

5

airbrushed in vertical passes leaving a highlight at the nearest point. The mask on the top surface is removed and a light tone lightly washed on. This completed button is covered with a sheet of paper and taped along the nearside edge to prevent any possibility of overspray.

Next, the rectangular panel beneath the arrow is tackled: the mask is removed from the entire area and moved down to leave a small 'L'-shaped strip as a shadow area. This is lightly airbrushed, and then the masking is removed altogether, along with the masking covering the arrow and the blue band around the lens. These areas are all cylindrical and are treated in the same way, shading from the bottom up to the highlight at about two o'clock.

The protective paper is moved to cover these areas and work started on the double button: the masking is removed from the vertical edge, which is modelled to a highlight at about eleven o'clock, and then the masking is removed from the face. Because the buttons are slightly convex they need to be darker at the bottom than at the top, so the application is graded with the airbrush to achieve this. As before, the areas that have just been sprayed are protected. The trigger button is done next and is treated in the same way.

The airbrush is cleaned out and switched to red, before treating this button also in exactly the same way. (At this point I suddenly realized that I had completely forgotten the black band between the handle and the body so this was also sprayed in at this stage). The rangefinder cover is sprayed around the top with a light wash of sky blue to make it look silvery. The lens is also done at this stage by successively peeling off strips and overlaying orangey-browns. When faced with a problem like this it is important to get hold of some visual reference to work from. When I first did a camera I sought out a good photograph from a brochure and then simply copied what I saw in the lens and this worked very well. When doing this demonstration I felt confident enough to do the lens from memory which was, in retrospect, a mistake because it took a lot of effort to get it to the stage you see here, which is, as a result, desperately overworked.

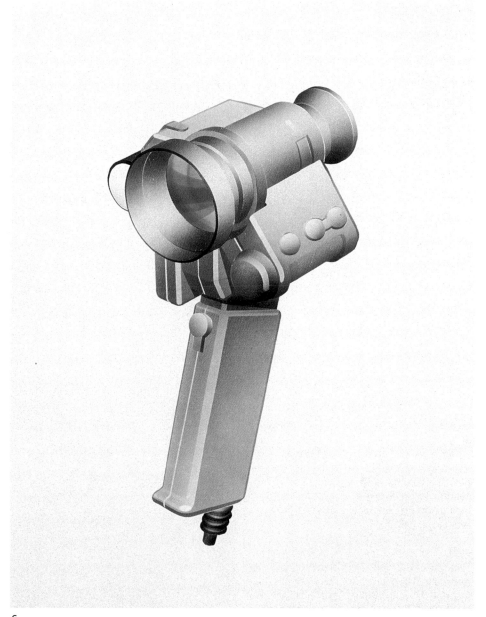

6

6. All the masking is removed again to look at the whole drawing. At this stage I considered that I had not put sufficient contrast into the drawing and decided to remask the black areas and darken them further. Excessive masking on oversprayed areas can cause tiny patches of paint to lift off with each new mask; the surface was showing signs of this happening, so I elected to use a paper mask for this work. To do this, a piece of tracing paper is simply laid on the drawing. The areas to be cut are drawn on it and then trimmed out one at a time. In this case the mask was retained in position by coins around the crucial edges (special care had to be taken not to let the spray lift the mask). I rolled back each segment, leaving the end still attached

to the sheet, and weighted it with another coin. This allowed all the lower-facing dark areas to be toned down a lot further, but extreme care had to be taken not to leave a tell-tale line at the point where the rolled-up segment leaves the surface of the drawing.

7. The final photograph shows the completed drawing with all the edges tidied up using crayons (a dark bluey-grey for the falling-away edges on the grey parts and a white for the highlight areas throughout). With the airbrush work, all the detail of the microphone had been lost but the master was kept firmly attached to the board throughout, so it was still in perfect register. The back of this one area was lightly coated with white pastel and the necessary detail traced through; the holes were blacked in with a fineline pen and the edges of each hole modelled to a highlight at about seven o'clock with the white pencil. Finally, white gouache was used to create highlights on all the near corners and radii.

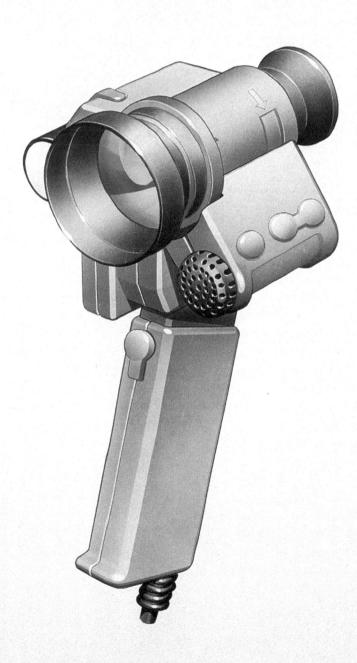

Example 2:
Hand-held control unit
by Don Tustin

Control panel or 'fascia' design is one area that responds well to airbrushing, especially if the client wants a realistic rendering of the finished product. If the view is elevational (or nearly) you can use dry-transfer lettering for all the graphics and obtain extremely convincing results, and the two-dimensional format means that results can be obtained almost as quickly and more accurately than other media.

Stages

1. The drawing is first roughed out on tracing paper using traditional drafting tools. It is an elevational view which has been 'tricked' around to show some of the top surface. The back of the tracing paper is then covered with graphite from a 2b pencil lead and traced down on to Hollingsworth hand-made paper (pre-mounted to board). It is a 'not' surface which means that it is slightly abraded. The traced down drawing is then covered with tracing film to contain any overspray and the section over the drawing removed, so that masking can begin.

2. The background around the drawing is masked first using a series of patches along each edge (rather than a sheet over the whole drawing) – this is done to minimize the risk of overmasking and then pulling the recently painted surface away with subsequent masking; it also saves on film. The display, label and buttons are also masked in preparation for the first pass with bodycolour. The upward-facing surface of the unit is also left masked as this will be lighter than the forward facing surfaces. The chosen medium is gouache with a small amount of Doc Martin's ink as necessary. The basic blue is mixed up from a combination of Prussian and Peacock blues and Permanent white to the consistency of slightly creamy milk – be sure to mix a lot more than you need as it is difficult to rematch later on. The drawing is then turned horizontal so that the blue can be sprayed in long sweeping actions along the axis of the product. A ruler, with the bevel edge face down to achieve a softer line, is used as a mask for the left-hand highlight, and a small amount of black is added to the colour in the airbrush bowl to achieve the 'darklight' on the right-hand side of the unit.

The extreme left–hand edge of the highlight is masked off (although the contrast which this leaves is softened later) to suggest some reflected light and the left-hand horizon line is put in freehand or by using the upturned ruler as a guide along which the airbrush can run. The reflection across the top front of the product is masked and sprayed, taking great care with the amount of colour applied as the mask does tend to hide the level of contrast. A small amount of Doc Martin's yellow is then whiffed along the highlight and above the front face reflection to add warmth and suggest sunlight. The masking is then removed and the drawing remasked around the top surface – this is then blown in leaving a minor reflection across its surface.

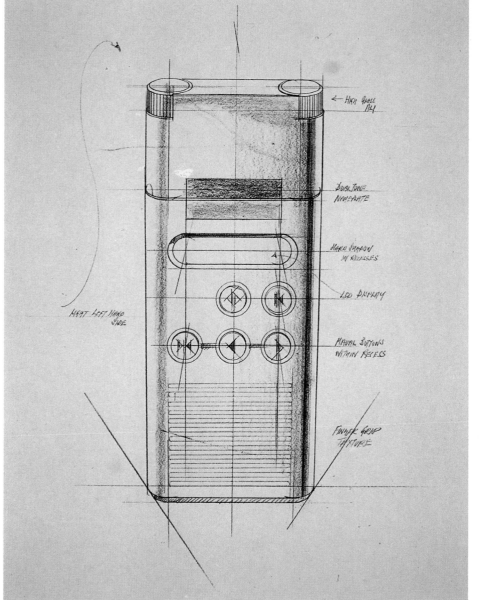

1

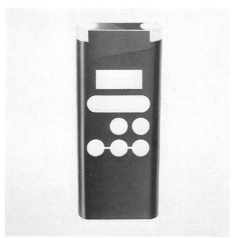

2

3. The next step is to spray the turned aluminium control knobs. The barrels are masked up first and sprayed using a grey gouache mixed from pure black and white. As a general rule it is advisable to lift the mask as little as possible during spraying but sometimes it is necessary to check on the level of contrast between parts sprayed earlier and the areas currently being sprayed. Remask for the 'spun' tops and cut the 'x' shape into the mask and spray using the same grey; finally, a little sky blue ink is whiffed onto the tops. Experienced designers will cut against their guides when masking ellipses, but the novice should not be tempted as the ellipse guides will almost certainly be ruined.

4. The drawing is then remasked for the button recesses. Since the overall colour is becoming darker some black is added to the blue for the darker tones now being sprayed. The dark faces at the upper left of each recess are put in first and these are toned out to light in the bottom right. In this example the mask was slightly overcut so that after spraying the white highlight would be left – this could equally have been done with a brush towards the closing stages of the drawing. Some yellow ink is whiffed over the highlight to add warmth.

5. This shows the same stage as the previous photo but with the masking removed to show the result. Note the slight tearing away of the surface on the left-hand side caused by leaving the mask in place over a lunchbreak; depending on the heat and humidity of the studio this is usually ok, but never leave a mask on overnight as by the time you return it will have removed large chunks of earlier work. As a result of this, some patching was required as the drawing progressed.

3

4

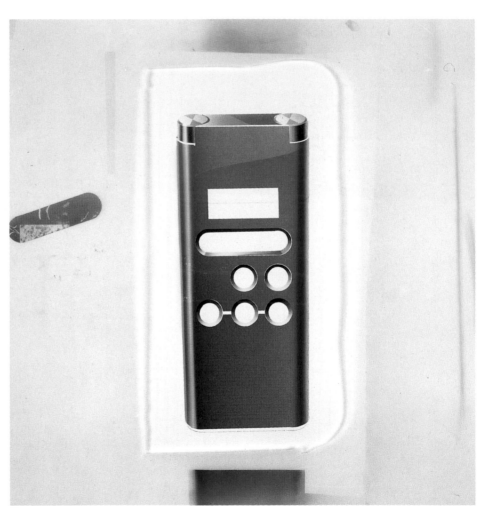

5

6. The next areas to be sprayed are the buttons themselves, the display, and the label area. The masks for each button were cut 'off' the drawing using the compass mounted scalpel blade and then placed in position. To achieve the glossy finish, a second piece of film was overlaid and cut to the shape of the reflection in each button. The lower half of the button was sprayed first and then the mask was removed and the lighter area washed in over the top to give the slightly domed shape. The LCD display is sprayed in using a slightly green colour and a hand held ruler as a mask.

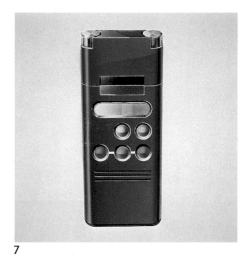

7

7. The two colour label has been masked and sprayed in and the drawing is shown at about the halfway point in the finishing off process using a variety of different materials. Technical pens with black and white ink are used for the shutlines across the front of the product and, along with a fine sable brush, for the knurling on the knobs.

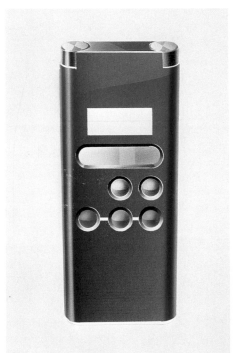

6

8. The finished drawing. The whole drawing has been refined and 'tightened up' by adding darker reflections and bright highlights to produce contrast. As part of the 'working up' process the texture slots on the front surface are put in by hand and all the edges tightened up. The surface is then fixed before remasking for the background, which is sprayed in with a light grey. A drop-shadow in a darker shade has also been added to seat the image. Finally the graphics were applied using dry transfers and the borders around the drawing cleaned up with a soft rubber ready for presentation.

8

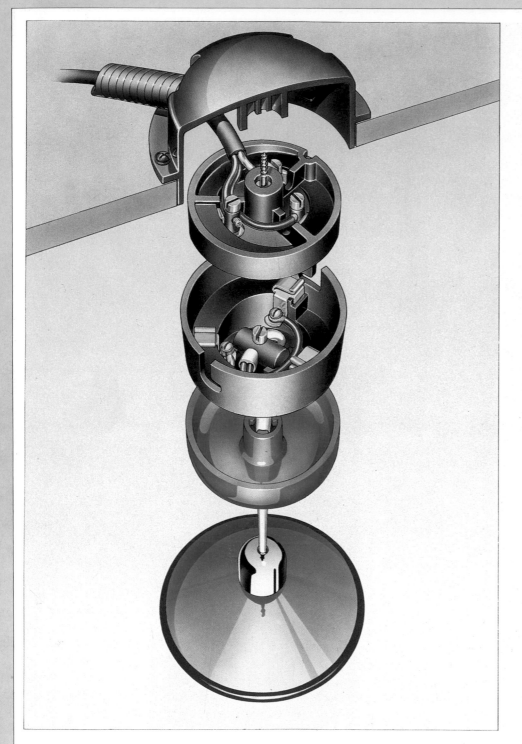

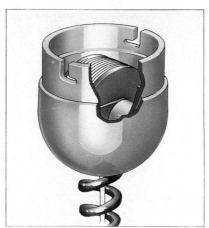

Light fitting

This explanatory visual was done for a General Electric Plastics calendar. After the idea had been roughed out and approved by the client, it was detailed up with a pencil. This was traced off onto tracing paper using technical pens, but only on falling-away edges (obviously we didn't want a black line around a highlight). Next it was enlarged photographically via an inter-negative and printed onto old-fashioned bromide paper, and then dry-mounted to CS10 board ready for airbrushing. Two prints were taken so that one could be used to practise on.

All the green areas were done with the first mask: note the crisp, well-defined highlights and the reflection of the boss in the flat surface of the inside of the cover. All the grey parts were tackled next, working from dark to light with minimal replacement of masking. Three further masks were used for the red, beige and yellow areas, before putting the airbrush aside and finishing off with gouache and crayons.

Right: Electric wheelchair
For Lombard Engineering
by Peter Ralph

This is an airbrushed elevation of the type more fully described on p.145. It shows a design for an electric wheelchair produced as part of a mid-project progress report for the client. The drawing not only shows the overall look of the project, but also accurately shows the construction, materials, ergonomic constraints and overall dimensions that have shaped the design. The drawing is done at half-scale onto Art board using airbrush Indian inks and Desinger's gouache.

Below: Forklift truck
For Boss Trucks International
by Peter Ralph

This drawing not only defines the overall product identity but also identifies access, visibility and servicing ergonomics. It can be easily reproduced and is also dimensionally accurate. The elevational views are monochrome rendered to provide some anticipation of the three-dimensional appearance, spacial ergonomics and intended livery. The technique involves airbrushing directly onto the film with transparent inks: either solvent type inks, acrylic based inks or shellac based inks. With film, the risk of cockling of the paper is minimal, but the risk of the colour pulling away with repeated masking is proportionally increased. Heavy grades of tracing paper, on the other hand, are more porous and therefore take the ink well, but are very susceptible to cockling if the surface is allowed to become too wet.

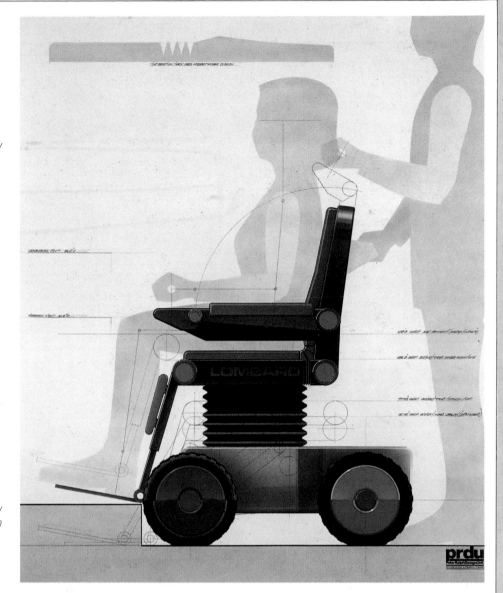

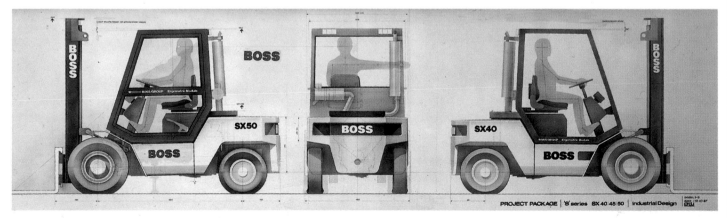

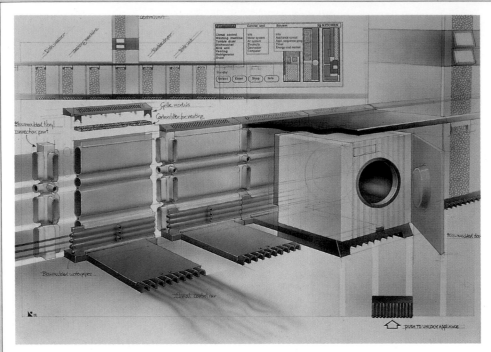

Right: Safety helmets
by Seymour/Powell

Commissioned for the 1985 General Electric Plastics calendar, this view uses airbrush for the helmet shells and marker for the rest, with careful inter-cutting between the two to achieve a good match. The underlay was built up from the yellow helmet and then reduced on a Grant enlarger for the two others. The shells were airbrushed first using Magic Color inks onto CS10 paper, and then the visor and liners were drawn onto marker paper and coloured up separately. All the elements were then assembled onto a new sheet of white paper and a whiff of ink sprayed onto the visor (either side of the highlight) to give it some presence. The background was set up and photographed, and the enlargement 'knocked back' with two layers of polyester film and one of K Trace.

Above: IQ Kitchen
For General Electric Plastics
by Roland van Gils

This is an example of a descriptive rendering which explains many different aspects of the proposed concept. As well as showing the styling of the finished kitchen, the cut-away and transparent views expose many of the detailed workings and construction of the system and the various units. The basic drawing has been done in ink before airbrushing with coloured inks.

Below: Modular process control system
by Don Tustin

The underlay was drawn out to scale and then transferred to water-colour board. The meters and buttons were masked out, and the dark-grey background panels airbrushed in with gouache. The latter were then remasked so that the doors could be sprayed darker. The shadows under the knobs, the beige meter recesses and the red graphic panels along the top were all airbrushed next. The silver back panel and shadows were also airbrushed, while the rest of the rendering was done by hand with a brush and dry-transfer lettering was used for the graphics.

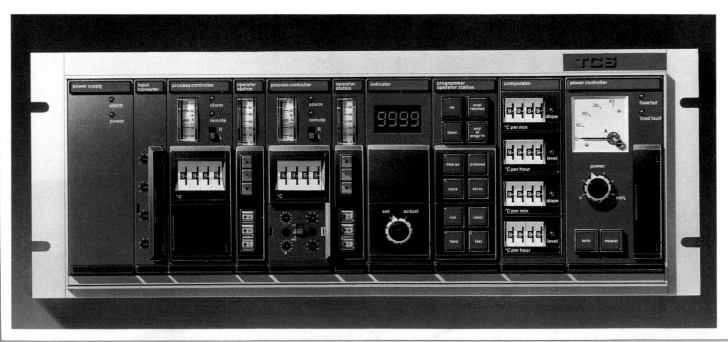

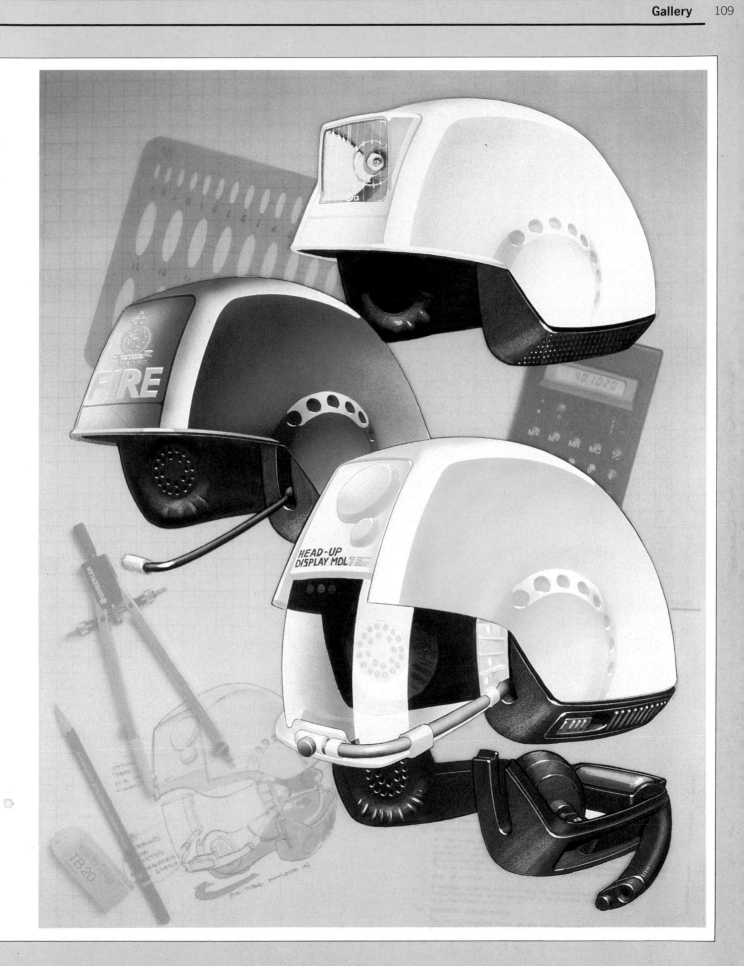

8 Coloured Paper Rendering

Using coloured paper as a base for rendering has rather gone out of fashion despite the advantages it can offer in some applications. It really comes into its own when rendering transparent materials, metals, jewellery, fabrics and furnishings, for quick and effective sketch rendering, and for objects which are largely of one colour.

The usual approach when working on coloured paper is to use the colour of the paper as the *mid-tone* value of the colour of the object, and then to darken the shadow areas with marker, pastel or crayon, and lighten in the light areas with pastel, crayon and paint. By using light media on the darker ground, high-contrast highlights can be produced which really make the drawing come alive. This also explains why the technique works well for metals and transparent materials which, of course, also tend to have high-contrast highlights. There is a further advantage in using coloured paper for transparent objects: the secret is to work from the back to the front. Objects appear transparent because we see the background behind them, and usually this background is modified in some way by the presence of the object in front of it. The coloured paper itself can form this background and the object can be sketched in with the minimum of marks using both light and dark pencils, and one or two markers.

Because of this economy, the technique works well for sketch rendering: ideas can be drawn straight on to the paper using a light pencil and modelled up very quickly. Since you are not working from light to dark (as you would be on white paper), you do not have to worry so much about the tonal balance of the final sketch: you are starting from a mid-tone and working either side of it. Of course, if you use a very dark paper then you will be working from the darker tones back towards the very light tones, such as in the car drawing on page 10, which can produce some stunning results but is, perhaps, slightly more difficult to do well.

The main disadvantage of coloured paper is that it is not transparent and so you can't simply slip the underlay underneath and trace it through, as you can with layout paper. If you are not confident enough to sketch directly on the surface, or if the rendering is to be in any way a finished drawing, then you will have to trace the underlay down onto the coloured paper. This is done by rubbing the back of the underlay with an appropriate coloured pastel so that is evenly coated, and lightly brushing away excess dust; the underlay is then taped to the coloured paper and traced through using a fairly hard pencil.

Alternatively, tracing-down papers, which work like carbon paper, are available in a variety of colours and are used between the underlay and the coloured paper.

Using coloured paper becomes less appropriate if the product you are drawing is made up of more than one basic colour; the odd flashes of colour in small quantities are of no consequence, as these can be put in with opaque paints such as gouache. Anything more, however, is a problem, because the base colour is so dominant that it effects any transparent media laid over it. For example, laying a Cadmium Red marker across a blue paper will only create a darker blue, or perhaps, a dark purple. This can be enlivened by overworking with a red crayon, but the result is never as strong as the original, bright Cadmium Red.

Both Ingres paper and Sugar paper have some 'tooth' (roughness) which makes pastel and particularly coloured crayons work extremely well. Because of their high rate of absorption, however, they drain the colour out of markers in no time at all, making it almost impossible to obtain a flat finish of any consistency; infilling of very large areas with marker, therefore, is very difficult to do and should be avoided where possible. If you allow the marker to dwell on the paper, it very quickly forms a darker patch which is difficult to blend in, although, if the marker colour is darker than the paper colour (such as with black), this is hardly noticeable. Nevertheless, when using marker on these papers you need to plan where to end each stroke and how to make the streaking effect of the marker work for you, rather than against you.

Example:
Pencil Sharpener

The pencil sharpener is to be predominantly blue with a black front and a transparent cover beneath, making it a suitable candidate for rendering on coloured paper. The view is planned so that we see through the transparent cover to the base below, and out through the side to the background. Clearly the shape is identical to the basic cube and can be treated in the same way: the left-facing surface will be reflecting the ground off to the left, and the right-facing surface the ground off to the right. The top will be reflecting light from above, and so this will be lighter than the two sides. The back corner will be lighter than the near corner to add contrast to the bright highlight running around the nearside radii. Note the reflection of the handle in the upper surface (seen as an interruption of the general reflection in this surface), which, more than anything, adds to the impression of a glossy finish.

Stages
1. The basic underlay is drawn up using the cube method described in Chapter 3. Note how the centre of each face is located using diagonals so that the hole on the front face and the centre line for the handle can be exactly located on the same axis. The handle is then drawn from this centre-line upwards, and backwards, from the back face of the sharpener.

The exact position of the reflection is worked out according to the method described on pages 59–60. First, the top face of the sharpener is extended horizontally until it meets the front vertical face of the handle. The points at which the lines describing this front face meet the extended top face are the points from which the lines describing the front face of the *reflected* image will spring. Next, a vertical is dropped from the centre of the top 45-degree ellipse of the handle; this line will bisect (in a perspective sense) the line where the extended top surface and the front face of the handle meet, and is extended on downwards. An equal distance downwards (in perspective) is marked off to locate the centre of the reflected ellipse, and a minor axis that shares the same vanishing

point as its real counterpart is drawn through this point. The ellipse can then be drawn in, and tangential lines drawn to it from the previously defined points (where the handle meets the extended top face). All the unwanted construction lines are removed, particularly those defining the extended top face which will otherwise be confusing.

A light blue pastel straight from the box is used to coat the back of the underlay and rubbed in lightly with a tissue. The smooth side of the Ingres paper is used and the underlay taped down, before being traced through with a fairly hard pencil. Before the tracing has progressed too far, one corner is lifted to make sure that a satisfactory result is being obtained on the paper. The underlay is left taped to the Ingres paper along the top.

2. The marker work is tackled first: a Black is used for the front, without worrying if the previously traced-through line-work is totally lost, as this can be put back later. The left- and front-facing surfaces (including the handle and its reflection) are treated with a Mid Blue. The left-hand face is graded by using an Antwerp and a Prussian Blue towards the top where contrast is needed for the highlight. Antwerp Blue is used to darken the underside of the handle parts and the area behind the clear cover. When the latter is dry, the entire cover is overlaid with a Steel marker and then again on its left-facing surface. The Black marker is used again on the left-facing surface of the black part.

3. The front face is masked off with tape and some white pastel dust is wiped over it, grading slightly from the bottom upwards; the same is done on the top leaving the back corner brighter. The pastel is rubbed away over the clear front face to leave some bold reflections (this can also be done with the Steel marker) and removed from the handle reflection (because this is in front of the reflected light).

4. White crayon is used to put in the highlights along the radii, keeping them sharp on the glossy parts and slightly diffuse on the matt-black front. The shut-lines are defined with a black and a white crayon, and the blue parts are sharpened with a dark blue.

The highlights are finished off with white gouache. No attempt is made to 'ground' the drawing, rather a simple rectangle is drawn to settle it on the paper and create depth. To add to the impression of transparency, this line could have been continued behind the transparent cover.

2

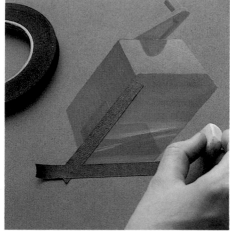

3

1

4

9 Automotive Rendering

There is no specific technique associated with automotive rendering, but it has a chapter to itself because it has developed so much faster than any other area of design. When it comes to drawing and rendering, the automotive designers are the pathfinders for the rest of us; techniques developed in the car studios filter downwards into industrial design studios and colleges. This is because much of the car designer's role is dedicated to styling and, wherever styling is important, so drawing and rendering skills also become important. Short of making a model, it is impossible to communicate subtle changes of form, both to yourself as you work and to others, if you cannot draw them.

Sadly, there is a fair degree of animosity between auto designers and product designers, particularly in Europe. The auto designers would argue that the product designers have lost their artistic roots and try to spread their expertise too wide, so that they become average at everything rather than good at one thing. The product designers, on the other hand, view the car designers as mere stylists, whose work is shallow and superficial, and who are unconcerned with real design problems and intellectual issues. The two views are ridiculously polarized, and both sides should have more respect for the abilities of the other. The product designers in particular should not be so quick to denigrate the work of the stylists; if they had half their styling skills, the shops would be full of products that are good looking and desirable, as well as functional.

Philosophy apart, the method of working in the auto industry is different to most other industries; in particular every aspect of presentation is more finely honed – even the loosest sketches are visually informative and graphically considered. Because the process is so 'rendering intensive' there are, inevitably, a lot of clichés. Those within the industry read right past the clichés to the design being portrayed, while those looking from outside are often bewildered by them. For example, car drawing relies heavily on visual experience, in other words, because we know that a car has four wheels and that each wheel has a tyre, there is, therefore, no need to construct and render the tyres or underside details of the car. As a result, nearly all car drawings have their tyres completely blocked-in in black, or treated in some other abstract way. Similarly, it is difficult and time-consuming to draw the interior of a car as it might be seen through the glass. To save time, therefore, many car designers lay bold reflections across the

glass. There is nothing wrong with this because they are concerned with communicating the overall *design* to themselves and to others in the studio. It is only when visually inexperienced outsiders see such drawings that they become open to misinterpretation.

Serious students of rendering will already have seen, and experienced, the many techniques used in the car industry; what follows in this chapter will serve as an introduction to a subject which, in itself, is big enough to fill a book.

Example 1:
Sports Car

by Ken Melville

Vellum is a semi-transparent tracing paper which has a coarser surface-texture than most tracing papers and, consequently, will accept crayon and pastel, which would skid across the surface of most drafting papers. It is also a great deal more absorbent than tracing papers (although nowhere near as absorbent as layout papers) and so accepts markers well. Marker ink will not, however, go right through the paper, although it is clearly visible when viewed from behind. Because both front and back surfaces are identical, both sides can be used. By markering on both sides the tonal range of a single marker can be greatly extended and some interesting effects obtained. Vellum is almost impossible to find in Britain but is widely available in the United States.

View
This is a deliberately easy view because the eyeline runs right through the middle of the car and there is very little angle to the perspective. Many automotive drawings are done with a low eyeline – either elevations or front and rear three-quarter views – because they are simpler to draw. A car is a difficult thing to draw and, if you are working through ideas, you need a view which can be repeated quickly without worrying too much about getting the perspective right. Indeed, if you are a beginner at car design, it is a good idea to start with a side-elevation with the vanishing point between the wheels. As you develop the details around the front, the side-view can be 'cheated' around so that it includes some of the front (although this is not strictly correct), and the perspective can be carried through to the rear wheels and roof

pillars. The side-view can then be 'cheated' around to show the rear of the car in the same way.

The view shown here, however, is a true three-quarter view. It has been slightly foreshortened to bring out the dynamic qualities of the sports car. The car is also tilted to give the impression of movement as if under high G forces, with full opposite lock applied.

Stages

1. The underlay is traced through on to the vellum using a fine ballpoint pen; note how the quality of line becomes deliberately faded towards the back of the car to enhance the impression of speed, depth and form. The car is to be black and there is a horizon running along the body side. There is another reflection detail along the side glass with a broad reflection running down the steeply raked screen. Where there are no reflections in the glass, elements of the interior can be seen. The Black marker is applied in these areas, leaving the sills and lower surfaces of the tyres white because they will be picking up ground tones.

2. Next, the drawing is turned over; black applied on this side will appear as a washed-out dark grey on the other side. The Black marker is used to soften off the edges of the reflections and in the tyre highlights. The underside of the tyres is loosely masked off with the black tape and, using a tissue dampened with solvent, ink is drawn off the marker and on to the tissue and immediately reapplied to the masked-off area to obtain a graded effect. The Black is also used on the area of the screen unobscured by reflection to give the impression of looking right through the car and the rear window glass.

3. Some grey and dark-blue pastel dust are mixed together and used to grade the bonnet from the front to the back (the forward-facing panel is, of course, darker than the upward-facing surface which is reflecting sky) and also from left to right. Using pastel on the back of the drawing is a good idea if the drawing is small, or if the areas where it is to be applied are small, since it is difficult to control in these situations. As with marker on the back, it also extends the tonal range, and there is the added benefit that it remains undisturbed as the drawing is built up on the other side. Yellow ochre pastel and the same grey pastel are mixed together to create a ground tone and this is worked over the downward-facing areas such as the front bumper, wheels and sills.

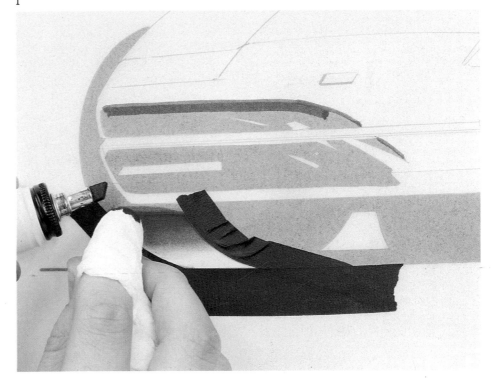

1

2

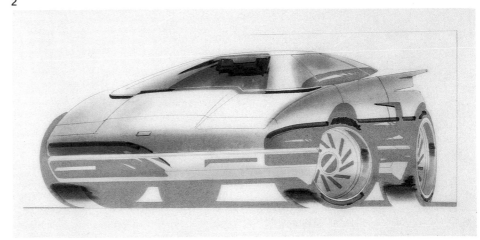

3

4. The drawing is turned over and both pastel mixtures are worked on the front to strengthen the darker tones and increase the tonal range. A sweep is used to mask the application of pastel on the edges of the bonnet bulge, and the pastel is graded on the body side so that it gets darker as it nears the top (this gives the maximum contrast between this surface and the adjacent, but very light, bonnet surface). Using a sweep as a guide, the pastel is rubbed out on the upward-facing edges of the bumper and body panels. White gouache is mixed up and used fairly dry to highlight the facing edges of all the shut-lines, the top and bottom of the wheels, and the screen.

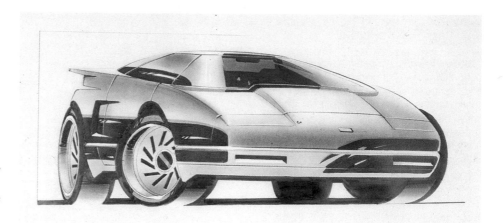

4

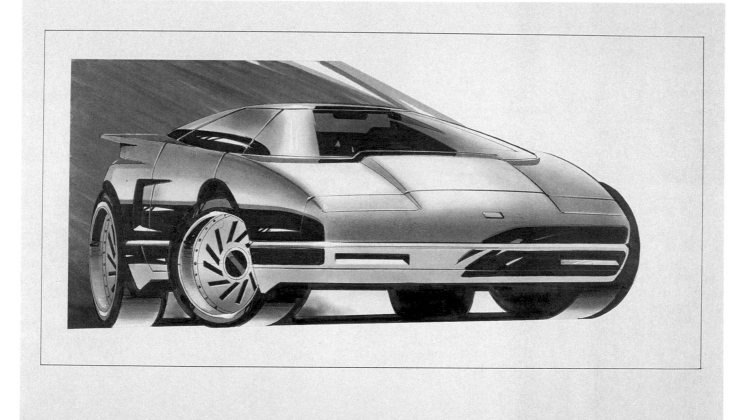

5

5. The rectangle behind the car is traced onto a separate sheet of paper (the profile of the car did not require masking as it would be cut out later). The surface of the paper is dabbed with cleanser to begin with and then a Cadmium Red marker is streaked across, followed by a Black in the bottom left corner. A tissue dipped in cleanser is used to work the colours together and care is taken to avoid it becoming grubby. The Black is made really strong in the bottom left corner. The page is turned over and the extreme right worked at

to produce a more graded effect.

The background is cut out and mounted using a spray adhesive. Then it is carefully cut just inside the line of the car (3-4mm) to ensure an overlap and avoid seeing the background through the drawing. The trimmed edge of the background is peeled off and the finished car mounted in place.

The red background is reflected in the back, upward-facing edges of the car and so it appears to overlap the drawing in these areas. A white crayon or white paint is used

just to 'pull back' the edge so that the back of the car is defined.

Two observations on the finished drawing: note that the reflection of the screen in the bonnet would probably not occur in reality, but that it works well and helps to define the bonnet shape. Also note that the reflection areas are not solid black but are broken up with white streaks; this reduces their visual mass and prevents them dominating the drawing.

Example 2:
Mid-engine Sports Car

by Julian Thomson of Lotus cars

This is another example of a rendering done on vellum using marker and pastels. The designer has chosen an interesting view with the major body panels open to show the intended hinge configuration and the engine layout below. To further complicate the task. the designer has also chosen a more difficult aerial view rather than the usual 'low to the ground' dynamic view so often favoured by auto designers.

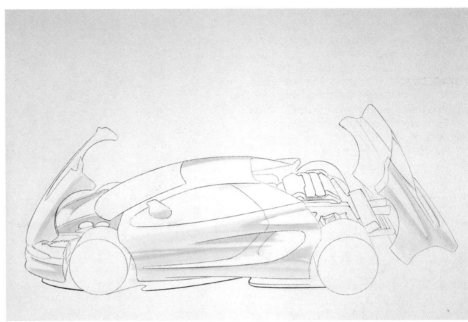

2

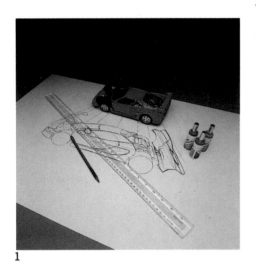

1

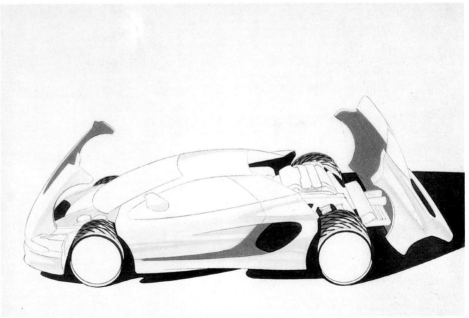

3

Stages

1. Setting up an interesting perspective for a car can be difficult for the inexperienced designer – one way around this is to use a single point perspective which is much easier to control. In this example the car is to be shown with its body panels open which, while adding to the level of detail required, makes the drawing more descriptive of the car's layout and construction. Model cars can be a great help in setting up this kind of view, if only to help understand what happens to the perspective when door and body panels are opened. Use the model to help you determine the best view and even. to save time, take a polaroid which can then be enlarged on a photocopier to provide a basic underlay on which to work.

2. Vellum paper is used for its durability which allows it to be overworked with a rubber without damage to the surface. A ballpoint pen is used for laying out the underlay as it is unaffected by the solvents in markers and is very precise for defining shutlines; it can also, to a degree, be erased on Vellum. Cool Grey 3 and Warm Grey 3 markers are used first on the back surface of the paper to define the body panels; later in the process these will be completed on the front of the paper with pastel.

3. Next, a black marker is used on both the front and the back of the paper; use of the marker on the back shows through as a grey colour. A dark grey could have been used on the front of the paper to achieve the same result but more care, and therefore more time, would have been required where colours overlap. Note how the ground shadow has already been put in to 'seat' the car and to provide the necessary contrast so that the body panels begin to look white.

4. Many of the details, such as the parts in the engine bay and the wheels, are now laid in with various colours of markers. The undersides of the hinged panels are further darkened as the overall tonal values become more established. The horizon line on the side windows is put in with a hint of the interior showing through, using the black marker again on both the front and back of the paper.

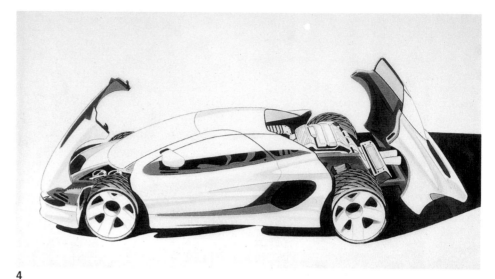

4

5. The window areas are put in on the backside of the paper: this is done by masking them off with low-tack masking film to avoid a lot of cleaning up of edges afterwards. On the side window, the dark grey/blue pastel is worked down to the horizon line to leave a highlight, and on the windscreen it is worked from the far side of the car to the nearside. The paper is then turned over and pastels used to model the bodywork: pale sky tones for the upward facing surfaces, and a hint of pale yellow in the lower surfaces to suggest ground tones.

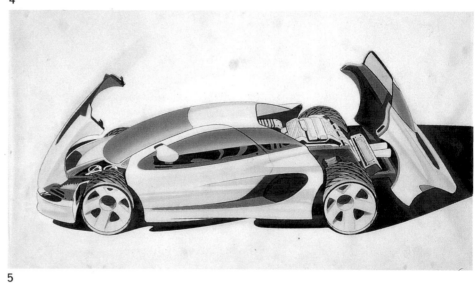

5

6. The whole drawing is then covered with masking film so that the background can be put in. This is done with a lint wad soaked with black Flo-master ink on the front side of the paper and blue marker on the back. It has to be done quite quickly so that the ink has no chance to seep under the mask and ruin the drawing. Never leave the masking film in place for very long as not only do you increase the risk of seepage, but also there is a real risk of pulling off pastel and crayon work underneath.

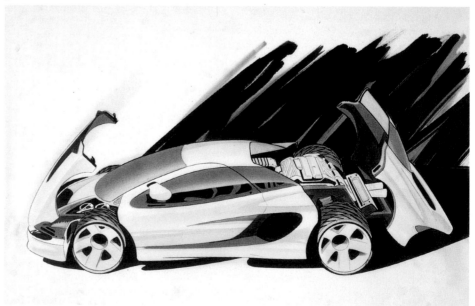

6

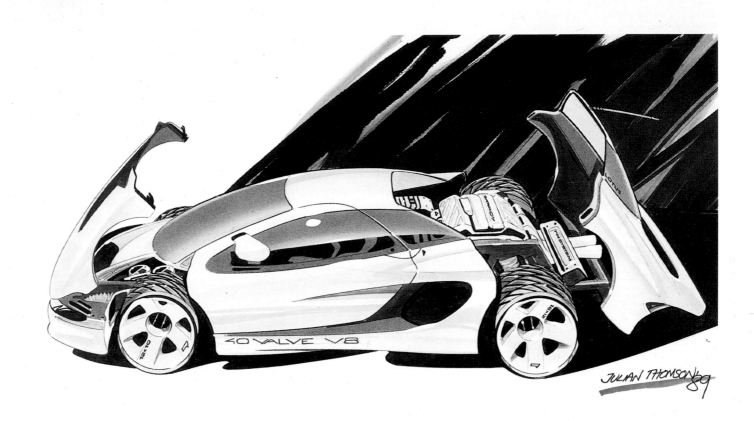

7

7. The finished drawing. After the background has been allowed to dry the whole drawing is lightly sprayed with fixative, trimmed out and mounted down to board, and a red felt tip pen is used for the wheel and bodyside graphics. To achieve really crisp highlights these are cut into the paper to reveal the bright white card background; and where this is not possible white gouache has been used. If you use this technique, be sure to have the drawing laminated or it will buckle and crinkle over a period of time, especially if subjected to changes of temperature and humidity.

Example 3:
Coupé

by Anthony Lo of Lotus cars

View
This example shows the kind of fast descriptive sketching technique used by car designers to fine tune and hone the body shape around specific details. The overall design for the car has already been well worked out and the designer is sorting through ideas for the design of the rear of the car. For this reason the view shows both the back and side clearly and yet the view retains sufficient dynamism to provide atmosphere. With this sort of drawing it is important to retain a 'sketchy' feel and not allow the rendering to become so important that it overtakes its true function, which is to help the designer sort out the design. Thus, as the drawing progresses, the work will concentrate around the near corner of the car and be allowed to fade away towards the front.

Stages
1. Using a black ballpoint the view is sketched out freehand from an existing underlay without too much concern for overlapping lines and exact perspective. The paper is Letraset marker paper chosen for its opacity and brilliant white surface although, unlike Vellum, it cannot be worked on both sides or masked with film.

2. The car is to be black and so, in the classic manner, will reflect a lot of colour in the sky and ground tones. A black marker is used for the reflections and this is progressively faded towards the front using cool greys until the value at the front is only a Cool Grey 7. The lighter areas of the interior which will show through below the horizon line are also treated with the lighter greys, along with the lower back line of the rear bumper. A Lipstick red has been used for the reflection on the rear lights and locally darkened with Cool Grey 7. Note also how the tyres have been loosely modelled using the same combination of black and grey.

3. The next phase of work is to use deep blue pastel for the reflected sky tones. The pastel is graded softly to white along the bodyside horizon line and close to the back reflection, leaving the tone at its strongest in the area between. Try to do this without recourse to a rubber which will inevitably leave a sharp edge rather than the soft blur which helps describe the soft contours of the car.

1

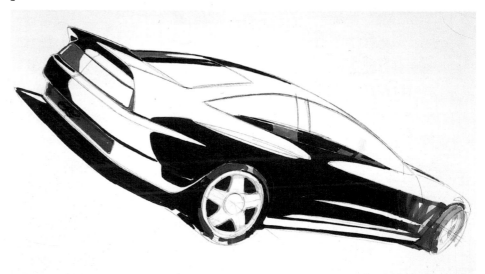

2

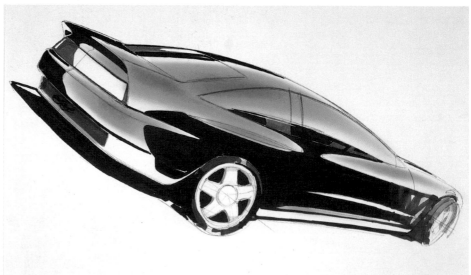

3

4. A whiff of purple pastel is added to the sky tones to underscore the impression of dusk lighting, and a warm grey added in the lower surfaces and wheels to give ground tones; red pastel is used to finish off the tail lights. The drawing is near completion and only needs tightening and highlighting.

5. The finished drawing. Minor highlights are put in with a rubber before the whole drawing is sprayed with fixative. A white crayon is then used to lay in the body panel shutlines and these are further contrasted with a black ballpoint pen. Finally, high contrast highlights are dotted in with white typewriter correction fluid which has the advantages of drying extremely quickly, giving a very brilliant white, and being impervious to later application of water-based paint.

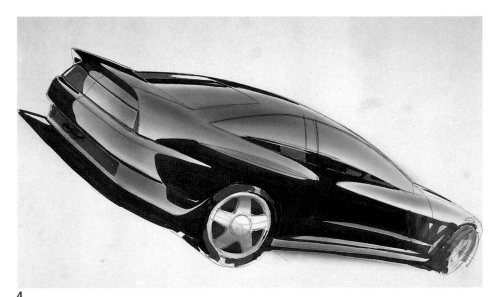

4

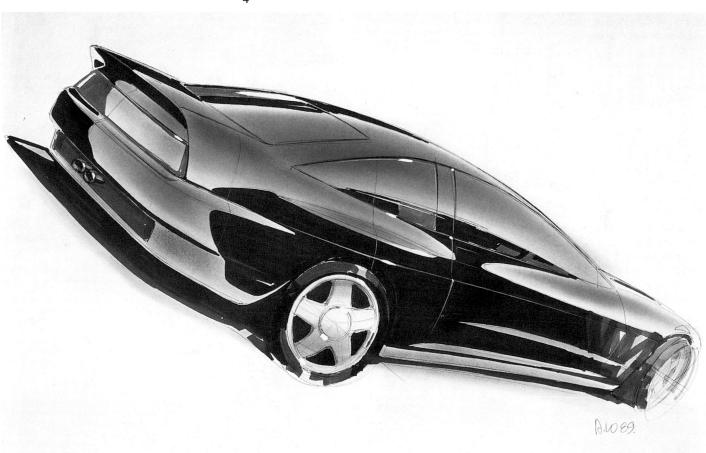

5

Example 4:

Two-seater City Commuter

by Ken Melville and Gunvant Mistry

In the automotive business the full-size tape drawing is the intermediate step between renderings and fifth-scale package drawings on the one hand and the clay model on the other. A drawing is a lot quicker and cheaper than a model and allows several alternatives to be reviewed so that one can be progressed to a model. Because the drawing is based on a true 'package' (the dimensional, operational and ergonomic details of a car) there is no possibility of 'cheating' and, like the generator on page 78, the drawing can give a true indication of size and proportion. Surprisingly, what looks good at fifth scale needs a fair amount of modification to make it work well at full size.

To those who have never done a tape drawing it may seem a mystery why anyone would wish to use tape to actually draw with, but, as soon as you try, you understand why: you can make extensive changes to the shape without constantly erasing and redrawing, you can easily lay down a curved line and, if you are unhappy with the rate of curve, peel it off and try again.

When using tape in this way, the trick is to anchor one end and keep it in tension with one hand as you use the other to guide the tape around the curve. To help get a smooth curve it is sometimes useful to create the curve using a thicker tape (which bends more consistently) and then lay the final, thinner tape butted up to it; the first tape can then be removed.

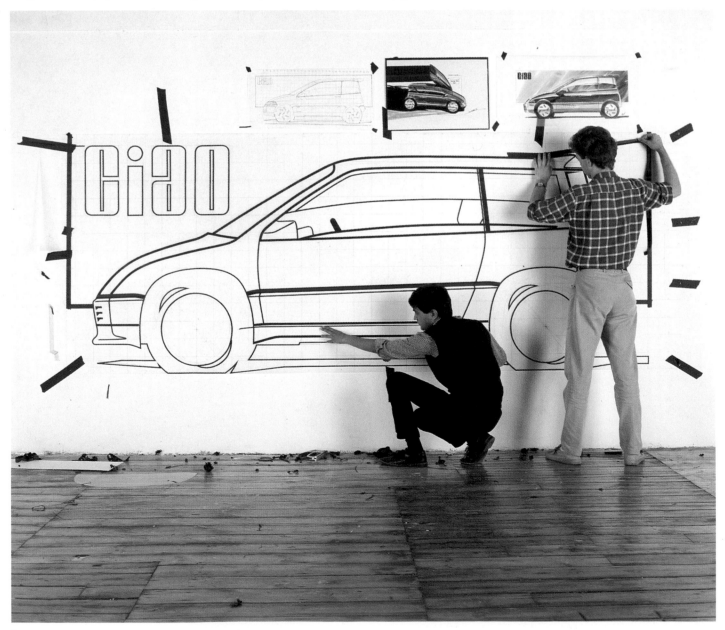

1

Package

A two-seater city commuter, wheelbase 2m (6ft 6in), height 1.33m (4ft 3in), overall length 3m (10ft). Called Ciao City. Based on a BMW 1000cc motorbike engine: flat four transverse, approx 90bhp.

Preparation

Choosing a site. Make sure that you have plenty of room to operate, with sufficient blank space around the drawing to avoid cramping the image. You will need to step back from the drawing to give yourself an 'at a glance' appraisal of how it is progressing; this needs at least twenty feet if you are to take in the whole drawing without having to turn your head.

Paper. Vellum, Crystalline, or one of the Polyester films work best, with the first two absorbing much more ink than the Polyester, which is virtually impervious. Polyester film is expensive, but dimensionally stable and very tough. The drawing is taken off the wall and replaced several times as well as being subject to constant abuse as tape is ripped off and masks are cut, so a tough paper is essential.

Stretching the film. It is important to stretch the film very firmly because as you lay down tape you put it in tension, and if the film were not stretched it would cockle. Stretching is done at the mid-point of each end, and then at the mid-point of the two longer sides; these are all held with 2in tape and then a couple of staples put through both tape and film for final stability. The corners are then stretched in the same way so that the whole is like a drum skin.

Transferring the design. To help in the transfer from the fifth-scale package to full size, a 100mm grid is drawn first (film which is pre-printed with a grid is available) so that the view can be accurately scaled. Be prepared for a dramatic change to the design because your perception of proportion and detail will change once the design is roughed up in full size. Be sure to step back as far as possible to give yourself a broad view of the whole drawing.

Planning. Work out exactly in advance what you intend to do; you will find there is very little room for manoeuvre once you begin. Render up the drawing at fifth scale in almost the same way as you intend for the full size, and practise the detail areas if you have any doubts. This example is to be a black car with a horizon along the body side. Running above the horizon, and in the glass, is a dark band;

2

this is sometimes called a 'double horizon' but could equally represent something long and dark in the foreground which is therefore obscuring the horizon behind it. Because this band is dark, we can see right through the glass to the background behind the car. On the other hand, where the glass is reflecting light, we see nothing through the glass. The background is there to emphasize this and therefore help the glass to look transparent, as well as throwing the drawing forward and providing warmth to contrast with the cool colouring of the car. Its sharp, rectilinear form also helps frame the car and 'settle' it graphically so that the composition works well.

Stages

1. *Tape drawing (1).* The design, and the planning for the rendering, are well worked out at fifth scale first before even contemplating moving up to full size. Once happy, and reasonably confident, a grid is drawn onto the fifth-scale view – either on a clear overlay, or simply drawn over the top, so that this can be scaled up to full size. The grid is then drawn five times up on the stretched film and the design transferred to it using a pencil to rough in the lines, followed by tape. The photograph shows this stage in preparation. Note the three reference drawings pinned above.

During this stage the film is subject to a fair amount of abuse as tape is constantly applied, removed and reapplied. This can

leave traces of adhesive and grease (from hands) on the surface, so, to be safe, it is best to do the final drawing on a fresh sheet. Once the design looks right, a new sheet is stretched over the top and it is re-drawn taking into consideration this time round where the first application of colour will be.

2. *Tape drawing (2).* This shows the drawing on a fresh sheet of film and ready for the first application of colour. Note how the window horizon is clearly defined but that along the body side has yet to be taped, although the wheel-arch eyebrows are in.

Next, those parts are identified which will eventually be white in the finished drawing and can therefore be masked off and forgotten about until near the end. This does not include broad white areas which need light airbrushing, only those small areas which are well defined such as the door shut-lines, upper surface of the body panels and bumpers, and the split line between the two lower panels.

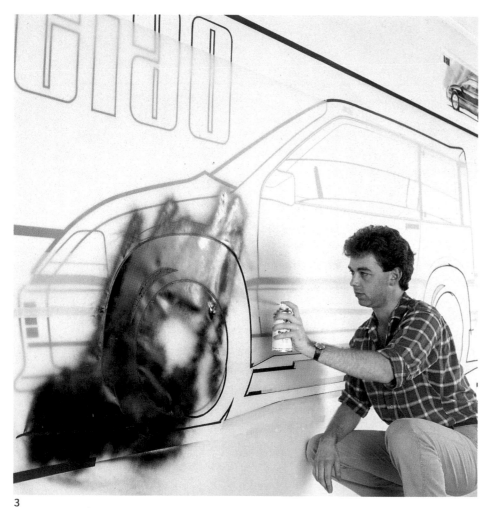

3

4

3. *Black (1).* All the black areas are carefully masked out using lightweight tracing paper which is overlaid across the drawing as far as the spray is likely to carry, and then a bit more. The black areas are then trimmed out with a scalpel along the middle of the underlying black tape. The tracing paper is held down along its entire length with more black tape to prevent the paint getting under the mask. Very small areas (such as the tyre highlights) should not be masked out with paper; only tape is used to cover over the underlying white. The entire area is then sprayed with paint (in this case a Marabu acrylic) and allowed to dry.

4. *Black (2).* This photo shows the masking paper and tape removed.

5. *Working on the reverse side (1).* The body-side reflection is put in using a thin tape so that when the drawing is turned around it is easier to see where to mask. The staples are lifted out and the sheet reversed, re-stretching it as before. The body-side reflection (including eyebrows and reflection detail at the central 'hotspot') and the shadow under the mirror are masked out. Also masked at this stage are the details within the car that are not obscured by reflected light: the headrest and the insides of the A and C (front and back) pillars. Finally, the small rear-light detail on the roof will reflect the same information as the body side, so this should also be masked. All these areas can now be sprayed with the same flat black as the wheels.

The lower parts of the two indicators are masked out and some orange Flo-master ink wiped in, and some sky blue is also applied to the headlights (perhaps a little too strongly).

The highlights on the tyres are sprayed black from behind so that they appear grey on the front side. The small amount of interior (roof lining etc) is also done at this stage using black Flo-master and cleanser so that it fades out somewhat from the top to the bottom, to match the sky graduation that will be applied later on the front.

The base grey of the body panels which have been masked out is done with Flo-master on the back so that the real modelling can be done from the front. When wiping on colour in this way it is a good idea to use straight cleanser to start with to get the ink flowing. The grey is wiped to the same central 'hotspot' as the body-side reflection, and once this masking is removed, this hotspot is sprayed with white Marabu acrylic to reinforce the impression of a sunset/sunrise coming over the horizon.

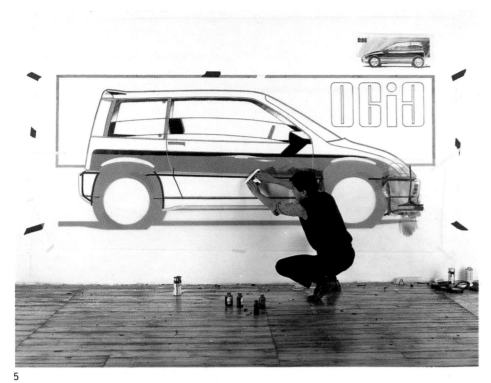

5

6. *Working on the reverse side (2).* All the tapes which were aiding masking on the back are removed so that there is no black edge to the shapes once the film is turned around again.

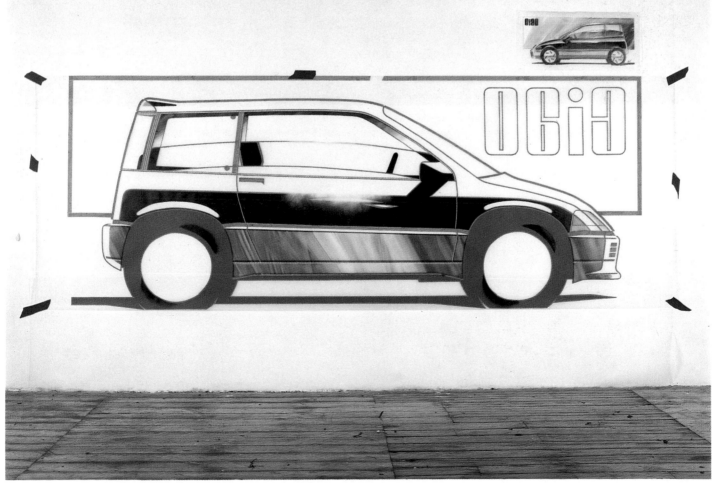

6

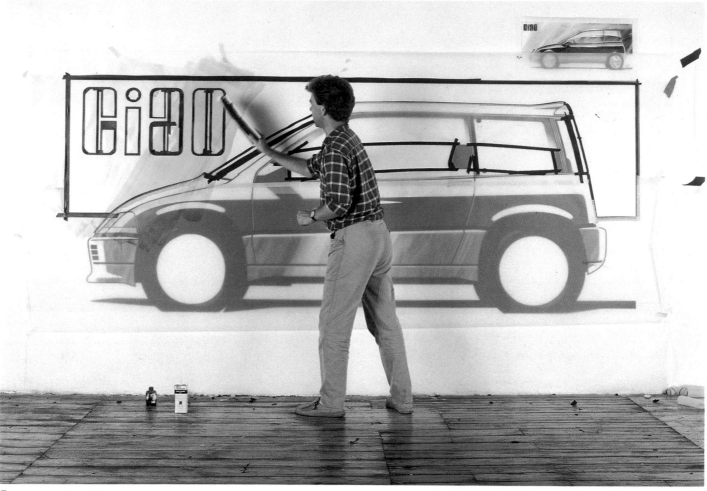

7

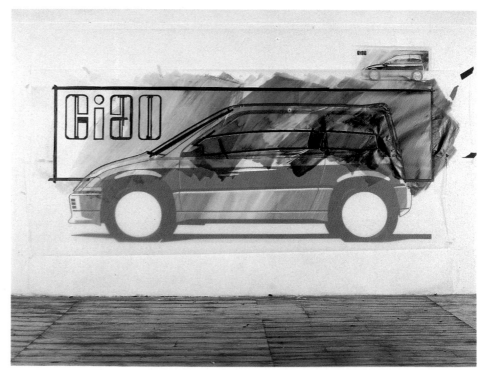

8

7 and 8. *Background (1)*. The paper is re-stretched and the background masked out including the lettering. Where there is no light being reflected in the glass, you will see right through to the background, so these areas are also masked out. The screen and rear window have been masked to allow the background to be reflected as this will suggest the amount of curve in the plan-shape; a tape has been left so that after colouring a white line will be revealed. Finally, the rest of the drawing is thoroughly covered over with tracing paper. Photo 7 shows the drawing during the first application of colour which is wiped on boldly from the top left using a 30cm (12in) giant marker. To prevent the colours becoming muddy four separate swabs are used, one for each colour, and one for cleanser only. Photo 8 illustrates how important it is to cover everything!

9. *Background (2).* This photo shows the drawing at exactly the same stage but with the masking removed.

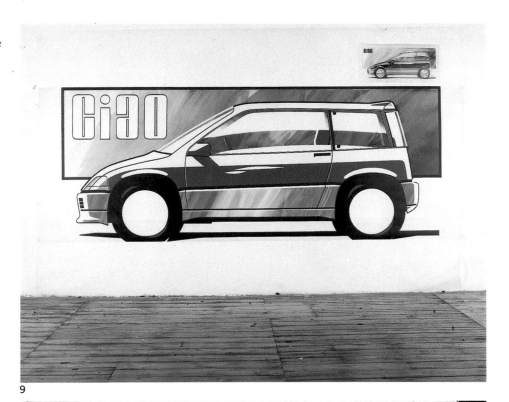

9

10. *Body-side reflection (1).* The areas above the horizon and the wheel-arch eyebrows are airbrushed next using inks. All but these areas are carefully masked out with tape and tracing paper ready for spraying. The eyebrows are sprayed to a central highlight so that they nearly blend with the underlying black at either end. Blue ink is loaded into the brush immediately after the black so that the area nearest the highlight has a bluish tinge; once complete and dried, they are covered over for protection from overspray.

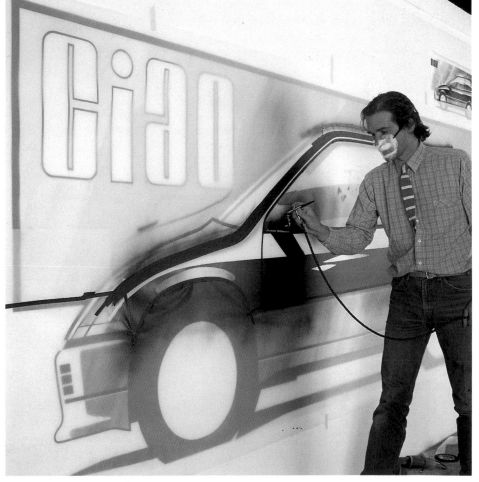

10

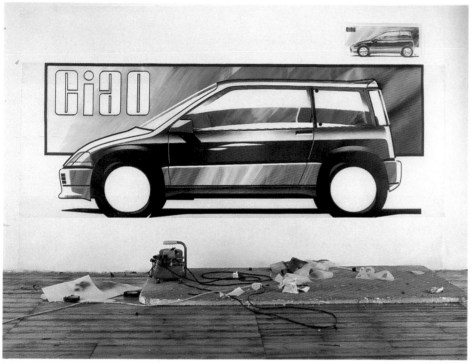

11

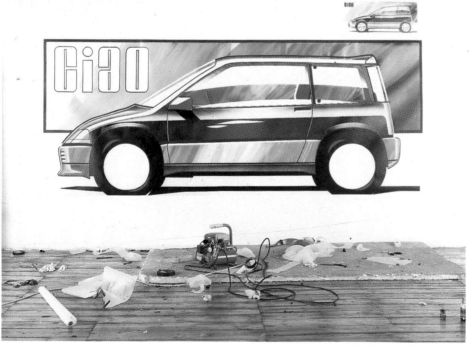

12

11. *Body-side reflection (2)*. The area above the horizon needs careful planning and we elected to leave a broad white highlight along the radius, up the A pillar and right along the roofline, so this is masked out first. The rest of the area needs to be toned towards the same central hotspot as on the lower panels. Before beginning to spray, some tape is laid along the top of the body panels (just below the glass); this will be removed after the first few passes with the airbrush to leave a slightly lighter part where the bodywork curves into the window and is therefore picking up reflected sky tones. As with the other black areas this is oversprayed with blue loaded into the brush on top of the black.

Looking at the drawing at this stage, we decided to darken further the area below the horizon, as this required some modelling towards the centre to match the adjacent areas and emphasize the plan-shape. This was therefore masked up and sprayed until the tone of the black in the darkest areas matched the newly sprayed areas above the horizon.

12. *Bonnet and rear*. The bonnet is masked up next so that the reflection used on the screen is carried through and down to the headlights, but deflected by the kick-up in front of the screen. The rear of the car is also sprayed during this phase as the airbrush is ready-loaded with black. The front and rear bumpers are sprayed next, starting with the darker, under-facing surfaces and then the front- and rear-facing edges. Finally during this stage, the hotspot is masked out and Marabu white acrylic paint sprayed to create maximum brightness.

13. *Window reflection*. The area above the reflection in the glass needs airbrushing with sky blue and so this is masked out and very lightly sprayed to match the grading done earlier on the insides of the pillars. As with the body-side reflection, white acrylic is used to brighten the hotspot (being very careful to avoid runs).

14. *Wheels and details*. The wheels are done completely separately on layout paper (Frisk CS10 paper would have been better but was not available). The radial slots are divided up into easy areas and sprayed in sequence from dark to light so that masking does not need replacing. They are then given a complete graded tone from top to bottom to suggest a gentle curve. The lettering is cut from red Chromolux (high gloss) and stuck down before finally sticking the whole wheel down to foamcore and trimming out. The finished wheels are attached, using sticky pads.

All of the small details, such as the window 'roundels' are put in using local masks (also the top of the mirror which was forgotten earlier). The headlight needed quite a lot of airbrushing to overlay the slightly greeny-blue colour that was erroneously applied on the back of the drawing, and restore it to a more sky-blue colour. White tape is used along the shut-lines and on the top edge of the lower body panel (in the middle) to suggest a highlight. The front fender-line looked too harsh and was re-masked so that it could be further softened off. Finally, the rear light was sprayed using local masks.

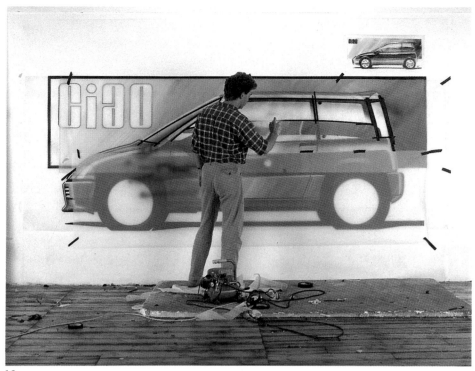

13

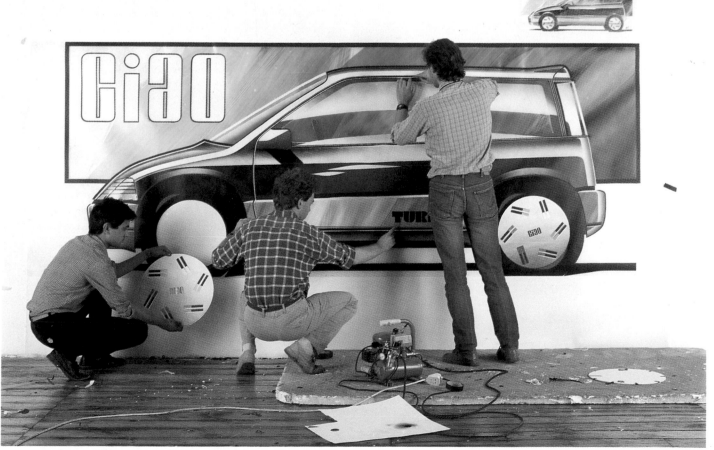

14

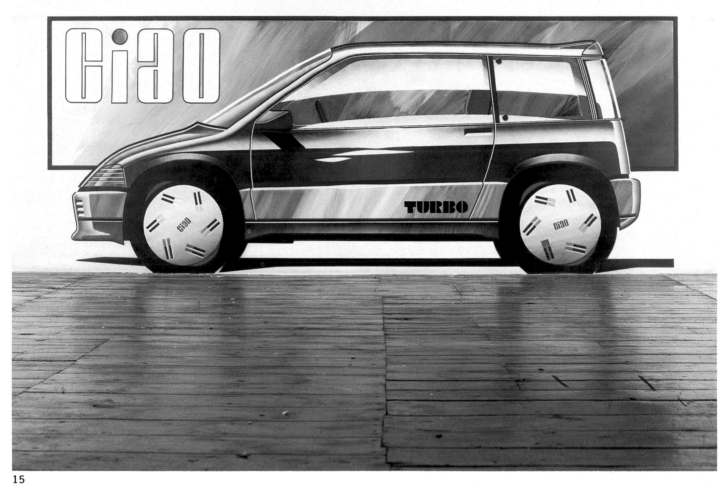

15

15. *The finished drawing.* The drawing is removed from the wall so that the entire presentation area can be cleaned up, and is then re-stretched with the wheels firmly on the ground.

Interiors

Within the car industry there are often two completely separate styling/design departments: one for exteriors and one for interiors. While there is obviously a lot of cooperation between the two, there is also a fair degree of rivalry. The exteriors department is looked on by many as the glamour side of the business, and most aspiring car designers want to start their careers there. In reality, the challenge of designing interiors is a great deal more demanding and, in many ways, far more like an industrial design project. A car exterior is basically a single component with five or six extra parts, such as bumpers and mirrors, whereas an interior is made up of perhaps seventy components, each of which has to be considered and designed in detail, and yet fit and work together as a complete interior.

Generally speaking, more visuals are done for exteriors than interiors, because an exterior is more about shape, form and other emotive issues, whereas an interior has to address the problems of packaging, detailing and the coordination of disparate parts. As a result, the types of drawing differ slightly, with interior renderings tending to be more like product drawings than the more stylized exteriors.

An exterior visual takes a lot for granted; it relies on the viewer to fill in much of the detail from visual experience. A line here, a reflection there, and an image can be constructed from almost nothing. As a result it is easy to cheat in order to show off the best features of the design: wheels are grossly enlarged, ride heights lowered, tyres widened and so on. With an interior visual, on the other hand, it is very hard to cheat — you can't leave out details because the eye simply doesn't fill in the gaps. Even parts not strictly relevant to the design need to be included for completeness, otherwise the drawing is like a face without a nose. Depite this, there is still a lot of the car designer's art in the design of an interior, the basic issues are the same, and the emotive and styling input is as strong. Few designers of interiors will therefore settle for a wooden portrayal of their design on paper, and will strive to produce a dynamic and stylish drawing that is every bit the match of that produced by designers of exteriors.

Example 5:

Sports-car Interior

by Simon Cox of Lotus Cars

View

In the exteriors department, drawing styles come and go like fashions, but in interiors changes of technique tend to evolve more slowly (partly because there is less actual drawing done and more reliance on mock-ups). For this reason it is easy to produce a boring view of an interior, particularly if the same basic view is constantly recycled as an underlay. In this example, the view chosen of the interior is slightly unreal to solve basic problems of perspective and lighting: for example, defining the perimeter line of the interior avoids the problem of where to end or fade out the drawing. Remember that the objective is to establish the theme for the design rather than definitive recommendations for colour and trim which will come later. For this reason an exterior view of the car is generated at the same time to help reinforce the design theme.

Planning

Lighting is always a problem when rendering interiors because, in reality, light would come in from all sides through the windows. Because of the slope of the screen there would be a fair amount of top light on the dash panel at the front which would fade into deep shadow near the floor. The result of such all-round lighting is to soften off shapes and reduce contrast, neither of which is really desirable if you are trying to describe detail. For this reason it is better to adopt a convention that makes the task easier, such as imagining that the roof has been removed, that the light source is more consistent, and that the whole interior is floating independant of the car. In this example, the graphic qualities of the interior are being explored and the interior is deliberately rendered without too much depth. If more illusion of depth is required, it pays to reflect a lot of light off the top surfaces and to render the lower surfaces much darker. This can be further strengthened by losing detail as the drawing gets deeper into the interior.

Stages

1. Once the designer has the idea for the interior worked out in his mind, perhaps as a result of several loose sketches, work can begin on the final drawing for presentation to management. Using some of the earlier sketches a freehand underlay is produced using ballpoint pen on Vellum paper. The plan view is deliberately chosen to give a 'cockpit' like feel to the interior of this advanced sportscar.

1

2. Next a black Pentel marker is used on the back surface of the paper to produce grey tones on the front and to provide flexibility when overworking later with pastels.

3. The same black Pentel marker is used on the front of the drawing to punch up the deep shadow areas such as the deep recesses on the interior and the tyres and ground shadow of the exterior.

4. A Cadmium Red marker is used on the back surface to lay in the basic red colour of the trim. Using the marker on both sides of vellum extends the tonal range of the colour considerably as well as keeping your options open when you come to use pastel. Thus the Cadmium Red on the back appear as a lighter tone on the front.
 Grey pastel is also used on the back at this

stage to define the basic body contours of the exterior and to start blocking out the basic colours for the areas of grey trim on the interior. After this, nearly all of the work will be done on the front of the paper so that progress can be monitored without constantly turning the paper. At the stage the photograph was taken, work has just started on the front side of the paper with the addition of some red pastel to the interior. The advantages of working on both sides begin to pay off as the red pastel overspill can easily be rubbed out without worrying about inadvertently erasing adjacent areas of grey pastel because they are on the reverse side of the paper.

5. Further grey pastel is now used to punch up the contrast of areas of grey trim. Also at this stage grey/blue pastel is used on the

frontside of the exterior view to complete modelling of the surfaces. A red crayon is used to define the falling away edges of the car to help tie the image to the red interior below, and the same crayon is then used to put in the texture of the trim. This is done by sourcing something of similar texture – in this case a sheet of textured rubber – and laying it under the drawing and then overworking with the crayon. Some of the grey areas of the interior trim are treated in the same way.

6. The finished drawing. Red fluorescent gouache is used to reinforce the red pencil work and tie the two views together – this somewhat unreal technique gives terrific presence to the drawing and will make it stand out at the final presentation. White gouache and crayon is used for defining

2

3

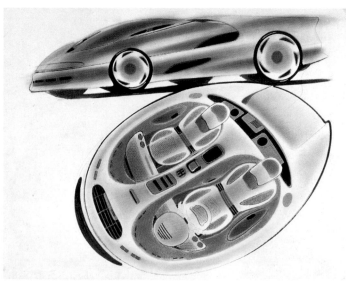

4

5

details and laying in highlights, and a dark grey crayon is used to tidy up some of the ragged edges to help separate the various details and forms, such as around the binnacle. The same grey crayon is used to put in key contour lines which help explain the surface shape of the interior.

The finished drawing is then cut out, and stuck down to board; it is then masked with film while black Flo-master is swept on with a lint pad – the mask is then immediately removed and some of the remaining white flashes spotted with yellow pastel. Finally a grid is drawn over the background using a white crayon over the dark areas and a dark grey crayon over the white paper. For both speed and accuracy, this can be done by simply aligning one edge of the ruler with the edge of the paper and drawing along the other; the ruler is then shifted to align with

the new line, a new crayon line drawn, and the process repeated until the grid is complete. The final drawing is then mounted to card. Avoid using too much spray adhesive because where there is a lot of marker work on the back surface of a drawing, there is a risk of the solvents in the adhesive disturbing the marker inks. A better and more permanent solution is to have the drawing laminated in plastic, using a sufficiently thick polyester to both support the drawing as well as protect it.

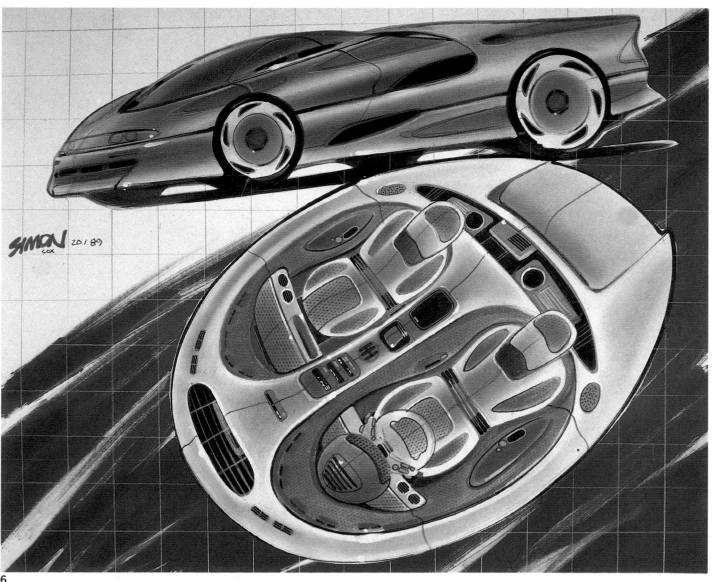

Above: Citroën BX
by Ken Melville

Typical of the kind of work often demanded of junior designers is to come up with ideas for body styling options to create model variants from the most basic version to the top of the range fully-kitted versions. In this example the basic BX design had already been established and the designer was asked for detail changes for an up-market model (hence the detail notes which give the drawing so much of its character). The basic perspective was therefore derived from an earlier rendering of the car and the ideas incorporated as the drawing was built up. Final rendering was done with pastels and marker and a variety of other media for 'tightening up'. Note the very dark ground reflection on the reflective surface, split up with horizontal lines, and the way the wheel trims are reversed out.

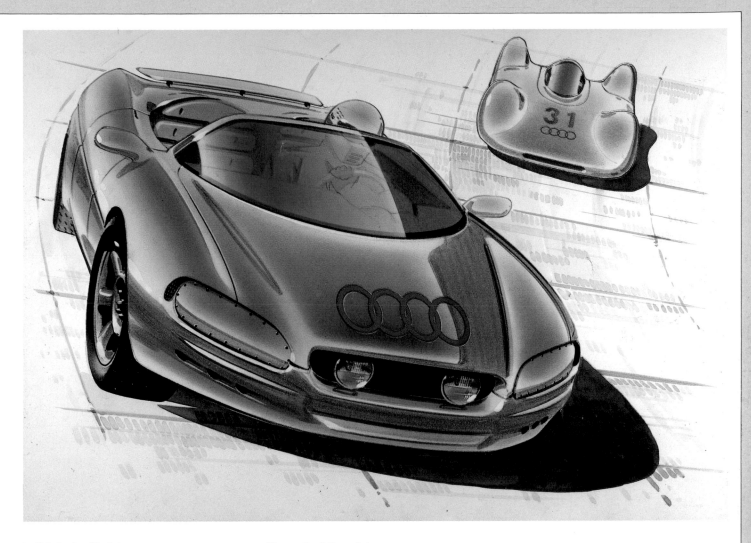

Left: Interior Sketch
by Simon Cox

This is much more typical of the type of drawing produced for an interiors studio. The emphasis is on producing drawings quickly and fluently so that ideas and variations can be explored, rejected, and worked up prior to making full size mock-ups. It is freehand sketched with a ballpoint and fineliner onto Vellum and fast rendered with markers and pastels.

Above: Audi Speedster
by Grant Larson

The imagery for the drawing was deliberately conceived to relate back to the era of the speed confrontation between Daimler Benz and Auto-Union which took place on the Avus Strecke in Berlin. The cars themselves are drawn on Vellum paper using principally marker and pastel. Metallic finishes are always difficult to achieve because the reflective metal particles within the paint and below the lacquer layer tend to produce 'darklights' rather than highlights. Note the use of warm yellow pastel in the bodyside and in the windscreen reflection and the dawn/dusk like setting to provide good contrast to help model the surfaces.

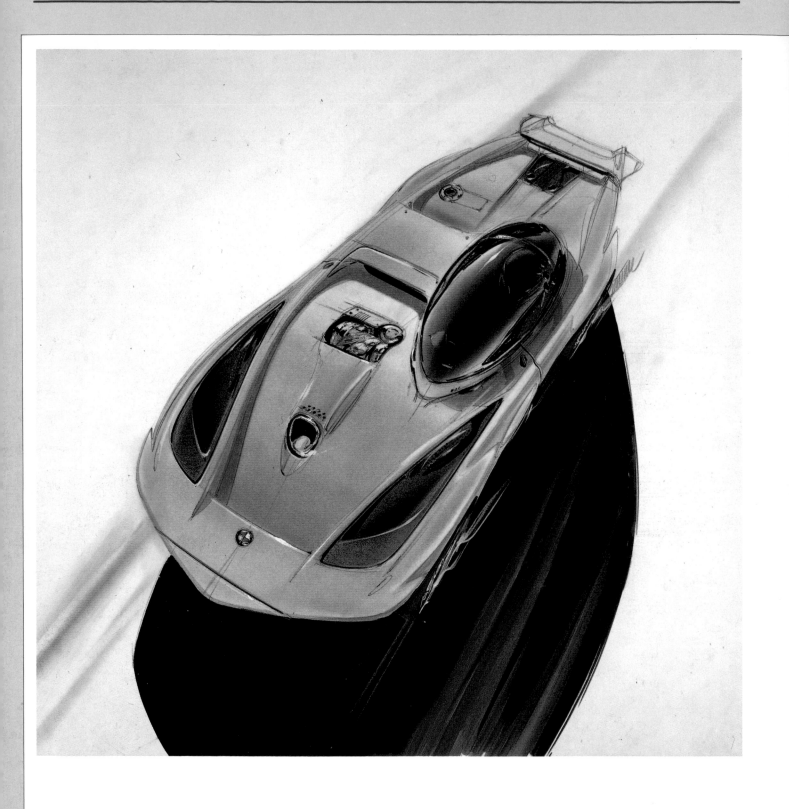

BMW Sports car and Concept car
by Stefan Stark

These two atmospheric visuals show what can be achieved through freehand sketching using dramatic views and lighting conditions. The objective of this kind of sketch, which typically may be done very early in the design process, is to make the idea presentable (and therefore able to compete with more finished renderings) without losing atmosphere or impact. The drawings are done with marker and pastel (sometimes referred to as chalk in the auto design business) onto vellum paper. The line drawing is done first with pencil or ballpoint using both sides of the paper – if used on the reverse the line is less visible and therefore more subtle. The perspective can be controlled on the backside of the paper and then traced through if necessary, or left on the reverse, or a combination of both. It is not important that the perspective is 100 per cent accurate as long as ideas can continue to be incorporated as the drawing progresses and provided the drawing remains a sketch rather than becomes too fixed and firmed up. A lot of lines help to promote a 'sketchy image', where a single thick line would make the drawing look too cartoonlike.

Atmosphere can be enhanced by choosing dramatic lighting and shadows, or through the suggestion of motion. Use the marker and pastel to describe the form of the car by going from light to dark and also from warm to cool colours (as in the top surfaces of the silver car). Note also that the highlights are not just picked out in pure white but that yellows and whites have also been used.

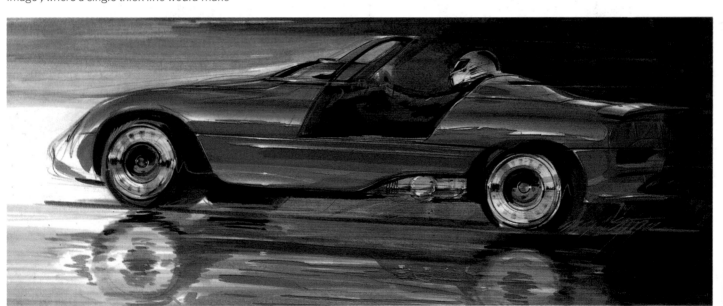

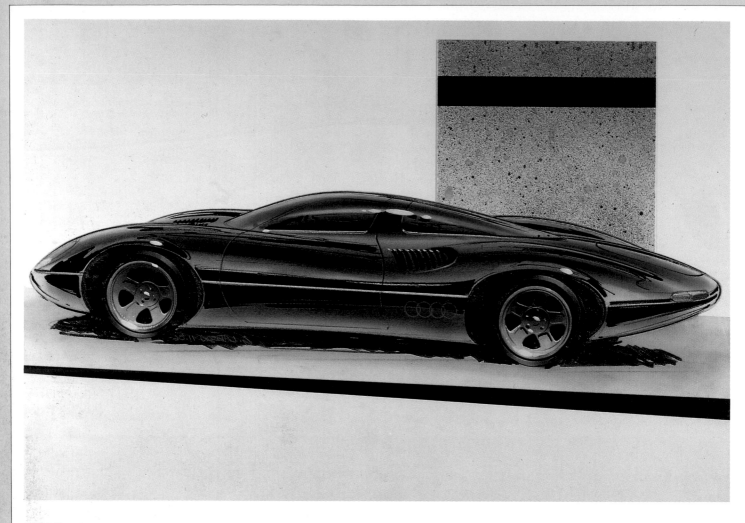

Black Sports car
by Grant Larson

*The basic body shape was borrowed from
the Jaguar XJ13 prototype and drawn just for
fun. To render black glossy surfaces it is
necessary to reflect plenty of colour from the
surroundings. In this case, warm ground
tones are thrown up onto the tumbled home
bodyside, and evening sky tones are
reflected in the upward facing surfaces. The
drawing has been loosely sketched onto
vellum paper and worked on both the front
and back with marker and pastel. The
background has been achieved using a
variety of splatter techniques and then stuck
down to the drawing – note how it reflects in
the falling away edges of the bodywork.
Overall the drawing has that enviable
'sketchy' quality which makes the image look
relaxed, informal, and persuasive.*

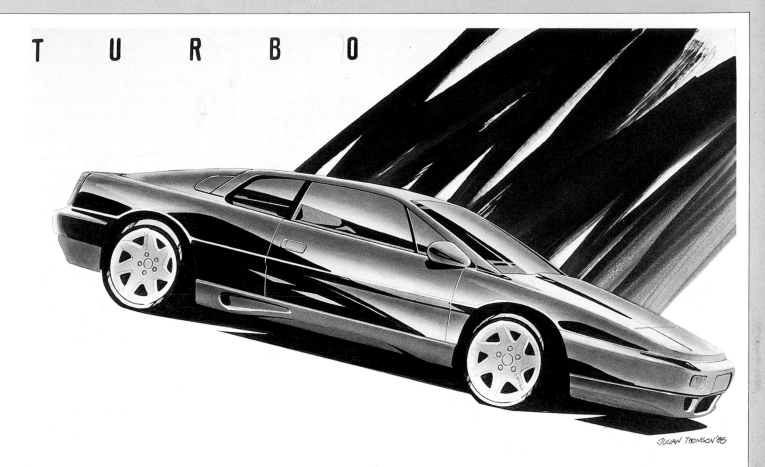

Lotus Esprit Turbo
by Julian Thomson

This is a high quality presentation drawing produced to show senior management the definitive appearance. It is necessarily quite tight, controlled, and comparatively cliché-free, because it has to show the final design rather than simply a styling idea or broad product image. It is drawn on Vellum using the techniques described in this chapter.

Two-Seater BMW Roadster
by Pinky Lai

This sequence shows the production of a full size 'sketch' using only tape. This type of drawing is sometimes produced at an early stage in the design process and because of its size, allows management to assess overall proportion and dimensions better. As a variation on the air-brushing/brush-wiping technique shown earlier in this chapter it can be much quicker as well as offering a better impression of soft contours. The final drawing is built from three separate layers of film overlaid one on another using only black tape; each subsequent overlay tones down the layer beneath to produce a transition from light to dark. Thus the number of available tones is determined by the number of layers of film.

1 The design has already been loosely worked out at a smaller scale and this information is transferred to the first and most important layer of stretched polyester film using black tapes. Note how the light direction and highlight location is marked and the areas of tape removed to produce the highlights. The line work is kept deliberately fluid to describe the soft shapes and retain the spirit and imagery of the car. The shadow of the car thrown onto the background is created using the stretched silhouette of the car offset to the right, and some wheel shadow below.
2 The second layer of the drawing: during the normal work process this would be laid over the first layer as it was being worked on, and is there to produce lighter grey tones. For the purposes of this demonstration it is shown separately. The tail lights and their

reflections have been put in with markers.
3 The third layer of the drawing which, when finally assembled, will show the lightest tones of grey. As it is being worked on it is positioned over the top of the previous two layers, but for the purposes of demonstration is shown separately.
4 After the third layer is complete, the layers are disassembled and the last two layers reassembled in reverse order. In this case a clean sheet of film has been interposed between them to push more contrast into the tonal transition.
5 The top layer has been repositioned to produce the finished drawing. The only remaining work is in cleaning up some of the more ragged lines and laying in the remaining highlights. The wheels are full size photographs taken from a model.

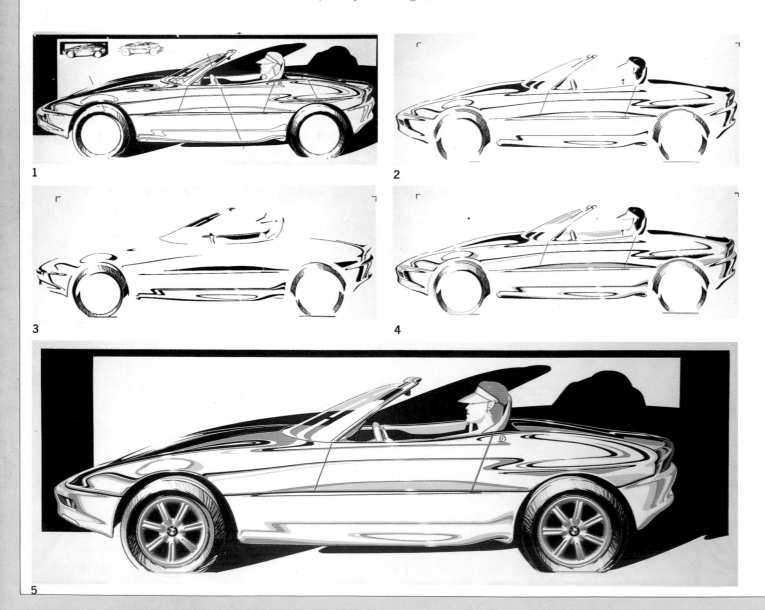

1

2

3

4

5

Concept sketch
by Anthony Lo

A descriptive loose sketch for a car which shows the designer's mind at work as he draws. The shape of the exterior is mapped out using contour lines and even the section through the lower rocker panel is clearly shown, along with the engine position and configuration and the location of the winch behind the front bumper. The freehand technique gives the drawing a fluid, dynamic quality which clearly identifies the drawing as part of the design process rather than a definitive visual for management approval.

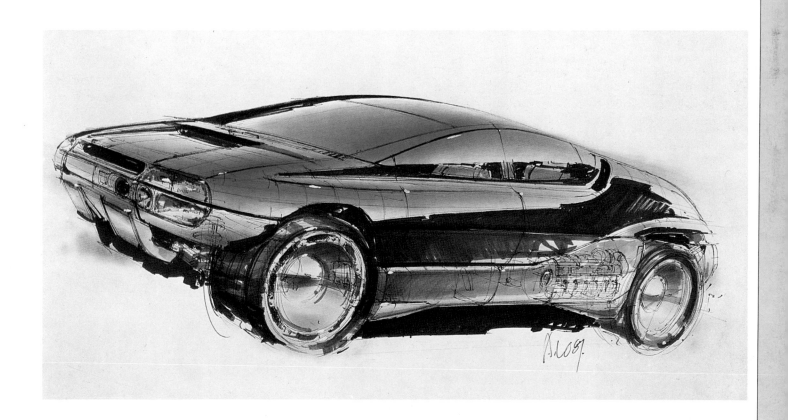

10 Descriptive Drawing

Apart from full colour presentation visuals, there are many other types of drawing that a designer may be required to produce. The most obvious, and demanding, are the orthographic technical drawings that cover everything from GA (General Arrangement) and parts drawings to fully measured perspectives. There are many books on technical drawing and it is also one subject which is well covered by design education, and so is not dealt with here.

Of the other types, most are usually done to describe a design concept further in terms of its construction or use, or simply to establish scale, or to illustrate the product in use.

Cut-Away Drawing

Doing accurate cut-away drawings can be a difficult and laborious process that demands very careful construction. For the designer, absolute technical accuracy is probably unnecessary; on the other hand, a cut-away view can be very descriptive of how a product works, or is put together. The best compromise between accuracy and clarity is achieved by being very selective about *which* parts are cut away, and by how much. Concentrate on revealing those parts which really need description, and avoid showing those which do nothing to add to the viewer's understanding and also take a long time to draw. It is usually possible to overlap revealed areas in such a way that the one nearest to the viewer obscures all but the *key* parts of the one beneath, and, in this way, saves drawing time.

It is absolutely vital with a cut-away to get the basic perspective correct. With a normal visual you cannot, of course, see anything of the other side of the product, and the furthest unseen (but inferred) corner can be grossly misplaced before the view starts to look slightly odd. With a cut-away, however, if you do not start correctly, the perspective errors become more obvious as you lay in interior detail. The drawing should be built up in the normal way, blocking in the major shapes first, and roughly locating key points on the inside with respect to the outside (most easily done if you are working from a fairly resolved GA). Some designers prefer to begin on the inside and work out to the exterior shell, but this can involve you in a lot of unnecessary work. I prefer to firm up on the outside so that the product looks complete and correct, and then begin to sketch in the interior detail, cutting away and revealing as I go. The tightening up of the line-work is left until I have finally decided on that which is to be cut

Freehand Line Drawing

Freehand drawing has more character and is quicker to do than a drawing done with rulers and guides, which can look very sterile. It is also useful to give a conceptual feel to the design.

Below: Agricultural machine
For General Electric Plastics

Like the beer-making machine, this drawing was done for reproduction in a calendar and shows an idea for an agricultural power-pack. The final drawing was done freehand with technical pens. At the layout stage, however, the drawing was fully developed using straight-edges and guides, and these were only discarded for the final inking. Note the graphic effect of having elements breaking out of their surrounding box, such as the man's foot, and the flexible drive cable.

A clean sheet of tracing paper was laid over the underlay and the image traced through freehand using two sizes of technical pen. A 0.7mm was used around the perimeter of each major part to establish that it was in front of the one behind, and a 0.3mm was used for all the other lines. To add depth to the drawing, an intermediate line thickness was introduced for falling-away edges. Finally, some good quality dye-line prints were run off, and the drawing coloured with crayons (although any medium can be used).

away and revealed, and that which is not.

Once the line-work is complete, the drawing can be finished using any technique. For straight descriptive work, particularly if the drawing is for eventual reproduction, a superb effect can be obtained using commercially available dry-transfer tones. These are available in a wide variety of percentage tints, dot and linear patterns, and graded tones. If it is important to separate graphically and identify one revealed part from another, with no requirement for realism, then completely flat colours (also available in stick-down sheets) can be used either with or without tones. If you have the time, then you can render the complete cut-away machine, as here, as if it were a real cut-away product of the type found in a science museum, an impression strengthened by the bright red cut-line.

Left: Beer-making machine
For General Electric Plastics

I wanted to indicate how the machine might work and so chose to do this cut-away view which shows the filter trays clearly. The main parts of the drawing were done with a series of overlaid brown markers; note how, to get the transparent effect of the smoked polycarbonate, you can see the base and handle in silhouette through the right-hand container. The top surfaces were done with brown pastel, and a white crayon was used to model the other parts. The bright red cut-line was initially put in with a red pencil, and then overlaid with red gouache. The simple flow diagram illustrating the brewing cycle provided a nice background behind the main product and both these drawings were cut out and mounted to the airbrushed background. The beer bottles were done in a much looser and bolder style, with a classic window highlight on the upward-facing surface.

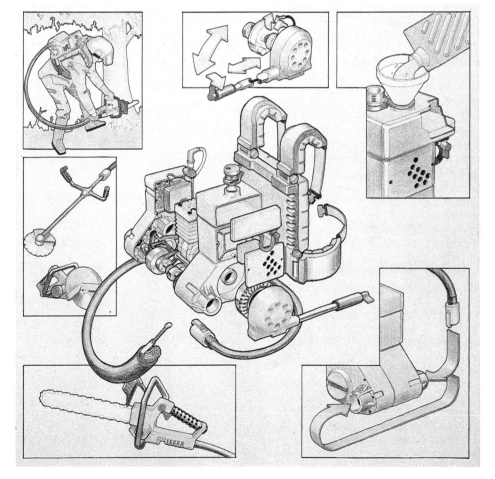

Exploded View

Few designers get involved in really accurate exploded views because they can take a very long time to construct. In our office, however, they form an important part of our initial concept presentation: each concept is invariably presented as a visual, a foam model, *and* an exploded view. This kind of 'schematic' exploded drawing is enormously useful in explaining the disposition of parts, method of assembly and general layout. It is also very helpful in winning the confidence of engineers, as they can see immediately the pros and cons of each concept from a moulding and construction point of view.

Don't be put off by the apparent complexity of the drawing because, even if you are no great draughtsman, producng exploded views can be a quick and easy process. Usually you will have some sort of reference from which to start – either a three-quarter view which you have created for a rendering, a rough model, or even a similar real product which lends itself to modification. If you are using a Polaroid, remember to use thin black tape along the major axis, ellipses, and in some cases the split-lines so that, when enlarged on the photocopier, the basic view survives intact.

Once you have an underlay with the correct view you can begin to construct the exploded drawing: first, lightly draw in the basic shell of the product from which everything else will be stripped; next, extend perspective construction lines in the appropriate directions, and then reposition the original underlay to show the exploded part away from the product, but broadly still in perspective, and trace it off. Obviously, the further you get from the centre the more distortion will creep in, and you will always need to adjust the perspective as you go along. The trick is not to explode each part too far from the next (unless it is important to show some special feature within). This avoids distortion and saves on the amount of internal detail that needs to be drawn. Often, at the concept stage of a product's evolution, much of the internal detail is necessarily rather vague, and in any case you do not wish to commit yourself to something too definitive. Equally, the internal detail might be difficult or time-consuming to draw, or insufficiently resolved, even though you may be completely confident of its eventual resolution. In these cases, be sure to explode parts to lie directy in front of this type of area.

Fryer

In this case, the same underlay from the visual (on pages 84 and 85) was used to create the perspective for the exploded view. The body of the fryer was drawn first and the minor axis of the ellipse projected upwards along with the two sides. The underlay was then repositioned successively to draw the cover, filter housing, etc. The control-panel elements were extended along the line of the perspective towards the front and redrawn; the base was projected downwards and the handle was projected towards the front, using a new perspective from the centre outwards.

1. This shows the underlay practically finished: note that all the construction lines are left in and that the fryer top has only been exploded a little way – sufficient to reveal the container and rim moulding but not so far that the entire interior needs detailing. This is the original underlay, which was subsequently enlarged with a photocopier as the drawing needed to be quite large, but it was more convenient to work at a smaller scale where my largest ellipse guides were still usable.

2. The entire drawing is then traced on to marker paper using a Fineliner. I usually do this freehand without the benefit of straight-edges and guides because it is far quicker (by a factor of 4) and also gives the drawing a loose, less defined quality which is more consistent with concept presentation. Obviously, if the drawing is for reproduction or needs to be definitive, a more rigid drawing might be appropriate. When tracing off it is advisable to start with the foreground parts or you risk drawing in things which are behind and out of sight. On edges where you

1

would expect to find a highlight, particularly facing edges, break the line at the appropriate place to suggest the highlight. Finally, I use a thick Overhead Projection pen around the entire image wrapping everything into one; this works particularly well where the background will show through at a later stage, such as on the bottom of the control panel.

If you have more time, or want a more classy result, you can vary the line thickness more: very fine for near-facing edges, slightly thicker for falling away edges, thicker still for drawing around a complete part (to separate it visually from the one behind) and ultra-thick around the perimeter of the drawing.

3. From here on, the process is much as with any other marker rendering, and you can go into great detail modelling each part and 'floating' it in space with thrown shadows. The risk with doing this is that the whole drawing becomes too illustrative and, again, too definitive for this stage of the design process. I prefer to use the very minimum of modelling to achieve a three-dimensional result: only Pale Blue has been used for the darker areas (twice up in places) and a Cool Grey for the two metal parts. At Seymour/Powell we do not render exploded views in the actual colours and finishes of the product; we prefer to do everything in monotone or with minimal colour differentiation.

Shadows thrown by 'hovering' parts are deliberately minimized to avoid the drawing becoming too blue, and also because they are hard to predict.

4. A whiff of Pale Blue pastel is used to complete the modelling, and white gouache highlights used in the normal way. The completed drawing is trimmed out and Spray Mounted to the graded background. A drop shadow has been drawn in with a Manganese blue to make the drawing 'sit' on the page.

Descriptive 'lead-off' lines complete the image and are very important for the composition and balance of the finished drawing. If you are not very experienced at this kind of thing, it is advisable to take a photocopy and decide where you want them to be so that you do not have to do any overlapping lines.

2

3

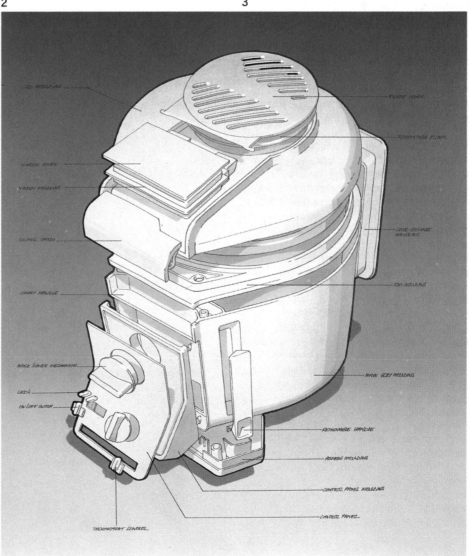

4

Domestic workstation
For General Electric Plastics
by Roland van Gils

The drawing shows the construction and wiring for a domestic workstation with one main view and two detailed views. It has been coloured with a small amount of marker but most of the work has been done with coloured crayons. For the background areas the drawing was placed over a textured panel and then overworked with the crayon — much like a brass-rubbing. Note how the linework of overlapping areas, where one part lies in front of another, is left intact but simply ignored when colouring. This gives a loose constructional feel to the drawing and at the same time clarifies some of the technical details of the concept.

Induction cooker and ultrasonic dishwasher
For General Electric Plastics
by Seymour/Powell

This axonometric view was drawn onto film using technical pens and self-adhesive dot tones and then a 5× 4in black-and-white photograph taken and printed onto resin-coated paper. This was then airbrushed with flat colour with no modelling of the parts (except the control panel detail). Care is needed when using inks on photographic paper because excessive build-up of ink will lift off easily with subsequent overmasking.

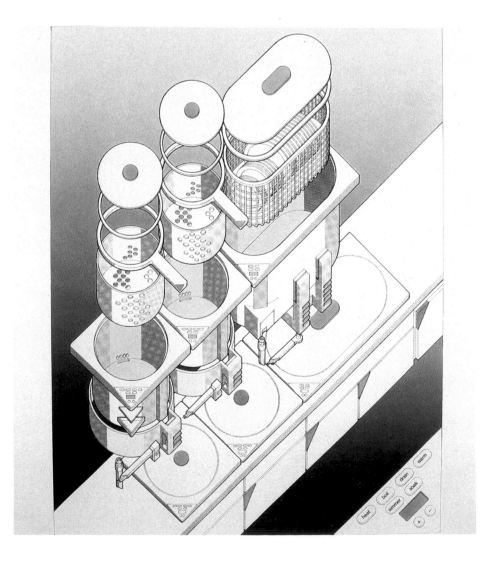

Rendered General Arrangement Drawing

The designer's work is not all concept and ideas – indeed, much of his time is taken up in the resolution of the idea into a realizable product. Inevitably, once the model-making stages are underway the designer depends less and less on his presentation skills because he no longer needs to create the illusion of three dimensions. Often, however, there is a phase after the initial concepts, where the chosen theme is developed through to a General Arrangement drawing. During this phase, the final layout is decided, dimensions are fixed, ergonomics resolved, production methods finalized and so on; this is the real meat of the design process where the designer juggles with all the conflicting factors to perfect the final solution. The decisions made during this phase need to be discussed with the client before a finished model can be commissioned, and often it is sufficient to present only the finished GA drawing. Sometimes, however, as a result of development, the concept has changed slightly and the client may therefore need to see the implications of these changes in a more visual way, particularly if he is unaccustomed to reading technical drawings.

In these situations you could, of course, do a new visual of the design, but the traditional visual does not reflect the detailed nature of the phase that has been completed. The solution is to render up the finished GA drawing (provided there are sufficient complete views) in the chosen colours and complete with graphics. You can use any technique for this if you work on prints taken from the original tracing, alternatively you can work directly on the tracing with the advantage that subsequent prints come out beautifully modelled not in colour, but in monotone.

Designers who are very skilled at this type of presentation use it much more interactively than simply colouring up a finished GA and can therefore combine the design/search phase and final presentation within a single drawing.

Tractor control console

For the Massey-Ferguson Manufacturing Co. by Peter Ralph

The drawing was done by overlaying heavy-grade tracing film over the full-size concept layout for the cab and controls. The theme was evolved progressively in pencil, ink and airbrush, and repeated corrections and adjustments were made with reference to engineering 'hard' points, problems of appearance, ergonomics and manufacturing feasibility. The hard surface of the film allowed for repeated erasing without breaking up the surface which might happen with art board or paper.

The technique is a flexible, continuous process, in which the designer can present ideas to himself, selecting and rejecting, until a rounded, overall concept appears.

Because it conforms to the established engineering design communication process, the drawing can be understood by, and disseminated throughout, the client organization – both to management for corporate assessment, and to engineering for detail development.

client; Massey Ferguson Mfg Co
project; Tractor Control Console

CONCEPT 2

prdu
PeterRalphDesignUnit

Machining centre
For the Newall Engineering Co.
by Peter Ralph

In this example, the proposed design was traced down onto Frisk CS10 Artboard with the aid of a drafting machine and then airbrushed in the normal way with gouache and inks. The process was greatly speeded up, and accuracy maintained, by using the drafting machine when cutting masks. This does, however, produce a high turnover of plastic drafting scales!

Primary chaincase
For Norton Motors Ltd.

One aspect of a design job for Norton Motors was to restyle this primary chaincase so that it looked less like something off a 1960s BSA and more appropriate to the high-technology Wankel engine lurking behind it. The job did not allow us to modify the case's mating surface, as this would have incurred heavy re-tooling costs. To ensure that the proposed design would fit, the engineering drawing for the old chaincase was used as an underlay for the new design ideas. In this way, all the bosses and centre-lines were correctly positioned and we ended up with a full-size view of the proposed design.

The drawing is a working drawing, and one of several alternatives generated. It was drawn out with a fineline black marker first, and then coloured over entirely with a Cool Grey 8 marker; the darker areas were put in with a Black. The Norton roundel was heavily pastelled from top to bottom with white, and then the name cut back in with the grey marker to produce a slight shadow. The edges were then picked out with a black and a white pencil. The red background square was done with a Cadmium Red marker edged with a Venetian Red, which was also used to suggest a shadow beneath the case.

Rendering as Model

As a fast and effective means of getting a concept into three dimensions the card model is hard to beat, particularly if the product has many flat panels. Modern foamcore cards are rigid, light and easy to use, and so allow the designer to build up an informative image of the product very quickly. A sketch model is not, however, a finished model and sometimes, if it looks finished, it can mislead the client into believing that the concept is a great deal more advanced than it really is. On other occasions, for example when producing two or three alternative ideas at an early stage, adding realism to the model can do much to remove the starkness of the

white card which is usually a feature of sketch, or space, models. Indeed, when designing generators for Yamaha, I have used the technique of laminating renderings to the model to establish detail and provide the illusion of slots, fixings, control panels etc. Obviously, this is only possible if you are working on scale drawings such as the GAs on the previous pages.

Truck cab
For Leyland
by Peter Ralph

In this example the model was rendered in the flat onto Frisk CS10 Artboard, and assembled much like a cut-out from the back of a cereal packet. The folded card 'capsule' was then planted onto a wooden chassis raft and wheels. Note how the grilles, wipers, grab handles and even shadows were all rendered to enhance the three-dimensional impression.

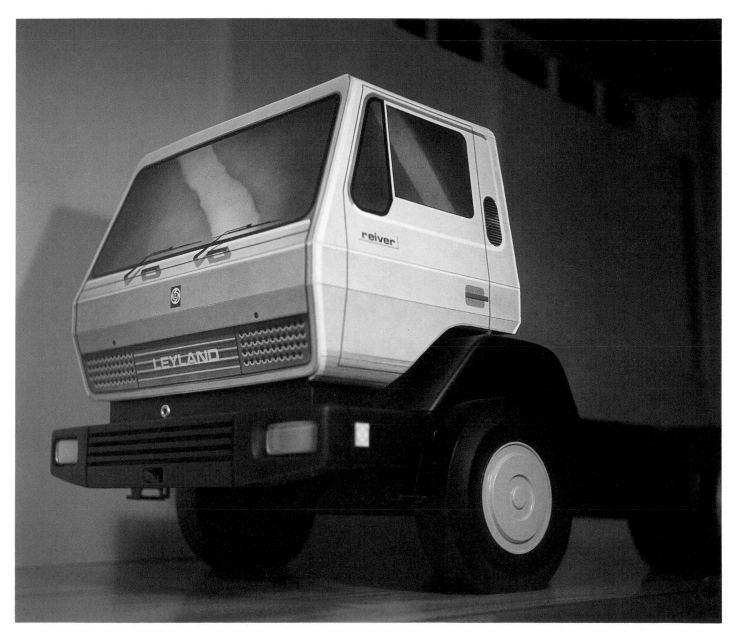

1

2

3

Advertising rough (1)
by Richard Seymour

1. As with the previous example, the drawing is completely laid in with a black Ball Pentel and a black Pantone fineliner around the pack itself.

2. A Pale Blue marker is laid across both sky and mountains, a Light Green for the hills, and a Barely Beige for the rock outcrop and background.

3. The mules have a base colour of Light Suntan with Burnt Sienna overlaid to produce the shadow areas; the two are then blended before they have time to dry completely, using the Light Suntan. An Africano marker is used for the deep shadow areas such as those cast by the head, the traces, and on the underside of the body, etc. Yellow Ochre is used for the traces with Dark Suntan overlaid where they get darker. Warm Greys are used for the wagon and a Nile Green to model the background crudely. The pack itself is put in with Cadmium Red, and the men roughly coloured with the same markers as for the mules; a Pale and a Pthalo Blue are used for the man's shirt.

4. A white crayon is used on the mountains, and generally for highlighting; the side of the pack is shadowed with Venetian Red and Cool Grey 1 markers. Finally a sheet of tracing paper is lightly sprayed with Spray Mount, and tacked down across the whole drawing; the foreground areas (including the lettering) are then cut away so that the colours are at full strength in these areas, and they therefore stand out from the background.

Below right: Advertising rough (2)
by Richard Seymour

This is another example of the technique used in the previous examples but with different lighting. Note, in particular, the use of blended markers and white highlights for the skin tones, and the use of a Pale Blue marker for the shadow areas of the white overalls.

11 Backgrounds and Mounting

If you have put a lot of effort into producing a superb rendering you must ensure that you maintain the standard right through to the final client presentation. Too often designers produce an adequate rendering and then fail to put those finishing touches that can transform the adequate into the exceptional; remember that the quality of your presentation reflects on the quality of the work that precedes it. A shoddily presented drawing can reflect badly on the design work you have done and, equally, a superb presentation can do much to lift what may otherwise be less than perfect work. No matter which, the quality of your overall presentation reflects on you – if you are a professional who is good at your job and have high creative standards then you will settle for nothing less than the best. We have all seen how, when the work of different designers working on the same job is put up for comparison, those concepts which are beautifully presented invariably start with an edge when the decisions are made. Rival designers construe this as an unfair advantage and it may well be that their ideas are better but, if they do not ensure that their work is put forward in the best light, then they have only themselves to blame.

Format and Consistency

If you have several concepts based around a single theme, or several alternatives for a single product, it is a good idea to present them consistently. Where possible, choose one board size (probably one of the A sizes) and stay with it even though this may mean cutting large drawings down and doubling up with the smaller drawings. Also, if possible, choose either landscape or portrait and stick to it. If you are using some sort of background, then ensure that it is the same throughout, or use a simple coloured line or detail to provide a visually linking feature that ties the drawings together. Many designers and design groups evolve their own trademarks which become a 'signature' used in all presentations; this is not necessarily the company logo but can be as simple as a graphic flourish on the end of a line, or a particular type of background. If the drawings are referenced in a report, then they should be numbered for identification; this is a good idea anyway, because it helps during discussions when people refer to this or that concept. Always make sure that your name or the company name appears somewhere on each board – you never know who might see the drawings eventually, perhaps long after the person who commissioned them has left the company, and they might want to know the name of the talented designer who did the work and how to get hold of him. The best way of doing this is to either have a rubber stamp made up, or print a sticker which can be used on the back of each board.

Composition and Backgrounds

Once you have decided on the format, and assuming that you have not done so already, you will need to consider whether to remount the drawing to some sort of background. It is certainly adequate, and sometimes even desirable, to present the drawing simply on a blank sheet of white paper. On the other hand, you can usually do a great deal more to improve the overall image, if only to 'settle' the drawing on the paper.

Organizing the image(s) on the surface to produce a harmonious and graphically balanced board is the most important aspect of the final presentation, after the drawing itself that is. Even if you are simply repositioning the drawing on a fresh sheet of white paper, you should consider carefully just *where* on the paper it should go. It is as an aid to this composition that backgrounds really come into their own. Everyone knows how a mediocre painting can be transformed by a decent mount and frame, so consider first why this happens. Careful study of the microscopic movements which the eye makes when studying a picture (or even a document such as this page) has shown that the human eye scans the perimeter of the image first, before moving onto the detail. This is why the general layout of a letter is so important and can make such an immediate impression on the reader. By tidying up the perimeter line and retaining the eye within it, the picture frame works in the same way. Similarly with your rendering, if you simply plonk it onto a sheet of white paper, you leave the eye with the meandering perimeter line of the image and nothing to stop it wandering off. Equally, the meandering silhouette does little to relate to the sharply defined rectilinear edge of the paper or board, and so sits uneasily on the paper.

An appropriate background can do much

to make the product look more dynamic and exciting, or perhaps simply emphasize a particular line or direction (as with the motorbike on pages 81–83). It can assist the viewer's understanding of the product by placing it in some appropriate context that illustrates where, or how, it is used. A background can also do much to make the image look more three-dimensional, either by throwing it forward, or making it appear to sit on a surface. Equally it can be used to link a series of dissimilar images on a board.

The possibilities can be broken down into two main types: composition and technique, although, of course, they can both be used together.

Compositional elements

The picture frame. This is a simple line drawn inside the paper edge which, working just like a mount or frame, retains the eye and settles the drawing.

A shape. A rectilinear shape, either simple line or block colour, behind the image not only throws it forward, but can also visually tie the irregular shape of the drawing to the edge of the paper or board.

'Seating' the image. Often it is better to have the product apparently sitting on a surface rather than floating around in space. This can be achieved by actually drawing the surface or by simply laying in a shadow beneath it. With the former, tiles (sometimes reflective) are very popular as they are easy to draw, and car designers in particular like to show their vehicles sitting on reflective surfaces so that a mirror image is seen in the ground. If the viewpoint is very low so that the horizon is on the surface itself, the underlay can be simply flicked over to produce the required image, otherwise some more accurate construction is called for.

3 - W H E E L R E C R E A T I O N A L V E H I C L E

Concept drawing for a sports three-wheeler
For General Electric
by Richard Seymour

This is an example both of a realist background (here applied to a quick concept drawing) and of an image seated on a surface. The view was intended to be a pastiche of a well-known rendering by Syd Mead, but since the concept was rejected, the sketch was never progressed through to a finished visual. Note how the tiles are reflected in the wheels to make them look

chrome, and also how pale blue crayon has been used to create the white bodywork.

Realism. You can, of course, set the product in a complete environment, drawing everything and anything around it. This is effective, but time consuming; often it is sufficient to suggest elements of the environment that are more economical to produce.

Lifestyle. Particularly when doing concept boards for research, there is a need to show the product in use, or simply to suggest the kind of people and activities associated with it. This kind of lifestyle background requires considerable drawing skill and if you are not very confident it may be better to opt for something simple. The obvious shortcut is to find some photographic reference which can be enlarged and traced off or, better still, take your own photograph. By doing this you obviously have a lot more control over what is being shown in the background than by simply selecting the images from magazines or other pictorial sources.

Background techniques
There are many examples of different backgrounds throughout the book which you can refer to; the following is a summary of techniques, and includes some that are not illustrated.

Graded. Graded papers are available commercially, if somewhat expensively, and add an effective professional finish to drawings. If your budget won't stretch, or, more likely, the colour required is not available, then they are easily airbrushed; using an airbrush also allows you to be more adventurous and produce graded tints which change in colour. With simple masking you can add to the effect – for example, use dry-transfer lettering (perhaps the product name or model number) in the background before you apply the graded tone. After airbrushing, remove the lettering, which has been acting as a mask, to reveal the underlying colour in the shape of the letters.

Streaked. Much loved by auto designers but declining in popularity, this effect can be achieved in several ways: by using the pastel and solvent method (as for wood in the preceding chapter), by using giant markers and solvent-based ink, or by simply using the felt from inside the marker. With all of these methods, you will need to either mask or work on a separate sheet of paper and then trim out. Curiously they always look a little messy (as opposed to dynamic) if they are not worked to a crisp edge, if, in other words, the turn-around area at the end of each pass is left in the drawing.

Right: Rubbing down a magazine or newspaper picture

1. Choose your picture and soak liberally with a solvent like Flo-master. If the paper is relatively impervious, do this on the facing surface of the picture. Lay the picture face down on the paper.

2. Rub the back of the picture hard with the back of a spoon – lift a corner now and again to check that the image is transferring. Peel off the original and allow to dry.

Below right: Lawnmower
For General Electric Plastics
by Seymour/Powell

The main view was rendered with Magic Markers and coloured crayons and the exploded view drawn with technical pens onto CS10 paper. The photograph was covered with two layers of polyester drafting film so that the overlaid mower stood out. Before final sticking down, a 'drop-shadow' was airbrushed on the back of the film to make the main view 'sit'.

Rubbed-down picture. If you can find a suitable background picture in a magazine or newspaper, a ghosted impression of the original can usually be transferred easily so that the viewer has a hazy impression of the subject. This can be done by dissolving the printing ink with a suitable solvent as shown in the illustrations above. Before you do this, however, take another example from the same magazine or newspaper and run tests to find the solvent which best dissolves the printing ink – paraffin works well for most newspapers, but can leave an oily finish.

Tracing paper overlay. As with the example illustrated right, a photograph can be easily 'knocked back' by overlaying it with tracing paper or film. Sometimes a rendering can be lost against a strong background. By spraying a light coat of glue on to a sheet of tracing paper, laying it across the whole board and then trimming around the product image to remove the paper locally, the main drawing can be re-emphasized.

Spatter finish. This is achieved by loading some ink into an old toothbrush and wiping a knife across the bristles so that spots of ink are thrown onto the paper. Mask well!

Batik. Some interesting batik-like effects can be obtained by using wax to resist the application of coloured inks. Try wiping a plain white candle in broad strokes across the surface before using a giant marker.

1 2

Producing a 'filmed' colour finish
1. Submerge the paper in a shallow tray of water and quickly squirt your chosen colour onto the surface of the water.

2. Reach through the water and draw the paper up through the film so that the colour is transferred onto the surface of the paper.

3. Immediately lay the paper onto a wooden or laminated drawing board and stick all four edges with gum-strip (not masking tape), so that, as it dries, it will stretch and therefore remove unwanted cockles.

'Filmed' colour. This is the finish often seen on the inside covers of old books – a sort of marbled finish. It can be achieved by floating the inks on the surface of a bowl of water and pulling a piece of paper through them to pick up the colours (see illustrations above).

Mounting

Mounting a finished rendering to a sheet of card has a subtle effect on our perception of it – somehow it assumes more authority than its unmounted rivals. Be careful, because this means that a client can view mounted sketches as 'more final' than unmounted ones. Generally speaking, however, mounting a rendering produces only positive benefits. Firstly, because the added whiteness behind the colours can be seen through semi-transparent layout papers, it makes the colours more punchy. Secondly, it smoothes out all the wrinkles, creases, and general unevenness that the paper has suffered through constant handling. And thirdly, the final board is easy to handle and prop up at the client presentation.

On the surface it seems the simplest thing in the world to stick a sheet of paper to a board, but the process is full of potential disasters for the inexperienced. It's a hard way to learn, but once you have ruined a complicated drawing (or worse – one of your boss's drawings!) then you will not make the same mistake again. These though are a few tips to help you avoid some of the pitfalls.

Boards

You must remember that, as boards will inevitably bend during handling, the paper stuck to them (if it is on the outside of the curve) must stretch, because the outside of the curve is longer than the inside. The glue must also be able to accommodate this movement if, when the board is relaxed, you are to avoid the drawing bubbling off. The only way to achieve this is to dry-mount the drawing so that there is an unbreakable, consistent and yet moveable bond between the two. The alternative, of course, is to choose a very rigid board that will not bend and, in terms of traditional artboards, this means using an eight- or ten-sheet construction which is both heavy and expensive.

Recently on the market, however, are the foamcore boards, which are just very expensive. These are exceptionally light and immensely rigid and, better yet, can be cut with a single pass of the scalpel. They are available in a variety of thicknesses up to about 10mm; in some parts of Europe these extra-thick boards can be found in builder's merchants where they are sold as wall insulation and are, consequently, much cheaper than in graphics stores where they tend to be premium-priced. Foamcore is also very useful to the designer as a modelling material for mocking up sketch models.

When cutting board, use a sharp scalpel or knife, and a steel-edged rule, and, if you are not absolutely confident, always put the rule on the side of the work and the scalpel on the side of the waste, so that if you slip you won't ruin the drawing. If you are cutting through thick artboard, get the cut established first with a couple of gentle passes of the knife, before applying any pressure. Finally, always mount the paper down first, before trimming the board, so that you have no problems aligning the two and can trim both board and paper together.

Glues

Most popular by far are the spray-glues which are aerosol-based. They are popular because they are so easy and quick to use; this is particularly important if you are mounting a cut-out drawing which has an irregular perimeter – one quick spray and the whole lot is evenly coated with no risk of the glue getting on the wrong side. (Before the advent of these glues most designers used rubber-based cements which were applied with a spatula; as you worked your way around the back of the paper, there was considerable risk of your inadvertently sliding the front of the paper with the drawing over some glue which, because of the need to have glue right to the very edge, had been overwiped onto the baseboard). It is a tribute to their effectiveness that so many designers continue to use spray glues despite the considerable risk to their health. The tiny atomized particles of glue hang in the air and can be easily inhaled into the lungs where, of course, they stick. If you continually spray

against the same backdrop you will notice how the overspray builds up on it quite quickly and, to a far lesser extent, this is what could be happening to your lungs. Eventually, someone will perfect an electrostatic glue applicator that ensures that all the atomized particles are attracted to the nearest earth (the paper) and therefore not left hanging in the air, but until they do, be sure to take sensible precautions. Try and set up some sort of spray area or cabinet which is well ventilated (preferably with an extractor) and always use a mask.

There are two popular types of spray glues, one fairly light-tack that allows repetitive repositioning (Spray Mount), and one heavy-tack (Photo Mount) which gives a firmer bond but little scope for repositioning. I always use the former for mounting small cut-out drawings, and the latter for mounting the completed sheet to the mounting board.

There are, of course, alternatives to spray glues, such as the rubber cements (Cow Gum) and dry-mounting. Neither are as quick and both have their problems. Some rubber cements, because they are solvent-based, can actually dissolve any marker inks there may be on the reverse side of the paper and start spreading the colours around! With dry-mounting, you should test all the materials which you use to check that they are undisturbed by the high heat needed to melt the glue. Under these conditions, marker colours can lose their sharp definition and look slightly fuzzy.

Both rubber cements and spray glues can be loosened with lighter-fluid, but check first that this does not adversely affect any of the other materials. (This, incidentally, is one of the disadvantages of using foamcore board because the lighter-fluid is absorbed by the porous foam and stains the surface before it can evaporate). Finally, watch out for sharp changes in environmental temperature and humidity – excessive damp or very hot conditions can make the paper expand and bubble off. Indeed, in very hot conditions (in a studio with a glass roof and inadequate ventilation), I used to keep A3 renderings awaiting presentation in the fridge!

Protecting the Drawing

Having mounted the rendering to a piece of board you should consider how best to protect the surface in a way that enhances the overall quality of the presentation. At its most basic, a simple fly sheet of coloured paper taped or glued to the back of the board and folded across the front will perform adequately. If the sheet is like a thin card (such as the high-gloss Astrolux or

Chromolux) then always score the fold lightly so that the cover does not bow. Clients do have an annoying habit of jabbing their fingers into the finished drawing to make some point or other and leaving a terrible mark or, worse, smudging the pastel. Of course, it doesn't really matter by then, but it is a little irksome when you have just poured your all into the creation of a beautifully finished drawing. The solution is to overlay a sheet of protective film which protects the drawing from such attack, and allows offending marks to be removed.

If you have the time, the most professional way to do this is to have the drawings laminated. In this process, the drawing is sealed between two sheets of clear flexible plastic, with all the air squeezed out under pressure. If you decide on this approach, then do *not* mount the drawings to card as there is a limit to the thickness which the machine can accommodate; simply remount them to another sheet of white paper to bolster the colours. It is sometimes possible to have the backing sheet of black, rather than clear, plastic which can look cleaner, but should only be used if there is no risk of dulling the colours. You can laminate in a variety of thicknesses of plastic with the thinnest being a lot cheaper than the thickest; the process gives the drawing considerable rigidity, so that it will prop up against a wall, and looks extremely slick. Laminating does not seem to affect the drawing in any way, although it is always a good idea to run a test first to make sure. It is also absolutely irretrievable once done, so be sure that you photograph the drawing first and that it really is finished. Because it gives a completely sealed surface, you can write notes and comments on the surface and wipe them away – this can be quite a useful technique if you wish to point out key features of the design but do not wish to permanently disfigure the drawing. One great advantage of laminating is that it seems to offer good resistance to fading brought about by exposure to ultra-violet light. Nearly all types of colouring media fade eventually although some colours are more fugitive than others. Markers, in particular, are not really intended to last for centuries and fade quickly, so if you want to keep drawings always cover them and store in a drawer away from light. Laminated drawings, on the other hand, seem to last much better; indeed some examples which have been framed, and hung in a light room for three years, show no discernible deterioration of the colour (as yet).

An alternative to laminating is to use a sheet of acetate lightly glued to the surface of the drawing (see adjoining illustrations for

how to do this). The main advantage of this method is its accessibility; there is no need to visit the local laminators, or pre-book their time, with the attendant risk that their machines may be out of action. There is also the (remote) risk that they will contrive to mangle your precious artwork in the rollers and, of course, they may not be available at 2 o'clock on the morning of the presentation when you need the work done! The acetate protects the drawing, and offers some UV protection; it is also removable if you need to photograph the drawing or make some alterations.

A third way of sealing the surface of the drawing with a film of plastic is heat-sealing. This is usually done in a dry-mounting press with both pressure and heat and is therefore only suitable for drawings which are undisturbed by the heat – be sure to test first. With marker drawings the process can blur the edges of the colour quite badly so that the drawing begins to look a little fuzzy; also, if you have used white paint or crayon on top of black marker then the process might make these areas mauve rather than white!

One final alternative is the traditional fixative which can be sprayed onto the surface of the drawing; these are now quite sophisticated products which can be built up layer by layer like varnish to give a good finish and adequate protection. They are easy to use, but somewhat unpredictable: as with heat-sealing, they can turn white paint on black marker to a nice mauve colour. On the other hand, they can often give a sharp lift to the colours, so, as with the other methods, test first. Some companies are now offering UV-retardant fixatives (e.g. Marabu) which have a significant effect on the life of the colours.

Presentation

The professional is not only concerned with *what* he is presenting, but how he presents it. Every designer knows the importance of this but there are those who do it with style and panache, and those who fumble nervously through it and do nothing to give the client confidence in the work being presented. If you are presenting good quality work that you are proud of, then the task will be easier than if you are trying to paper over the cracks of a less than perfect job. It is a shame, however, if the work is good but you simply spread it out on the table for the client to leaf through haphazardly. It is difficult to offer any constructive advice to those who find it hard to stand up in front of others and talk through their work because it is mainly an issue of self-confidence and confidence in the work

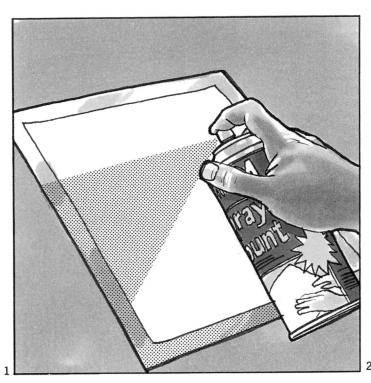

1

2

Using acetate sheet to protect a visual
1. Choose a fairly heavyweight acetate, preferably from a pad rather than a roll so that it lies flat and does not curl. Cut a sheet of layout paper about 10mm smaller than the acetate all round and lay it in the middle so that only a 10mm edge of acetate is visible. Spray this lightly with Spray Mount.

2. Remove the paper mask and carefully lay the acetate over the rendering. Use a soft brush to apply pressure all round and ensure a good bond. Unlike laminating, the protective sheet can easily be removed at a later date if necessary.

you have done. It may be useful, though, to look at the two main methods of presenting work, the gradually unfolding story and the overview, so that the inexperienced have at least some starting point on which to build.

The unfolding story
With this method the designer controls what the clients see, and the order in which they see it. The designer can therefore apply an order, chronological or otherwise, that shows the work in the best light, and, just as important, the clients have nothing to distract them – they must listen to what you say rather than allow their thoughts to dart ahead to the next drawing. This method allows you to take the clients through your thinking and illustrate *why* you made the decisions you did; they can see how the idea developed, how you modified it, what you were striving for, what you rejected and so on, and are thus better able to understand the final concept and are probably a great deal more appreciative of the time it took to do the work (and therefore less likely to flinch at the size of your bill!). I usually assemble the best of the preceding work into a sketchbook with a spring binder, and mount only the final concepts to board so that they can be pinned, or propped, for comparative purposes.

Some designers photograph all the work and present it as a slide-show rather than as drawings – this can have much impact but also makes it difficult for the clients to check back to something they saw earlier. For this reason, a slide show should always be backed up by the real work so that discussion is possible afterwards.

The overview
This method really demands that you have access in advance to the room where the final presentation will take place. You can therefore pin all the work up in the most advantageous way so that when the clients enter they see everything at once. This offers the maximum impact 'up-front' and the clients can see immediately how much work you have done and its overall quality. However, even though you may take them through the work, the element of surprise is lost and they may become restless because they are eager to progress to some later stage they saw when they first entered the room. It is also more difficult to present preliminary sketch work because the sketches tend to assume the same weight as the rest of the presentation when given the importance of a place on the wall, and, anyway, there is usually insufficient room for all the back-up work.

Both methods have their advantages and the final method is usually decided by the type of work you have produced, and the place where it is to be presented. Whichever you choose, it is a good idea, if you have the facilities, to reduce all the drawings down to A4 and add them to your final report in a neat bound booklet, ensuring that you have enough copies for everyone who will be at the meeting. This allows every person at the presentation to carry away a complete record of the work you have done, which they can use during project discussions in situations where the finished boards might prove clumsy and unwieldy. Be sure that you only give this out *after* your presentation (to prevent them jumping ahead).

12 Conclusion

Most of the techniques described in this book are those which I personally have used and developed since I completed my further education. Nearly everything was initially learnt from someone else and then developed into something which I could begin to call my own. I had always been interested in drawing but became more so while working alongside car designers at the Royal College of Art. Their techniques were eminently suitable for the cars and trucks which they were designing but less so for the consumer products that I needed to draw.

Immediately upon leaving college I was thrown in at the deep end and required to render a huge variety of things from woodgrained electric fires to brass reproduction lighting – it was a baptism of fire that forced me to take the bare bones of what I had learned at the RCA and make it work. Each new job became a challenge as I struggled to draw clear mouldings, pressed brass, mahogany veneer, or whatever the project demanded. Gradually a style emerged that I could call my own, but this was not just a formula applied like a colour-by-numbers picture. If there is a style that other people recognize as mine, then it is evolving constantly because every drawing represents a new problem: it may just be rattled off, but more likely, as I learn from colleagues, and as new materials become available, I will experiment before taking refuge in a tried and trusted technique.

If you are already a designer but have no particular aptitude for, or interest in, rendering and therefore have difficulty surmounting those occasional presentation problems, this book will still be a useful source of reference. If you are a beginner, don't be afraid to copy from others. In some colleges, this is (surprisingly) rather frowned upon — it won't help you to design, or draw a good perspective, but it will help you understand the materials you are using and how to get the best from them. Look through the magazines that regularly carry examples of renderings (such as the excellent *Car Styling*) and try to reproduce a drawing. As you try to figure out how the designer achieved this or that effect and then emulate it yourself, your mind will be darting ahead, working out how to do it next time, and most important, how to do it better.

One of the factors which will encourage you to change and develop your techniques is the development of new graphic materials — just as the marker has almost completely replaced gouache and other brush-based media, so new materials constantly offer new opportunities for the designer. It is important, therefore, to keep in touch with the latest developments.

If you enjoy drawing, then be sure to build on and advance beyond what is here. Rendering is not a religion, there is no dogmatic way of doing this or that drawing; take what you can from these pages and then, through experimentation and learning from others, move on to develop your own techniques.

Index

This book is for Fiona and Alexander

SON OF TWO WORLDS

A retelling of the timeless Celtic Saga of Pryderi

HAYDN MIDDLETON
ANTHEA TOORCHEN

RIDER

LONDON · MELBOURNE · AUCKLAND · JOHANNESBURG

Copyright © Haydn Middleton 1987
Copyright © Anthea Toorchen 1987

All rights reserved

A Rider Book first published in 1987 by
Century Hutchinson Ltd, Brookmount
House, 62-65 Chandos Place, Covent
Garden, London WC2N 4NW

Century Hutchinson Australia (Pty) Ltd
PO Box 496, 16-22 Church Street,
Hawthorn, Melbourne, Victoria 3122

Century Hutchinson New Zealand Ltd
32-34 View Road, PO Box 40-086,
Glenfield, Auckland 10

Century Hutchinson South Africa (Pty)
Ltd PO Box 337, Bergvlei 2012, South
Africa

Designed by Philip Mann/ACE Limited

Set in Garamond by SX Composing Ltd,
Rayleigh, Essex

Printed and bound in Italy by
New Interlitho Spa

British Library Cataloguing in
Publication Data (copy to follow)

ISBN 0 7126 1779 5

Middleton, Haydn
 Son of two worlds : a retelling of the
timeless Celtic saga of Pryderi
 1. Celts—Folklore 2. Legends—
Europe
 I. Title
 398.2'2'094 GR137

ISBN 0-7126-1779-5

B E F O R E

Here, at the seam between the seasons, the twilight merges with the dark.

Here, on May Eve, the new year is shedding the old.

Fresh fires blaze on the hilltops, here, close to where the land meets the sea. A new time is coming – a new man is waiting.

One man, set apart from the rest, nameless, his eyes dull, his hands hanging free at his sides. He has been chosen. He has helped to choose himself. A strong man, cast up by the winter, the first man of his kind.

Behind him the huddled crowds are murmuring. He came from them. Soon he will be leaving them. There is a kind of fear among them, a drawing back. No one has told them to do this. They are responding, collectively, to the insistence of their land.

A lean horse rears up outside the enclosure. An old white mare, screaming into the darkness, coaxed then calmed by the horsewoman. She leads the mare in through the ramparts. The man turns. A man, a mare and a woman.

The mare voids herself. The crouch-backed crowds draw closer.

Hands reach for the mare, a haggard beast, birth-worn, but chosen too, mortally emblematic of this territory. They force her to the ground, easily, and hold her there. No one speaks. The man makes himself ready. The mare's neck is free but she will not turn to look at him. She is listless. She knows. He needs to share her knowing. He must take possession of that part of her.

He approaches her, surrounded by the fires, small against the darkness. He moves through the smell of her, the foetid stench of the land that will be his. Still she will not see him. She snorts, resigned. His penis brushes her haunch. She steadies herself.

And then he mounts her. He thrusts himself inside the heaving horseflesh. Except for him, there is silence. No one can say a word. He is alone with her. Already he is distancing himself from the rest. He rends the silence with his calling. The mare struggles to move with him. She succeeds.

His eyes are closed but the darkness is gone. There can be no end to this circuit. He is beating the bounds of his territory inside this old animal. Through her he is taking his temporary possession. And it awes him. The land and the mare are so much more than he is. So much more.

7

At last he spends himself and he rises, unaided — the principle of leadership incarnate. No one has told him to do this. He is the first. He knew what he had to do, and now he knows more. The mare beneath him thrashes. As the long night thickens, he marks out the course that must be followed.

The watchers peel apart, there is movement on all sides. A cauldron is dragged into the enclosure, suspended, men and women come running with water, a fire is kindled beneath it. The man stands apart, silent in the concourse, empowered. He indicates the mare, still held fast to the ground. His eyes meet hers, only briefly, but that is enough.

At once the creature, stunned, is hacked into great squared lumps and tossed bleeding into the cauldron. The man watches the horseflesh seethe. His eyes are sharp now but he is seeing from within. When he knows that the time has come he walks to the cauldron. His face is streaked with tears.

The crowds draw back. He climbs into the cauldron. Cautiously at first, then in a kind of triumph, he sluices himself with the broth. He reaches for a joint of the mare, his mate, and rubs it over his face and shoulders. Then he bows his head and laps from the broth at the level of his chest. Still he is learning, still he is discovering how to see. The tears come faster now.

And the crouch-backed assembly circles closer, eyes down, arms reaching, clawing. The man beckons to them. His people. He is the first and they are the last. He moves, splashing broth on to the earth. Some scuttle forward and press their lips to the sodden ground. He makes them rise, and one by one they put their mouths to the rim of his cauldron.

He watches them, partaking. He watches them withdrawing afterwards, every one of them, crying out, lamenting, wailing. They are so distant from him. He feels the necessary disgust. They have shared in his rebirth.

He draws himself to his full height, primed, unclean, smothered with broth and gore. His people eye him warily. Laughing, he steps from the cauldron. He is the first. He will be their head. He will hold their land in trust. They will look to him for knowing.

Under a sky veined with dawn he stands at the entrance to the enclosure. The fires burn low on the hilltops. The fresh season has been born from the old. No one moves, no one sleeps, the vigil continues. But only the head man hears.

Only he can make out the shape of the voice, the voice of someone old in the throat of someone new. He who is head, *says the voice,* Let him be a bridge for his people.

The head man closes his eyes and he can see the speaker. A golden-haired clean boy, a beautiful youth with the eyes of a colt, smiling shyly.

He who is head, *says the voice again*, Let him be a bridge for his people.

The head man looks deeper inside himself. The youth is a part of him, a better part, the fruit of his assumption of sovereignty. He is inching towards an understanding. In the exercise of his authority he will see, when he has to, with this boy's eyes.

He turns to face his expectant people, inert, unseeing. He raises his eyes above them, and there, stark against this first dawn, he sees the mound.

It rises above him but it holds no menace. The voice speaks again: This night was only a beginning. Take your place on the seat of power. One of two things can happen. You will receive blows and wounds or you will see a wonder. . . .

The head man hesitates. The mound is not steep but only he can climb it. Any man would have hesitated. The land beneath his feet is shifting. He gazes at his people and he wonders whether, after all, they are irredeemable. Every one of them looks like an aberration – but from what, from what? Then he hears the voice again,

He who is head, Let him be a bridge for his people.

He who is head.

He. . . .

9

THE
FIRST
BRANCH
BIRTH

Rhiannon, the beautiful Celtic horse-goddess, comes to prehistoric Dyfed. She tells its ambitious chieftain *Pendaran* how he might have her. Pendaran duly enters Rhiannon's homeland of Annwvyn (the magnificent Otherworld). He wins her and takes her back to Dyfed as his consort. Twice she conceives and twice she is discovered in her childbed with a foal. After conceiving a third time, she bears a man child. Rhiannon insists on calling him *Pryderi*, a word which means Trouble. A foal, which is Pryderi's alter ego, also appears at the birth.

1

*P*endaran led his people well because he couldn't afford to lead them badly. Combative they were, bloody-minded herding people. Their land was called Dyfed, the tongue on the face of the island of Prydein. Dyfed, a coarse, bumpy tongue, lapping at the western sea.

Pendaran had been chosen, primarily, for his strength. He was a man born to meet challenges. Even now he considered himself equal to the physical expectations of his people. That, however, was not enough for him.

There had to be more. He led his people as a man alone, increasingly dismayed by their sheer ineptitude for living. It was as if a blight lay on them, a wilful kind of blindness. Pendaran himself was neither cultured nor wise. (How could he have been?) He knew little of the land to the east and nothing of the sea to the west. All he knew was Dyfed. And Dyfed was not enough.

Yet his waking life was bolstered by his dreams. He talked of these dreams to no one. They reached far beyond his capacity for words. He dreamed, repeatedly, that he was a stag, brought down by a pack of white dogs with red-tipped ears. He dreamed that as a stag he died, then as a man he arose, to visit an unblemished land where he was hailed as the Head of Annwvyn.

This was the land in which he and his people belonged, he knew that. A cauldron simmered at its centre. He fought a duel there for a prize which he himself could never possess. And in this land he slept with the whitest girl, a girl of acumen and finesse.

While Pendaran made the circuit of his wintry sea-beleaguered Dyfed, he sifted these dreams for meaning. And as he did so, one sentiment, dressed in words quite unlike his own, insinuated itself inside his mind: *He who is head, let him be a bridge for his people.* . . .

Pendaran longed to lead his own people into the unblemished land with the white girl. The longing brought him stranger dreams, dreams with texture rather than sequence or coherence. It's right that I should be disturbed in this way, he told himself. That's why I am who I am. That's why I was chosen. (Sometimes he wondered whether any of his people suffered similar disturbances. But he could never quite bring himself to ask them.)

He was at Arberth, on the Eve of May, when the boy spoke.

He approached Pendaran towards dusk. He came from the direction of the squat mound which loomed above the compound. There was an embarrassment about him. He seemed to be confounded by the combination of his own boldness and beauty. In answer to Pendaran's question, he gave his name as *Gwri*, Gwri Golden hair. This wasn't a name known to Pendaran. He liked it. It conjured in his mind images of questing, of constructiveness.

Gwri pointed to the mound. At that distance, in the failing light, Pendaran couldn't tell whether it was natural or man-made. There are stories about that mound, Gwri told him.

Pendaran nodded. He had guessed that there were stories. (The thought presented itself again, with new urgency: *He who is head, let him be a bridge for his people. . . .*)

It used to be said, Gwri continued, That whenever a true leader sat on that mound, one of two things would happen. He would receive blows and wounds, or else he would see a wonder.

Gwri looked into Pendaran's eyes, and laughed, and blushed. Stories, he repeated, shrugging, then he withdrew.

Pendaran watched Gwri disappear into the assembled crowd. He dared not call him back. He felt an uneasy yearning for him, for his shyness, and for his peculiar choice of words. (Variations on those words, Pendaran sensed, had been spoken before, deep inside him, or deep inside someone like him.) He wanted to know more. So he walked with his attendants to the foot of the mound. Then, unaccompanied, he walked the short distance to its summit.

He sat on the damp grass and he didn't expect to be struck down.

He saw fires on the distant hilltops, small against the darkness. Men have sat like this before, he thought. The first man and the man after him. I'm at the end of a line which will presently continue. These ideas pleased him. He listened to the low talk of his men down below.

Slowly the quality of their sound began to change. Pendaran realized that he wasn't listening to them at all. He was hearing birdsong, loud, sleep-inducing birdsong which seemed to drain the air around him. He fought against the music and he kept himself awake, but he knew that those below him were already lost.

He stood and the birdsong drew pictures in his head. For the first time he saw speed. Vivid, fibrous images of movement, shadows preceding the footfall, shod hooves trampling the bracken beside an endless highway. The thunder of that movement shimmered through him. Fast, fast, uncatchably fast! And he opened his eyes wider.

On the road beneath him she was passing at a stately pace.

Still the thunder of her shook Pendaran, yet she was barely trotting, a delicate step, an all-consuming confidence. A blaze-white phantasm steadily moving out of his vision. But what exactly *was* she?

Pendaran scrambled down the mound, still transfixed by what he saw. But what *was* he seeing?

If it had been the place for words, the word would have been *Horsewoman*.

First he saw the mare and second he saw the woman who was astride the mare. But there was no distinction between them. Pendaran stopped to look harder – there was now no woman. He looked harder still – now he could make out every detail, even to the bow of the woman's upper lip. She was smiling. The horse and the woman were two parts of the same whole.

Pendaran swallowed. Distant as she was, he sensed that she was receiving him already, taking him to her. Hurriedly he shook a sleeping attendant awake and he pointed along the road which she was travelling.

Follow! he cried. Ask! Find out what it is that I have seen.

The attendant, slow-eyed, set off along the road and Pendaran clambered further up the mound. Still he could see her. She was moving so slowly. Her pure whiteness stabbed at the darkness all around. She would be passing beneath him like this for as long as he lived.

The attendant returned, breathless.

Lord, he called up, I can't do it. I can't do it on foot.

Pendaran heard, but still he was watching her. *She was moving so slowly*. He nodded

his head, acknowledging his attendant. (*Why had he not caught up with her? Why?*) And when Pendaran looked again, she was gone.

During the next day Pendaran found the word yet he was reluctant to acknowledge it: Horsewoman.

Horsewoman. All he could feel was his need. She had taken a part of him into herself. He wanted to give her the rest, all of him, unconditionally.

So on that second evening, he made his attendants bring horses to the foot of the mound. As soon as he heard the song, saw the sight, he cried down,

There! Now! Go!

One attendant roused himself, a different man from the night before. He mounted his horse and drummed away up the road. Pendaran never took his eyes from the Horsewoman. All he was seeing was the horse, a beautifully toned young mare, and all he could feel was his need. Slowly, so slowly.

The rider came back drooping. Lord, he called up solemn-faced, I can't do it. It's not in my horse to get close.

Pendaran did not look down. But did you *see*? he asked.

No, the rider replied in a quiet voice. No.

And again she was gone.

Pendaran spent the next day in thought. Only he could see her. Only he could stop her. But he sensed a complication. He sensed that his people had *wanted* to sleep, had *wanted* not to see. No one had told him, and he knew that he was right.

So on the third night he went to the mound with no company but a horse of his own. He sat on the summit and waited. This time the song was sweeter, the thunder softer. Pendaran remembered things he could never have seen: a crowded enclosure, a man set apart, a man and a mare and a simmering cauldron.

She was there.

Pendaran descended, and followed at speed on his horse. She was there, high-stepping, leisurely, but still he couldn't catch her. The finest, whitest, firmest sight but he couldn't reach, he couldn't reach. Even though he caught her scent he couldn't catch up. (A strong scent, a stench, a primitive smell that went with the land.) On and on he thrust but serenely she stayed ahead of him until at last he cried,

You! Stop! For me! Stop for me!

And immediately there was stillness on the road. Stillness and silence. Pendaran watched. She was turning, a cream-coloured, clean-limbed mare, long head, bluish eye, fluid mane and tail. She was standing, waiting, at an angle to his approach.

Why didn't you call out before, said a voice, a sharp, mocking voice. You only had to call.

Pendaran, still breathless from the chase, looked up perplexed. The voice belonged to the woman astride the mare. He brought his horse up alongside her. He reached out and laid his hand on the mare's flank. It was fleshy, warm, coarse-haired. Then he looked at the milk-white woman, and he saw the strangeness of her beauty.

As he gazed at her pellucid skin, he could still hear her pounding the road towards him and pounding the road away from him. Constantly her loveliness was approaching and receding. And when he looked away, she left no image in his mind. All he knew was that she had come for him. And he wanted that.

What are you? he asked, wide with wonder.

I'm here for you, she replied. My name is *Rhiannon*. My father is Heveydd the Old.

Her words meant little to Pendaran. She carried within her an ambiguity which he would never be able to resolve. Pendaran kept his eyes on the mare because he found that easier. The woman reached down and stroked its quivering side. Rhiannon, daughter of Heveydd.

Where is your father's land? asked Pendaran, glancing behind him. He was aware that they weren't alone.

Annwvyn.

Pendaran's face opened. A word from inside himself. Annwvyn – so familiar. Annwvyn, he repeated to her, dully. And he remembered a stag in its death throes, smothered by a fierce pack of dogs.

The white mare was growing restless. Pendaran felt shamed by her presence, her swarming, secretive presence. He looked back along the road and he saw the crowd of his people, cowering, seeing now, waiting.

When his eyes returned to the woman he knew that she could unleash discord. One part of him welcomed that discord, craved it. But another part recoiled. He wished, almost, that a different man had been granted this unimaginable privilege. He wished, for the first time, that he was still, forever, one of those cowering further down the road.

What exactly do you want? he asked, his eyes falling again on the uneasy mare.

She said what he expected to hear. It thrilled him and tore at him: You.

Her smell was so rank, so powerful. Pendaran looked from the dark faces behind him to this vision before him. There was rain on the air. It was sorrowfully cold. *He who is head, let him be a bridge for his people. . . .*

How can I have you? he asked when he could think no longer.

You're sure that you want me?

Pendaran looked at her hard. Now there was the look of the boy Gwri about her. The same look, but with Gwri's embarrassment turned to candour. I want you, said Pendaran with great deliberation. I *want* you.

There is another man, she told him, A rival to you. His name is *Gwawl* She paused.

Tell me what I must do.

And she told him, briskly, scarcely looking at him. She told him how he could outflank Gwawl.

Why is she doing this? Pendaran thought. Why has she come? And why am I

listening to this, me, nodding? But when she was speaking, while her lips were dancing, his need for her grew more profound with each word.

She finished, and Pendaran looked at her, expressionless. He doubted that he could do what she wanted. He knew that she could see his doubts. She handed him the sack which he would be needing, one year and one day hence. As he took it, Pendaran looked back at the faces of his people. He saw their trust. And he felt shamed, now, before them.

I'll meet you then in Annwvyn, said Rhiannon, making ready to ride on. A year and a day — it isn't long. She smiled, but the smile was nothing but a veil.

Pendaran, who had been to Annwvyn only in his dreams, simply nodded. It was becoming too much for him: Rhiannon, his people, his obligations, too much. She turned away from him.

How am I supposed to conduct myself in Annwvyn? he called after her, suddenly resentful.

She didn't look back. No one there will fail to recognize you, she said. Watch the way my people behave. You'll soon find out what you need to know.

And when she was gone, Pendaran dwelt on her parting words, and he knew them to have been of the first importance.

2

The year passed and the day passed.

In all that time Pendaran saw nothing of Rhiannon, although often at night he would hear the swelling song of her birds. Their music came, he sensed, from a great distance, across an expanse of silent water. Yet sometimes he could see the birds themselves, three of them, close to him, in and around the compound.

The birdsong stilled the craving in him. It reminded him of both woman and mare without making him despair. It connected him, however tenuously, with the land of Annwvyn.

Pendaran told his people nothing of his assignation. Occasionally one of them would shuffle forward, and press him about the vision he had seen at Arberth. But Pendaran evaded their questions. (One day, he imagined as he stared into their suspicious eyes, One day I'll be answerable to you. One day it won't be as easy as this, for me.) And his disenchantment with his land and his people and his endless responsibility deepened.

On the appointed night he took the sack which Rhiannon had given him, and returned to Arberth. Before making his way to the summit of the mound, he had sought the boy Gwri. But no one had owned to knowing him, no one. As he seated himself on the grass he thought he heard dogs barking. When the birdsong began, he abandoned himself to sleep.

On waking he found himself in daylight. Warm, pearly sunlight, unusual for that season. The song of the birds was fading. Pendaran, refreshed but anxious, descended the mound and saw that the compound was gone. He took the road which led in the opposite direction, and continued along it until he contented himself that this land was not Dyfed, but Annwvyn.

This is where I could always be, he told himself with a slow smile, This is where I want to stay.

Nothing around him was unfamiliar, save almost everything.

The contours of the land around him were Dyfed's contours. This sky had sheltered him before, and he'd breathed this air all his life. Yet there was a sense of completion about this place, a many-layered complexity, which was foreign to his

own world.

It showed in the people's fluid movements, in their tone and fineness and quality, in an effortless harmony between dwellings and landscape. Pendaran went on his way, exhilarated.

This is how Dyfed could be, he realized, If only. . . .

He saw animals which were unknown to him. He saw nothing which offended him. *Watch the way my people behave,* Rhiannon had suggested. *You'll soon find out what you need to know.* There was no suspicion in the looks he received. Not once was he called to account for himself. The people around him had dispensed with rancour. They had no need at all for Pendaran's brutish kind of government. No need. Pendaran envied them even their worries.

Eventually, towards dusk, he came to an orchard. Below the orchard stood an array of comfortable whitened buildings which Pendaran knew to be the place of Heveydd the Old. Music was coming from the largest of the halls. He decided to follow the music to its source.

He passed through open courtyards. The music grew in strength and he recognized its refrains – magnificent orchestrations of the birdsong which he knew so well. No one stopped him, no one questioned his right to be there. *No one there will fail to recognize you. . . .* On all sides preparations for a banquet were well in train. Pendaran felt confident here, competent. The enormity of what he had to do did not disturb him. Not yet.

He passed a row of stables. (Although he looked for the mare, he didn't catch sight of her. He thought that he could smell her, the pungency of her, but she was nowhere to be seen.) Then he entered the banqueting hall, clutching his sack to his chest. The hall wasn't large but it was quite beautifully proportioned. On a dais before him, behind a heavy table, sat the woman and the two men.

Heveydd the Old sat to the right of Gwawl, Pendaran's rival – the man to whom Rhiannon was being given that night. And to the left of Gwawl was Rhiannon herself.

At the sight of her, Pendaran stumbled back and hid himself among the crowd around the seething cauldron. She appeared to him as a blaze of pure whiteness,

incandescent danger, and he was consumed as never before by his desire for her. Her and her alone, regardless of the consequences. The very strongest of his previous passions now seemed to him like indifference.

A steward handed him a joint of meat from the cauldron. Distractedly he put it to his lips but as soon as he began to eat he found himself relishing each mouthful. This was sweeter flesh than any he had known before. He couldn't imagine what animal could have given flesh like this. He was tempted to stay where he was, one of the many, eating more, accepting drink, basking in the warmth and the conviviality. Then he looked again at Rhiannon, and that was enough.

He elbowed his way to the front of the throng, and assumed a supplicant posture below the dais. The spirited music stopped.

It was Gwawl who spoke because the banquet was being given for him. First the banquet, then the woman. You're welcome, he said to Pendaran, You're welcome here.

Pendaran eyed him cautiously. *(No one there will fail to recognize you)* Gwawl was tall, auburn-haired, lithe, infused by the same whiteness as Rhiannon, an unassailable whiteness, inherently noble. Pendaran swallowed. How could he hope to outwit such a man? And Rhiannon was resting her hand on his arm, poised, complementary. At that moment, Pendaran didn't know whether he wanted her or envied her.

I'm here to ask a favour, Pendaran said quickly. He felt crass.

Good, said Gwawl. Speak and I will grant it.

Rhiannon tightened her grip on Gwawl's arm. Fool! She hissed. Why did you answer him like that?

It was a collusive whisper. Pendaran had been meant to hear. He glanced at her. There was no sound but the crackle of the fire and, distantly, the whinnying of horses. Rhiannon tossed her hair. (She wants something from me, Pendaran thought. She has all this but still she comes to me. What can I possibly have for her?)

Lord, Pendaran said, unfurling his sack, I ask for food enough to fill this little bag.

Gwawl, smiling, called a number of men to him, and asked them to bring food. Quickly they began to load delicacies into the sack. Pendaran, holding its neck open, watched Rhiannon absently caressing Gwawl's arm and side. I'm being used, he thought. I'm nothing but a means to their end.

It was just as Rhiannon had told him: the capacity of the sack seemed to be infinite. However much was put inside, it still seemed quite empty. Pendaran felt ashamed: this subterfuge was trite, unworthy, it belittled him further in a place where he longed to be accepted.

Gwawl spoke. Friend, he said to Pendaran, amused. How long can this go on?

Pendaran kept his eyes on the sack. He said what he'd been primed to say: There can be an end only when a good man presses down the food inside with his feet and says, Enough.

You are that man, Rhiannon said to Gwawl. Put an end to this.

Gwawl rose. He rested a hand on Pendaran's shoulder to steady himself before stepping into the sack. Pendaran, who couldn't look into his face, knew from Gwawl's grip that he understood exactly what was happening.

As soon as Gwawl was inside the sack Pendaran twisted it to make him lose his balance. Gwawl fell head over heels, Pendaran closed the neck, knotted the drawstring. There was no way out. The music began again, the banquet continued.

When Pendaran looked up Rhiannon had gone. Feeling nothing but regret, he searched the face of her father. Should I kill him? he asked, indicating the thrashing bound figure at his feet.

You couldn't kill him, Heveydd the Old replied, Even if you wanted to.

Pendaran nodded, more hopeful now. So should I release him? The guests were milling around him, fresh food was being drawn from the cauldron.

Heveydd made no response; he looked as if he might shrug. He seemed concerned but uninvolved. Then Rhiannon was at Pendaran's side. He smelt her before he turned to see her. She swayed gently where she stood, like a horse avoiding flies. Are you mine now? he considered asking her, but already he knew the answer, and

he couldn't bear to hear her say it.

You can't kill Gwawl, she said. It's not in you. Release him. There won't be any question of revenge.

Pendaran untied the sack and Gwawl emerged laughing. Pendaran would hear that laugh again. Gwawl was no longer the same man. He didn't deserve to bear the same name. He seemed so much more *formidable* now, the kind of man who might have been able to bridle Rhiannon.

There's no question of revenge, Gwawl laughed, But you can't stay here, and trouble will follow you as a matter of course.

Pendaran looked imploringly at Heveydd the Old. The old man pursed his lips, sympathetic. What he says is true. Enjoy the banquet. The banquet is yours, my daughter is yours. But then when it's over, you will have to go back.

Pendaran turned to Rhiannon. She pressed herself into him and said nothing.

Gwawl laughed again. There was neither malice nor amusement in his laugh. As long as this banquet lasts, he said, You can regard yourself as the Head of Annwvyn. And the laughter suddenly became general. Even Rhiannon was trying not to smile into Pendaran's shoulder.

Wise man! the new Gwawl called back to Pendaran as he left the hall. You're a wise man now!

I couldn't have done anything else, Pendaran whispered urgently, beseechingly, to Rhiannon. She was drawing him down to the floor.

But as the guests stopped their laughing and went on with their eating and drinking, Pendaran was unable to tell whether it was Rhiannon or a pack of famished stag hounds that was swarming beneath and across him.

3

I t began in the way that Pendaran had anticipated.

Rhiannon took her place beside him and his people treated her with circumspection. He watched as the women approached, silenced by the lustre of her hair, the translucence of her skin. Only women approached. Only women sensed the vulnerability in her.

Rhiannon provided a gift for every woman who came to her: not trinkets but subtler presents. She taught them, briefly, wordlessly, how to see from the inside, how to respond to the voices within. She opened their eyes to vistas of Annwvyn. Not all the women wanted her presents. But those who did, treasured them.

Dyfed's men could not understand Pendaran's appetite for Rhiannon. Pendaran himself couldn't explain his enthralment, even though she spoke to him eloquently with every part of herself. She was so much more than he was, awesomely more. Forever she was passing back and forth beneath him. Yet this elusiveness itself made him all the madder for her. Every time, he soon came to realize, was the first time.

Sometimes he wondered whether she had come merely to *show* that she couldn't be possessed. He never asked her for reasons. (Whenever they talked conventionally, their conversation was too cryptic for that.) *Why have you come?* he would ask wordlessly as she slept, always tangled around him. *Why have you come? What do you stand to gain?* But wherever she travelled in his land, Pendaran sensed that she was investing it with an echo of Annwvyn.

What, she said to him after the second year, Is it that you want most badly?

She was dragging at her hair. Curled on the floor below him she was all whiteness, smoothness, a promise of warmth in a dank, filthy land.

I want you, Pendaran replied dully. He was weary of admitting it to himself. He felt used up by his wanting, discardable.

Apart from me? Rhiannon persisted. What do you want apart from me?

Pendaran raised his eyes. I want to be wise, he said quickly, not knowing what he was saying. I want to be a stag. . . . *I want to be a bridge for my people. . . .*

It was the first time he had said the words. As soon as they were spoken he felt the

awful space that they'd gouged out of him.

Rhiannon reached up and stroked his legs. Not you. It's not in you, she told him
gently, and Pendaran knew the truth. She held him by his thighs. Your son, she was
saying, Your son will be the bridge. . . .

Pendaran wiped his face, aching, empty. My *son?*

Rhiannon smiled her veil of a smile. She drew him down on to her, and then she
turned him and smothered him with herself. *Stag*, she called him. . . .*Head of
Annwvyn*. . . . And *Pwyll*, which is *Wisdom*. . . . There was something in the way in
which she took him to her – an abandonment, a corrosiveness – which made
Pendaran quake. And through it all, slicing through the swirl of her birdsong, he
heard that crowing laugh, the laughter of the man who had been Gwawl.

The course of Rhiannon's pregnancy was swift. Within weeks her balance had
altered. After half the normal term she seemed ready to deliver. Yet she adapted her
behaviour in no way to accommodate the changes. Gifts came to her from Annwvyn.
Horses, white hunting dogs with red-tipped ears: marvellous gifts to be shared
between her and the unborn child who would be Pendaran's son.

Pendaran allowed her to go her own way. He would watch from inside as she
wandered in the rain among the horses. Every time is the first time, he would think.
Often she walked near the compound gateway. She seemed to be waiting, waiting
for someone to arrive. Watching her pass to and fro in the mud beneath him, all
Pendaran could feel was his need. And he was no more able to hold himself from her
than he had been before.

Rhiannon wanted him too. She continued to offer herself to him, openly, hungrily.
Pendaran's people watched her reaching for him, and Pendaran knew that, in their
eyes, the sight was diminishing *him*. The men of Dyfed were biding their time.
They needed their head man to have a son, and this woman from the outside could
at least give him an heir. They bided their time, and Pendaran grew anxious.

However often he probed Rhiannon's belly he felt no life, no movement. Huge
though she was, he sensed that something like his own emptiness was filling her
out. But whenever he looked into her eyes he saw confidence. Only Rhiannon knew
what she was carrying, inside, where Pendaran himself longed to remain.

On the night of the birth, Pendaran was away, making his circuit of the land. It was the Eve of May, on the cusp of the seasons. Pendaran's people sent out no word to him. He learned nothing until he returned to the compound, slow with fatigue. Then he caught sight of the six women he had appointed to wait on Rhiannon.

Speak! he cried out as they shrank from him. Behind them the horses from Annwvyn were standing proud in the gusty rain. Speak!

Lord, one woman answered from the huddle, You can't blame us. It was the birdsong. We all slept. You can't blame me, any of us, you can't.

Pendaran rushed to Rhiannon. He saw the looks on the faces which he passed in his haste. He saw them. The first time is every time, he sang to himself in silent delirium.

Rhiannon lay, discharged, face down, on the rutted floor. Her arms were reaching above her head, her right knee was drawn up. She was lithe again, she was crying out to him through her silence. Blood was smeared across the floor and over her legs.

Pendaran flinched. The child? he asked. My child?

Slowly Rhiannon raised her face from the floor. She wouldn't look back at him. She looked as if she were gazing at the dried blood. She shook her fine hair, matted now but gorgeous in its coarseness. Still she wouldn't look at her man.

Pendaran took in the smell, pungent, foetid, unlike any smells he knew. He saw the broken wall, the evidences of struggle, he heard the dying echo of her anguish, *someone's* anguish. . . .

The child? he repeated, so much more tentatively.

Rhiannon raised herself on to all fours. She was splendid. Finally she reared up and stood on her feet, her back to Pendaran. The boy is gone, she told him.

Gone?

And then Pendaran saw the foal, tan-coloured with the look of a yearling, asleep against the shattered wall.

Taken, Rhiannon said, her voice unsure. The child was taken.

Pendaran took her from behind, forced her round. Her face was large with crying. My people? he asked her. Was it them?

She looked down, shook her head. There's nothing you can do, she said. Nothing.

He glared at her through the foetor and the shame, and she snaked her arms around him. As they embraced, Pendaran's eyes never moved from the foal, sleeping peacefully amid the debris of a dream. And on the following day Pendaran was summoned.

He had to go. The answering was about to begin.

Mostly men, they were – a handful of women, but mostly men. Pendaran came to them on Preseli Top, cold under the brighter sky of the new season. One of them came forward immediately. There was no ceremony about these people, no deep respect, only the reserve born of ignorance.

Lord, said the man, Put her by. Take another woman in her place. You need a son. This woman cannot give you a son.

Pendaran stared into the range of faces. (How could they know? How could he explain? Where their ignorance ended their malice began.) I know that she's had a son, he said, too softly for anyone to hear, I trust her, I need her, we all need her. Then he drew himself up. Another year, he said, Give me one more year, with Rhiannon. She'll bear another son.

The spokesman turned sideways to hear the debate behind him. Pendaran saw the vindictiveness eating at his profile. When silence fell, Pendaran watched the spokesman narrow his eyes. Clearly he felt confounded, cheated.

One year, the spokesman announced, nodded coldly, then withdrew.

Pendaran had won a reprieve. They owed him that much. But he said nothing of any of this to Rhiannon. If she were to be saved, she would save herself. If she were to fall, then Pendaran would fall too. He had long since stopped thinking of any kind of life without her.

And before that season had spent itself she conceived again. Every time is the first time, Pendaran assured himself, Every time is different. He wondered, often, whether his need for her, his need to *believe* in her, was a form of derangement. Yet he continued to discharge his duties to his people as diligently as ever.

Towards May Eve he prepared once more to make the circuit. I can delay, he told Rhiannon looking at the size of her, I can be here with you.

She smiled, shook her head and wandered back to resume her vigil at the gateway. *There's nothing you can do. Nothing. . . .* There was so much Pendaran couldn't understand, so much he dared not imagine. All he could feel was his need. All he could see was the unblemished land, the people who flowed without fear. All he could taste was that flesh from the cauldron.

He left six women at Rhiannon's disposal. He arranged for signals to be sent to him, should the crisis come.

He knew that the crisis would come. On May Eve he saw red fires on the hilltops. At once he travelled back to his woman, cursing himself - unconvincingly – for ever having left her.

He heard Rhiannon before he could see the compound: screams that curdled the night air, feverish ululations. He could have moved faster to the place where she was. He could have reached her sooner. Nothing stood in his way but himself.

From outside, he heard the thunderous destruction, the squalling eddies of tumult – woman, child, woman, terror-stricken horses, the barking of the dogs from Annwvyn. He picked his way over the sleeping forms of his people. (They looked so enviably *oblivious*.) By the time he reached Rhiannon there was only birdsong and the dawn.

He couldn't bring himself to approach her. She lay contorted in a corner, her face obscured by her hair, a new foal's head against her breast. All around her was ruin. Pendaran tried to hide from his own grossest fears.

Rhiannon raised her head to him. The ordeal had aged her.

Why did you ever come here, Pendaran said, To me?

There was a scuttling behind him. The six women, aroused, had come to survey the devastation, murmuring, absolving themselves. Pendaran knew that soon he would be summoned, again. He gazed at Rhiannon and he wondered how it might have been without her. The crowd at his back was swelling, the mood was growing ugly.

Pendaran stopped thinking. He strode to where Rhiannon was crouching, enfolded her, and whispered loud enough for all to hear, I *want* you, I *want* you.

4

She has come among us, said the spokesman, And she has brought confusion.

The rain was slanting hard at him, forcing him to shout. Pendaran nodded. He was cold and he was afraid – not afraid of what this baying, restive crowd might *do*, but afraid of what he might *hear*. He searched for the words to describe the banquet in Annwvyn. *That* was what they needed to know. Why had he never even tried to share his dream with them?

She's not a natural woman! the spokesman cried.

Pendaran closed his eyes. He nodded. . . . He came from them. He himself had drawn, initially, from the same impoverished stock of ideas.

Twice! Twice she has borne. . . horses!

The crowd seethed. The words had been spoken. Pendaran could see no eyes, only fear, unknowing. He knew that they were wrong, all of them. He couldn't begin to tell them why. But for him, even *this* left her untainted, even this. He thought of her still as he'd seen her from the mound. Horsewoman. The first time is every time.

Put her by! Take another! She's betraying us all!

Betraying? More than one voice was coming at Pendaran now. He looked through the rain at the flailing arms.

She bore children, he told them levelly, Boys, not horses. The children were taken, the foals were put in their place. (This was what Pendaran had understood from Rhiannon's reticence. Both times he had shied away from confronting her. It wasn't in him to confront her. This had nothing to do with courage, or responsibility.)

Take a woman of your own kind! Take a woman you can know!

Pendaran scanned a horizon which never came any closer. He wanted to scream at the sky. He yearned for sunlight, cleanliness, a life without rancour. I won't put her by, he told them, faltering towards an ignoble concession. If you're sure she's done wrong, then let her be punished. But I'll never put her by. . . .

Punishment. Pendaran saw grim smiles on the forward faces. It would do. Punishment would be enough, for the meantime. They told him at once what they had in mind. . . .

Rhiannon was waiting for Pendaran in the stables, flanked by the two foals. Already she knew what he had to tell her. Her punishment – her penance – was to last for seven years. Each day she was to stand by the compound gateway, confess her heinous wrong to newcomers, and offer to carry them on her back up the main trackway. Seven years. She stared at him without accusation.

I couldn't have done anything else, said Pendaran, his face streaked with tears. I know you're innocent, but I couldn't have done anything else.

Rhiannon covered herself with a smile. She called one of the dogs to her.

Who took them? Pendaran turned to the wall and asked, Who took my children? Where are they now? In Annwvyn?

Rhiannon tossed her head in a passion of patience. Annwvyn, she repeated, then mused on the word. There are so many Annwvyns.

What does that *mean*? Pendaran shouted, still not daring to approach her.

She crouched and held the dog against her face. Blood clung to her feet and thighs. There was more living in her, Pendaran knew, than in the whole of his septic territory.

They had names, she said, I gave them names before they were taken.

Pendaran nodded, shook his head, pressed his forehead against the wall.

Llŷr was the first, she continued, slowly, lovingly, *Llŷr* which is *Sea*. The second was *Mabon – Youth.*

Thank you for that, said Pendaran to the wall. There was no sound but the baying of the dogs from Annwvyn. I couldn't have done anything else, he repeated, I couldn't. . . .

And at first light on the first morning, he watched from inside as the first man

climbed on to the back of Rhiannon.

There was no birdsong. His assembled people did not sleep. There was no thunder now, only laughter – chattering and loud laughter. Slowly, so very slowly, Rhiannon hauled the first man up the muddied track.

Is this why she came here? Pendaran asked himself. And the question didn't seem as absurd as it should have done.

The second man mounted her. Pendaran saw the vulnerability in her, the flimsiness at ankle and throat which he had never seen before through his need. She was making no sound. Some women had gathered by the gate to sing dirges. She would not raise her face to Pendaran as she stumbled past.

It was under the third rider that the change came. The thunder of movement shimmered through Pendaran, he recoiled from the blaze of whiteness. Speed! That speed! He narrowed his eyes but all he could see was the stately mare. He looked again and there was the rider, clinging frenzied to the mare.

He could *feel* the rider receiving the knowing from her. He knew that the rider, overstretched, hadn't grown enough for knowing of that kind.

Pendaran, pursing his lips, heard the rider's scream as he hurled himself back to the earth. He heard the commotion and the withdrawing. He looked out again in the teeming silence, and he saw Rhiannon standing at the gateway, alone.

It was seldom, in the months which followed, that any man sought to be transported by the Horsewoman. Only Pendaran had the confidence to go near her – the confidence, and the inability to hold himself away.

Stag, she called him repeatedly as he rode her in the way that she herself demanded. *Pwyll*. . . . Her abandonment no longer distressed him. He relished her need for him, her readiness to meet *his* needs. He felt that, perhaps too late, he was inching towards an understanding of at least the woman in her. The names she whispered to him were genuine names. Between the two of them, they were believable. I want you, I want you, he would moan, more to himself than to her, long after she had left him for sleep.

After the third conception, the creature inside her grew at the same accelerated

speed as the previous two. The winter was especially hard, wastes of snow smothering the wastes of thorn. Though no one rode her now, Rhiannon refused to spend a single day away from the gateway.

Pendaran went out to be with her. She looked new: the third pregnancy had restored all her vigour. Her eyes were searching the horizon. She was waiting, waiting for someone to arrive. (Someone like herself?) Pendaran smoothed his hands across her belly and this time he felt the life.

Tell me, he pleaded with her, Tell me what I must do on the night. Tell me and I'll do it.

She reached for him, smiled, but continued to look out. Show trust, she told him. Share your trust. It's in you to do that.

I couldn't have done anything else, Pendaran kept telling himself through the nights, I couldn't have. But that year he made his circuit early, and he returned to the compound at dusk on May Eve.

Rhiannon was not at the gateway. A shifting crowd was there in her place.

Where is she? Pendaran asked, genuinely afraid that she might have gone from him.

No one spoke immediately. They chose to protract his unease. Pendaran saw the loathing in them, the impotent, festering hatred. They were the bearers of what they believed to be bad news, he knew that. Yet he could see from their eyes how they were longing to bring him so much worse.

Tell me! he said, louder.

A stranger came. A man. She welcomed him. . . .

A man? Pendaran repeated.

A man of her kind. Tall, milk-white, auburn-haired. He called himself *Teyrnon*. She welcomed him, here. She took him to her. She'd been waiting for him. Him. . . .

Him. The words came back to Pendaran: *There's no question of revenge.* The words, the hand on his shoulder, the laugh. . . .

Where is she? he asked again, fearsome now to widening eyes.

He took her there, they said pointing, To the stables. There. . . . He sent the six women away. . . .

Pendaran continued up the trackway, passing the stables, looking neither to left nor right, closing his ears to the horses. *There's nothing you can do.* . . . He had to trust himself. He went on trusting himself as the twilight merged with the dark. He looked out, above and beyond the compound, at the fresh fires that were blazing on the hilltops.

Pendaran – one man, set apart from the rest, his eyes dull, his hands hanging free at his sides. He had been chosen. And that was enough. It was all that was in him.

His people were sleeping. They could never resist the birdsong. They needed that sleep as badly as Pendaran needed his dreams. (But did they need the dreams too? Did *they* dream?)

He sensed the rearing up from the stables before he heard Rhiannon screaming into the darkness. He closed his eyes and he saw the stranger coaxing her, calming her, forcing her to the ground and holding her there. A man, a woman, a coming life. The stench hung heavy over them all.

Pendaran's eyes were closed but the darkness had gone. There could be no end to this circuit. He was seeing from within, seeing the face of Golden Gwri. The boy was shrugging, candid: *I'll be the bridge. Let me.* . . .

Pendaran made his way outside, exhilarated. The sound of Rhiannon was filleting him but still he laughed. The wonder of it was too much for him. He strode through the uproar of the horses and the dogs. Up ahead of him a wall was falling.

He heard the squalling of the child. The land beneath him trembled, burst. This! he cried out, This is why she came! For this! And, momentarily, he glimpsed the completeness of Rhiannon's great motherhood, her eternal, ever-anxious splendour. Then he came to her and he saw.

She was hunched against the remnant of the wall, bloodied, her child curled up startled in her lap. A boy, with hair the colour of gold, already far older than a baby. Pendaran began to weep. I know this, he gasped, I've seen a wonder. This is

how the first man stood, and the man who came after. I *know* this. . . .

But if he hadn't seen it before, now he stared at the cord which issued from the boy's stomach. Tough, blue-black, sinewy-strong and impossibly thick, almost as thick as the torso of the child. That cord was no part of Rhiannon. It had coiled through the wall, wrecked the wall, it extended far, far out into the fire-strewn darkness.

Rhiannon was wailing, clutching the boy tighter. Pendaran could do nothing. *Nothing.* There was a wrenching at the cord, a sudden tautness. Rhiannon steadied herself. Pendaran sank to his knees. As he hid his face in his hands he felt the stranger brush past him, the man who called himself Teyrnon. Pendaran trusted him. He trusted him as he'd never been able to trust himself.

He heard the stranger raise his arm, cry out *Enough*! and slash at the mighty cord. He heard the outside roar of anguish as the severed end crashed to the ground.

The stranger touched Pendaran's shoulder. Here is a boy for you, he said gently, If you want him.

When Pendaran dared to look, he saw Rhiannon and his son, unharmed. And he saw, in the place of the cord, the amputated arm of no beast that he knew. At the end of this shrivelling arm was a claw, and inside the claw, already struggling to its feet, was a new foal.

The stranger was gone.

Rhiannon offered her breast to the boy child in her lap and he drank eagerly. Pendaran recovered himself. In that ruin of a stable they came together: a man, a woman, a child and a foal. Outside, the fires burned low on the hilltops. The fresh season had sloughed off the old. Pendaran could hear his people approaching. They would see the boy. They would exonerate Rhiannon.

This is why she came. Pendaran told himself again. For *this*. . . .

When the child had drunk enough, Pendaran took him. He was so fine: fine-featured, fine-toned, *finished* in a way that none of Pendaran's people had ever been finished.

Gwri, said Pendaran, looking to Rhiannon for approval, Gwri?

She smiled, exhausted, and dragged her hair from her face. *Pryderi*, she said with finality. And the jostling crowd which had gathered behind Pendaran looked on in some bewilderment, because *Pryderi* was *Trouble.*

The boy, although tired, was singing softly to himself in Pendaran's arms. The song was familiar. Everyone present knew it. Several of the men squirmed forward, past Pendaran, and pressed their lips to Rhiannon's discharge on the ground. One woman led the foal away.

It's you that I want, Pendaran whispered to the boy. You will be the bridge. You.

His people eyed him warily. The distance between first and last had been restored.

The precocious boy continued to sing until he fell asleep.

THE
SECOND
BRANCH
GROWTH

Pryderi is fostered out to the fallen sea-god *Manawydan*, who prepares him for an initiation raid upon Annwvyn. As the future Lord of Dyfed, Pryderi must take possession of a cup, a cauldron, seven supernatural swine – and also the enigmatic *Cigfa*, a goddess of sovereignty. Many such expeditions to Annwvyn have ended in chaos. But Pryderi, astride the colt which appeared on the night of his birth, is destined to succeed almost in spite of himself. On returning to Dyfed, he learns of Pendaran's death. Heavy-hearted, he establishes his own divinely inspired regime. The colt stays in Annwvyn.

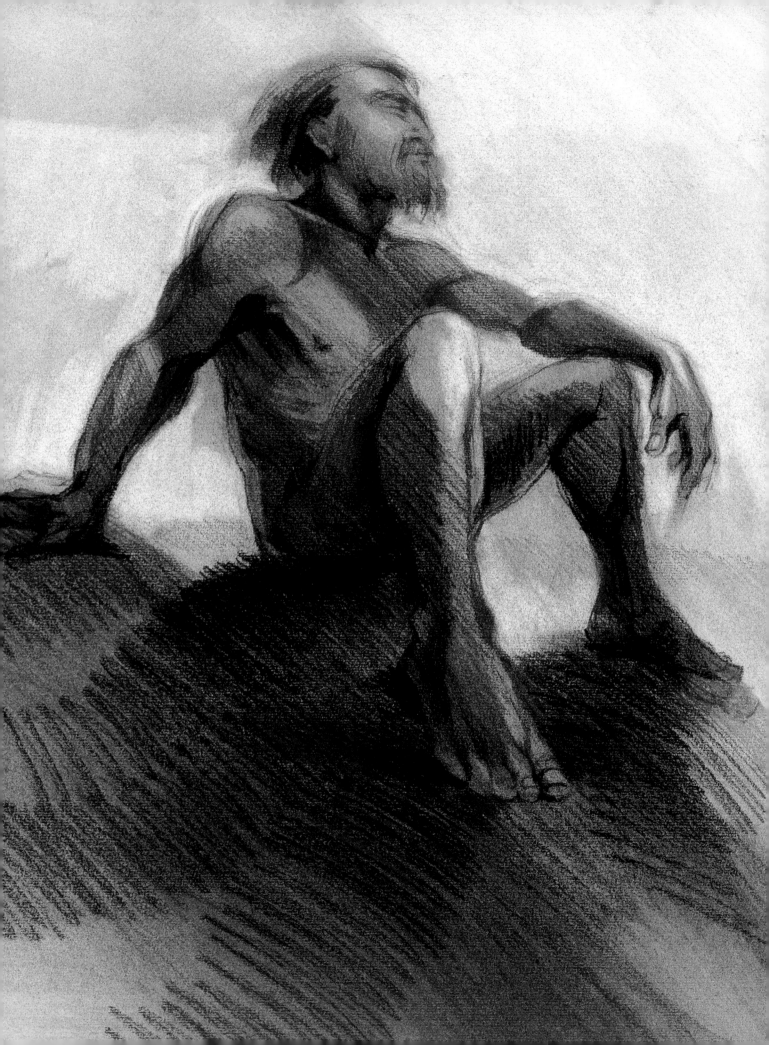

1

The lame man came by water.

He came to Dyfed at the end of Pryderi's fifth year. A crowd formed above the strand where he dragged his great coracle ashore - a crowd which shrank from him, then swelled, as he made his way towards Arberth. He walked briskly, making light of his limp. And as he walked he looked about him, smiling, raising his hand from time to time as if in reassurance.

Pryderi, far away at the compound, came running as soon as he heard the people's whispers. (The hybrid boy took an innocent pride in his speed. When the mood was on him he could chase the fastest hind and catch it by the ankle.) Zestfully now he raced back and forth behind the throng which lined the path from the sea, craning his neck to catch a glimpse of the lame man and his smile.

Pryderi, like the others, didn't have to be told. He knew that this man was different. His grey hair marked him out, his thick grey beard, and that face which hovered beyond the reach of ageing. But Pryderi also saw the heaviness in the stranger's smile. And when he saw it, he wondered, immediately, whether *these* were the unknown eyes which he had always felt were watching him.

Pryderi followed the lame man's progress with stealth. The people at the pathside stank of fear. These will be my people, he thought, proudly. And he valued them all the more for their trepidation.

The lame man had stopped to gaze up at the mound. He cupped a hand over his eyes against the morning glare. He was looking amused. Pryderi understood: the people were meant to *see* him looking amused, unimpressed.

Blows and wounds, the lame man cried suddenly. He nodded, bending his leg at the knee with some effort. Blows and wounds or a wonder. Oh, I know, I know. . . .

Still smiling, his eyes swept across the range of stupefied faces. None of those present had ever heard such a voice. The voice of someone new in the throat of someone old. It seemed counterfeit, mocking. But Pryderi wasn't surprised. Pryderi had already connected the stranger's appearance with Rhiannon.

At the compound gateway, no one challenged the lame man's right to enter. Pryderi slipped through behind him. None of the people dared to follow. There was only Rhiannon now, approaching from the stables. And behind her, Pendaran, leaning

against the wall of the first building, watching, solemn-faced, waiting.

Thus did the four of them come together: a woman, a man, a boy and a stranger.

Rhiannon came to embrace the lame man. Pryderi studied his father. Pendaran looked back, smiled, and then turned, indicating that the boy should follow him into the building. Pryderi ran up the track, quickly past Rhiannon and the lame man. Rhiannon called out to him but he pretended not to hear.

Pendaran was seated. He opened his arms and Pryderi pressed himself hard against his father. Although still an infant, he had the build and strength of a boy more than twice his age. He gripped his father's shoulders. He felt the trembling, sensed the helplessness.

Rhiannon's voice prised them apart. Pryderi closed his eyes before he turned. His mother had so many words at her disposal.

She was close enough to touch him. The lame man was standing in the doorway behind her. Still he looked amused. But his demeanour implied that he was in this company against his own better judgement. (He *is* the one, Pryderi felt sure, Those eyes have been on me all my life.)

Rhiannon touched Pryderi's shoulder as she passed him, then sank down beside Pendaran. Her arm rested loose along his thigh. Pryderi, still facing the stranger, listened to the urgent rhythms of her talk.

Manawydan, she was telling Pendaran, The name of the lame man was Manawydan. From an island adjacent to Prydein. A haven. A safe home. . . . Pryderi listened to her talk of safety with some impatience. He knew of no dangers in Dyfed. His father's territory was his own territory too. How could there be dangers? But he understood where her words were leading.

He turned to face his parents. Rhiannon had furled herself around Pendaran. She was running her face against his cheek, up and down, up and down, coaxing him, calming him, smoothing away his concern with an invocation of names which Pryderi had never previously heard: *Llŷr, Mabon, Llŷr, Mabon. . . .* And it seemed that the invocation was proving to be conclusive.

By now a brave cluster of Pendaran's people had spirited themselves inside the

compound. They were pressed against the wall outside, tense and murmuring. Pryderi caught their one recurrent word: Fosterage.

Fosterage. Pryderi had anticipated as much. Rhiannon herself had spoken to him of fosterage. It was, after all, the covention.

With a cry Manawydan stumbled forward as the first crush of people spilled into the room. Narrow-eyed, they shuffled sideways until they had lined three walls, silent, noxious, their faces bloated with confusion.

Fosterage. The word was on Rhiannon's lips now. Fosterage.

Pryderi watched her fingering his father. He couldn't deny his fear of her. Fear, and a resentment at her attempts to instil in *him* her own arcane conviction of transcendence. Night after night, the endless ambiguity of her raked at Pryderi in his sleep. In spite of himself he dreamed of mounting her, of riding her into the ground, then watching her open up beneath him, part into darkness and finally swallow him whole.

Still she spoke of safety. Swarming across his father, showing him the respect of her glowing-white serpentine body. Pryderi knew that Pendaran had no answer to her. And he guessed, correctly, at the agony that rode on the back of his father's voicelessness.

She pulled herself away from Pendaran and shrank into silence. Pryderi knew that the words would have to come from his father. *Her* words from *his* lips. It could not be otherwise. Manawydan had stepped up to Pryderi's side. Pryderi flinched. He reeked of foul water.

Pryderi could only look into his father's face. He had no idea whether Pendaran had known of this in advance: this particular arrangement, this particular man, this particular time. There was a tightness about the head man's features now, a glaze to his eyes. Pryderi nodded, even before his father could bring himself to say the words:

You will go with this man.

The sigh which issued from the three walls gave Pryderi a new resolve. He smiled at the people who would be his, and the smile, he hoped, would convince them that he was going to return. Manawydan's hand alighted on his forearm. Inoffensively he

shook it away. Then he stepped forward to embrace his father once more.

This time Pendaran stood. They held each other close. There was no need for talk. Rarely had Pendaran tried to reach his son through words – only on those occasions when he had fought to describe what he meant by the bridge. And the stag. And the golden-haired boy called Gwri. And his visit to Annwvyn. But it wasn't those times that Pryderi remembered now. At length they drew apart.

Pryderi crossed to Rhiannon and embraced her too. He knew that he would never be able to leave her behind in the way that he was leaving Pendaran.

I'm ready, he said to Manawydan. The lame man turned and ambled ahead of him out on to the track.

Outside, near the stables, there was a commotion. Manawydan had stopped walking. He seemed, from his expression, to have been expecting this. One of the women was shrieking. A horse was stepping past her. A splendid white, blue-eyed colt – the creature that had appeared in the compound on the night of Pryderi's birth.

The horse must come, Manawydan called back to Pryderi in his shrill, unlikely voice. Bring the horse.

So Pryderi, who had in the past demurred whenever Rhiannon had suggested that he should ride the colt, now allowed the creature to precede him out of the compound, and then on towards the sea.

The walk was a long one. Pryderi shuffled behind the limping man and the colt, trying to maintain his aplomb in the eyes of the watchers. So many watchers, cowed and beseeching, people at home in the mire of the night.

I will return, Pryderi told the last of them as he came to the water's edge. And at that moment the sound of his father rolled towards him from the distant compound. Roaring, delivered, the sound of a death in life. Pryderi was going to carry that sound with him for a very long time.

The coracle had room enough for the three of them: a man, a boy and a sprawling colt.

Your island, asked Pryderi as the coracle swept away, manifestly without guidance, from the tongue of Prydein, How far is your island?

The lame man arranged himself against the horse's flank and ignored Pryderi's question. On the water now he looked less anxious. Beneath his weight of beard his face was flushed and mobile. *The first word from the cauldron*, he said playfully, more to himself than to Pryderi, *When was it spoken?*

Pryderi, at a loss, looked back at his homeland. They were moving fast across the undulations of the sea. Already Dyfed was scarcely visible. But Pendaran's roar continued to echo loud inside his head, and the sound was like an accusation.

You must distance yourself, said Manawydan, at his ear. And after a considerable silence he continued, You're different. You'll be the bridge, eventually. You'll succeed where your father could only dream. You'll be the swineherd.

Swineherd? Pryderi repeated without twisting round, I don't know what you mean. (Manawydan's breath was damp on his neck. The stench of both man and colt was overpoweringly sour.)

You're coming with me to be safe, Manawydan told him.

I was safe with my father, Pryderi countered, turning quickly.

Manawydan kept his face close to the boy's. Your father, he said carefully – and something in his tone made Pryderi think at once of Rhiannon – Your father could not have prepared you to receive the cup of sovereignty. Your father could dream. But you. . . . (He drew back.) You will be different.

Pryderi looked hard into the lame man's eyes. Ageless eyes, searching and sharp, a look that felt so familiar. Pryderi recognized that whatever lay ahead of him now was a kind of privilege. But it was a privilege which he himself had never sought, and one which he didn't, therefore, feel inclined to prize.

Your eyes, Pryderi began, I've always thought that your eyes. . . . (Then he paused and changed his mind, for he was by nature a more assertive boy.) I know, he said, That you've been watching me. I've known.

Manawydan settled back against the horse's flank. He laughed quietly and shook his head. A mist was wrapping itself about them. Still Manawydan seemed happy to let the coracle choose its own course. Pryderi began to shiver. But he had no fear. He felt only irritation, and a longing to be back where he belonged.

Manawydan resettled himself and rubbed his thigh absently. Pryderi watched his soft fingers kneading and pushing, kneading and pushing. He didn't want to be with this man. He didn't want to be the beneficiary of this kind of privilege.

But very soon he grew drowsy, and he drifted into sleep. As he slept, he dreamed, vividly, that he was standing in a valley. This valley was both known and unknown to him. Gorgeous rich meadows extended across its floor, and on either riverbank there stood a flock of sheep, one white, one black.

Each time a white sheep bleated, a black sheep would cross the river and turn white. Each time a black sheep bleated, the reverse would happen. Pryderi watched in wonder. He felt happy in that place. But his happiness was clouded by guilt, an awareness of the dereliction of some duty. Close by, a golden-haired young man was sitting on a mound. And in front of him, beside the water, there was a tall tree. From root to crown one half was green with leaves, while the other half was loud with flames. . . .

Pryderi was woken by Manawydan's hand, gentle on his shoulder. He looked beyond the lame man's smile and he saw an island. A clean, unpeopled island. His dream was receding, too fast. He heard birdsong, loud and welcoming. I don't want this, thought the boy. I don't want any part of this.

And Manawydan, rising, looked to the shore with pleasure as he declaimed:

> *The first word from the cauldron, when was it spoken?*
> *By the breath of nine maidens it is gently warmed.*
> *Is it not the cauldron of the Head of Annwvyn, in its fashion*
> *With a ridge around its edge of pearls?*
> *It will not boil the food of a coward or one forsworn.*

2

On Manawydan's island Pryderi lost track of the time. The seasons ceased to follow a familiar pattern. Under the relentless pale sun he could trace neither growth nor decay in the land around him. But he was able to mark the changes in himself, the awkward maturation, the passage to a form of adulthood.

From the very beginning Manawydan gave him the freedom of the island. It was a congenial place, airy, laid to crops, pervaded by an aura of lapsed majesty. And, since it was less than half the size of Dyfed, Pryderi came to know it more intimately than he had ever known his own home territory.

He went about on foot, ignoring Manawydan's reiterated suggestion that he should use the colt. He would run, awesomely fast, along stretches of the shore, breaking off to stare at the indistinct horizon, then run on again until sheer exhaustion swept the longings from his mind.

He understood that he was being watched, constantly, and not necessarily by the lame man. More than once he saw the white mare, tossing her head in high places, nuzzling the colt in the stables, streaming along a particular strand at low tide. And in his dreams he saw Rhiannon's face, twisting up beneath him, scrutinizing, supervising, but preparing none the less to open up and swallow, open up and swallow.

No structure was imposed on the boy's days and nights. Pryderi grew stronger, faster, but his fosterage involved no specific guidance, save when Manawydan taught him to play the board game *gwyddbwyll*. Often he was left quite alone on the island. These were the long periods when the lame man took to the sea. He never offered an explanation for his absences. Pryderi never inquired, having guessed early, from Manawydan's smell and from his versified reminiscences, that his favoured element was water.

It was only in the evenings, when they ate together, that they conversed to some purpose. Yet the talk was less significant, somehow, than the eating, the fact of sharing, the companionship. Pryderi, coming from a land without agriculture, had never tasted bread before. And the animal flesh, cooked in an exquisitely decorated cauldron, was always succulent and plentiful.

You like this meat? Manawydan asked him once.

55

I do, answered Pryderi, who had seen neither sheep nor goats nor cows in any of the fields. What is it?

Swineflesh. Pork. The noblest meat of all.

And on the following day Manawydan led Pryderi to the sties and indicated his seven sleeping pigs. The boy eyed them, fascinated. These creatures were as new to him as the fields of corn and the windmill and the watermill had been. But in their silence they cried out to him in a way that the colt had never done.

Swine, he repeated. But only seven?

Manawydan began to shuffle away. Only seven, he said. On this island, only ever seven. . . .

And slowly Pryderi came to appreciate the importance of the *cauldron* from which Manawydan so meticulously served the meat. There had been nothing like it in his father's land. Nothing like the ambience it created when its contents seethed above a full fire. Pryderi, easily intoxicated by Manawydan's liquor, sensed an infinite possibility, a promise of lasting light, when the flames began to warm that cauldron.

He perceived, at length, that the vessel was the true measure of the difference between this island and Dyfed. It seemed also to encompass all the lesser differences: differences in time and habitat and fertility and stillness. Such a cauldron, he thought, Would enhance my father's land.

And in its transforming presence Pryderi lost his mistrust of words, but as he did so, Manawydan's conversation became ever more oblique.

I don't understand, Pryderi often thought, How this is preparing me to receive the cup of sovereignty. And whenever he asked Manawydan to explain what he *meant* by the cup of sovereignty, the lame man would simply laugh, then recite fragments of poetry about an armed raid on a land called Annwvyn.

Annwvyn, Pryderi said one evening, You talk of Annwvyn. My father told me the same name, long, long ago. He told me that he went to Annwvyn.

Manawydan nodded – the way he always nodded when Pryderi spoke of Pendaran.

You will go to Annwvyn, he said, When you are ready. You will visit Annwvyn before you return to Dyfed.

Pryderi narrowed his eyes at the ridge of pearls around the cauldron's perimeter. How will we know when I'm ready?

Manawydan sipped his liquor. The fire cracked between them. What do you see in your sleep? he asked.

Pryderi glanced away. There was menace in that question. Too much menace (and prurience) to elicit the truest answer. So Pryderi told him of the known-and-unknown river valley, of the flocks of sheep, the burning tree and the young man on the mound. This was honest enough. The dream had been recurrent. But his keener dreams had been of riding, of his mother.

Nothing else? asked Manawydan when he fell silent.

Nothing. Pryderi knew that his colour was deepening, that he was glowing with a heat not from the fire. But he wasn't prepared to speak further.

He took to ever more strenuous exertions by day. Still he shied away from the colt. He turned himself into a powerful swimmer. Twice he swam so far from the island that he could make out a haze of land on the far horizon. At least, it looked like land. And Pryderi sensed that it was not Prydein.

But his body was making harsher demands on *him* now. Demands with which he could scarcely deal. By day as well as by night, the memory of Rhiannon grew big in him: long and white and intricate, twined about his father, taking him into herself and drawing the pain from out of him. He had watched it all, so many times. There had been no attempt to conceal it from him.

Pryderi began to see the white mare more often, in inaccessible places. Sometimes he inflicted hurts upon himself but the craving persisted, made him all the madder. All he could feel was his need. Not for Rhiannon exactly. Not that. But for a woman, for a kind of responsibility.

What do you see in your sleep? Manawydan asked him, again, over the *gwyddbwyll* board.

57

Little enough. Pryderi's voice was low, rancorous. Then he blurted some words which seemed to come to him from nowhere: *I fear for my father.*

Manawydan nodded. He asked no questions. He appeared to be satisfied.

After that Pryderi's head became crowded with worse dreams. He dreamed of an arm, bursting through a wall and seizing him, remorselessly, low down in his body. He dreamed of Pendaran, screaming, while nine distorted women dined off his living flesh. He dreamed of younger women, showing themselves then withdrawing, showing themselves and withdrawing. And through it all he could feel the eyes watching him. Laughing eyes. Knowing eyes, not Manawydan's.

Leave me! Stop watching me! he came awake shouting one night. Manawydan, visible through the shadows, was leaning against the wall. Pryderi smelled his distinctive smell and suddenly he lost himself.

How long must I stay in this place? he cried. Why do you keep me here? What must I do? Why can't I go? Now!

Manawydan sank slowly to a sitting position on the floor. Who do you think is watching you? he asked, quiet, so patient.

How should I know! Pryderi was storming about the room, flailing his arms, neglecting to cover his bulbous penis. How can I know? You tell me nothing. You *explain* nothing.

Manawydan bowed his head. He seemed close to anger himself but he remained silent.

Pryderi was standing above him now, tremulous. A loud straining youth, full of himself, arrogant with frustration. Why can't I go to Annwvyn? Why can't I go there now, then return to my own people?

Manawydan's eyes glinted at him. *Your own people?* You must distance yourself. Because of your mother you're different. Different from your father, from all of them. Won't you understand that?

Pryderi would not desist. Must I *die* here? Must I die before you let me go?

Death, Manawydan said tersely, Is only the centre of a long life. But no, you won't die here. This place is safe. That's why you're here.

I don't *want* to be safe, though! I want my home!

Manawydan looked furious, jaundiced, sanctimonious. Home, he laughed. Home. You *do* understand about your mother's difference?

Pryderi glared down and he felt his first full surge of spite. This man – this man who was preying on him – seemed to require him to forswear his own father. *That* was what he wanted. He wouldn't be content until Pryderi had delivered up Pendaran.

I understand, Pryderi said with slow malice, That you're an old cripple, I understand that. I know that you watch me in the night, just as you're watching me now. . . . And I don't believe in what you're doing. I don't believe that *you* know what you're doing, here, with me.

A great silence descended between them. . . . You had brothers, Manawydan said at last to Pryderi's feet. (His speech was hesitant, his tone uncertain.) Llŷr, Mabon. Hybrid boys like yourself. They were taken from Dyfed. You would have been taken too. In time. That's why you are here. For your safety. Not because I want or need you with me. And when you are finished here, you will be able to enter Annwvyn on your own terms. You will be the swineherd. . . . I've said enough.

He struggled to his feet and moved out into the corridor. Pryderi followed him, palpitating, but still fractious. Llŷr, Mabon. He'd heard those names before. But what did he care about brothers? He gripped the lame man's shoulder.

Why must I go to Annwvyn? he asked. What's there?

Manawydan turned his face to the wall but kept his back to the boy. *The better part of yourself,* he said morosely, Now let me go.

It was a long time before the two of them spoke civilly again. Pryderi, although still seething, became more subdued. He swam listlessly in the cold sea. He spent nights out under the cold sky. He avoided the companionship of the cauldron and, as the weather deteriorated, he survived on what foods he could find in the wilds of the island. But there was no release from his craving. He needed to be with his people.

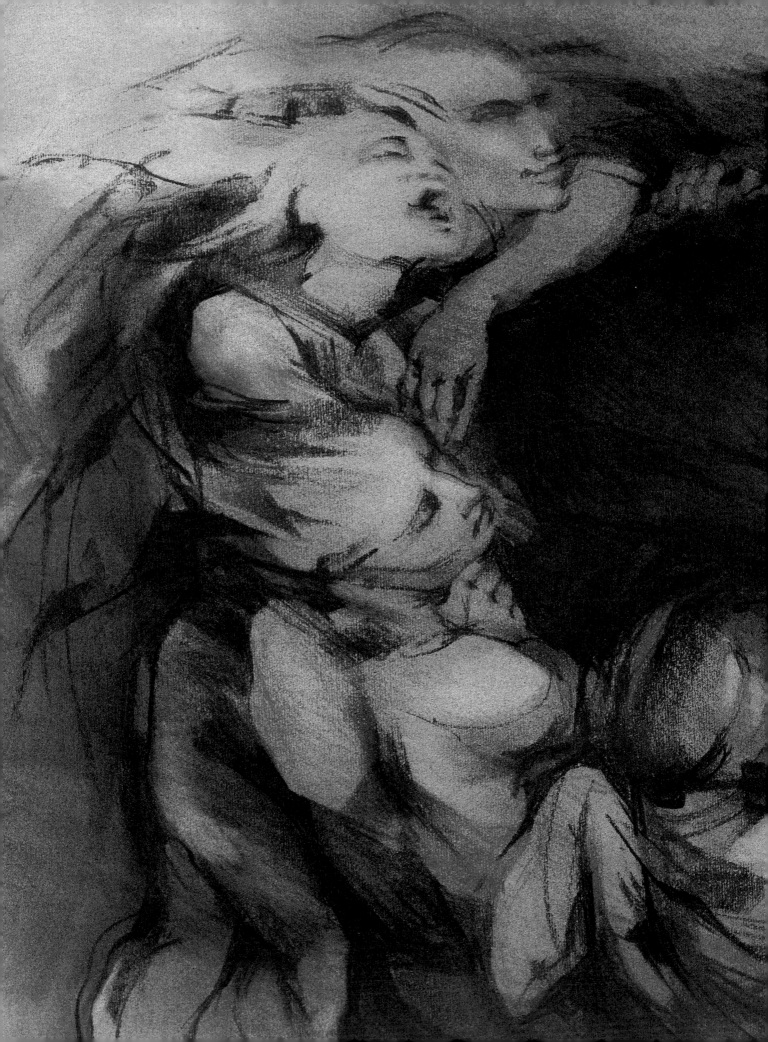

He needed, above all else, to be with women.

One morning, after he had stopped sleeping rough, he emerged from his dormitory to find that there had been a light fall of snow.

It was the first snow he had seen in that island and it looked misplaced, derisive. On the ground in front of Pryderi's dormitory, a wild hawk was killing a duck. As soon as the hawk heard Pryderi it rose. Immediately a raven settled on the duck's lifeless form. For longer than he knew, Pryderi stood transfixed by the sight. Then he became aware of Manawydan's stench, close at hand.

What are you thinking? asked the lame man.

Pryderi said nothing. Manawydan, coming closer, repeated his question, and still Pryderi could not speak.

Tell me, said Manawydan. I think you should.

Pryderi blinked. He felt awkward, belittled. He pointed at the carnage in the snow. There, he said with great difficulty, Those colours. I can imagine a young woman, a girl. Her skin as white as the snow. The blackness of her hair like the raven's feathers. Red spots in her cheeks like the drops of blood, there, there. . . . (He turned to face his foster father.) I could be . . . better, if I was with such a girl. I *need* her.

Manawydan nodded. There will be girls. In Annwvyn. But the girl you describe might not, in the end, be suitable. Can you accept that?

Pryderi, tears forming now, raised his head and stared at the higher ground.

Three evenings later the two men were sitting together again. Pryderi felt obliged to speak solicitously of Manawydan's lameness, having referred to it before with such venom.

Was it a wound? he asked.

Manawydan looked at him, surprised. It was a wound, he said. But that's of no consequence now. (He smiled thinly.) You won't have to stay here for much longer. You're rash. You're still so young. Every time is the first time, I know, I know. . . .

Pryderi warmed his hands at the fire, gazed at the distortion of his own image in the side of the cauldron, and ached with the red, white and black of his fevered imaginings.

With the rekindling of the fire beneath the cauldron, the snow disappeared from the island. But Pryderi no longer felt inclined to smother his need in an endless round of physical exertion. He stayed within the precincts of Manawydan's home. He avoided the stables, but again and again he would return to the sties. He would sit, rapt, on the wall above the seven pigs, and his thoughts would be of Prydein.

He remembered more and more of his former life. In particular he pored over those few tangled exchanges with Pendaran. *A stag,* he had called himself, A stag in Annwvyn, the Head of Annwvyn, responding to the suggestion of a young man's voice. *Gwri, Gwri. . . .* Pendaran, a man who dreamed of sovereignty. A man who had sought in vain to be a bridge for his people.

And the anguish in Pendaran's roar came back to Pryderi. Across the sea, across the unnumbered years. A roar that had swept on ahead of him and was waiting, now, in another place.

Each evening Pryderi sat alongside Manawydan, restless, moody, past the point of bitterness.

Manawydan noticed this new sullenness, and he was sympathetic. There had never been much warmth between them. But now at last the older man contrived a distant respect for the younger. They drank heavily together. Pryderi was allowed to help himself from the cauldron. His instinct told him that Manawydan was looking for some kind of approval from him, always in addition to a denial of his own true father. But Pryderi was determined to provide him with neither.

This island, sang the boy in a stupor one evening, Is a perfect prison.

Quite so, said Manawydan tiredly, Quite so. But our term is nearing its end.

Our term? Pryderi was astounded.

Our term. It won't always be like this. Believe me.

That night, Pryderi dreamed of his valley. The sheep continued to cross the river,

half the tree continued to blaze. And Pryderi was screaming at the young man on the mound. Beautifully poised he was, soft-featured, with two stag hounds curled at his feet. And he couldn't hear Pryderi's screams. Pryderi fell silent. Looking down, close to despair, he saw that he was astride the white colt, his colt.

As soon as he woke he stumbled out to the stables. All around him he could sense an opening out, a powerful new understanding. He saw invisible walls bursting apart, letting in the dawn and the day's first birdsong - familiar birdsong, a song from another time, loud, penetrating, invigorating. The colt was standing ready.

Pryderi hoisted himself up on to the creature's back. It felt softer than he had expected. More supple, less resistant. He felt completely at ease up there. No seat could have been more natural. Manawydan appeared at the stable doorway. In his hands were the bones from the previous night's meal. The birdsong swirled through the stable, scouring away any of the virulence that remained between them.

Now? asked Pryderi, scarcely audible.

Now.

Manawydan turned and limped out on to the path which led down to the sea. The colt required no handling: it carried Pryderi through the dawn at the right pace, in the right direction. The feel of the strong back beneath Pryderi brought him a new pleasure – new and gloriously shameless. He *knew* then (although he could not have explained it) that his sojourn on this island had been essential.

The coracle was waiting. Pryderi slung himself down into the water. Manawydan eased the colt into the spacious vessel and opened his arms to Pryderi. They held each other.

You're not coming? said the young man.

Manawydan shook his head. The bones of the swine were still in his soft hands. Later, he smiled, We'll meet, but later. For the present you'll be able to find your way without me. In the place where you are going, no one will fail to recognize you. Watch the way my people behave. You'll achieve what you need to achieve – for yourself and for your own people.

Pryderi watched him return to the path, then pushed the coracle out into the deeper

waters and clambered inside. Elated, he looked back to see the sunlight breaking over Manawydan's island. The lame man himself was resting on an outcrop of rock. Around him, now, the seven pigs were milling. And, high above them all, the white mare stood proud against the morning sky.

Every time is the first time, thought Pryderi as the birdsong died away. And he felt as if he had shed a skin, although not all of it yet was dead.

3

Pryderi, fearless, drifted southward in the coracle. The water about him seemed as still as a meadow, but he was crossing it at great speed. With the lengthening of the day the sunlight sharpened. The sea itself seemed to become translucent. Occasionally he caught glimpses of fishing boats, too distant for him to hail. He flexed himself and he felt unassailable. Somewhere across these waters lay the promised land of women.

Death is only the centre of a long life, Manawydan had told him, warned him. Now, as a line of shore faded up from the water, he sensed, strongly, that his life was going to be abbreviated – a *necessarily* short span - and that this, all this, might turn out to be nothing but a prelude.

He felt only a sensation of deliverance, though, as he led the colt through the shallows, then went back to pull the coracle on to land. Immediately he mounted the beast, and was happy to allow it to choose its own pace and find its own route into the interior. Death's not waiting here, thought Pryderi. Not for me. Not yet.

The contours of the land weren't completely alien to him. (The sheer *lushness* was unfamiliar, as were the clarity of the light, the fluidity of the people's movements, and the easy relationship between landscape and structures. But the terrain itself dipped, soared and stretched in a manner that was reminiscent of his homeland.)

Welcome, a voice called up to him, a thin unchallenging voice. *Welcome, swineherd.*

Pryderi frowned. The voice couldn't possibly have carried from even the nearest group of men and women. Pryderi rode on, and twice more the words came to him on the light wind: *Welcome, swineherd.* He pursed his lips, leaning lower on the colt which was now gathering speed. There was so much still to know. But he was prepared to inure himself, temporarily at least, to the inexplicable.

The colt took him a great distance from the sea, avoiding the larger settlements, and bringing him, at sunset, to the limits of a dense forest. Skirting the forest, they came to a sizeable lake. At its far side stood a complex of buildings, simply but elegantly constructed in the fashion of Manawydan's quarters back on the island.

A groom came to meet them as they followed the lakeside path. Pryderi dismounted and allowed the colt to be taken from him. When he looked across the lake, he saw a white-haired man sitting at the water's edge. He was watching two young men fishing from a boat. As soon as the man caught sight of Pryderi, he rose, and made

his way into the courtyard of the nearest house. He was lame.

From the opposite side of the lake, Pryderi headed towards the same courtyard. He expected to find the lame man only a short distance ahead of him, but when he arrived the man was nowhere to be seen. One door was open, so Pryderi entered the house and found himself in a large and extremely crowded kitchen.

He saw her at once, bending beside a stone bench.

A wraith of a girl, ill-used by the look of her. A girl of quick movements, darting glances. Where he could see her flesh, it was whiter than the flower of the whitest crystal. Her hair and eyebrows were black as coal. And when she noticed him, the two tiny red spots flushed up into her cheeks.

No one there will fail to recognize you. . . .

The girl, as if in warning, immediately glanced across the kitchen, to where a strong-armed butcher was hacking at a carcass. The butcher put down his cleaver. He greeted Pryderi warmly, and directed him, above the bobbing heads of his staff, to the main hall. Pryderi looked over his shoulder at the girl as he went. All he could see was his need. She smiled at him, briefly, shyly, but she was crying out to him through her silence.

In the main hall a cauldron had already been suspended above a fierce fire. The household rose to greet the visitor, but the white-haired man, his host, remained seated on a brocade cushion. On the floor in front of him stood a goblet, brimful of liquor. He beckoned to Pryderi to sit beside him, and they spent some time in pleasant but inconsequential conversation.

As evening progressed into night, Pryderi was seduced by the rapturous atmosphere which was emanating from the cauldron. He had experienced nothing remotely like it, even on Manawydan's island.

Repeatedly he looked at the goblet, which remained untouched before his host. He began to think less about the kitchen girl and more about the man at his side. Quite apart from his lameness, the old man's appearance was subtly similar to that of Manawydan. It lay not so much in any similarity of features as in the *knowingness* that permeated those features, the faintly quizzical concern.

70

You're glad to be here? he asked.

Pryderi nodded, accepting a fresh joint of pork from the cauldron.

Do you know why you're here?

Pryderi shrugged, his mouth crammed full. Not exactly.

The old man smiled. Others had begun to listen. What do you expect to find?

Women? said Pryderi innocently. (The laughter around him began.) The cup of sovereignty? (The laughter billowed, and Pryderi grinned in his turn.)

The talk meandered on to the hunting of stags. There was no malice in what the others were saying, no provocation. Their keenness for the sport seemed genuine. But Pryderi, who was tired and surfeited, felt that their good humour was in some way being won at his expense.

He gazed about the high-ceilinged hall. Handsome lissom women had been introduced into the company. In corners unreached by the firelight he could see them sinking down to couple with the men, and his thoughts rushed back to the kitchen girl. But then, purely for entertainment, two young men started to wrestle in front of the host. Pryderi recognized them as the fishers from the lake, one golden-haired, the other auburn.

They fought skilfully, and when at last one prevailed, the host invited Pryderi to pit his own strength against the victor. With little enthusiasm Pryderi rose. His opponent, the auburn-haired lad, was bigger than himself, supremely confident, laughing through his breathlessness. I don't want this, thought Pryderi. I surely can't have come here for this?

The company quietened, the contest began. And, almost as soon, it was finished.

Pryderi's awesome power could not be matched. His opponent withdrew, still smiling, having lost all stomach for the struggle. As the rest of the company applauded, the host reached up and touched Pryderi's haunch.

You're a strong man, he said levelly, Necessarily strong. You'll encounter no one stronger than yourself now. And tomorrow, the colt will take you where you

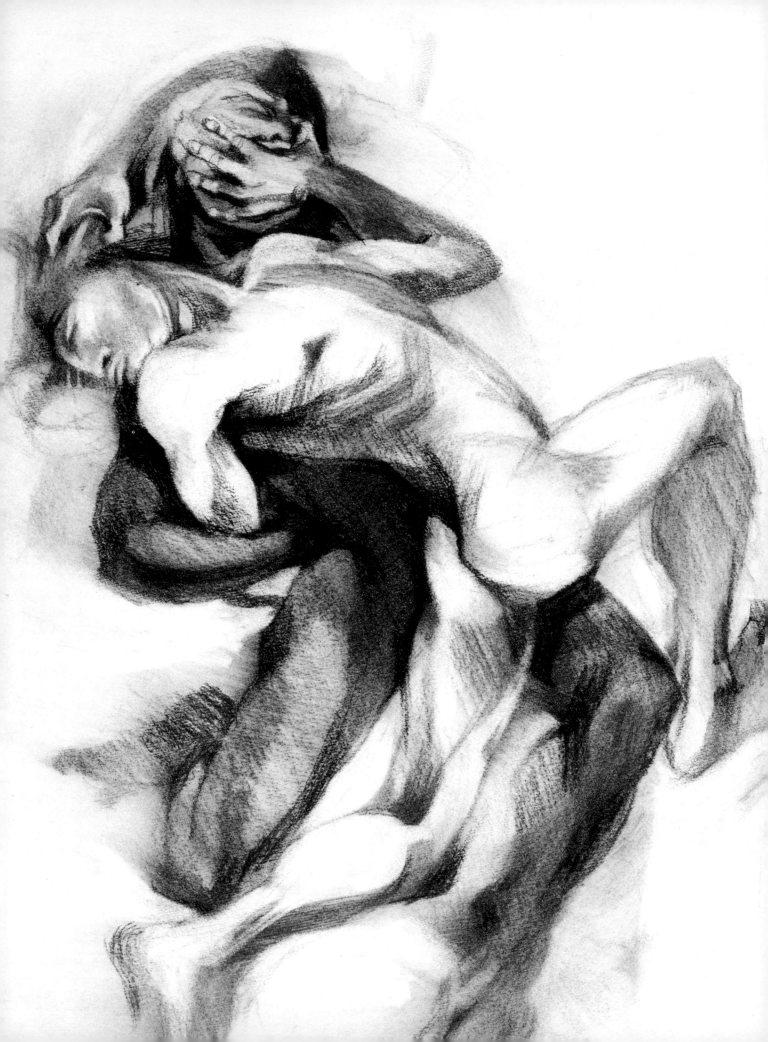

you need to go.

But Pryderi was more interested in his vanquished opponent, who was being received into the shadows by the women. The fight, he knew, had been a sham. There was no real danger here. No true challenge. The only trouble, here, in this good place, could come from within himself. He understood that even then.

He spent that night in a splendidly appointed room. Before he woke, at daybreak, he felt fingers on his legs and torso. Although he could not see, he knew them to be the kitchen girl's. He felt her straddling him, driving him on, compelling him to spend himself too soon.

When he arose and looked out, he saw that his colt was waiting, swathed in a mist of its own cold breath.

It pained him to have to leave the girl behind, before he had even spoken to her. But as he resumed his journey she still seemed very close, and her image gained clarity in his mind. Pryderi felt that the essence of her was all around him, that she was *harboured* by the very earth he was trampling, the air he was breathing. *She might not be suitable,* Manawydan had told him, *The girl that you describe might not, in the end, be suitable. . . .*

He rode on through the day. The land had changed greatly, as if it had aged to the point of decrepitude during his overnight stay at the lakeside. Even the ground beneath the colt's feet seemed flimsy, little more than a veneer. Pryderi sensed a darkness coiling constantly beneath him. He knew that this light could not last, that he would be unable to remain in this light. And occasionally the thin voice would float past him on the breeze: *Swineherd, Swineherd.* And he wondered, idly, if it might be the voice of the kitchen girl.

At dusk the colt led him through a level meadow to an imposing, sequestered homestead. All around there was the singing of birds, melodious, almost choral. Again a groom appeared, to attend to the colt. Again Pryderi went on to walk through the first open doorway.

He found himself in the main hall. As soon as he entered, the company inside burst into into life, as if from a tableau. An old white-haired man waved a hand above the tumult.

Welcome, he cried to Pryderi, Welcome, nephew.

Nephew? said Pryderi, taking his place beside the man.

I am your uncle. Your host last night was also your uncle. Does this surprise you?

Pryderi accepted a joint from the cauldron. No, he said truthfully, I can't be surprised. Not here. And we went on to refresh himself at his uncle's lavish table, saying little, staring at the cauldron, listening to the talk around him, which was again of stags. This is all for me, he thought, This evening would have no centre without me. And he felt so sad.

He drank, that evening, to excess. In his own mind his uncles had become two forms of a single person – a person which also embraced Manawydan, and which, incontestably, embraced Rhiannon too. He began to feel uneasy. From time to time he tapped his foot on the floor, and, each time, a morbid echo rose up and swaddled him.

Will you play *gwyddbwyll?* asked his uncle.

Pryderi nodded, aware of the fatuity of refusing. The board and a set of superbly crafted pieces were brought up. Then a young man came forward, golden-haired, lithe, noticeably similar to the weaker wrestler in the previous household.

They played three games and Pryderi won each time. You're wise, said his uncle, touching him on the shoulder, Powerful enough and wise enough. You have come into two parts of your strength, but the third is still wanting. (Then he looked up, at the doorway through which Pryderi had entered, and shifted the conversation to lighter matters.)

But as he was speaking, Pryderi sat forward. He had heard the silence descending at the far end of the hall, heard the silence, seen the company parting. And before he could see the cause of it he reeled back, stunned by the raucous, discordant wailing that had filled the entire hall.

Then he saw. He saw the golden-haired boy step slowly across the width of the hall. Above his head he held the sturdiest spear. Three streams of blood ran from its socket, leaving bright trails on the ground when both boy and spear were gone.

Pryderi looked in appeal at his uncle. But the old man alone had not been distracted by the sight of the spear. He was continuing to talk, discursively, of swine, of cups and bridges.

Pryderi, bemused, scanned the hall. A sudden sense of the kitchen girl's nearness was overwhelming him. But the company's keening had risen to an even higher pitch. And at last Pryderi saw why.

He saw the wide platter being borne up where the spear had passed before. He saw the man's head – the bloodied severed head – that rested upon it for all to see and bewail. The shrieking around Pryderi was becoming intolerable, yet the old man's monologue would brook no distraction.

I should probably be listening to him, Pryderi told himself before standing. He could see only the back of the head on the platter: the matted tangle of hair, the sadness where the shoulders should have started. He felt sorrow himself. But he also felt a burden of guilt, an awareness, more acute than ever, of the dereliction of some duty.

There's no question of revenge, he heard a voice telling him, a woman's voice, No question of revenge.

It was only then that he looked closely at the platter bearer. At first glance, he'd presumed it to be the same golden-haired young man. Now he saw that the bearer was a girl. As she disappeared into an outside chamber Pryderi felt a curious dismay. The uproar in the hall diminished immediately into satisfied laughter. Pryderi, confounded now, had an intimation that the entire performance had been facetious.

He sat and gazed, alarmed, into his uncle's face. The old man had at last fallen silent. He returned Pryderi's searching look, apparently expecting him to speak, to seek explanations. But Pryderi, weary of being tested in this indirect fashion and sensing that he would receive only indirect answers, sought, at that moment, nothing but a place to sleep.

A chamber was made ready for him. Before he retired, however, the bearer of the platter returned. There was a defiance about her as she approached the host, this time holding up a goblet. Although Pryderi was close to the old man's side, the girl took exaggerated care not to look at him.

Her name is *Cigfa,* said Pryderi's uncle, portentously, while she was still some distance away.

The name set Pryderi's mind teeming with a deeper disquiet; it suggested grossness to him, falling blades, the dissection of animals. He studied her as she came close, appreciating her sensuality without in any way wanting her or needing her. She lacked the frankness of the girl he had known first. Lovely as she was, majestically as she held herself, she had no voice for him.

The old man took the proffered goblet, drank, and made as if to hand it on to his nephew.

But the girl Cigfa stepped forward, and, smiling broadly at Pryderi, knocked the cup so that the rest of its contents splashed on to the floor. Then she turned and quickly left the hall.

She can be yours, the old man told Pryderi. Win her.

But Pryderi had no mind to win her. No mind at all. It was not *her* face that paraded through his dreams that night. He was awoken at dawn by a concatenation of sounds which his night-time mind could identify with ease: a sad small voice wailing deep inside him, the slow passage of time in a distant land, and the roaring of a cornered stag.

I don't want this, he thought, looking out at the colt, I don't want her. And if I do win her, I shall be losing something far more valuable, something I'll never be able to recover.

But he knew that it was going to be almost impossible *not* to win her. And he knew that each of his supposed triumphs in this ritual land was diminishing him further, driving him closer to the final humiliation.

4

When Pryderi rode out of the homestead that morning, he found himself in a kind of wilderness, a wasted place, desolate and lifeless. Where once there had been forests or pastures, now eddies of smoke drifted in from the horizon on a silent wind, grazing at the detritus, occasionally enveloping both man and horse.

But it was not just the land that had declined. Pryderi felt a species of decay within himself. Only his conviction was gathering strength — the conviction that the better part of his life had already passed, that, from the moment he had seen the severed head, there could be little ahead of him but sorrow and bereavement.

The colt carried him a great distance that day. He knew neither where he was going nor what would be required of him when he arrived. But he was certain that his path would lead, inexorably, to Cigfa, to the *winning* of Cigfa, the woman whom he did not covet. And he could not think of Cigfa without seeing again that head on the platter. That head which *he himself* now felt some dark responsibility for having severed from its trunk.

The landscape eventually offered him distraction. Its barrenness conjured vivid visual echoes of long-destroyed armies, and of those same armies' aspirations before their ruin. Men had passed this way before the devastation. Men who hadn't returned. Men of whom Manawydan must have been speaking when his conversation had shaded into poetic recitation. Pryderi felt that he was inching towards an understanding of what Manaydan had only hinted at. He guessed that, amid the brambles and the shattered masonry, he was striking at that same awful vein of knowing:

> *In the four-cornered enclosure, in the island of the strong door,*
> *Where the twilight and the black of night move together,*
> *Bright wine was the beverage of the host.*
> *Three times the fullness of* Prydwen *we went on sea,*
> *Save seven, none returned. . . .*

The verse was coming to him fresh from the dust and from the abyss beneath the dust. Men have been passing this way for ever, Pryderi said, after repeating the verse aloud, And a part of me belongs here. A part that will remain here long after I have gone.

The ground beneath him shifted gently, like a confident creature flexing in its sleep. Pryderi felt chastened but not afraid. (He understood the difference between danger and drama.) *Swineherd, Swineherd . . .* sounded to him, on that day, like an assurance that he would come through unscathed. *Swineherd, swineherd. . . .*

And then other voices, weaker and more poignant, swept through him. Voices from times past, and – he intuited – from times still to come: *Dogs of Gwern, beware the wrath of Pierced Thighs!* And again: *Before the portals of the cold place, horns of lights shall be burning. . . .* And faintest but most excruciating of all: *He who is head, let him be a bridge for his people. . . .*

Pryderi was close to tears when his horse led him into the courtyard of a burnt-out mansion. He dismounted, and in the failing light he could see only women – nine preoccupied young women. They promised him hospitality, but urgent business prevented them from attending to him at once.

Pryderi led the colt to a byre, and then, until pure darkness fell, he watched the women at their extraordinary work. At intervals a horse would approach from the far side of the mansion, a man's corpse slung across its back. Each time, the girls would lower the corpse to the ground, bathe it in a cauldron, and then, under their ministrations, the lost life would gradually resurface. The restored men were unable to speak, but in every other way they were quite perfect.

> *Three times twenty-hundred men stood on the wall.*
> *It was difficult to converse with their sentinel.*
> *Three times the fullness of* Prydwen *we sailed.*
> *Except seven, non returned. . . .*

During the meal that evening Pryderi sat beside a dark-haired girl whose cheek he had watched reddening in front of the fire.

Those men, he asked her, How did they die?

The girl turned her eyes on him. She said nothing, but Pryderi took her silence for an honest one. He believed that in truth she had no answer. And he felt her compassion for him, her possible susceptibility to him. He continued to contemplate her, until ultimately she became indistinguishable from the butcher's girl at his lame uncle's house. And all he could feel was his need.

Will you sleep with me, he asked, Tonight?

Already she was withdrawing. I am a land not for you, she called back to him, smiling sympathetically.

A *land?* Pryderi cried out.

A land, a cup, and a woman, she replied, There's no way of separating them.

Pryderi hurled the debris of his food into the fire. There's no reason to any of this! he shouted.

Oh, there is, said a girl close by, stretching out to place a hand on his shoulder, There is. And you don't even have to see it. You, in yourself, being who you are, are reason enough. . . .

Who *am* I, then? said Pryderi, louring.

You will be the bridge between two worlds.

79

No! he cried, rising, Not that! What *am* I? Me, now, here!

But the girl had returned to her own conversation, and Pryderi dropped to the ground, to sleep a tormented sleep next to the dying fire. No one approached him in the night. No dreams came close. But the tiny voice inside him wailed on until dawn. And as he headed slowly in the direction from which the corpses had been brought, another of Manawydan's verses took hold inside his head:

> *Perfect was the prison of Gwair in Caer Sidi. . . .*
> *No one before him went into it,*
> *Into the heavy blue chain which held him, faithful youth,*
> *And before the spoils of Annwvyn dolefully he chants,*
> *And till the day of doom shall he continue his lay. . . .*

These spoils of Annwvyn, he wondered, were they intended for him? A cup, a cauldron, a woman called Cigfa – and eventually a land, a land over which he would be sovereign, a land linked to Annwvyn by the pure white fact of his birth? But Pryderi, having at last reached a margin of the wilderness, still anticipated nothing but loss.

In the distance he could hear a pack of stag hounds flushing a herd of deer. He yearned to be back with his father, back among people with whom he could share his trust. He longed, even, to be back on the quiet island with Manawydan.

He looked down. The colt had come to a standstill, at a point where three well-defined paths suddenly presented themselves. Pryderi raised his head, to be confronted by a familiar scene.

There was the valley of his dreams, there the gorgeous meadows, there on the riverbanks the two flocks of sheep, and here in front of him the tree, whole as yet, whole as yet. . . . Above his head was the high mound. Looking down from his eminence was the golden-haired young man with his greyhounds.

Which way now, brother? Pryderi called up sardonically, his eyes on the tree.

Not *brother,* came the abrasive answer. Look again.

Pryderi cupped his hand over his eyes and squinted up. It was Cigfa, laughing now. How could he have mistaken her sex? She pointed a finger and began to speak: You have options. If you stay here, you will shortly see the hounds driving an exhausted stag out of the forest down to the water's edge and then. . . .

Pryderi, sensing incandescent danger, interrupted her. What of this path? he asked, indicating the narrowest of the three.

Cigfa smiled and nodded. Deep inside himself Pryderi felt a withering. Her eyes seemed to be seeing everything that he had been and was ever going to be. (Entering you, thought Pryderi, would be like taking possesion of my own mother. But he knew that *she* was the land meant for him. And he knew that, in reality, he had never had any options at all.)

You will need this, she said, tossing down a kitchen tool – a meat cleaver with a gleaming blade. Pryderi recognized it. He'd seen it in the butcher's hand, back at the home of his lame uncle.

Silently he dismounted to pick it up, then climbed back on to the colt, which had meanwhile turned to face the narrowest path. Behind him he could hear the sheep bleating in their sequence, hear the crack of the flames, feel the burning of her eyes.

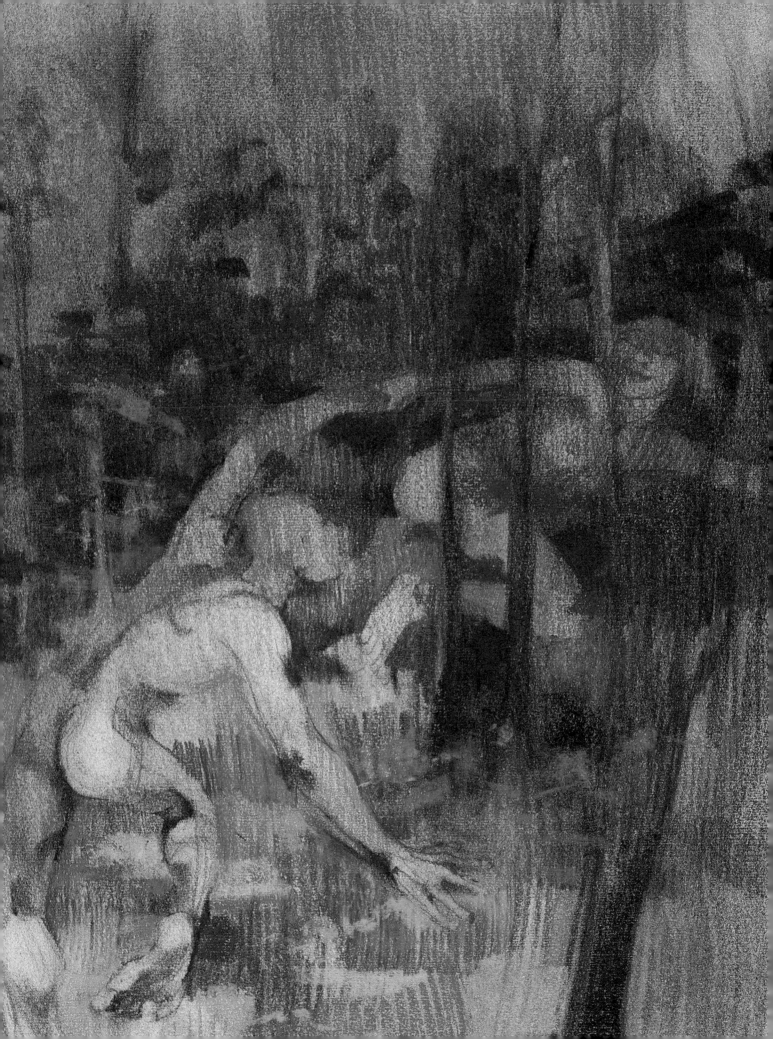

Her eyes. Hers!

Not Manawydan's eyes, not Rhiannon's. It had been Cigfa! Drawing him from his birth to this point, then guiding him on towards the centre of his life. Cigfa's eyes. But also, in the most curious way, the eyes of all his father's people *through* Cigfa. . . .

Pryderi twisted round but behind the curling smoke he could scarcely see the mound, let alone the woman upon it. And because the cries of the stag hounds were sounding perilously close, he allowed the colt to lead him away from that place of discovery.

But the path was interminably long. Circuitously it led them back into the waste land, back among the echoes. Pryderi, fingering the blade of the cleaver, felt the stirring beneath him time and again. I am not prepared, he thought, sensing none the less that all the necessary preparation rested in his blood, in the fact of his delivery from Rhiannon's womb.

Night fell and the horse forged on through the darkness. Pryderi felt older, heavier, more despondent than he had ever thought possible.

Come now! he roused himself to shout, Come now! Show yourself!

The silence beleaguered him. He felt as if time itself were passing through him, annihilating his infancy, his youth. He did not welcome these transformations but all he could do was remember. Memories not his own, memories transmitted: the hacking apart of a mare inside a dark enclosure, one man lapping at the broth of its flesh, the disintegration of a strong wall, the shriek of a newborn child, a single blow slicing a claw from an arm. . . .

No one there will fail to recognize you. . . .

The ground reared up beneath him. Pryderi was thrown from his horse. He hit the path and the path was writhing. Just below its surface he could hear the histrionic lamentation. His fingers closed tight around the cleaver. Dust and stone billowed into a tumulus beside him, then burst apart showering him with an overwhelming stench of putrefaction. The ground wanted him. The ground was wanting to swallow him.

83

Pryderi stood but the ground reached up to throw him again. All the men who have died here, he thought (with strange detachment), as he scrambled to his feet to face the chaos, All the men, all the men. . . .

He could see nothing. Nothing. But he knew that there was an arm, like a cord of appalling strength and thickness, paying itself out quickly, wetly, from the new crater beside the path. The ground erupted again but Pryderi staggered and kept his footing.

Then he saw it – the outline of a stone spearhead against the flank of his own white colt. A hideous thing, huge, crusted with age and use. And almost at once it was there, poised quivering high above his head. The colt lowered itself into the dust and began to rock with the increased turbulence. Its eyes were open but they were quite without expression.

Pryderi steadied himself, picked out the arm's enormous wrist, and slashed at it, once, twice, three times with the cleaver. And as he struck, he roared *Enough! Enough! Enough!*

There was no sound but lamentation as the spear dropped to the ground. A thin dawn light was veining the sky. Pryderi sank to his knees. The spear shaft had rolled a short way out of the raggedly sundered claw, which was already less than half the size that it had been before. Pryderi, incapable of further movement, watched it continue to shrivel, contract, then smooth itself, almost ironically, into the shape of a drinking vessel.

He threw the cleaver away from him, aware that everything he had accomplished in Annwvyn had been inglorious. He knew that he'd been consistently outmanoeuvred, and that, although countless better men had failed here before him, his own success owed nothing to his prowess as a *man*. Drama, he breathed to himself, not danger, not true danger. . . . I haven't proved a thing.

And a familiar voice answered: *You couldn't have done anything else, believe me. You've done what it was in you to do, nothing less. This was what your father wanted for himself, for his people, yet couldn't attain on his own.*

Then he heard the footfall behind him. He felt the heat of her eyes before her hand slid over his shoulder to reach for his chest. Her golden hair smothered his face as he turned. She was pressing herself, too hard, into the side of him.

I'm here for you, she whispered, and momentarily Pyderi felt certain that he had heard those words before. They thrilled and they tore at him in equal measure. Now, she said, working at him with her mouth, Now you can be the bridge.

Pryderi fell back. The lamentation beneath him was echoing, unbearably plangent, into silence. Show trust, Cigfa was telling him, Share your trust. . . . She picked up the cup and rubbed it briefly against her cheek, murmuring.

Then she was upon him again, bearing down with the massiveness and expectation of an entire people, but guiding him smoothly into her temporary possession.

5

Cigfa administered herself to Pryderi until the day was well advanced. The intermittent rain showers seemed to stimulate her zeal. She swarmed across him with a generosity, an intimate abandon, which surprised and partially shocked him.

He took pleasure from the sensations which she was releasing, but the fear continued to pulse within him. And through it all he remained objective, mournful. The smell of this girl was undeniably a smell from his own past. It was, he felt sure, the stench of his father's people, of their fear. She was so much more than he was. So much more than he would ever be. She encompassed an entire world, an entire sex. A land, a cup, a woman – of course they couldn't have been possessed individually. Of course.

This is the way forward, he thought, Her body, her eyes, her beside me, around me – leading me, as my mother led my father. And I couldn't have done anything else. I couldn't. . . .

But still he felt mortified. Still the image of the head on the platter would not leave him: a head, he now acknowledged, which he had *chosen* not to identify.

Cigfa drew away from him, reached out for the claw cup and offered it to Pryderi. He took it, staring dubiously at the small measure of rainwater inside. But when he drank, the liquid refreshed and restored him as effectively as a full cauldron meal.

He looked about him. The colt stood ready but the spear was gone. And the land in the immediate vicinity, far from showing signs of the recent dramatic struggle, was burgeoning. As far as Pryderi's eyes could see, there was nothing but conflicting shades of green. Now he felt truly invulnerable. (Safe, he presumed, in the way that Rhiannon had so badly wanted him to be safe.) This land would never again have the capacity to open up and swallow him. This land, in a certain sense, had become his own.

And now? he asked Cigfa. Do you come with me now, to Prydein?

Cigfa raised herself to her feet. The transcendent woman. She would be his companion, she would preside. Go on ahead, she said to him. Go back the way you came, back to where you first saw me. I will be waiting.

Pryderi closed his eyes. He had imagined that there would be no more testing. He

had imagined that there was nothing left in him to test.

I will be waiting, Cigfa repeated. She sounded so compliant, almost plaintive, commiseratory.

Pryderi rode away, slowly, from his woman, leaving behind the cup and the cleaver. He carried the smell of her with him. Rank and unrefined, the smell of Dyfed, his land and her land. But when he had ridden a short distance, he realized that the smell was still coming *to* him not *from* him. He realized, with astonishment, that it was rising from the land through which he was travelling.

He looked quizzically to left and right. This was indeed the route that he had taken before. Yet nothing in the panorama was unchanged. In fact the harsher terrain now reminded Pryderi even more strongly of Dyfed (although his recollections of that land had been blurred, possibly falsified, by his lengthy absence).

I am the bridge, he thought (again attempting to stifle his fears for Pendaran), I can bring two worlds together, me. And the voice breathed behind him, *Swineherd, swineherd. . . .*

Sooner than he expected, he came to the beautiful river valley. The mound still stood dominant. But the tree was gone, the sheep had departed. Instead he saw before him a multitude of watermills and windmills, similar in design to those which had stood on Manawydan's island. He rode on through that land in transition until he came close to where the nine young women had given him shelter.

In place of the shattered mansion, a comfortable-looking dwelling was standing in the grounds, large enough for just one family. Although it meant leaving his specified route, Pryderi dismounted and walked up to the house. Since the door was open he entered, and he found her in the kitchen.

She looked up from her kneading, a vision of black, red and white, and she shook her head at Pryderi, smiling.

This is the head miller's house, she said, and went on with her work.

Pryderi leaned against the wall. He had never seen a lovelier girl, never *imagined* such unimpeachable beauty, cool and yet simultaneously collusive. His duty was to travel on to his uncle's homestead. He knew that. But he stood transfixed until he

felt the blow of a cleaver handle between his neck and shoulder.

He turned to find a squat, strong-armed man who, laughing genially, introduced himself as the head miller. And will you stay with us tonight? he asked, searching Pryderi's face.

Pryderi looked away. The girl at the bench was a land not for him. He understood the futility of wanting her. But he was still rash, still fundamentally unconvinced by the nature and the quality of his commitment to Cigfa. I will, he replied abjectly, I will.

Pryderi remained in the house for one day, then a second, then a third. In all that time he remained in the small chamber set aside for him, consuming the food and drink that was left at his door, closing his ears to the voices of the sequence of messengers sent by Cigfa.

This, he told himself, Is the truly perfect prison. Perfect, because in the depth of each night the white-skinned, black-haired girl would come, in tears, to offer herself. And although her sobbing never ceased entirely, Pryderi had not dreamed that a man could be left so replete by a woman. Every time, in the course of each night, she was exquisitely different. Every time, he whispered to her, Is the first time.

He didn't stop thinking of Cigfa, of Pendaran, of his obligations to the people who would one day be his. (The stag, bellowing in the forest close by, constantly reminded him even if he had longed to forget.) But his conscience could not induce him to leave that place.

Perhaps I'm not *worthy* to receive sovereignty? he wondered, with some compunction, as he awaited the girl on the third night. I'm unworthy to be my father's son. But if I can travel no further than here, then so be it. Death is, after all, only the centre.

He slept fitfully before the door opened. She came later than on the two previous occasions. Loud but distant birdsong was announcing the imminence of dawn. Pryderi rose up to embrace her but she pressed him down. And before he could identify the more atrocious differences in her she had clambered astride him as if he were a horse, and impaled herself upon him.

Mule! she screamed into his face, and slashed at him with rough thongs. Mule! Mule! It was the voice of someone old in the throat of someone new.

Pryderi rocked his torso from side to side, crying out in pain and alarm. But she held him fast in the vice of her bone-narrow thighs. Even when she began to ride him she kept him completely immobilized.

What are you? Pryderi breathed as her misuse of him gathered a grotesque momentum. In this darkest hour, he could make out none of her features with clarity. But from what he *could* see, his tormentor was an anatomical abomination: a stomach which swelled up over her breasts, a cruelly warped backbone, hips as wide as her legs were short. This was no woman that he had ever come close to knowing. Yet at the same time he felt a spasm of recognition. There were elements in her voice and her smell and, most awesomely, in her *hideousness* that spoke to him of Cigfa.

What *are* you? he gasped again. Then he saw the flash of a blade high above him. *No!* he screamed. No! No!

No? she leered, crouching lower to blow her putrid breath deep inside his head. *No?* but slowly she brought down the cleaver and pressed it furnace-cold against Pryderi's chest. No? she asked. Then what?

Pryderi was weeping silently. What must I do? he said. Tell me.

In the grey dawn light he was being exposed to the secrets of her physiognomy. Her mismatched eyes, the teeth as yellow as broom, the high cheeks and senile sagging jowls, her raven-black sweep of hair. . . . Pryderi wept louder. Threaded through her deformity was a beauty that he knew, a beauty for which he had yearned long before he had ventured into Annwvyn.

Head of Annwvyn! she spat at him from her eminence. (It was her voice, *her* voice. The voice that had thrilled and filled him for two long nights.) You deserve no greeting and I offer you none. There's no shame in you. No worth. Because of you! she shouted, tightening her grip on the cleaver again. All because of you!. . .

Pryderi tried to strain away from her. He could bear to look at her no more – neither at her nor at any of the others. He'd discerned at long last the skein which connected this miscreation with every other woman in Annwvyn. He'd perceived that, in

truth, there was only one man in this theatre of a world and only one all-encompassing woman.

Outside in the forest the dogs were coming closer, and then he heard the roaring of the stag. What must I do? he panted again. But he had already anticipated her answer.

Slowly she swung herself off him, this transcendent woman so obscenely distorted. She turned and made to leave the chamber. The cleaver remained beside Pryderi. In the doorway she nodded, once, in the direction of the dogs' brutal music.

The beast is better dead, she said before disappearing. Offer the head to the woman who is yours.

Cigfa! Pryderi called out after her, but the name signified nothing.

His colt was waiting to take him to the water's edge. Pryderi listened intently to the baying of the hounds as he rode. Around him the birdsong was swelling, thickening, acquiring aural textures quite unknown to him.

He could afford to think of nothing but his duty. Bridge, swineherd, the spoils of Annwvyn. And the words: *You couldn't have done anything else . . . You've done what it was in you to do, nothing less. This was what your father wanted for himself, for his people, yet couldn't attain on his own*

They reached the river. He knew this river from a less careworn time. He knew this land, no longer Annwvyn but still not quite Dyfed. He was almost home. But the whole of him had never been in Dyfed, and less of him was returning now.

A short distance along the bank, a white mare was lapping at the shallow water. The stag, proud but spent, emerged from the forest with the first dogs already leaping and clawing. Pryderi had seen such dogs before: shining white with red-tipped ears. Rhiannon had kept them by her in the compound. Rhiannon. . . .

The dogs were unanswerable. Down came the stag, quickly, almost as if with relief. The colt led Pryderi forward. The dogs writhed and ripped, numberless as a colony of maggots, obscuring the dying beast. I am not worthy, Pryderi cried as he dismounted, to set about driving the hounds away from the carnage.

And it was then that the stag roared as Pryderi had known that it would. Delivered, finished. The sound of a death in life, a roar that had been rolling towards him ever since he had left his father's land.

I am not worthy! Pryderi bellowed back, then he brought down the cleaver. And after slicing the stag's head from its shoulders, the blade ripped deep, deep into the hard earth beneath. So deep that Pryderi had to leave it there, buried.

Before he could look up he knew that she was watching. Reverentially, he lifted the stag's head from the ground. He turned. The colt had disappeared. But Cigfa was there, holding up the empty platter, and Pryderi could see the miller's wife in her smile, the hag's foulness in her lips, all there, all there. An entire people concentrated in a single woman. One woman investing an entire territory.

Behind her, close to the entrance to the compound, a grey-haired man sat astride the white mare.

It was Manawydan. The mare was Rhiannon. Pryderi understood. Conclusively joined: two of the three beacons who had given his life its light and its shadow. And at last he acknowledged the truth that he had been unprepared to face ever since Cigfa had borne aloft that severed human head. He accepted, now, that Pendaran was dead.

Pryderi placed the stag's noble head upon the platter. And, as Cigfa looked into his eyes, nodding, he murmured: *He who is head, let him be a bridge for his people. . . .*

Then Cigfa turned and made her way down to the track which led toward the compound. Pryderi followed her, on foot once more for the colt was gone, smiling strangely at the shoals of people who had gathered to watch his homecoming.

His people. Faces which were familiar, faces which went with the stench of fear, faces disinterred. Pryderi did not allow himself to show his grief until he had entered the compound. None of his people dared to follow. Not yet. There was only Cigfa now, and Rhiannon, approaching from the stables. And behind her, Manawydan, leaning against the wall of the first building, watching, solemn-faced, holding the claw cup.

Thus did the four of them come together: two women, two men.

At Manawydan's side were the spoils of Annwvyn: a pearl-rimmed cauldron, turned on its side, and, milling about it, seven white pigs with flame-red ears. Here, in Dyfed – the spoils of Annwvyn, the dowry of Cigfa.

The man who had been lame walked steadily towards Pryderi but stopped short when he came to Cigfa. He exchanged his cup for her platter. Cigfa, in turn, held out the cup to Pryderi.

Welcome, swineherd, she said to him. Head of Annwvyn. Lord of Dyfed. Drink.

Dutifully Pryderi sipped the strong liquor from the cup. Then, empowered, he passed the empty vessel to Rhiannon.

His mother opened her arms and Pryderi pressed himself, weeping, against her. Sovereign, she whispered to him, Now you can be the bridge. Only you. You can light the fire beneath the cauldron in *this* world. You can ensure that the swine remain here until their number has doubled. You. No one but you.

I never denied him, Pryderi wailed into her shoulder. I never foreswore him. Never. So how was I to blame? For his dying, how was I to blame?

Rhiannon gripped his back. He was my jewel, she said dully, But you. . . you could have done nothing differently. And then she added, turning her head, He died before you left this land.

Pryderi drew back from her, incredulous, but he was remembering Pendaran's distant roar, the roar that had pursued him through Manawydan's island and then rolled ahead of him into Annwvyn. So long ago? he murmured.

Rhiannon smiled. Longer for you, she said, Than for anyone else. To us, here, it was only yesterday. But now you are ready. You have come into all three parts of your strength. The girl is yours, the cup is yours. And they. . . (She indicatd the gateway with a nod of her head), They are now yours.

Pryderi turned, and he saw behind Cigfa the first crush of his wide-eyed people spilling into the compound.

But no voice spoke inside him.

THE
THIRD
BRANCH
FULLNESS

Pryderi, the bridge between two worlds, has enhanced Dyfed beyond all recognition. But he is dissatisfied with his own life. He chafes at the constant company of Cigfa – and also at that of Rhiannon and Manawydan, who have now come together. Pryderi's world-weariness as sovereign leads to the desolation of his territory. Then he withdraws completely into an Otherworld *caer* or fortress. Rhiannon follows him inside. It is left to Manawydan to revive Dyfed by introducing agriculture. Manawydan finally prevails upon *Gwydion*, the all-knowing shape-shifting god, to bring back Pryderi and Rhiannon from their voluntary exile.

1

At the seam between the seasons, the twilight was merging with the dark.

In Pryderi's land of Dyfed, the new year was casting off the old.

Fresh fires blazed on the hilltops, there, close to where the land met the sea. And Pryderi, the proven sovereign, stood apart from his people.

Behind him the crowds were murmuring. Huge crowds, for Pryderi had amassed a territory three times broader than Pendaran's. Thankful people, raised from the mire by the years of Pryderi's lordship.

They had no fear. On May Eve they knew exactly what course to follow. Pryderi had marked it out for them so many times before. Alone he stood, the bridge made flesh, the hounds of Annwvyn curled awake at his feet.

His gaze was fixed on Rhiannon. Crouched beneath the cauldron, she carefully stacked the last of the kindling. In that night with no stars, the marvellous vessel seemed to be hanging from the sky itself.

A hush fell as Cigfa guided the seven swine forward. Before her she held the claw cup, brimful of liquor.

Pryderi moved in her wake, unhurried, large against the dark. On each May Eve he conducted himself faultlessly, diligently, for the sake of his dead father.

He came to his women, touched them and smiled. A broken smile. The sovereignty was his, the title and the trust were his. But the women would always have so much more. They would always, in themselves, *signify* so much more. He nodded at Rhiannon and she withdrew to fetch the brand.

While Pryderi waited, he raised his hands, as if to grasp the cauldron. But his reaching fingers hesitated. Then they fell, and Rhiannon was beside him, offering fire.

Pryderi took the brand. With a single sweep he set the kindling alight. Cigfa immediately proffered the cup, which he drained, then handed back. A cry went up from his people, followed by a flurry of movement on all sides.

Swiftly, skilfully, the pigs were slaughtered, hacked apart. Pryderi took each joint and placed it in the cauldron. Encircled by the shouting and screaming, he remained impassive. Surrounded by the land which he had enhanced, he looked sorrowfully remote.

As the night thickened, Cigfa and Rhiannon ushered the people forward, in threes, in sevens. Confident people, smiling as they came to receive the broth and the flesh from Pryderi. They took it with gratitude, but they took it as a right, no longer as an unimaginable privilege.

Until the sky was veined with dawn, Pryderi went about his work in a kind of trance – so distant from the supplicants, knowing that they *wanted* him to be distant. Necessarily, his sovereignty had split him from his people forever.

The fires burned low on the hilltops. The fresh season had been born from the old. Satisfied as Pryderi's people were, not one of them slept. Stretched out in their hordes, they looked up at their lord, the dispenser, alone against the towering mound.

He was strong, limber, inscrutable. His eyes narrowed as he strained to hear a voice inside, a voice which might guide him as it had guided his father. But his face soon relaxed. No voice had spoken – neither then nor on any of the previous May Eves. Pryderi looked about him. He looked back at the mound, accusingly, as if it had eyes to register his glare of accusation. Then he sank, as always, to the ground. And there, as always, Cigfa and Rhiannon were waiting to receive him. . . .

From the base of the mound, Manawydan marked all this.

His eyes moved from the cauldon to the mature sovereign and then on to the people he had freed, the land he had made full. This was the Dyfed that Pendaran had dreamed of. This was the fat land - indistinguishable, at times, from Annwvyn.

He looked harder at Pryderi. Cigfa and Rhiannon, so similar in their knowing silence, were soothing him. Manawydan knew that their soothings were no longer enough. And he knew why Pryderi had gradually withdrawn from them all: year by year his duties had become less taxing, his annual round had become more insipid. Nothing more was expected or demanded of him. As Lord of Dyfed, his time of challenges had passed almost as soon as it had arrived.

Manawydan could still see the raw young man inside Pryderi. He could see that young man *chafing*. And he foresaw him acting out of rashness – some catalytic act which would lay him open to the retribution of Annwvyn. Manawydan feared for Pryderi. He feared for him as a father fears for his son.

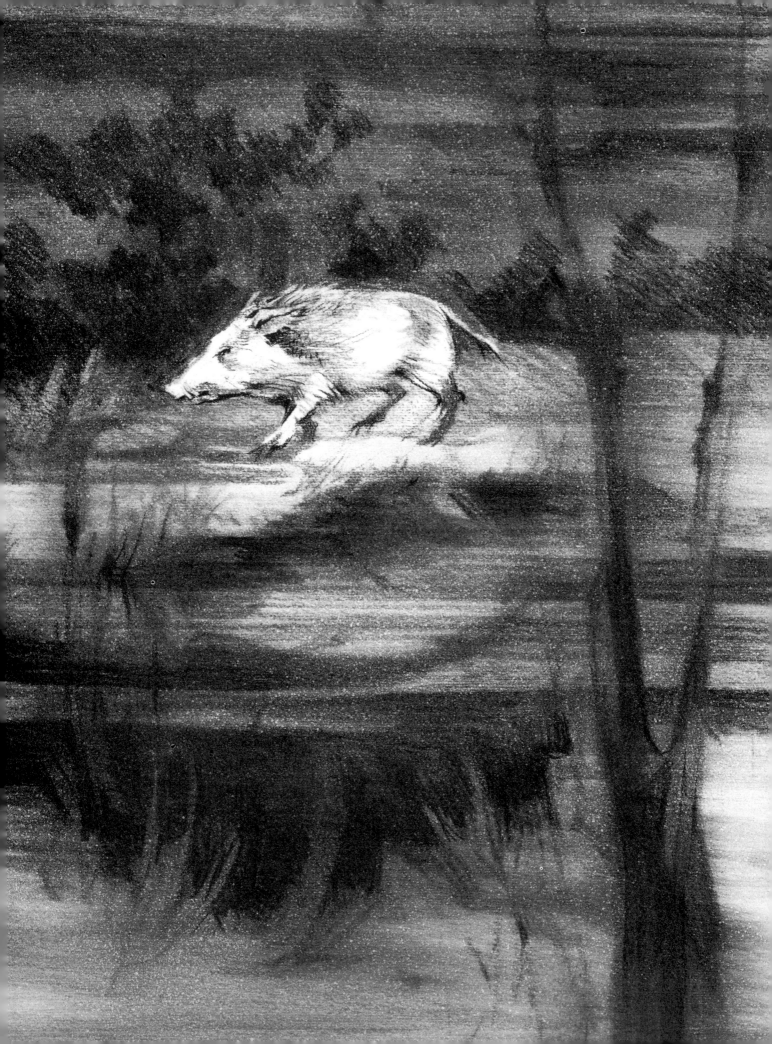

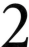

2

That year, as ever, Manawydan travelled on the circuit with Pryderi, Cigfa and Rhiannon. Two men, two women: two uneven and inseparable couples. In the eyes of Pryderi's welcoming people, they formed four parts of the same whole.

Wherever they went, the cauldron and the seven swine went with them. Each night the swine provided the staple food for the feast. Each morning, restored, they were waiting to move on. Strangely, though, they would not breed. The sows, like Cigfa, seemed incapable of issue.

One morning, during their stay on the island of Gwales, Manawydan woke soon after dawn. He had slept on the hall floor, where the previous night's carousing had ended. Rhiannon, coiled about him, was still asleep. The svelte form of Cigfa was close at hand, sleeping too beside the hounds. But Pryderi was pacing the floor, between two doors that he had thrown open to the sunlight. Manawydan went to him. He touched his shoulder but Pryderi broke away and strode to the far wall, to a third door which was closed. He leaned, arms folded, against this door.

This is a fat land, he said.

It is now, said Manawydan, smoothing his beard. You made it so. Pryderi's face darkened. (Sometimes, thought Manawydan, he can look as old as I.) Not me, he said, pushing himself away from the door. The cauldron, yes. The swine, yes. Cigfa and Rhiannon, perhaps. But not me. Never me.

Thoughtfully he approached the cauldron suspended above the embers. Then he gripped its rim, arms wide apart, knuckles vehemently white. For a moment he looked as if he were intending to shatter it.

Manawydan stepped forward. Pryderi glanced up at him and smiled.

What will ever happen? he asked. To me? Now?

Manawydan looked into his eyes. I don't know, he said, troubled. (Pryderi had never been so open about his discontent.) I've never known. I don't have that gift. I'm more like you than you imagine I am.

Pryderi nodded at the women. You mean you're not like them? he asked.

Manawydan closed his eyes. (There was Pryderi, bestriding two worlds, and here he was himself, belonging no longer to either. It was a similarity of sorts.) I'm closer to you, he said truthfully, Than I am to them now. He closed his eyes again. Once, he added, it was otherwise. . . .

Pryderi dropped his head. He didn't relax his grip on the cauldron. His hands seemed, to Manawydan, to have adhered to the rim. And for some reason, that notion made the older man uneasy.

All I know, Pryderi said to the cauldron through clenched teeth, Is Dyfed. . .

Manawydan nodded. And Dyfed is not enough?

Pryderi looked up, combative. Is *this* what you wanted, all of you? he asked, rolling his eyes around the sunshine-stippled hall, at the satiated bodies, at the flourishing mainland beyond the opened doors.

Manawydan considered. It's what your people wanted, he said softly.

My people, Pryderi repeated. Not really mine though, now. Hers perhaps. (He indicated the sleeping Cigfa.) Not mine.

Manawydan couldn't answer. He knew how Pryderi resented Cigfa. He knew how he'd always envied her *knowing* of his people, the ease with which she moved among them, the way that she was *of* them in a way that he could never be of them again.

You could be the lord of this land, Pryderi told him. I've let you take my mother. You could take the territory too. It has no need of me.

It *does* have need of you, Manawydan replied, softer still. Then he added, for his own benefit rather than Pryderi's, No land has ever needed me.

Pryderi looked hard into Manawydan's face. Oh, he said, smiling again, The passive lord! The ungrasping chieftain!

Then he tore his hands from the cauldron and swept across to the closed door. Manawydan watched him fling it back – so forcefully that he lost his balance and stumbled. Through the doorway there was nothing but water, sunshine scintillating on an expanse of morning water.

Contemplating the stillness, Pryderi seemed to slump where he was standing. He seemed to be buckling under a great new burden of sorrow. Manawydan, the man who had come by water, wasn't surprised by this change in him.

I must go on alone, Pryderi said at last. I'll take the pigs, and the dogs, but I'll go on without you.

Rhiannon began to stir. She had been listening. Now she sat up on the floor – as lovely as on the night she'd first appeared in Dyfed – and she dragged back the hair from her eyes. She didn't speak. Her expression was unreadable. But the sheer *relentlessness* of her gaze was telling Pryderi, eloquently enough, that he must stay.

Pryderi gazed back at her, then he turned to Manawydan. I do not imagine, he said with his sorry smile, That you have ever heard a woman talk better than she does.

And the first of the hounds scrambled to its feet, padded across to Pryderi and swarmed about his calves. He could not go. He couldn't be alone.

They went on to complete the circuit together. They roamed at leisure through Pryderi's delightful land, a land abundantly stocked with honey and fish, the best of all hunting-grounds.

But still Manawydan could see the chafing inside Pryderi – and this made his own fears all the more vivid. And the vision of a *caer* began to disturb his sleep. A colossal fortress, four-cornered, shining cold in the night. He saw the massed sentinels on its ramparts, but when he shouted up, they could give him no answer.

Manawydan thought he understood. Rhiannon's lost children were inside that place of detention. He knew that there was a cell there too for Pryderi. *A perfect prison,* a prison which Pryderi might *choose* to enter. He said nothing of this to either Rhiannon or Pryderi. But sometimes in the long days he would hear hoarse laughter high above him, and a familiar voice, taunting. *Husbandman!* it called, *Husbandman!*. . .

In time they returned to Arberth, to the court beneath the mound. Cigfa and Rhiannon made ready for the feast at once, setting up the cauldron in the newest of Pryderi's halls.

During the first sitting, Manawydan watched Pryderi closely. He seemed scarcely to

be noticing the swirl of activity before him. His face was drawn, his head tilted to one side. But slowly his forbidding expression softened.

My lord? said Manawydan, edging closer.

Pryderi's smile became triumphant. The voice, he said.

What does the voice say?

That I must take my place on the seat of power.

(Manawydan pursed his lips, and passed a finger across them.) Nothing more?

Pryderi shrugged. That I will be struck by blows and wounds, or I will see a wonder.

Do you think, Manawydan asked, This is a voice you can trust?

Pryderi simply looked past him, at Rhiannon. She was hiding behind her veil of a smile.

Manawydan, deeply uneasy, persisted: Is it a voice that you recognize? (He couldn't help recalling the *caer,* and also, for no clear reason, a distant confrontation: a meeting in a less dangerous place, when Gwawl had warned Pendaran, *Trouble will follow you as a matter of course. . . .*)

It is a voice, said Pryderi, rising, That men have heard before me. Many men. My father. . . .

And he stepped down from his dais, skirted the musicians and headed into the twilight.

Manawydan surveyed that teeming hall before following him out. He saw the fearless faces, the warm and easy safety. And he marvelled at the distance that had already been covered. Does he understand, Manawydan wondered, That he could put all this in jeopardy? Does he have any idea? (And, dejectedly, Manawydan sensed that Pryderi *did.*)

Cigfa and Rhiannon had already left the hall. Manawydan caught up with them at

the base of the mound. Pryderi, halfway up, looked down.

All of you? he asked disparagingly, then continued his ascent, indifferent as to whether they accompanied him or not.

In the dim light, they could see little enough from the summit. Down below, out of curiosity, a small company of Pryderi's people had gathered. Beyond them the smoke from the cauldron fire billowed through the hall roof, and occasional strains of the musicians' songs floated as far as the mound, then faded.

This is a fat land, Manawydan said, rueful, with a sweep of his arm. Then he sat beside the two women.

Pryderi, still standing, glanced about him, nodding. Manawydan knew that, for Pryderi just as for Pendaran, their Dyfed could never be enough. He felt sympathy but also alarm. He knew that this would prove to be an end. *(Husbandman! Husbandman!* the voice whispered, clearer than ever. The voice which he knew to be Gwawl's. But none of the others chose to hear it.)

At last Pryderi sat, and the four of them watched as the last light failed. Then they sat deeper into the night, restless, not speaking.

Pendaran sat here, Manawydan kept thinking, And Pendaran never doubted that he would see a wonder. . . .

Rhiannon was staring into his eyes. The blaze-white phantasm. Many times he had imagined Rhiannon's couplings with Pendaran. Too many times. Her jewel, she had called Pendaran her jewel. For him, she had come to this world. For him, she had abandoned Gwawl and set in train this tragic sequence. All for him.

Manawydan watched the men below drifting back towards the hall, their curiosity dampened by the waiting. He could hear little now save the distant baying of the hounds. The last thing he remembered seeing was Pryderi, looking skywards. But the first sound, shortly before dawn, came churning from below.

It was like a single peal of thunder, initially barely detectable. But then the echo of the peal changed tone, drew itself out into an almost human wail. A beseeching cry, a sound that went with the life of Pendaran.

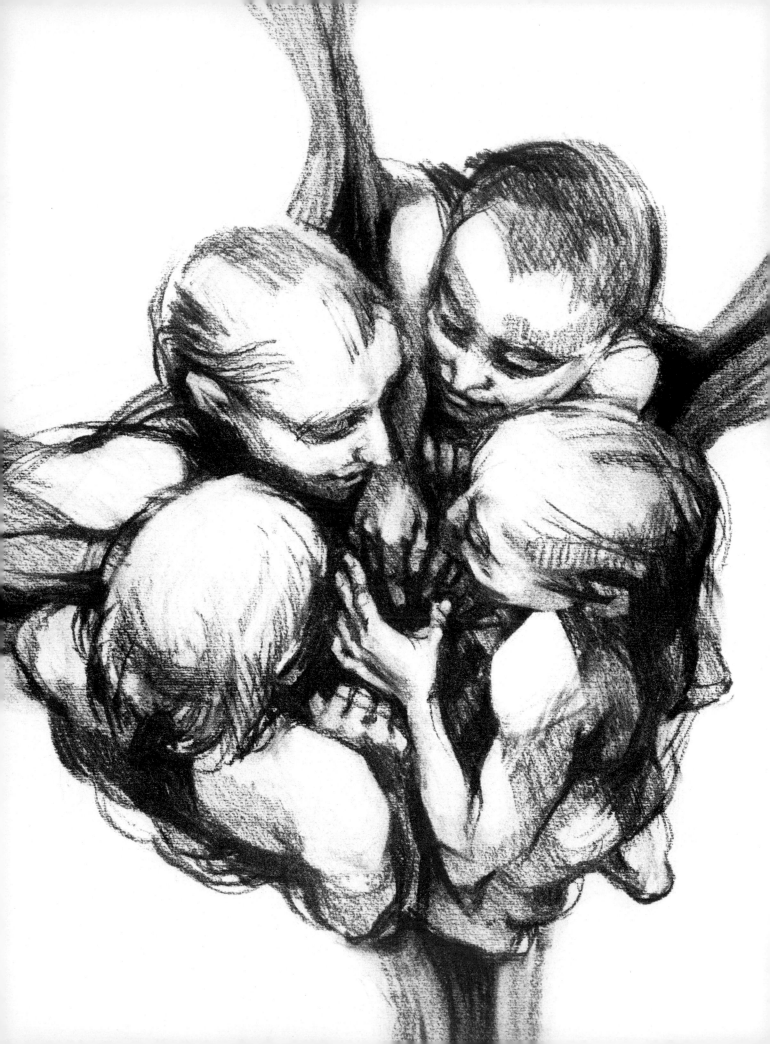

Before Manawydan could begin to identify it, the mist coiled up around them all. Cloying skeins, thick and damp, shrouding them one by one. Manawydan struggled to his feet. He tried to call out but the words failed in his throat. He felt the agony in his thigh moments *before* the one stunning blow prostrated him.

When he came to, the mist had slipped from them, and all around there was silence and a searing brightness. Pryderi helped Manawydan to his feet. Shielding their eyes, the two men looked about them dumbstruck.

Under the artificial light they could see far into the distance on all sides. And nowhere was there any sign of life. No flocks, no herds, no smoke. They could see clean through the court and not a soul was there. No people, no swine, no cauldron, no fire.

At last, out beyond the stables, one of the dogs barked, then another. The hounds of Annwvyn had been spared. Only them.

Manawydan, freshly crippled, leaned against Pryderi. In front of them, Rhiannon and Cigfa were still seated. Already there was a new leanness to Cigfa's face, the start of her slow decline. Rhiannon, by contrast, appeared radiant. This light, thought Manawydan through his pain, could have been designed to set off her beauty.

Pryderi put his arm about Manawydan's shoulders. As the brightness yielded to a red dawn, he scanned his emptied land. Then, quietly at first, he laughed.

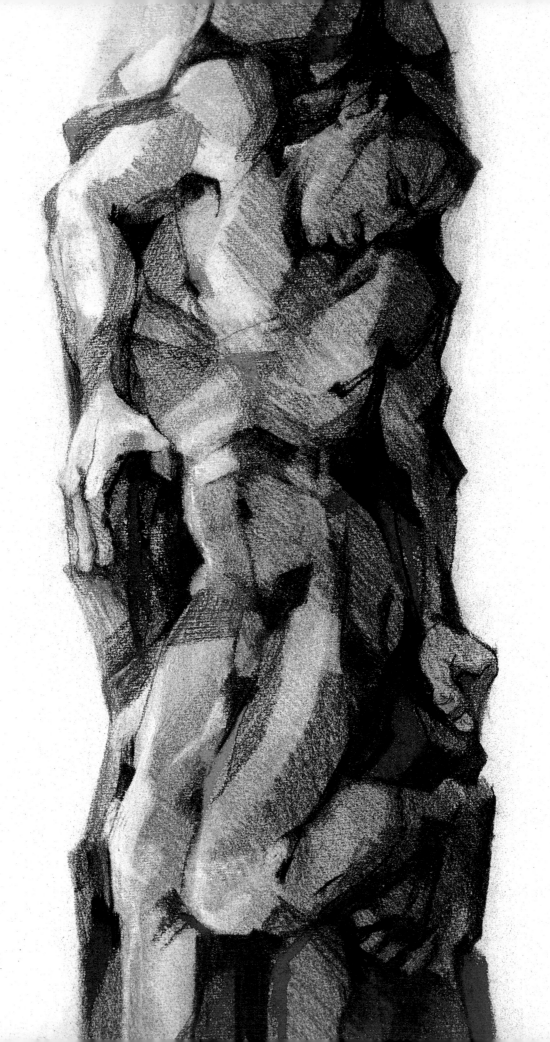

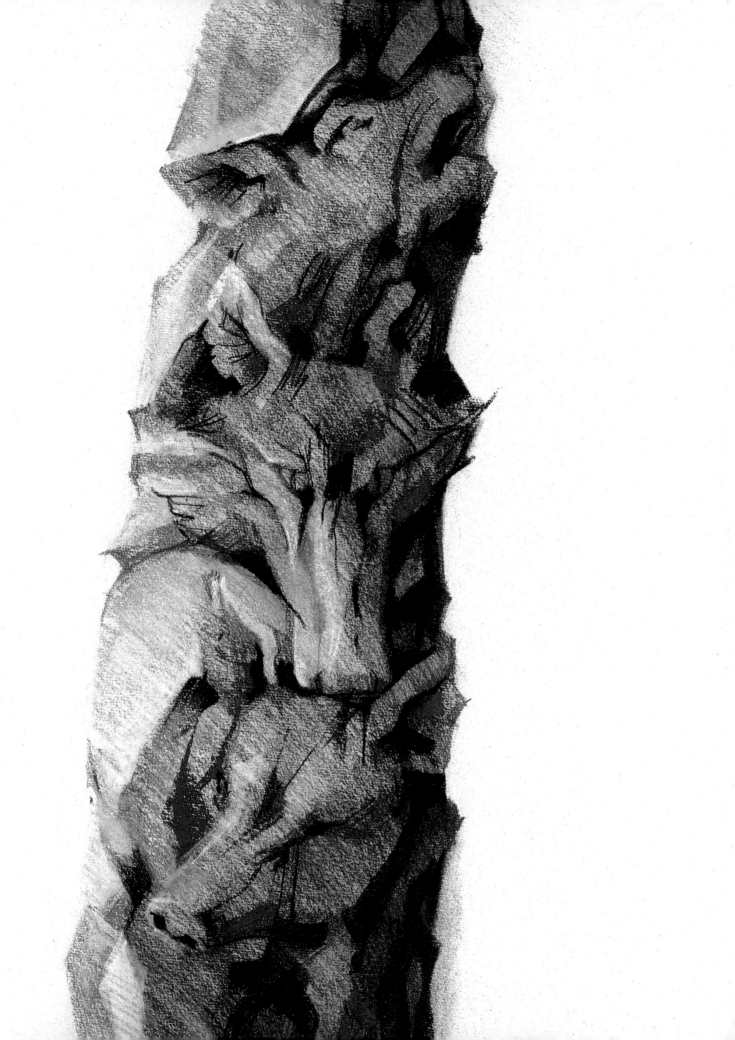

3

For one year Pryderi led the others through his husk of a territory. Then for a second he led them back the way that they had come. They travelled slowly: Cigfa's condition deteriorated by the day; Manawydan, lamer now than he had ever been before, found every step a challenge.

But Manawydan accepted that they had to keep moving. Often in the evenings, huddled about a fire, he would study Pryderi's flushed, unseeing face. And he would understand the sovereign's need to continue the search for his people, to try to win back what had been lost.

When the several courts' provisions ran low, the lame man caught fish enough to feed the four of them. Then Pryderi would disappear for days with the hounds, and return with red flesh from the forests. There was no question of these survivors starving to death. Neither did they ever lose heart.

This interested Manawydan. He was aware that Cigfa and Rhiannon drew sustenance from sources far beyond his understanding. But *Pryderi's* new equilibrium intrigued him. Since the night on the mound, Pryderi had been far less anxious, constrained, unfulfilled. He seemed to be relishing the sheer unexpectedness of his experience. And, although he never said as much, he seemed confident that the desolation of Dyfed would not last.

It was a confidence which the older man couldn't share.

As the second year came to its end, Manawydan's presentiments of danger surfaced once more. Again the voice of Gwawl came to distress him: *Husbandman! Husbandman!* it mocked. Manawydan dreamed repeatedly of being locked *outside* the luminous fortress. He dreamed of that feeble trick by which Pendaran had cheated Gwawl of Rhiannon. And he awoke, each morning, with the conviction that he was going to be in some way *responsible*.

At the year's end they returned to Arberth. Traditionally this was the place where every celebration began. (Manawydan had often wondered why Pryderi hadn't ascended the mound a second time – but he had never charged him with it.)

When Pryderi saw the mound, a change came over him. Quite without warning, the patience of two years deserted him. That evening, for the first time, he spoke with bitterness of the misfortune.

Is it me? he railed at the three of them. Was I to blame? Was the fault really mine?

Manawydan looked deep into the fire. Pryderi was on his feet, mobile, expansive. It's not you, said Manawydan.

Then *what?* Pryderi bent down suddenly to close with the older man. By instinct Manawydan raised an arm in defence. Tell me what! Tell me why!

Manawydan looked away. I can tell you nothing, he said, mortified. Nothing.

Pryderi straightened himself and rounded on Rhiannon, resplendent in the fire's glow. And you, lady? he breathed.

Rhiannon smiled. She reached out and caressed his ankle, then ran the palm of her hand over his calf. My son, she said, My son. (Her smile widened, but her eyes appraised him shrewdly.) You must respond, she went on incongruously, In whichever way you think best.

Pryderi sank down until his eyes were level with hers. But was it *me?* he pleaded.

No, said Cigfa from the shadows. Her voice was weak but still assertive. It was because of *what* you are, not *who* you are. . . . Because of circumstances before you came to be.

Manawydan, seeing the confusion in Pryderi's face, wished that it could have been simpler. (Sometimes, although he never dared to say so, he felt that the women wilfully compounded Pryderi's difficulties.) Cigfa held Pryderi's eye. There was a cadaverous look about her, frail, bilious, preternaturally aged.

You know, Pryderi asked, looking from Cigfa to Rhiannon, What is going to happen? To me?

There was a long silence before Rhiannon spoke.

You are the bridge, she said eventually. You are unique.

Pryderi screwed up his face in a kind of anguish. You won't help me? he said.

It's not a question of help, said Cigfa. You must respond in whichever way you

think best.

Propped up on her elbows she stared beyond Pryderi to the mound's silhouette against the darkening sky. Pryderi twisted around to follow the line of her vision.

I shall be responsible, thought Manawydan. I shall do for him what the others can't or won't do. And when he too gazed toward the mound, he saw the faintest afterglow of a towering *caer,* and in the silence he could hear the sentinels' footsteps.

They remained at that court, morose and uncommunicative, for a full year. Pryderi's only pleasures were to run with his hounds, to hunt wild beasts for whose roasted flesh he then had little stomach. Late one night, Manawydan found him pacing the overgrown track where long ago Rhiannon had been made to carry men on her back.

Tomorrow we will hunt, Pryderi said without breaking step. There is a new quarry close to us now. I know it. (He laughed a strange raucous laugh.) We'll hunt and forget.

The following morning they left before the women woke. Pryderi's spirits were high. On the outward journey he chattered ceaselessly to his hounds, exciting them for the chase which he knew lay ahead.

Sure enough, before noon the hounds caught a scent. At once the pack raced into a small copse and disappeared from view. Pryderi, who usually preferred to run with them, remained alongside Manawydan. The two men watched the copse without speaking. Then they started as the hounds came drumming back towards them.

When the fastest reached Pryderi, its eyes were wide with fright and it was trembling – not from exertion but from fear. The hounds which came up behind it were similarly troubled.

Pryderi, smiling, made for the copse immediately. The hounds went too, taking care not to outrun their master. Before they were out of Manawydan's earshot, they stopped dead. A silk-white boar had crashed out through the bracken at the copse's edge. Seeing the hounds, it sweetly changed direction and veered away in the direction of the court.

Pryderi hollered after it, shaming the hounds into giving chase. He returned to Manawydan's side, and stood, hands on hips, marvelling at the size, pallor and speed

of the boar. Then, when the heaving creature turned to face them on dainty legs, standing at bay against the hounds, the two men closed in.

Manawydan, limping, put a hand on Pryderi's shoulder. Pryderi, thinking the older man needed his support, strode on. But Manawydan was vainly trying to restrain him. He had seen the shape of the wolf inside that boar, and the shape of the stag.

The creature is not from this world, Manawydan said, struggling for breath. Leave it. Avoid it.

But Pryderi wouldn't listen. And when they were within striking distance, the boar backed away, turned and ran again towards Arberth. So it continued until Pryderi and Manawydan came within sight of the court.

Manawydan, stunned, gripped Pryderi again. Pryderi had already halted. Ahead of them was no mound. Manawydan shielded his eyes from the brightness.

What are you seeing? he asked Pryderi, unsure whether this vision were meant for him alone.

Pryderi didn't answer. Manawydan let go of him and stepped closer. The *caer* was just as he had dreamed of it. Tall, prodigiously tall, constructed from translucent stone unknown to Dyfed. The sentinels gazed out from the ramparts, oblivious to the white boar which rushed in through the portals, closely pursued by the pack of Pryderi's hounds. Immediately the clamour of the hounds ceased. The silence seemed to splinter through the entire land. Then Pryderi stepped past Manawydan, purposeful, smiling.

I can only offer my counsel, Manawydan called after him — hopelessly, because he knew that Pryderi had no reason to listen, And I counsel you not to enter this *caer*.

Pryderi, breaking into a trot, smiled over his shoulder. My dogs, he shouted back, I can't give up my dogs. And besides, the voice advises me to follow them.

Manawydan made after him. He had seen the wolf and the stag in the white boar. He knew that Pryderi was being enticed back into Annwvyn. And he knew that Pryderi was fleeing into the *caer* of his own free will. There was no question of duress. The sovereign was simply responding in the way he thought best.

He watched Pryderi slow down at the portals, and peer inside to find no trace of the boar or his hounds. Manawydan was close enough to see what *was* inside.

Neither man nor beast. No sound and no shadow. But a shimmering airy courtyard, open to the sky, with a fountain encircled by marble. The fountain seemed to be set in the centre of the *caer,* but its refreshing waters fell in every corner, leaving no stone wet.

And beside the fountain, over a marble slab, a broad golden bowl hung from chains without end.

Don't! Manawydan cried out to Pryderi. But he himself shared Pryderi's compulsion to lay hands on that bowl – unlike the lost cauldron, yet somehow so poignantly reminiscent. And Pryderi was already inside the *caer,* crossing the courtyard to the marvellous vessel, looking about him delighted.

He's lost to me, thought Manawydan. I can no more go in there than he can now come back.

And his heart went out to Pryderi with his bright, keen face. Pryderi - unable to resolve his own ambiguity, rushing to embrace an early death.

Pryderi circled the bowl three times before stepping on to the marble slab. He saw Manawydan watching, harrowed, just outside the portals. I must respond, he shouted defiantly to the lame man, In the way I think best. . . .

They were the last words Manawydan heard him speak in the *caer.* Pryderi closed his hands around the rim of the bowl. Then contemplating its interior, his expression became in rapid succession troubled, stupefied, beatific.

Manawydan sat and stared at him for the rest of the day. Pryderi had made no discernible move since the moment he'd grasped the bowl. He seemed to be petrified, an extension of the slab on which he stood.

Dusk fell but the light inside the *caer* stayed limpid. Manawydan could understand why Pryderi had gone inside. He could see the attraction. But he also sensed that the figure in front of him was only the shell of Pryderi, just as the land about the *caer* was only the shell of Dyfed. The true Pryderi had been spirited away to a different place, darker, deeper.

First Llŷr. Then Mabon. Now Pryderi. The three exalted prisoners of the Island of Prydein.

Manawydan felt Gwawl's breath at his shoulder. *Husbandman! Husbandman!* crowed his voice. But when the lame man twisted round he saw only Rhiannon, striding white along the track from the court. Manawydan stood to receive her: the bringer of death in life and life in death.

She came up, saw what Manawydan was seeing and rested her head against his shoulder. The hounds, then my son, she said as if in reproof. Now I must follow.

You?

She drew away from Manawydan and held out to him a sack. You don't have to use this, she said. Manawydan took the sack and he thought of Gwawl, writhing inside it. Rhiannon kissed him on the face. She looked serene, vindicated.

You know that I'll use it, Manawydan told her. You know it's not in me to do otherwise.

Rhiannon drifted away from him, already preoccupied, into the *caer*. It was where she belonged, the world from which she had chosen to displace herself. She was on the marble slab beside Pryderi. She was laying her hands upon the golden bowl.

A woman and her son, motionless in a dazzling dusk, two captives in the perfect prison. And the thunderclap wail issued from the ground again, and the *caer* was wrapped in a mist of its own making.

Impotent Manawydan laboured back to the court. The mist was spinning itself out as far as the gatehouse. There was a stench of corruption in the air, sickeningly sweet. Manawydan accepted, almost blithely, that the smell was his own, fused with that of the fast-decaying land about him.

A shadow approached from the court, gathering definition through the mist. Manawydan raised a hand to the shape that defied description. Part of it was horse but another part was woman – woman distorted beyond the margin of reason.

Manawydan staggered toward the apparition. It was Cigfa, astride a mule. In the starless dark and mist the two seemed to have been grafted together. Manawydan

called out her name but in reply she wailed, loud and long. In her hand were rough thongs which she flailed uselessly at the air.

Cigfa! Manawydan repeated, going to her, horrified by the speed and completeness of her degeneration. She withdrew from his touch, laughing behind her hand.

My own lord gone, she cackled, And you come for me so soon! Take me and the land is yours. Take possession, landless chieftain. Take possession!

Manawydan, desperate, grabbed her with one hand and held up Rhiannon's sack with the other. There are other ways to restore this land! he thought as he stared into her dreadful face. I *will* be the husbandman, if that's how it must be. But I'll never take you. I'll bring him back. There are other ways. I'll bring them both back. . . .

Then came the sudden swell of sound. Wailing, thunder, birdsong, laughter – an eruption of chaos from the towering *caer*. He closed his eyes and limped on to the deserted court. There was another way.

Cigfa wheeled around on her mule, and followed Manawydan through the cacophony.

123

4

Husbandman! Husbandman!

However far Manawydan travelled from the *caer,* its beacon light and its music pursued him.

Even when he beached his coracle on his own island, he knew that he hadn't escaped the sentinels' surveillance. Why do they watch? he wondered as he shuffled up to his granary. Why do they need to see what they already know?

He poured the seed into Rhiannon's fathomless sack – enough to sow three crofts. Every time is the first time, he assured himself as the chanting from the *caer* caressed the air about him. But in truth Manawydan felt close to succumbing.

Husbandman! Husbandman! Husbandman!

He dragged the sack back down to the shore. His island was clean and calm, safely placed between two contaminating worlds. But again he had to abandon it. He had *always* been abandoning that blameless island. And he vowed that the next return would be his last.

The coracle gathered speed. The revolving beam of the *caer,* ever brighter, swept the waters all around. Gwawl's crowing laugh came to him again. Not a malicious laugh, Manawydan realized now, but collusive, vulnerable, a laugh of resignation.

Enough, Manawydan whispered to the sack which he was clutching to his breast. After this time, enough. . . .

On his arrival in Dyfed he could find no trace of Cigfa. It had become a land unfit for any kind of habitation. Where once there had been forests or pastures, now eddies of smoke drifted in from the horizon on a silent wind, grazing at the detritus. And through this desolation the bright cold light of the *caer* was shining. And twisted around the light was the ceaseless song of decay, monotonous now, burning the heart out of all that was left alive.

Manawydan selected some ground on three sides of the court. He broke the crust of earth, then carefully tilled the soil within the areas he had marked. The days were dark. The noise from the *caer* was witheringly loud. Manawydan worked on, reduced to eating meat from long-dead beasts of the forest.

Husbandman, the voice whispered, almost encouragingly now. Manawydan took his sack of seed and he sowed all three crofts in rapid succession. With his work completed, the decline of Pryderi's territory was, at least temporarily, arrested.

One season gave way to the next, Manawydan found meat and fish easier to come by. The land all around regained its former colour. But still the people and their herds did not return. Still Pryderi remained in his fastness.

Through the days Manawydan occupied himself by constructing a watermill. At night, resting wakeful in the chambers of the derelict court, his thoughts would always turn to Rhiannon, to Llŷr and Mabon and Pryderi. He chose never to look at the *caer* directly. But often he mused on its subterranean cells, its keening captives, its laughing, whispering custodian. *The perfect prison,* he would repeat to himself, over and over, until the words lost what meaning they had ever possessed.

Sooner than he had expected, the wheat in one of his crofts ripened. Good wheat it was, the first seen in Dyfed. During the night before his intended harvest, he dreamed that Cigfa came to him. Not the distorted creature he had last seen astride the mule, but a firm, slender girl, holding up a cup.

She said nothing. Manawydan understood well enough without words. She was offering *him* the sovereignty. A land, a cup and a woman. All Pryderi's, all now his for the taking. . . .

Even if I were in the prime of youth, Manawydan came awake shouting at the dawn, I would still be loyal to Pryderi!

But when he went out to reap his wheat, the croft had been devastated. Only the naked stalks remained – each one sundered just below where the ear had been.

Manawydan looked about him in confusion. Mice were scuttling away in all directions but this was the work of no natural creatures. *Husbandman, Husbandman. . .* the voice on the breeze commiserated.

During the course of that day, the wheat of a second croft ripened suddenly in its turn. By twilight it was ready for harvesting. Manawydan was determined that this second croft should not be lost. He stayed awake through the entire night, listening, watching, a sharpened cleaver at his side.

Shortly before dawn Cigfa came to his chamber, even more beutiful than she had been the night before. When she proffered the cup, Manawydan dashed it to the ground.

No contents spilled out, Cigfa stood in front of him, weeping, available, the woman who went with the land, the woman whose fertility would mirror that of Dyfed. *Pryderi's* Dyfed.

No! cried Manawydan, rising. Never! No!

In the grey morning light, the revolving beacon of the *caer* shone brighter than ever across the cultivated earth. The second croft had been ruined just as the first had been ruined. Again there was the retreating horde of mice. Manawydan, without thinking, began to stumble towards the *caer's* portals.

Enough! he roared when he was close enough to see that the gates were now barred. *Enough!* The echo of his voice swirled back from the grey dawn sky, and the sound of it shook the track beneath him.

He had to keep vigil over his last croft. It was all he could do. Through that day he went among the splendid crop, knowing that on the following morning it would be ready to reap.

When it grew dark he remained outside the court. He lay down before the flames of a small fire. And on one side of him was the cleaver, while on the other was Rhiannon's sack. He did not expect Cigfa to appear but she came none the less.

In the glow of his dying fire he saw her standing in the croft. He could see only her head above the ears of wheat. When she began to move, towards him, her step was tentative, awkward. She came before him, smiling. Her arms hung loose at her sides. She held herself in a way which suggested that she was pregnant.

Manawydan, standing now, stared hard into the fire. It can't be, he said. It cannot be.

Cigfa knelt, placed her arms about his shoulders and rested her cheek against his beard. It *could* be, she said softly. There are many ways. This is one other way. Take possession. Now. . . .

I will not! the lame man said, casting her aside and taking up the cleaver and sack. But he had been distracted for too long.

The third croft was screaming with mice and not one ear of the wheat seemed to have been left on its stalk. Manawydan, raising the cleaver above his head, prepared to swing round and bury it in the treacherous Cigfa.

But when he turned, in his anguish and his fury, he saw not Cigfa but the shape of a tall, auburn-haired man, moving slowly away from him.

Gwawl! Manawydan bellowed. Instinctively he threw down the cleaver, then he stepped forward and reached for the custodian's shoulder. As soon as his hand touched the man, a torrent of discord broke from the *caer*. Manawydan closed his ears to the din of shattering masonry, of warped human voices. All he could feel was his need – the need to confine his tormentor.

The struggle was swift, conclusive. Manawydan's antagonist scarcely resisted. (Indeed, the lame man was sure that, through the tumult and the flailing of limbs, he continued to hear the crowing laugh.) Holding him down with one hand, Manawydan threw the sack's open neck over his head, turned him, and pulled the drawstring tight.

Enough! said a voice close beside him. Cigfa's voice, Enough.

Manawydan glanced at her. This was the pristine Cigfa, just as she'd been on the night they had climbed the mound. She seemed pleased, in her own sardonic way. He looked beyond her at his third croft and it was perfect again. The full sack beneath him was quite motionless.

And slowly the suggestion crept up on Manawydan that he had been outmanoeuvred.

It's not in you to kill him, said Cigfa. Release him.

Manawydan kept his eyes on the sack. Free Pryderi first, he said, as helpless as a child.

Cigfa came close and touched his arm. It's not a question of freeing him, Cigfa told him gently. He's been under no restraint. But he will come, now, because of you.

She urged Manawydan to look towards the *caer*. But all he could see was the mound, and, walking away from it to the court, Rhiannon, then Pryderi.

The lord of Dyfed was carrying the cauldron of Annwvyn. Around him were the seven swine and rushing on ahead were his hounds. His face was composed, unabashed. It was the face of a man who had grown used to wonders. As he walked, he looked about him at his Dyfed, profuse again, peopled again, not unlike the way it had been at its zenith.

Now untie the sack, said Cigfa, and Manawydan stooped to do as she asked. The man who stepped out was not Gwawl.

He was older, narrower, altogether more formidable. There was the look of the silk-white boar about him, and Manawydan, crestfallen, knew him to be *Gwydion*.

This land will now be safe? Manawydan asked him, hesitantly.

Gwydion nodded, indicating Manawydan's unspoiled croft, which was the way forward for Pryderi's herding people.

Pryderi will be safe?

He *was* safe, said Gwydion, With his mother. He was happy. But because of you, he has returned. Manawydan had no answer. Every time, he said as if in extenuation, Is the first time.

Neither Rhiannon nor Pryderi looked in his direction as they passed by. Cigfa withdrew to follow her lord into the court.

When will Pryderi die? Manawydan said when they were all out of sight.

Gwydion smiled. Not an unsympathetic smile. He needn't die, he replied. Until the number of the swine has doubled, he needn't die. But he will long for death. He will ask for death. . . .

And Llŷr? asked Manawydan. Mabon?

Gwydion turned and began to make for the north. Later, he called back, Their time is later. . . .

Manawydan sank to the ground. Without tears he wept. I couldn't have done anything else, he told himself. Not me. I responded in the way I thought best. And I can only, ever, respond in that way. It's all that's in me.

He looked out at the restored territory, at the plumes of smoke from fresh fires and the bustling at the gatehouse to the court. And his sense of detachment, from *both* of these worlds, was more exquisitely painful than any physical wound that had ever been dealt him.

He raised his eyes to the mound. The voice, which sounded so distant now, returned on the breeze. It sang one verse:

> *Perfect is my seat in Caer Sidi:*
> *Plague and age hurt not him who's in it -*
> *They know, Manawydan and Pryderi.*
> *Three organs round a fire sing before it,*
> *And about its points are ocean's streams*
> *And the fruitful spring above it -*
> *Sweeter than white wine is the drink in it. . . .*

Manawydan sat for a long while.

Towards noon he got to his feet. He walked briskly back down to the sea, making light of his limp.

THE
FOURTH
BRANCH
RETURN

Pryderi knows that his own death is imminent. Manawydan has abandoned
him, Cigfa has turned from him. Rhiannon then sends him away from his
own court. Twelve strangers come to his new encampment in the north.
One of them is Gwydion. Pryderi, desperate to return to Annwvyn, asks
Gwydion to release him from his lordship. Pryderi subsequently undergoes
a form of death which is also a rebirth and an exchange. Thus he passes at
last into the magnificent Otherworld. And at the same time *Gwri*, his
stallion alter ego transformed into mortal man, is released from Annwvyn
to assume the sovereignty of Dyfed.

1

Pryderi looked out.

As always she was there, Cigfa, down by the gateway.

Her eyes searched the horizon: farmsteads, granaries, mills, the mound. Still she was waiting. And when she wasn't waiting at the gateway, she would continue her vigil in the stables. Waiting so patiently, apart.

A land, a cup and a woman: Pryderi had come to regard them as his own in perpetuity. But now Cigfa had ceased to offer him the cup.

A new time was coming. Somewhere, beyond, a new man was waiting.

Tell me what I must do, Pryderi said quietly to Rhiannon, who stood behind him. Tell me and I'll do it.

Rhiannon came close and touched his shoulder. They looked out together.

In the cool courtyard the seven swine were roaming free. Still only seven of them. Pryderi knew that until their number doubled, there could be no release for him. At least until then he would have to remain the swineherd, Cigfa's restless consort.

If they won't breed of their own accord, he said, What can I do?

He stood firm as Rhiannon pressed herself into his side. She was reassuring him, seeking to remind him. Nothing more. (When they had been in the *caer* it was different. But memories of that *caer* had slipped from Pryderi almost as soon as he had left it. All he could remember, now, was the sense of completeness, the tantalizing nearness of kin, and Rhiannon, smiling, presenting him with the other side of herself. And that was enough to make him yearn to go back.)

How much longer must I wait? Pryderi asked, his seasoned eyes fixed on the woman at the gateway. Why will they not breed?

And Rhiannon whispered to him. *No one has spoken of breeding. . . .*

That night Pryderi stood over Cigfa as she slept between the two white stallions. He had heard her speaking to them. *Mabon,* she called one, *Llŷr* the other. Familiar names. And Pryderi was reminded, as so often, of his own white colt. The colt that

had come on the night of his birth.

He remembered that colt, so long ago, lowering itself into the dust of wasted Annwvyn, rocking with the turbulence from below, watching him without expression as he prepared to sever the claw from the beast. The blue-eyed colt, a stallion now in Annwvyn. The horse which had led him to sovereignty, then allowed him to return to Dyfed alone.

For whom are you waiting? Pryderi asked the sleeping Cigfa. And two words stood up in his head. The first was *Exchange.* The second was *Gwri.* Pryderi smiled. A narrow, abstracted smile.

When he left the stables, his people were fanning across their fields in the silver dawn. Self-willed people in a full, ripe land. Pryderi went to the wall of the sty and sat on it. Behind him the mound was lowering. He wanted to be away from that place, away from reminders of his own unworthiness. The seven pigs, whole again after the previous night's feast, seemed unquiet too.

You should go north, said Rhiannon when he saw her next.

Pryderi closed his eyes. It was as if a great part of his burden had already been lifted.

This at last was to be his release. His people, having learned to combine so fruitfully, no longer required his constant supervision. He accepted that he had made himself expendable. He had known that for so long. But still he was unsure what Rhiannon was intending. What of the cauldron? he asked. And the swine?

Take them with you. Take them to Rhuddlan by the Teifi. But leave your dogs here. (She smiled at the sudden concern in Pryderi's face.) They will be safe, she told him. They will be safe, with me. . . .

When he was ready to leave, Rhiannon embraced him hard and long. Having given birth to him, she now looked half his age. But the son no longer shrank from his mother's unnerving beauty.

And he knew that he would not be coming back.

Have I been a hostage? he asked her. Here, in Dyfed? I feel as if I have been, all

along, a kind of hostage.

Rhiannon looked through his eyes. She was no more than a girl before him, all-knowing, all-seeing. She nodded her head slowly, not in assent, but to show that she was weighing his question.

A hostage against what? he persisted.

Go to Rhuddlan, Rhiannon said.

A hostage for Gwri? (It was the first time he had spoken the name. As soon as it had been said he felt the awful space that it had gouged out of him.) Is it Gwri whose eyes have always watched me, whose voice has spoken inside me?

Go now to Rhuddlan, Rhiannon told him, turning away.

Pryderi parted from her, safe in the knowing that he could never truly leave her behind.

At the gateway Cigfa, her lips moving silently, watched him drive the pigs through. She appeared to be counting them out as they passed.

Are you mocking me? Pryderi asked as he came alongside her.

She made no reply. A splendid woman without issue, she seemed hardly to be there at all. Pryderi had never known her, never wanted her — not in the ways his father had known and wanted his mother. No indissoluble bond had ever been formed between them.

You were the bridge, Cigfa said, as if she were speaking in confidence to the mound, You were the mighty swineherd.

Pryderi looked at her levelly. Are you saving yourself for Gwri? he asked. Is he the one who waits?

Cigfa had no answer for him. She looked harder at the mound.

Who is Gwri? Pryderi beseeched her, fierce. And when Cigfa didn't reply he grabbed her by the wrist.

137

He's the better part of you, Cigfa replied with a smile, Now let me go. Let me go. . . .

Pryderi left Arberth with only a small company of men and women, and in truth he would have preferred to have been alone.

He walked slowly through his ordered territory, confused with relief. Wherever he passed, his people showed him all due deference. But he sensed that it was *they* who were distancing themselves from *him.* Their eyes were sharp. And when they saw collectively, they saw what he was unable to give them. They saw how, for them, he could only ever be the bridge.

The swine needed no directing. Soon Pryderi found himself following them along the required route. In the nights he slept beside them under the stars. He dreamed of a golden-haired clean boy, a beautiful youth with the eyes of a colt. He would wake up each morning full of tears. *Gwri,* Gwri: the name of the successor whom Pendaran had wanted. *Gwri,* whose words had set Pendaran on his way – and so confounded Pryderi.

When the caravan reached Rhuddlan, Pryderi established a simple court. Day by day his encampment was swollen by curious guests from the lands round about. Soon there were enough of them for Pryderi to kindle a fire beneath the cauldron. The swine were brought to him and slaughtered.

On the first night of feasting he wandered away from the fire and followed the river's course. When he turned to look back at the flame and the smoke, the echoes of revelry had become small in the distance. A single white horse stood motionless on the opposite bank, watching the water.

The night around Pryderi was still, satisfied. The whole of Dyfed was warming its hands at the red glow of the fires he had started.

Come, he said, looking to the stars. Come now.

On the second night of feasting twelve strangers arrived unheralded.

2

Pryderi heard new horses being quartered. He listened to the barking of new dogs near the pigs' enclosure.

From his dais, he watched the strangers entering the hall. Although he counted just twelve men, they gave the impression of being many times that number. A teeming presence, powerful and amused. His own people shied away from them. The guests, pearly-skinned youths for the most part, laughed at the effect they were creating.

Welcome, Pryderi called, raising an arm. Welcome to my refuge.

One of the men stepped toward the dais. He was older than the rest, bearded and confident, sinewy like Manawydan. As he skirted the fire he glanced at the cauldron. Inside it the joints of pork were already seething.

Lord, he said to Pryderi. This is the hall of a great man. We'd be glad to rest here tonight.

Pryderi nodded, immediately susceptible to his visitors. (Nothing is arbitrary, he told himself, elated. They've come because I need them to be here.) Sit beside me, he said. Your companions can take their places among my people.

As he sat down, the stranger rested his hand, momentarily, on Pryderi's arm. It was a collaborative gesture. Pryderi, exhilarated by it, chose to disregard his own people's refusal to mingle with the laughing young men.

What is your name? he asked.

No name that you know, the stranger replied with a confident smile. I am Gwydion, son of Don. One of the men with me here is my brother, *Gilfaethwy*. (He pointed him out.)

Pryderi looked from one brother to the other. You are from Annwvyn? he asked Gwydion.

Lord, the stranger replied after a protracted silence, Shall we eat?

Pryderi asked no more questions as the feast began. It was tense in that hall. The strangers, to a man, ate like predators. But Pryderi's people abstained. Pryderi

himself kept pace with his guests, bread and flesh, bread and flesh, and he shared many cups with Gwydion.

At one point, he called for a *gwyddbwyll* board and pieces. Gwydion played after the fashion of Manawydan. And Pryderi, remembering his foster-father's game well, was able to outwit his opponent time after time.

You're wise, Gwydion said to him at last.

No, said Pryderi, clapping his hands for more swineflesh, Never wise.

But this land, Gwydion said, apparently surprised. You have transformed this land. I knew the Dyfed of old. You have made it bloom. You have been the bridge. (He looked appreciatively around the hall.) That much you can't deny. And sometimes – you'll agree? – it is a form of wisdom *not* to calculate.

Pryderi, his interest quickening, searched Gwydion's face. A good astute face, the face of a versatile and eminently capable man. Whoever he was, wherever he had come from, Pryderi was predisposed to believe in him. Tell me, he said in a voice low with urgency, What I must do. Tell me now and I'll do it. For the sake of this land, my father's land, I'll do it.

Gwydion drew himself away. He was smiling but he looked undecided. In his hand was the bone of a pork joint, scraped white. The meat of these creatures is sweet, he said, So sweet.

Then have more! cried Pryderi, clapping, feigning exhilaration now. There is always more! (He's here, Pryderi had to remind himself, Because I need him to be here. He's here *for me*.)

The fire burned lower. Deep into the night scuffles broke out between the two companies below the dais. Drunken brawling which Pryderi was able to still with a single drunken shout. The young men grinned up at him. While Gwydion made Pryderi feel callow, these others seemed to be brandishing their youth at him.

It would be good, he said to Gwydion, To have some entertainment from one of your company. A song perhaps? A story?

Gwydion laughed. They have no songs or stories, he said. They are boys. Let me

speak to you. Let me speak to you of warfare.

He had a good tongue. He went on to describe what he called *The Battle of the Trees,* a strange fight at which he himself was present. It was a long and complex report. Pryderi, continuing in his cups, found it hard to follow. From the way his guest spoke, he could not tell whether Gwydion was referring to times past or to events yet to come. In the end he simply swayed, mesmerized, to the rhythms of the narrative. When it was over, the hall was dense with silence.

Now you must speak, said Gwydion, To me.

At once Pryderi began to talk of his sojourn in the *caer,* that dimly recalled golden respite which he had won with Rhiannon. But very soon his voice faltered.

Why do you stumble? Gwydion asked, kindly enough.

Pryderi closed his eyes. The darkness still swayed. Because I don't have the words, he said in his misery. And because, he added, I wish to be there still. This territory has no need of me. These people have outstripped their need of me.

Unlike Manawydan, Gwydion did not remonstrate with him. Instead he leaned closer. Again he touched Pryderi's arm. You could return, he said. There are many *caers.*

Pryderi hung his head. Is this why you came? he asked, his eyes still closed. (He was thinking of Gwri, whom Cigfa had called the better part of himself, and suddenly he was close to tears.)

How can I help? Gwydion whispered. Say.

Outside there was birdsong, a chorus for the dawn. Pryderi, half-opening his eyes, reached for the cup which Gwydion was holding. But his fingers brushed it clumsily. It fell to the ground. Slowly and irretrievably its contents spilled out.

Pryderi looked aghast into the body of the hall. All his people were sleeping. Only the glint-eyed young men had seen. I'm renouncing my realm and renouncing my trust, he thought. And he felt such shame.

He turned to Gwydion. The swine, he said before his nerve failed him, The swine

will not breed for me.

Breed?

I made a compact. It is proscribed to me to sell the swine or give them away until I have twice their original number.

And this is how you wish me to help you? asked Gwydion. You wish me to free you from those words?

Pryderi stared ahead of him at the cauldron, cooling rapidly now. I do. Free me, if you would. From the words.

Then come, said Gwydion, standing. Pryderi followed him out into the morning. The young men helped one another to their feet, awakening some of Pryderi's people as they did so. They all made their unsteady way outside, Gwydion leading them to where the horses and dogs had been quartered, next to the pigs' enclosure.

Here now, he said to Pryderi when they were beside the wall. Inside there were no horses, no dogs. Just fourteen pigs, small, white, red-eared, indistinguishable from Pryderi's infertile seven, save that one of the sows was heavily pregnant. Pryderi looked at them, initially, in disbelief.

My solution for you, said Gwydion, his breath curling in the cold. You can neither sell nor make gifts of your own swine. But you may *exchange* them - yes? - for the greater number. No one, he added conclusively, Ever spoke of breeding.

Pryderi turned on his heel. I can do nothing until I have spoken with my people, he said.

Of course, said Gwydion, resting his head on one side. I understand.

The confrontation came inside the hall. Already the seven swine were standing whole beside the cauldron, restored from the chaos of the previous night's bones. Behind them stood the race of Dyfed.

Pryderi saw the abhorrence in the eyes of the assembly. *You credulous fool* were the words that his people were still too obsequious to speak. Pryderi knew that

Pendaran had come before faces such as these, censorious, disparaging. They knew what he was going to say even before he set Gwydion's proposal before them.

One man spoke up, his eyes averted. This talk of exchange, he said, It's sophistry. (Pryderi heard the tightness in his voice, and he heard the billowing fear beneath it.)

Why does the stranger want our seven? asked a second man. He already has fourteen.

Pryderi tried to smile at them. Trust me, he said. He has come because we need him. I know that. Just as Rhiannon came, Manawydan came, when it was right for *them* to come.

The eyes stared back unconvinced. Pryderi himself had doubt. But nothing is arbitrary, he assured himself, Nothing before or during my life has been without purpose. And Rhiannon sent me here. She *sent* me. . . .

There was a commotion at the far end of the hall. Gwydion and his company strode in. Companionable Gwydion, composed, so eloquent. Yes? he shouted, grinning, to Pryderi.

The sovereign turned and walked up to the swine. All he could feel was his need — the need to be released. Yes, he replied shaking his head in irritation at himself. Yes, yes.

3

Pryderi had to drive the seven swine out of the hall himself. They went willingly. Not one of them looked back at him.

Gilfaethwy and the other young men were smiling along the riverbank. Pryderi loathed them for their smiles. Behind them a throng of his own people had gathered. Pryderi knew what they were seeing. He was powerless to act in any other way. It had never been in him to refuse the baits of Annwvyn.

Gwydion said nothing before he headed for the north. But the single glance he threw back at Pryderi was savage. In rapid succession there was the look of the stag in his profile, then, most alarmingly, of the pregnant sow, and then of the wolf. I understand that you can be anything you please, thought Pryderi, I understand that. But why don't you take me with you? Why do you make me stay, past my time?

He went to where the fourteen new pigs were rooting. When he stood among them he felt more isolated than he had ever thought possible. He wanted Rhiannon with him. He needed to be close to Cigfa. The loss of Pendaran, the withdrawal of Manawydan, they cut at him, ate at him.

His people were shuffling into a great circle. So indignant, so contemptuous, so many of them with the same unbearable thought that Pryderi could only laugh.

He raised his head, and scanned an empty horizon which would not come any closer. Somewhere, beyond, a new man was waiting. His eyes were seeing all this. Through the silence he was watching, making himself ready.

Pryderi pushed his way through to the hall. He stood before the cauldron with his hands resting on its rim. The metal was cold, and of no great thickness. The smell that came from its dregs made him wince. On the ground behind it lay the cup which he had mishandled. He lay down, curled himself about it, then slept an anxious sleep until night fell.

When he emerged from the hall, his people were still in their circle, stupefied, but closer now to the swine.

Bring kindling and fire, said Pryderi. And bring me the cleaver.

As soon as he had set the cauldron fire blazing, he addressed himself, bellowing, to the swine. He had never slaughtered his own pigs in the way that he massacred these. Never soaked himself so delectably in their gore, never screamed above the squalling of his victims. He hacked into fragments all but two of the new pigs. All but the pregnant sow and one boar, both of whom stared at him with impressive calm throughout.

Later that evening the cooked flesh was ample reward. Pryderi's people came alive again to the savour of that meat. Pryderi gorged his way through the night, answering their smiles with his own.

Then, when the women came forward, reaching for him, he saw no reason to turn them away. Black-haired, white-skinned women, tangled in the redness of his arms and his legs. Pryderi abandoned himself to them, roaring as his father had roared, so close to release, death after death in the middle of life.

And a white stallion raced through his dreams as he slept. Racing towards him, past him, away from its own kind of captivity. Blue-eyed, silvery white, with a mane flashing golden in the artificial dream light.

Pryderi recalled how he himself had felt on his passage back from Annwvyn: that the whole of him had never been in Dyfed, and that even less of him was returning. The thunder of this stallion was making him feel complete. Perhaps for no more than a moment, the ambiguity within him was resolved.

He woke on the following morning knowing that the exchange had been right, and would continue to be right. *Come,* said a voice inside him and beyond him, *Come now. . . .*

He rose. And immediately the differences closed in on him.

Where the bones of the twelve swine had been heaped, there were still only bones.

Where Pryderi was accustomed to hearing the new wholeness of his own swine, he heard nothing.

The cup was gone. He rushed to the cauldron. It was buckled, irredeemably cracked, and its foetid stench drove him back gasping.

He stumbled out into the daylight and saw at once the pregnant sow. Their eyes met. *You were right to do what you did,* said the eyes of the sow. *This doesn't make it wrong.* And Pryderi looked beyond her to see only the boar. This had been the true exchange. The versatile man had left him with mortal swine.

Pryderi's people were behind him already. He could not bring himself to face them. He knew how stubbornly they would misread what had happened.

You improvident man! one woman spat at his back. You vain, selfish, improvident man!

You were well named by your mother, wailed another. *Trouble!* Always trouble. . . . You have come among us – and you have brought confusion!

There was more. Much more. Pryderi could hear them weeping, dashing the useless bones into the dust as they scourged him with their sadness. But when he looked back at them there were no tears on his face.

Confusion! they spat at him again in vitriolic unison.

I brought you the spoils of Annwvyn, Pryderi shouted at them, turning. I brought you no confusion then. I brought the spoils here. Now they have been taken back. But see. . . . (With a sweep of his arm he indicated the full fields and the farmsteads and the two remaining mortal swine.) *This* is the way forward, for Dyfed, for you. Not trusting in creatures from Annwvyn for your sustenance. . . . Not depending on *me.*

How could we ever depend on you? said the spokesman from the day before, peering at him. He stepped close to Pryderi and he brought the crowd of mourners with him. You play with words, he continued. Forget your wordplay and retrieve the swine. *You!* Now!

Can you not see? Pryderi cried. All of this, the coming of Gwydion, it's a part of something larger. We – all of us here – we scarcely signify. . . .

We see nothing but subterfuge, said the spokesman, grimmer still. We hear nothing but words. Lead us and we will follow. Lead us again to the swine.

They will drive me to my death, thought Pryderi. Only then will they be satisfied.

By driving me to the centre. . . .

I stand at the end of one line, he said bowing his head. Presently there will be another. There will be a new man, better suited, more worthy. He will preside. I myself belong, now, to a time that has passed. . . .

But the old virulence had resurfaced in his people, and they had no use for his truth. What they needed was pursuit, reprisal, what they craved was a return to the old dispensation.

It cannot be, he told them. Believe me, it cannot be. This has to be an end.

Lead us! was all they would reply. *Lead us!* And in the end Pryderi capitulated.

At the head of his aggrieved people he set out along the path taken by Gwydion. A winding, improbable path it was. Soon they left Pryderi's own lands behind. But they passed quickly across the unfamiliar terrain, guided by those who had marked the passing of the twelve men and seven swine. Hour by hour their ranks were increased by new volunteers from Dyfed. It seemed to Pryderi that the whole of his territory was behind him. All but Cigfa, and Rhiannon.

When they encamped in the evenings, Pryderi would eat apart from his army. Although he said nothing, he suspected that they had constantly been given false directions. Sometimes in his sleep he would hear laughter, close by, quietly triumphant. It made him feel light. It widened the chasm still further between his implacable people and himself.

They said they were heading for the big strand, said a local youth, stepping towards Pryderi on the seventh morning. He pointed south, towards the western sea.

This is a tortuous route, Pryderi said to him, laughing abruptly.

The youth was equal to his quizzical gaze. There was an odd mixture of boldness and embarrassment about him. There are stories about that strand, he said shyly.

Pryderi laughed again. I wish to hear no more stories, he said. And the youth, blushing and shrugging, withdrew into the crowd that had emerged from his settlement. Pryderi carried the look of the youth away with him. Too late, he felt the chill of recognition. And when he doubled back to confront the youth again, no

one at the settlement owned to knowing him.

The pursuit was resumed. Pryderi knew that the end had to be near.

It was when the army of Dyfed came to *Y Velen Rhyd,* the yellow ford, that its quarry at last came into sight. There, on the far side of the stream, Gwydion stood at bay. He stood alone. There were no laughing young men. No swine.

Pryderi's people rushed toward the water.

No! their sovereign roared after them. And they stopped.

No, he repeated, coming to the water's edge and turning to them for the last time. Amid the rustle of murmurs, their faces showed surprise, even a trace of the old reverence. Pryderi feared that they would remember him only for his weakness. That was how it had to be. He had responded in the way he had thought best. He couldn't have done anything else.

Stand back, he said to them. It's not for you to fight. You cannot lose your blood on my account. I must face this man alone. . . .

When voices were raised against him, Pryderi held his hand imperiously aloft. *Enough!* he cried. I'll go alone. Can you not see? The swine are not with him. This is no matter for armies. Nothing that has happened, or is about to happen, is arbitrary. And should I be seen to fail, you will receive your due compensation, I promise you. Now all I ask is that you trust me. . . .

He heard birdsong through the silence before he turned. He felt more than one pair of eyes on his back.

But Gwydion was on his own. And in his hand was a sack.

4

*D*eath, Pryderi knew, *Is only the centre of a long life.*

He had no fear of dying. Here, at the right time, in the right place, he was ready.

Behind him the huddled crowds were murmuring. He had come from them. Soon he would be leaving them. He had been their bridge. They had looked to him for knowing, given him their land in trust. And now, at the end, he would have to leave them wanting.

Gwydion had spread his arms in greeting. A greeting which undeniably drew Pryderi to him at the expense of those who were watching. Pryderi eyed the sack in Gwydion's hand. His mind was full of noise: birdsong, the squalling of a child, an arm reaching out through a broken wall, a blue-eyed stallion still in flight. He looked into Gwydion's face and he cried out to him through his silence.

Pryderi stepped closer, into the shallow waters of the ford.

This was what you wanted, Gwydion called out, his arms still spread.

My people have driven me here, Pryderi called back. They wish me to recover the swine.

Gwydion allowed his arms to fall. He fingered the sack with both hands but kept his gaze on Pryderi.

There was no need for him to say a word. Pryderi understood that the swine, *those* swine, were gone for ever. Dyfed would be rich in pigs again – but creatures, from now on, of mortal stock. And Dyfed's planted fields would provide, again and again, for its people. This was the way forward, this was the path that led from dependence.

Pryderi stood tall and strong. My people, he said, They expect me to engage you in combat.

Of course, Gwydion replied, smiling. There seemed to be a brightness about him, an alluring glow. Pryderi knew that this man was all-encompassing. Why could the men and women of Dyfed not see that too? Why did they persist in mistaking the half for the whole?

153

Will Gwri come now? asked Pryderi. When I am gone? Is it *he* who has been held hostage, against *my* return?

Gwydion nodded, just as Rhiannon had nodded, to show that his questions were acute. You need not distress yourself, he said, Over Gwri.

But he's a part of me, yes? (Pryderi's voice was suddenly sharper, more insistent. He was seeing Gwri as the stallion become man, a whole and perfect man, where he himself had fallen short.) He's the better part of me?

No, not better, Gwydion said carefully. Better-suited, perhaps, to this land you have enhanced. You were the bridge that is needed no more. Gwri could not have been the bridge. His time is later, after. But through Gwri, through Cigfa, a part of you will always be in Dyfed.

The song of the birds skirled louder around Pryderi. He was seeing himself as a newborn child on that raucous first night, and even in his mother's arms, with his father standing before him, he was thinking: *There can be no end to this circuit.* He remembered it so vividly: hunched against the remnant of a wall, a taut cord pulling at his stomach, then the cord being slashed, and a new foal struggling to its feet beside him. . . .

The foal that, as a colt, had led him on to sovereignty.

The colt whose eyes had always been on him, even from its perfect prison in Annwvyn.

The white stallion which was thundering now through his dreams, towards the centre of his own life, here, at the yellow ford. Blue-eyed, golden-maned, so very white and fast, and right.

Gwydion was approaching. He gave no impression of physical strength. Lean and smiling, he moved almost delicately into the sodden ground. The brightness was still about him, stroking him, making Pryderi narrow his eyes. As he came closer, the air which Pryderi was breathing seemed to grow thinner. The frenzy inside his head disrupted the sequence of his thoughts.

Why should I trust you? he shouted at the versatile man. Why does it have to be

like this?

Gwydion kept on coming. You need trust no one but yourself, he replied. And the circumstances are of your own choosing. They always have been. You presume too much about those who have influenced you.

They were close now, no more than a man's length between them. Pryderi braced himself. Despite the tumult inside him, he knew his people had fallen quite silent. He felt that a measureless distance now separated him from them. In fact he doubted whether they were there at all, and whether they had *ever* been with him, around him, beneath him.

Feverishly he turned to see. And as he did so the ground beneath him reared up and Gwydion's hand alighted on his shoulder. Pryderi twisted round, rending the silence with his calling. He flung his arms about Gwydion, then dragged him down into the water.

There they fought, half-immersed.

But Gwydion was struggling to move *with* Pryderi, not against him. Pryderi soon noticed. This is no climactic struggle, he reminded himself with sudden clear-headedness, This is no more of a contest than any of the others. I could – even now if I so desired – prevail. . . .

And immediately it was as if Pryderi had extricated himself. As if he were watching the encounter from a vantage point high above the ford.

He saw his own arms and legs thrashing, he felt the pressure of Gwydion's embrace, he sensed his own breathlessness as the struggle wore on. But these were not his main concerns.

For looking down in his detachment he could see, where his people had been standing, the single form of Cigfa. And there, on the opposite side of the ford, was Rhiannon, waiting too. And between them, at the ford, two tired and smiling men drawing apart.

Then he watched Gwydion winning the respite, momentary but sufficient, to open out the neck of his sack.

His sack, Pendaran's sack, Manawydan's sack, first bequeathed by Rhiannon, but every time was the first time, every time was different.

Pryderi's eyes were now on Cigfa, and he was remembering what Gwydion had told him: *The circumstances are of your own choosing. . . .* A land, a cup and a woman, he had relinquished them all without undue anguish. He had chosen to be confronted by Gwydion, chosen to be grasped again, chosen at last to be hurled, so effortlessly, into the oblivion offered by Gwydion's gaping sack.

Not danger but drama, he cried silently as the whorls of song swept him on beyond the centre, *Not an end but a beginning. Not death but return. . . .*

It was over. The fine white stallion was upon him, pounding through him, emerging.

And Gwydion whispered *Enough!,* then pulled the drawstring tight before knotting it.

A F T E R

There can be no end to this circuit.

The sovereign, acquitted and unbound, sleeps through the sepulchral calm. In his sleep he clearly sees the stallion become man. This man comes from the sack, lifts himself from the earth and water. He walks toward the woman who proffers the cup, which he duly takes, along with the woman herself. Gwri, from out of Pryderi, a father for Cigfa's children. The necessary exchange, preparing the way for the countless exchanges to follow.

The sleeper dreams on.

His old land prospers in his absence. Head men come, preside, then return: the right man, the right descent. Sovereigns at the centre of a circle, dispensers, arbitrators.

Still Pryderi dreams, knowing that he will wake.

He is remembered less than perfectly by the generations of Dyfed. The son of Rhiannon, the son of Pendaran, prepared by Manawydan, released by Gwydion. His purposeful people confuse themselves over how he came, and when, and why. They talk, without certainty, of a final deception, there, at the far end of the bridge.

Pryderi, for his part, remembers one man. A man, a mare and a simmering cauldron. A man who was the first.

And in his sleep Pryderi smiles.

Then, slowly at first, the song of the birds breathes new life through him.

Wakeful, he hears the voices summoning him. Melodious voices. Pwyll! they cry, Head of Annwvyn!

He opens his eyes to the sunlight.

He is in a valley. Gorgeous meadows lead down to a quiet river, and on either bank a flock of sheep is waiting. Beyond them he sees the herds of swine, fine dogs, splendid horses, milling crowds of men and women. But all is silence, all save the birds are silent.

Ahead of him stands a single tree. Above his head is the mound. The tree does not burn. The sight of the mound — of no great height, it seems — fills him with neither guilt nor dread. Then

163

he realizes that his people are not seeing him.

He opens his mouth. He tries to rend the silence with his calling. But the people no longer hear him. His people, Gwri's people, forming their own circles now, responding — as they always have done — to the insistence of their land. Cigfa's people.

Pryderi's face is streaked with tears. This land looks glorious. Dyfed, the tongue on the face of the island of Prydein, lapping at the western sea. A part of you, *a voice has told him,* will always be in Dyfed. *Only a part, a good part, in the land of his father.*

He stands in that place until the sunlight begins to fail.

As the dusk then merges with the dark, warm lights appear beneath the sky. It is, Pryderi knows, the Eve of May. In the deep distance he hears the barking of hounds. Hounds which are not of this world.

Eventually, when the birdsong and the barking have been stilled, a hand touches his shoulder.

I'm here, *says the voice behind him, a woman's voice, the voice of someone old in the throat of someone new.* I'm here for you.

Pryderi turns.

Further Reading

There are many books, both academic and popular, on Celtic myth, legend and folklore. The following titles may be of interest to those as yet unfamiliar with the ancient literature of the British Isles. Much of this literature, it should be said, is extremely accessible to the non-specialist reader.

Texts
The Mabinogion, trans. Jeffrey Gantz, Penguin Classics.
The Mabinogion, trans. Gwyn Jones and Thomas Jones, Dent Everyman.
Trioedd Ynys Prydein (The Triads of the Island of Britain), ed. and trans. Rachel Bromwich, University of Wales Press.
Early Irish Myths and Sagas, trans. Jeffrey Gantz, Penguin Classics.
A translation of the early Welsh poem 'The Spoils of Annwm' is included in *The White Goddess*, Robert Graves, Faber & Faber.

Historical Context
The Celts, Nora Chadwick, Pelican.
Pagan Celtic Britain, Anne Ross, Routledge & Kegan Paul.

Studies of the Literature
Celtic Mythology, Proinsias Mac Cana, Newnes.
Celtic Heritage, Alwyn and Brinley Rees, Thames and Hudson.
Myths of Britain, Michael Senior, Guild Publishing.
Gods and Heroes of the Celts, Marie-Louise Sjoestedt, Turtle Island.
Celtic Myth and Legend, Charles Squire, NPC.

Contemporary Retellings
These are often intended primarily for children, e.g. *Island of the Mighty*, Haydn Middleton, Oxford University Press. But *Bran, Son of Llŷr* and *Taliesin and Avagddu,* both by Moyra Caldecott and published by Bran's Head, are successful attempts to present and develop classic texts for older readers.

By the same author:

The People in the Picture (Bantam Press)

Island of the Mighty (Oxford Myths and Legends Series)